FORM, SPACE, AND VISION

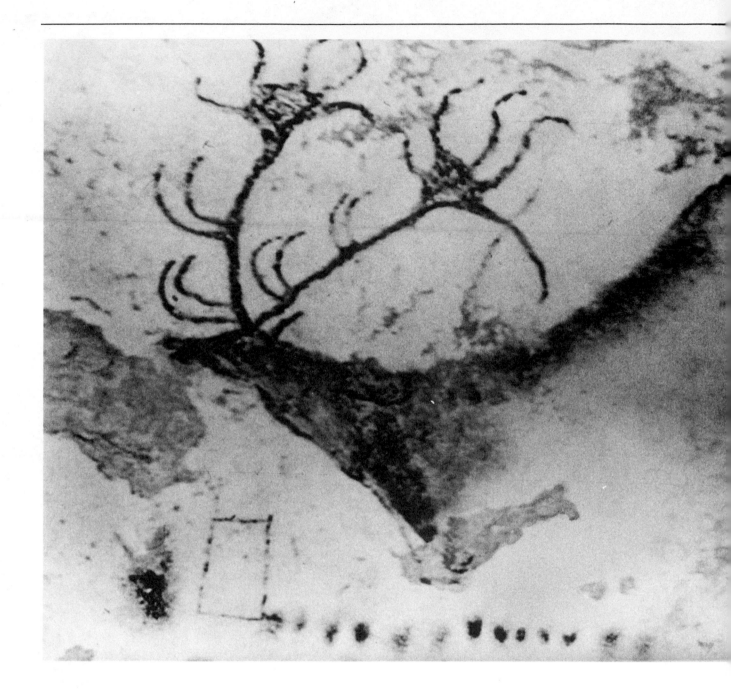

FORM, SPACE, AND VISION

an introduction to drawing and design

FOURTH EDITION

GRAHAM COLLIER

Library of Congress Cataloging in Publication Data

COLLIER, GRAHAM.
 Form, space, and vision.

 Bibliography: p.
 Includes index.
 1. Drawing—Technique. 2. Creation (Literary,
artistic, etc.) I. Title
NC730.C6 1985 741'.01'8 84-11662
ISBN 0-13-329442-0 (pbk.)

FORM, SPACE, AND VISION
Fourth edition
GRAHAM COLLIER

10 9 8 7 6 5 4 3 2 1

Production editor and interior designer: Hilda Tauber
Art production and layout: Gail Cocker
Cover design: Whitman Studio, Inc.
Manufacturing buyer: Harry P. Baisley

FRONTISPIECE: *Red Deer from Lascaux,* ca. 12,000 B.C.
Caisse Nationale des Monuments Historiques, Paris.

ISBN 0-13-329442-0 01

PRENTICE-HALL INTERNATIONAL, INC., *London*
PRENTICE-HALL OF AUSTRALIA PTY. LIMITED, *Sydney*
EDITORA PRENTICE-HALL DO BRASIL, LTDA., *Rio de Janeiro*
PRENTICE-HALL CANADA INC., *Toronto*
PRENTICE-HALL OF INDIA PRIVATE LIMITED, *New Delhi*
PRENTICE-HALL OF JAPAN, INC., *Tokyo*
PRENTICE-HALL OF SOUTHEAST ASIA PTE. LTD., *Singapore*
WHITEHALL BOOKS LIMITED, *Wellington, New Zealand*

CONTENTS

PREFACE vii

Orientation: why we draw 1

PART ONE **Mark and Space: the figure-ground fundamental** 11

1 The Graphic Encounter: marks and content 13

I. *The Basic Drawing Marks: Point, Line, Area* 13
II. *The Language of Graphic Marks: Natural Content* 21

2 Ground: space perception and structure 56

I. *Space and Figure-Ground Perception* 57
II. *Space Composition* 74
III. *Space as Positive and Negative* 97

3 Figure: basic structural characteristics 105

I. *Skeletal or Linear Qualities* 109
II. *Mass: The Structure of Solid and Spatial Volume* 127
III. *Composite Organization: The Organic Union of Parts* 142

4 The Textural Weave: figure and ground 153

Tactile, Spatial, and Expressive-Conceptual Aspects 154

5 **Dynamics: dual forces in art and nature** 166

 I. *Equilibrium/Turbulence, Stability/Motion* 166
 II. *Optical Dynamics and Illusions* 207

6 **The Human Figure: structure and action** 210

PART TWO **Vision: the creative factor** 221

7 **Immediate and Developmental Vision** 226

 I. *The Momentary Recognition of Subject* 226
 II. *Discovering and Developing the Motif* 244

8 **Creative Transformation: order, expression, and symbol** 253

 I. *The Imagination and Order* 255
 II. *The Imagination and Expression* 257
 III. *The Imagination and Symbol* 258

9 **Vision and Abstraction: using non-objective form** 270

GLOSSARY 282

INDEX 286

PREFACE

It is just over twenty years since the first edition of this book appeared, so it is time to omit the original Foreword written by Sir Herbert Read and reprinted in successive editions. Were he alive today I would ask him to look at this new edition and deliver a fresh judgment. As it is, the book must now speak for itself.

Form, Space, and Vision was one of the first texts to be used in basic drawing and design courses, and its long-lived success encouraged others to publish a variety of studio-oriented books. None of them, however, has seriously challenged the particular approach to drawing we initiated for developing objectivity in seeing, introducing the fundamental ways to graphically shape what we perceive, and then stimulating thought and feeling as a personal response. This fourth edition seeks to further develop and intensify these objective and subjective aspects of drawing.

To accomplish this, the text has been completely reorganized and rewritten. Each chapter now presents, in logically assembled units, *all* the relevant aspects of the theory under discussion, thus providing a more comprehensive body of information than was previously the case. The new presentation will enable instructors to focus attention more specifically and to give precise reading assignments. At the same time, many more detailed drawing exercises are provided to give both instructor and student a wider variety of choice when it comes to the actual practice of drawing. Somewhat over 60 percent of the masterworks and student drawings are new. In addition, diagrammatic materials are used wherever they can help to illustrate a difficult point. Such visual aids are an important feature of this edition.

We begin with an introductory chapter that answers a question frequently asked by students with little background in the visual arts: "What is so special about drawing and why should we bother to draw? In the Orientation we suggest why drawing is such a revelatory experience, and why we human beings need to draw out of ourselves the images that we call art.

Chapter 6 is completely new, introducing the student to the structural and dynamic problems which attend the drawing of the human figure. By treating the anatomy of the figure in a simplified way, the fundamental difficulties of figure drawing are exposed and graphic solutions suggested. The aim is to remove the average student's fear of drawing figures by providing a method which allows rapid sketching of the body in every conceivable position, thus stimulating enthusiasm and building confidence.

Recognizing that the primary role of this book is to instruct and guide the reader on a course of visual exploration and drawing response, I have modified the narrative approach of the previous edition. Definitions abound and stand out typographically; also charts, tables, and diagrams are used to consolidate information in accessible form. The practical work is assembled in the Workbook exercises at the end of each chapter or subsection of a chapter, and each exercise is numbered and titled for easy reference and identification. The new arrangement will keep the reader on track, conscious of the logical progression in theory and practice, and aware of the increasingly complex contribution he or she is asked to make.

All in all, my intention has been to find the happy medium between "a good read" and a solid learning experience.

In writing this new edition I have become aware of the single, most important difference between our approach and that of other texts: This book not only trains objectivity both in seeing and in the graphic "facts" of drawing, *but also encourages students to apply this knowledge to serve a subjective response*—to trust their own thoughts and feelings when involved in the Workbook exercises. This attempt to train the imagination constitutes both the appeal and the uniqueness of *Form, Space, and Vision*. It also, I suspect, accounts for the book's long life. You will find Part Two substantially expanded in order to introduce a more sophisticated account of the *creative* factor—the ways in which the artist's imagination transforms visual experience into the new forms we call art.

Our aim is not simply to suggest ways of handling drawing media, or to lay down rules of object representation. Rather our concern is with *how to see*—with the physical eye as well as with the "inner eye." What this book tries to do can be summed up best in the words of Max Scheler:

> The purpose of art is not to reproduce what is already given (which would be superfluous), nor to create something in the pure play of subjective fancy (which can only be transitory and must necessarily be a matter of complete indifference to other people), but to press forward into the whole of the external world *and* the soul, to see and communicate those objective realities within it which rule and convention have hitherto concealed.[1]

[1]Max Scheler, *The Nature of Sympathy*, trans. P. Heath (London: Routledge & Kegan Paul, Ltd., 1954), p. 253.

ACKNOWLEDGMENTS

A number of people have been very helpful in the preparation of this edition. I thank each of you individually, even though I cannot mention everyone by name.

Professor Robert Kiley's support and friendship over the last twenty years have been invaluable, and his insights have helped to clarify my thinking. I returned from a visit to Montana with some of his elegant brush drawings in the "Chakra" series, several of which are reproduced here.

I am indebted to my colleague, Professor Robert Nix, for allowing me once again to use a large number of his photographs of things common and uncommon. I also thank Professor Paul Edmonston for allowing me to use a number of his landscape drawings in this edition.

I would also like to thank those students who responded so well to the challenges of drawing in an art course that their work appears in these pages. Special thanks go to Betty Peebles, a graduate student in sculpture, who worked with me continuously on drawing projects for this book. The quality of her work shows how well good sculptors draw.

Once again I am particularly indebted to Mr. Henry Moore for allowing me to use a variety of examples of his genius—from simple sketches to full-blown sculptures. Many of the drawings have not been widely reproduced, appearing first in David Mitchinson's *Henry Moore: Unpublished Drawings,* and I am grateful to the author for allowing me to show them here.

Mr. Victor Pasmore is also well represented, to our great advantage. He enables us, better than anyone, to clearly see the progression from the representation to the abstract image. I also want to thank my old friend John Piper who is represented with two forceful landscape drawings and a figure study. One more artist whom I must acknowledge is Bette Lee Coburn, a painter of powerful mandalas, who has done her best to keep me at my writings over the years.

Finally, I want to thank Norwell Therlen and Hilda Tauber for their roles in bringing this book into being. I am always amazed to see how an editor-designer can transform the "sow's ear" of a manuscript into the "silk purse" of the printed page, especially when so many heterogenious elements have to be brought together. Hilda Tauber has succeeded admirably in achieving the happy medium between didactic and narrative extremes that I wanted.

I dedicate this book to Patricia, who has made so many things possible for me in my life.

GRAHAM COLLIER

FORM, SPACE, AND VISION

ORIENTATION
why we draw

[The artist is] a being who differs from you only in that he is able to master life by the use of his own specific gifts; a being perhaps happier than the man who has no means of creative expression and no chance of release through the creation of form.

PAUL KLEE

IN THE BEGINNING was the Drawing. At least fifteen thousand years before the appearance of writing, cave-dwellers were engraving lines on pieces of bone and impressing stains over rock walls. Indeed some scholars suggest that this form of graphic activity—what we loosely call drawing—was practiced as long ago as 40,000 B.C., during the Old Stone Age. These cave and rock drawings are the earliest images made by man of which we have any knowledge.

From these drawings we know about the Paleolithic people's obsession with the animals so necessary for their survival, and can testify to the keenness of their observation. In many cases the artist's empathy for his subject is evident through the expressive vitality of line and the spirited movement imparted to the image. When we look at the deer from the caves of Lascaux (see frontispiece) we find it hard to believe that the person who drew this with such skill and display of feeling lived more than thirteen thousand years before Leonardo da Vinci. The deer, portrayed as it kneels to drink, becomes an elegant curvilinear design from the tip of its twirling antlers to where the final arching of the back and rump disappear into space. It appears light as a feather, a tremulous creature more ethereal than earthly, "suffused," as the art historian Marcel Brion puts it, "with love of form, of life and of the animal."

Strictly speaking, the Lascaux deer is perhaps more a painting than it is a drawing—although the distinction between these two terms is often too fine to bother about. To me the essence of the verb "to draw" is the act of *marking*—of grasping, through the act, the fundamental form the work should take.

This can be done just as significantly by spreading paint to create lines and areas of visual clarification as by employing pencil or pen, which do the same thing only with perhaps a little more flexibility and structural refinement. I would define the difference by referring to the element of color. When color is used extensively, or when it dominates in one's perception of an image, then the work may be justifiably described as a painting.

One reason for starting with the deer from Lascaux is to point out that fine drawing has been going on for a long, long time. Another reason, and perhaps more important for our purposes, is to emphasize that in the beginning, art was not practiced to beautify the home or to satisfy cultural interests and become a commodity to be bought and sold. Instead, it was a way of participating in the forces which determined the fortunes of life itself. "Art was not," as Pablo Picasso once said, an "aesthetic operation," but a "form of magic, designed as a mediator between this strange, hostile world and us, a way of seizing the power by giving form to our terrors as well as our desires. . . ."

The animals that were drawn upon the cave walls and ceilings during a period of some twenty thousand years did not serve as domestic decoration. They are found in underground galleries and halls often far removed from the living quarters—secret places, difficult to access. And although we do not know with any real certainty why the Paleolithic hunters—for we assume that the artists came from their ranks—continued to draw and redraw every species of animal in these vast caverns, it is generally assumed that the act was a means of *bringing the animal into being* within the cave's sanctuary-like remoteness. To the prelogical mind, capturing the animal's liveliest characteristics of personality and behavior was a means of spiriting away the animal's very life force. Thus, to have caused the creature to materialize in the drawing became a magical way to possess it, and so to be capable of controlling its destiny, even to the point of subjugation in the hunt.

In other words, the first artists in history believed that *to create and retain, in some sacred place, the likeness of a thing vital to one's interests was to have power over the thing itself, and thus indirectly over one's own fate.* A powerful reason for drawing, was it not?

Drawing AS A MAGICAL ACT may well be a notion to scoff at nowadays. After all, the practice of art is widespread, no longer the prerogative of a gifted few. People have time on their hands and are trained and encouraged to pursue "cultural" activities that enrich their lives by providing an imaginative outlet. But such reasons for drawing and painting hardly have the "art for survival's sake" urgency which motivated the work of the Paleolithic hunter-shaman. Nevertheless, it would be a mistake to think that the present social proliferation of art has completely diluted the power of these early drives. We are still subject to an elemental and powerful inner life of thought and feeling which finds its outlet through the making of images.

Before smiling tolerantly at this suggestion, let us see if modern times have really freed us from the grip of naive and irrational forces when it comes to the way we regard certain images. For example, would you agree that we use a photograph of someone we care for not only to keep the details of their appearance alive in the memory, but also to promote a feeling of "closeness" to the other; that such a portrait can reassure us in times of uncertainty, overcoming the distance of separation by initiating a kind of telepathic communica-

tion—a magical or supranormal form of involvement which, psychologically, can be very convincing? Even when the photograph or drawing is of someone who has died, possession of the image still seems able to provoke a strong sense of continuity—an ongoing relationship between the living and the dead. And if this likeness were to be lost or stolen, then would one's concern be entirely rational? With the loss of the photograph the psychic connection is weakened and one might worry that things were not quite right, either with the person loved or with the relationship itself. And if the photograph were found, but defaced in some way, then the fear of a genuine injury to the other could become irrationally strong. (In remote parts of Spain and Italy, people still refuse to be photographed by a stranger in the belief that possession of one's likeness can give power over one's soul.) These examples show that when the thing or person represented is important to us, we still link the fashioned image to the real object in a psychologically significant way.

Although drawing today is not a matter of "seizing the power" in the hunt in order to survive, the magic of possession, in a modified form, still constitutes an important motivation to draw. For in making a drawing one is shaping consciousness in one's own way, and in so doing is affirming, clarifying, and possessing life more fully by giving experience a tangible and permanent shape. Otherwise, significant events are lost in the flow of time. Drawing enables us to capture the fleeting moment and make it ours permanently. Through drawing we may find a way, in the words of the contemporary British artist Francis Bacon, "to trap a moment of life in its full beauty."

Another way to capture the fleeting moment is through photography. Let us look at a drawing and a photograph side by side. The English painter Paul Nash was deeply interested in photography. He used the camera as a means of extending his own keen eyesight, as a third eye which could record, compose, and then fix the visual scenes that attracted him. In this way he compiled a large library of photographic prints that he could use as visual references for drawing or painting. Many of these photographs are not mere snapshots intended just to jog memory. They are appreciated as stimulating images in their own right—as examples of selective looking, of unusual visual composition—and are now part of the Tate Gallery's national collection in London.

Like many painters and sculptors, Nash was always on the lookout for the "found object"—a gnarled tree root, whitened bone, or weathered rock—that could excite his interest. Figure 0-1 is his photograph of such an object and Figure 0-2 shows the resulting drawing, which the artist called *Wood Fetish: Found Object Interpreted.*

The word "interpreted" is important here, for it speaks to the fundamental nature of the *artistic drive, namely: to transform the shape of external objects into a new visual form which fits more exactly the intensity and quality of thought and feeling aroused.*

It is when the found object acts as a catalyst to trigger new levels of self-awareness in the artist that it demands interpretation. Its meaning must be brought out. *Drawing provides the most effective means to discover the physical transformation which best yields this meaning.*

Look at Nash's photograph and drawing and judge for yourself. The changes wrought by drawing are self-evident. The features of the natural object have become more clearly defined; proportions are changed; new configurations of holes and ridges have appeared; and a dramatic chiaroscuro completes the transfiguration.

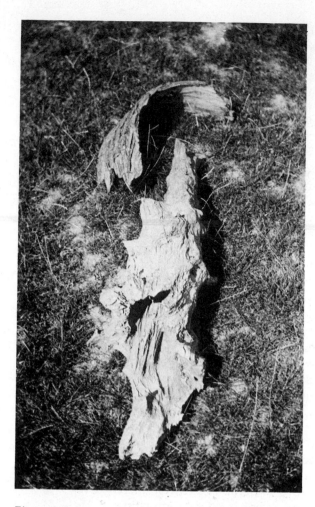

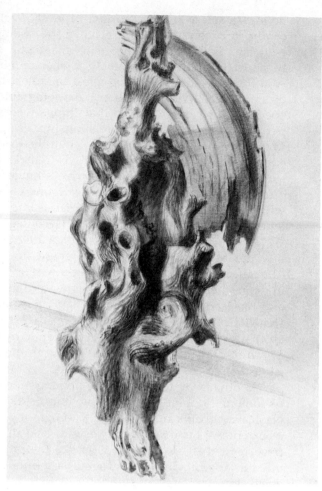

Figure 0-1
Paul Nash. Marsh Personage. *Found object 1934.*
TATE GALLERY, LONDON.

Figure 0-2
Paul Nash. Wood Fetish: Found Object Interpreted *1934.*
COLLECTION: MICHAEL SAUNDERS WATSON, ROCKINGHAM CASTLE.

Such are the capabilities of drawing to transform—to create the embryonic new form in a way unmatched by any other medium. This is all best summarized by the distinguished historian and philosopher, Etienne Gilson:

> If it is a question of duplicating reality, no sculpture done by an artist will ever equal a plaster cast done from nature. Nor will any painting ever equal the accuracy and completeness of a good photograph. But a true painter does not borrow his subject from reality; he does not even content himself with arranging the material provided by reality so as to make it acceptable to the eye. His starting point is fantasy, imagination, fiction, and all the elements of reality that do not agree with the creature imagined by the painter have to be ruthlessly eliminated.[1]

But shall we let Leonardo have the last word? Artists, he said, are "grandsons unto God" (*Notebooks*, II, p. 227).

[1]Etienne Gilson, *Painting and Reality* (Cleveland: The World Publishing Company, 1961), p. 133. I see no difficulty in taking the words "painting" and "painter" as synonyms for "drawing" and "drawer" in this context.

4

DRAWING AS A NATURAL FORM OF SELF-EXPRESSION is much more widely accepted today than in Leonardo's time. The modern educational system has opened a variety of doors for people, one being the oppportunity to learn and practice the art of drawing—for pleasure and for profit. With the great explosion in communications over the last fifty years, books, radio, television, film have all contributed to spread the "gospel" of art as culture. Couple this with the democratic stance of modern times—the tendency to place highly original and inspired work outside the mainstream, and to feel generally more comfortable with less élite performances—and we see that the stage is set for many of us to try our hand at one form of art or another. Furthermore, as people have more and more leisure, many are turning to drawing, painting, and sculpture as natural, accessible means of self-expression.

These conditions are a far cry from the Italian Renaissance, when painters, sculptors, and architects were members of a highly esteemed professional élite, and when genius was generally considered divinely inspired.

Today you don't have to be a genius to try your hand at art. Everyone can enjoy drawing for its own sake—for the pleasure of learning something about it and also of experiencing the magic it works by, in the words of Paul Klee, allowing one to "master life." It is certainly not necessary to possess the skill and insight of genius in order to reap these rewards.

We know today that the ability to draw is more universal than was previously thought. If one is not intimidated by the aura of exclusivity and uniqueness which still lingers in the wake of the Renaissance masters, there is nothing to prevent our approaching drawing naturally, thereby satisfying our need to live from time to time in the world of mind and imagination.

So far as we know, every hunter in a Paleolithic community may have made a drawing or two. Certainly, within a particular period, many hands were involved in these great galleries of the animals. And, quite obviously, some hunters were much better at it than others. I wonder, was there at any time a Leonardo of the caves? If so, it does not seem that his presence inhibited less able shaman-artists from having a go at making their own magic.

The best evidence we have nowadays to support the view that drawing is a natural way to make a personal statement is found in the art of children. I am referring to the fact that so many children take to drawing as often and as easily as a duck takes to water.

Children draw on sandy beaches with sticks, on rocks with sharp stones, on sidewalks with pieces of chalk, on walls with their fingers and—when wet Saturdays come around—on paper spread over the dining-room or kitchen table. This omnivorous, youthful appetite for drawing led John Piper, the English painter, to say one day—with a certain amount of exasperation—that, "Child artists are the natural enemies of adult ones." What he was getting at is that many children's drawings possess two vital qualities: They are vigorous and direct; and they carry an imaginative conviction. In contrast, adult drawings can appear self-conscious and labored, eclectic and pedestrian. Look at the sheer exuberance of the drawing by a 6-year old in Figure 0-3. What a great feeling it is to go bouncing up and down on the springiest chair in the house! Of course, you must not be caught; hence there is an air of secret adventure in Ruth's drawing. It is difficult to imagine how a more sophisticated adult drawing would capture the innocent yet intense quality of such levitations, convey the pleasing slinkiness of sliding into the seat for takeoff, and suggest the surprise and exhilaration that accompany an escape from gravity, hovering for a split second in space. But children rarely give a thought as to *how* to draw.

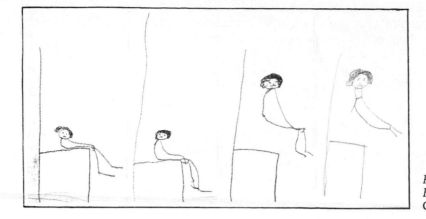

Figure 0-3
Ruth Collier.
Girl Bouncing *1957.*

Worries about technique or about matching predetermined "arty" standards do not generally inhibit their enjoyment of drawing. Consequently they tend to draw naturally, intuitively; the act becomes a means of shaping life's actual pleasures as well as its imagined joys and terrors.

As we grow older—usually by the age of 12 or so—we tend to become both self-conscious and self-critical about drawing. The need to be "photographically" accurate in rendering the picture takes over, and our apparent lack of skill inhibits further involvement. The stock response at this point—and it persists throughout adult life—is, "I can't even draw a straight line." An odd excuse this is, since the ability to draw a straight line has never been considered necessary for the practice of art. Contrast this with the reply I received from a youngster of about 5 who, responding to my "What are you doing?" said, without shifting his eyes from the paper, "I'm putting a line around a think." I had noticed him chewing his tongue as he worked, totally immersed in the emerging picture. His completely unstudied response provides a clue as to how children are able to draw so naturally, unconcerned about representational accuracy or adult standards.

For the average child, drawing is a form of knowing—a way of externally shaping, and so clarifying, the press of thoughts and feelings with which the young mind is absorbed. Yet we turn away from this first mode of self-expression—the pictorial way of visually consolidating our attitudes, our "knowings"—and words take over as formal education proceeds.

But I do not believe that the early habit of drawing is ever quite forgotten, ever quite lost. Many grownups will admit to an affectionate memory of days spent with colored crayons, assorted pencils, a paint box, paper, and a kitchen table cleared for action.

Keep this in mind when called upon later to make drawings. Because drawing is not necessarily a matter of breaking new and difficult ground, but rather one of taking up a familiar pastime—one which came naturally and supported a rich and satisfying pictorial imagination.

DRAWING COMES FIRST in the practice of the visual arts. This may seem too obvious to state. After all, we know that innumerable paintings and sculptures start life as drawings, and that architectural forms evolve from early freehand sketches. But I am suggesting that drawing comes first not only chronologically but because it is the primary way to fashion a visual image. The initial spirit of discovery can imbue the work with a certain creative vitality, a quality that may not be present in a more complex work of art where a

lengthy and demanding process of execution can often stifle those first, fresh insights. The reasons why the drawing pure and simple intrigues and holds our interest can be stated as follows:

a. The impressing of marks over a surface is the natural and primary way to begin any visual forming. Thus there is a directness and immediacy to such marks which carries conviction.

b. Because such drawings represent the first step in bringing the work of art into being, they are the immediate bridgehead to the creative center—to the source of imaginative thought and the deep wells of feeling—and so are likely to convey the essential spirit or intent of the artistic endeavor.

c. A built-in function of drawing is to search out and lay bare the structural "bones" of the emerging image—to establish the graphic signposts as to how material surfaces are disposed in space. Consequently, the act of drawing can impart a visual lucidity to the image, often in startling contrast to the confusing flood of visual impressions we experience in life.

One of my favorite examples of a drawing that illustrates the qualities we have been discussing is *Plum Blossoms* (Fig. 0-4), by the seventeenth-century Chinese master Tao-chi. Here is how the criteria just listed apply to this drawing:

a. The graphic markings have a directness and "rightness." They are impressed with an ease and finality which is completely convincing.

b. A lyrical atmosphere pervades the work. Its creative integrity springs from the heart and so conveys the essential spirit and intent of the artist.

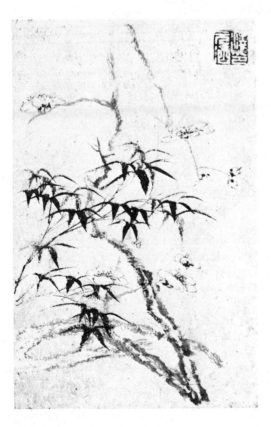

Figure 0-4
Tao-chi. Plum Blossoms, *early 17th C.*
From "Returning Home" by Wen Fong.
GEORGE BRAZILLER INC., NEW YORK.

c. As a pictorial statement the image is visually concise and clear. The ease with which we perceive the positional relationships set up between the various blossoms and bamboo, the nature of their rhythmic movements, and the spatial pattern which is thus created, indicates that the artist has given us the "bones" of the piece—the graphic essentials which say what must be said efficiently without overloading the page, and therefore the eye.

DRAWING MAY BE THE LAST MEANS OF SHAPING as well as the first. This statement is not a paradox, nor does it diminish anything we have said about drawing's prime role in setting things in motion. What it means is that a drawing can approach several creative levels. For although *all* drawings initiate the forming process, some remain as studies from which more complete images will grow while others—like *Plum Blossoms*—not only represent the genesis of a work of art, but also satisfy as a fully evolved creative statement; they seem to embody the first and the last word of the artist's response to the original stimulus.

Obviously, much depends on an artist's "creative condition"—whether it is simply a matter of *exploring* ways to shape ideas and express feeling; or whether a level of mental readiness has been reached which is so comprehensive in terms of imaginative awareness that the resulting drawing both originates the theme and completes it at one and the same time. Rarely is a study by Leonardo da Vinci simply a study; while a particular drawing may be but an exploratory note on the page, it is also, more often than not, artistically complete in itself.

It may be the mark of genius when even the simplest sketch usually seems complete. Nevertheless we should recognize that a range of artistic possibilities exist between the first level of creative initiation and that of full creative realization. A drawing can hold a position anywhere on this scale; it can be more or less whole depending on how commitment and skill came together to produce that combination of shape plus meaning by which a drawing lacks nothing. Writing about the Viennese artist Gustav Klimt, the art critic Arthur Roessler said: "Klimt destroyed thousands of drawings . . . if they failed to convey *the desired effect in the tersest possible fashion*." If this is so, I think Klimt was rather hard on himself, for it is said that "he could draw like an angel." Yet the part of the statement I have put in italics is perhaps as good a definition of the complete drawing as you will find.

IN SUMMARY, this chapter has tried to "set the scene" for what is to come by showing how worthwhile drawing is in itself, and giving some of the reasons why drawing has been so constantly used as a way of shaping awareness. I have touched on a few of the significant factors; some courses introduce other emphases. I hope that what has been said will set you off on the right foot. I hope it will cause you to recognize what drawing as an activity has to offer, and ensure that you approach the work in a genuine spirit of interest, if not of adventure.

The following recapitulation will help you to review the salient facts and reinforce the sense of personal involvement in art which I believe to be so important. No other chapters in the book are summarized, because each concentrates on a particular aspect of drawing instead of ranging over the art spectrum as we did in this chapter.

In the Beginning

- *The precedence of drawing.* The drawings and paintings of the Paleolithic period antedate all records by at least twenty thousand years. The need to make images must be seen as an early drive to graphically shape or picture life's important experiences.

- *Clarifying visual perception.* The Deer of Lascaux reveals the keenness of a master artist-hunter's eye. The stance and physique of the animal are acutely observed and are rendered with great assurance. The drawing thus becomes a clarification of visual experience—a way of analyzing and accurately recording what has been seen.

- *Personal expression.* The Deer also bears witness to the cave-artist's need to express, in the fashioning of the image, the nature and strength of his feelings for the animal.

- *Virtuosity of performance.* Skill in drawing is not a product of what we think of as civilization; but would seem to be a natural attribute of the master artist at least as early as 15,000 B.C.

- *The mystique of drawing.* In societies which give as much credibility to intuitive thought as to rational, the belief exists that to shape an image of a creature or person is to establish the power of psychic possession—that is, to forge a link between object and image which allows the artist, as creator of the image, to grasp and have mastery of that which is drawn. We assume that Paleolithic drawings on rock and bone served this purpose, ensuring success in the hunt because the animal, in the form of its drawn likeness, was the in the hunter's power.

Drawing as a Magical Act

- *Persistence of the mystique.* Although few people today could subscribe so naturally to the Old Stone Age belief in such sympathetic magic, nevertheless some deep traces of this prelogical attitude to object and image remain with us—particularly when our deeper and more important relationships with others are involved. A photograph of someone loved, acting as image, can establish a strong mental link to the other, even during long periods of separation and over thousands of miles.

- *The present psychological appeal of drawing.* The old mystique is still there, but has undergone some modification. In essence drawing is a means by which we can participate with some authority in the life of things—albeit in a more sophisticated way than that sought by the primitive artist who was struggling simply to survive. Now that survival is not the issue and we have time for reflection and enjoyment, we become aware that life slips away through our fingers as one event follows another. Drawing therefore is not only a way to visually shape and consolidate experience in the tangible image, but it also removes an event from the flow of time and allows us to possess life by rendering significant happenings permanent.

Drawing as a Natural Form of Self-Expression

- *The ability and tendency to draw is innate and widespread.* We see this in the intuitive approach of children who, when given the opportunity, are often prolific artists. They are not inhibited by thoughts of "professional" standards, or by doubts concerning their "creative" abilities.

- *Natural, unself-conscious drawings are vigorous and direct.* Children's work in particular bears this out. Turning to the crayon or the pencil to release and

give shape to the teeming impressions in the mind seems to be as normal for many a youngster as running or jumping for joy.

- *A picture (drawing) is worth a thousand words.* Verbal "knowing" should not be confused with graphic, pictorial "knowing." Configurations of lines and marks can carry meanings and feelings more adequately sometimes than words. The child-artist seems to move instinctually to the pictorial statement.

- *The early facility for drawing may never be quite lost.* While practice and guidance are usually necessary, that first flair for pictorial expression—for "putting a line around a think"—is generally capable of being rediscovered.

Drawing Comes First . . . and Also Last

- *To draw is the instinctive way to make a visual presentation.* Impressing lines, marks, and stains over a surface is the prime way to begin any visual forming—to effect the materialization of the graphic image.

- *Drawing is a bridgehead to the creative center.* As it is by drawing that the first seeds of the work of art are sown, it is more than likely that the process, when performed vitally, will carry the essential spirit or intent of the imagination.

- *Drawing serves two creative needs:* to originate the visual theme and to bring it to its finished, fully realized state.

MARK
AND SPACE

the figure-ground
fundamental

*Form alone can exist in its own right as the representation of an object (real
or unreal) or as the purely abstract delimitation of space or surface.*

WASSILY KANDINSKY

THE BLANK PAGE does not present a figure-ground situation. But mark it
in any way and such a visual duality is created. For by impressing graphic
marks over the once-empty surface, the material figure becomes apparent,
constituting that which is no longer perceived as space. By its presence, the
figure automatically creates definitive spatial divisions which cause the ground
to take on its own shape. Ground is therefore shaped space. Thus it is impos-
sible to make any markings over a surface without developing a figure-ground
situation. *All acts of visual perception, whether our involvement be with the three-
dimensional world or with an image on the page, depend on the presence of figure seen
against ground.*

All the work we are to do in Part One is intended to reinforce and expand
this basic definition. From the chapter titles alone you can see how compli-
cated the figure-ground possibilities can become. In the end, the physical *form*
of the work is determined by whatever figure-ground configuration the artist
finally decides best serves his or her intentions.

We commence in Chapter 1 by introducing the graphic characteristics of
fundamental drawing marks, and show how these physical properties work
perceptually to produce a figure-ground situation, and aesthetically to convey
the artist's intentions—the thought and feeling behind the work. In Chapter 2
we concentrate on space perception and composition—on the important role
played by ground as an essential element in forming any work of art. In Chap-
ter 3 we introduce two principal "families" or types of objects in nature, in
order to come to grips with shaping material figures in a work of art. Chapter
4 explores the textural complexities that arise when figure surfaces compete

with ground surfaces. Chapter 5 examines the problems of figure-ground plasticity and discusses the dynamics of drawing—the vigorous or static nature of a work's overall form. In Chapter 6 we put much of this knowledge to work in a study of the human figure.

The Workbook exercises in Part One gradually build up to the essential plasticity of drawing—to the creative possibilities inherent in manipulating figure and ground when forming the image. For it cannot be said too often that without the presence of the figure there is no perceivable ground, only shapeless space; and unless we discern the shape of ground created by the intrusion of figure, we cannot perceive the physical limits of the figure itself and so cannot visually grasp its shape.

Summing up, the major objectives of Part One are:

1. Familiarization with the graphic characteristics of drawing marks which constitute figure and shape ground.
2. Introduction to space perception and organization as ground becomes the perceptual and aesthetic complement to figure.
3. Analysis of the prime material features which make up the families of object or figure-shape.
4. Experience in handling the basic, dynamic possibilities of figure and ground composition.

THE GRAPHIC ENCOUNTER

marks and content

1

> Art is when one and one makes three. Drawing is when the magic begins—
> and sometimes ends. With a single stroke, light is separated from dark, and
> space and scale are evoked from a void. In the beginning of all the arts lies
> this graphic act by pen, pencil, brush or chisel with which, and from which,
> all else flows.*
>
> *COLIN EISLER*

EISLER'S STATEMENT recalls the initiatory magic of the drawing act, which
we discussed in our Orientation. Before we begin to analyze the basic
markings, a word of caution is needed: Analysis can kill the magic. Yet the
analysis is essential. The would-be artist, like the would-be pianist, must learn
what happens when hand and fingers move over the paper or the keyboard,
must know the range of the graphic or auditory possibilities and how to pro-
duce them. Ultimately one must let such knowledge sink to less conscious lev-
els. Creative freedom is difficult to achieve when one is preoccupied with
problems of technique. Nevertheless one's first encounter must be with the
graphic elements.

In this chapter, first we identify the principal drawing marks and describe
how they come about, and how they influence visual perception. Then we ex-
amine the physical characteristics of these marks, and see how their various
graphic qualities produce a language to serve the artist's creative needs.

I
The Basic Drawing Marks: Point, Line, Area

When one considers the variety of graphic markings available for drawing, it
may seem an oversimplification to name only three. Yet the range can be re-
duced to three essential conformations: *point*, *line*, and *area*. These can be put

*Colin Eisler, *The Seeing Hand* (New York: Harper & Row, 1975), p. 7.

together in any number of ways to produce a graphic harvest. The common element is, of course, *stain*, which we will look at in a moment.

POINT is the mark initially made as the drawing instrument touches the surface and is removed without making any directional progress over the ground. The action can be performed deliberately or casually, and can result in sharp, speck-like points or ones which are more blunted and diffuse—both representing concentrations of stain precisely located in space, and therefore fixed in time. You can see point as either the beginning or the end of motion in time and space—a specific physical "where" and "when." Furthermore, a series of points can imply *direction*. As the spatial intervals between points are reduced, the dots seem to string themselves together to become a line—a line of dots which move directionally over the surface as the eye works hard to connect them up.

The point, therefore, as a drawing mark, can be effectively used to specify location, to imply time, and to indicate direction. Figure 1-1 is a drawing made up almost entirely of point markings. Study the image and determine for yourself if the dotted formations work in the way just described.

LINE is the result of a point of stain being pulled, pushed, or stroked over the surface, calmly or excitedly, for long or short distances. The stain may be more or less concentrated as it moves, producing a tighter or looser line.

Figure 1-1
Jean Dubuffet. Paix 1959. Lithograph.
COURTESY JEAN DUBUFFET, PARIS AND STEFANO DELUCA, ROME.

The tighter or more compact the stain, the faster the line seems to move; the looser or more spreading the stain, the slower the line appears to move. Thus *motion* and *pace* of motion are prime characteristics of the line. Yet motion must take a direction, and therefore line provides the surest graphic way to direct the eye over the two-dimensional surface and, as we see later, into the illusory three-dimensions of pictorial space. Hence line is dominantly *directional*. A line moving through space also demarcates space—that is, sets limits to the void. It therefore, by mental association, becomes the obvious graphic means to "outline" a material object—which is, simply to separate it from space. Any such outline will necessarily show the shape of space now surrounding the object, which inevitably allows one to see the shape of the object itself. Consequently, line provides *definition;* it serves to define both matter and space by separating them.

All of these characteristics of line—motion, pace, direction, and definition—are easily discerned in Henry Moore's drawing, *Pen Exercise* (Fig. 1-2). Again, it is worthwhile to apply the statements just given to this graphic example, and let the eye take in the characteristics described.

AREA is the term I use for the conformation that results when an applied stain spreads beyond the compactness of a point or a line. In this context, area is simply a shape of stain. And because stain may be used concentrated or diluted, we can obtain dark- or light-*tone values* that can give the flat graphic surface an illusory three-dimensionality or solidity. (In Chapters 2 and 3 we examine different ways of using light and dark values to affect depth and suggest mass.) It is easier to develop a wide range of tonal values in a large rather than in a small stain area. (When a stain is fully com-

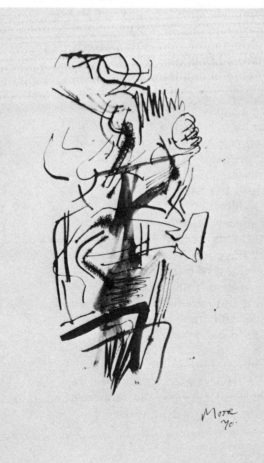

Figure 1-2
Henry Moore. Pen Exercise No. XV *1970.*
COURTESY OF THE ARTIST.

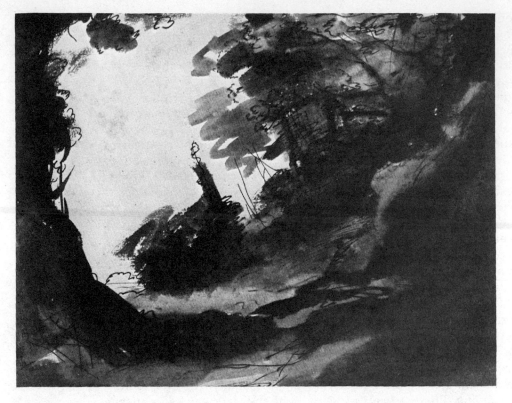

Figure 1-3
Claude Lorrain. Wooded Landscape *1635. Pen and brown wash.*
BRITISH MUSEUM, LONDON.

pacted into point and line, it becomes impossible to speak of "area" in this sense.) A rich variety of area shapes and tone values are produced by pulling, pushing, smearing, stroking, pouring, dripping . . . stain over a drawing surface, as we see in Claude Lorrain's *Wooded Landscape* (Fig. 1-3).

STAIN is the stuff of which marks are made. It is important to remember that the type of staining medium used will have a direct bearing on the shape a mark can assume. Thus the choice of instrument and the kind of physical action required to apply the medium—whether pulling, pushing, or dabbing, and with what degree of strength or pressure—all these are factors that play a part. A pen, for example, demands a fluid stain; likewise a brush of soft hair. However, a bristle brush or the naked finger is able to push and pull a more solid and intractable medium.

The kind of stain to be used depends upon what one has in mind or on the mood of the day. There are an enormous variety of mineral and chemical staining media. Sweat on a grubby finger can, on occasion, be as effective as the purest of inks saturating the finest of brushes. The universal quality demanded of any stain is that however fluid or dense, transparent or opaque the medium is by nature, it should lend itself to reasonable manipulation over the drawing surface; and that, ideally, it should permit contrasting values of light and shade to be exploited through concentration or dilution.

Figure 1-4 is a drawing by John Constable in which broad spreading areas of stain are used to create a landscape. In this rapid sketch, the renowned early nineteenth-century English landscape artist has made little use of line

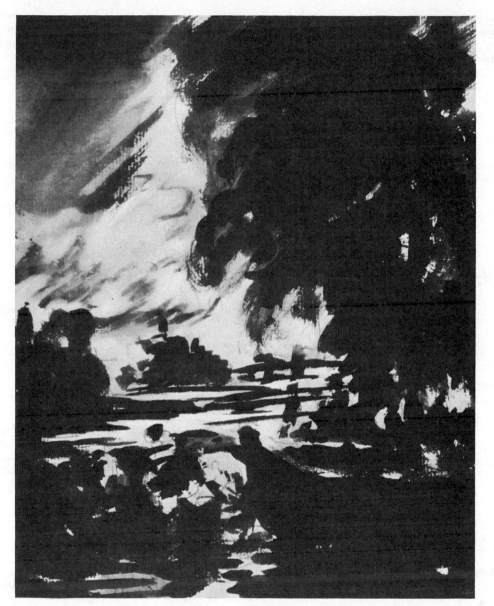

Figure 1-4
John Constable. Trees and Water
on the Stour. *Wash drawing.*
CROWN COPYRIGHT, VICTORIA AND ALBERT
MUSEUM, LONDON.

and point to present the scene in any detail. Instead, he diffuses the ink in order to form stain into areas which suggest the presence of trees and other natural shapes. Compare this use of area as a drawing mark with that of line in Figure 1-2. Upon studying Constable's drawing, we see that our definition of area must be amended somewhat:

> As stain spreads to form area, an *edge* is automatically produced at the extremities of the stain's flow. Such an edge, which is not a drawn line in the conventional sense, nevertheless acts as a line of drawing in the ways we have previously described, and is obviously used as such by the artist.

PHYSICAL CHARACTERISTICS OF THE GRAPHIC MARKS

Figure 1-5 is a series of diagrammatic sketches illustrating the fundamental characteristics of point, line, and area; and also showing how tonal variations of stain can be exploited to provide further variety. Each artist builds up a vocabulary of his or her own markings, and manipulates them physically to

POINT CHARACTERISTICS

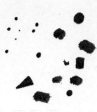

a) Points may be large or small, sharp or blunt, regular (geometric) or free-form.

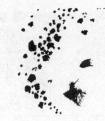

b) The way points are grouped or clustered suggests form; their spacing and scale suggest motion: direction and speed.

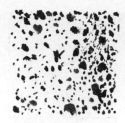

c) Distribution, spacing, and scale suggest surface dynamics—calm or restless areas.

d) Light or dark values as well as size and scale suggest spatial position.

LINE CHARACTERISTICS

a) Continuous or broken.

b) Angular or curvilinear.

c) Multidirectional: up, down, across, in.

d) Speed: from static to fast moving.

e) Weight: thick to thin; blunt to sharp. Suggests dominance and spacial position.

f) Weight in the one line: constant or varying.

g) Light or dark value of stain aids spatial position and dominance.

AREA CHARACTERISTICS

a) Skeletal surface suggested by linear spread of stain.

b) Mass-opaque surface formed by area spread of stain.

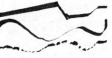

c) Mass-textured, with light and dark values produced.

d) Mass-transparent, with light and dark values produced.

Figure 1-5

Capable of values ranging from dark opaque to light transparent. Shown here: ink and pencil.

Figure 1-5 (continued)

speak a rich visual language. Rather than rely on verbal descriptions, we will look at two illustrations: Vincent van Gogh's *Boats at Saintes-Maries* (Fig. 1-6) and Claude Lorrain's *Landscape* (Fig. 1-7). These two works make radically different use of drawing marks, and demonstrate the wide range of possibilities that exist.

From the marks we see in Figures 1-6 and 1-7, we might call van Gogh the "Master of Point and Line" and Lorrain the "Master of Area and Tone." Bearing these categorizations in mind, study each work for yourself by comparing the true drawing marks of a master with the diagrammatic versions in Figure 1-5. In this way it should be possible to see how each man uses the basic elements of drawing, and stamps them with his own inimitable style. At the same time, remember that van Gogh and Lorrain are but two artists in a vast company going back to the hunter-artists of prehistoric Lascaux, and that

Figure 1-6
Vincent van Gogh. Saintes-Maries-de-la Mer *1888. Pen, brush, and ink.*
MUSÉES ROYAUX DES BEAUX ARTS, BRUSSELS.

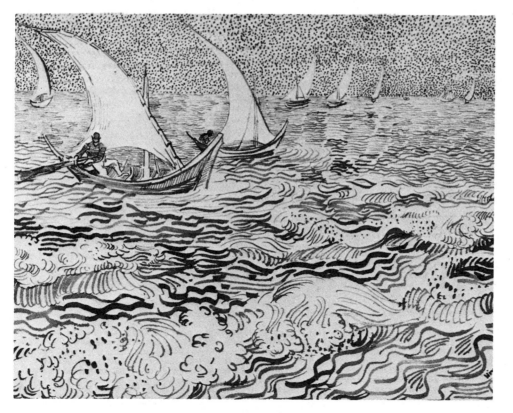

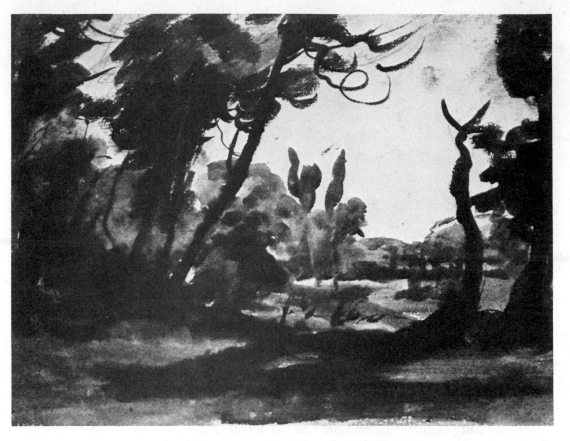

Figure 1-7
Claude Lorrain. Landscape *ca. 1635. Chalk and brown wash.*
BRITISH MUSEUM, LONDON.

therefore we can expect to find an almost infinite variety of ways in which basic drawing marks are used.

As you scrutinize *Boats at Saintes-Maries* and *Landscape*, paying particular attention to their graphic personalities, it will become obvious how important it is for the artist to know just what can be done with the chosen stain—how to ring the tonal and textural changes to suit his or her ends.

INSTRUMENT GESTURE AND TOUCH

Many different drawing instruments are available nowadays—from those old standbys of brush, pen, crayon, and pencil to the new and sophisticated ball-points and felt-tips. Sometimes nothing can beat an ordinary twig, plucked from a bush, sharpened at one end to a fine or chisel point and dipped in a bottle of ink, or, for that matter, the finger itself, rubbed in the stain and stroked across the paper, allowing the nail to impart a razor-like edge to the mark. In the drawings we have just studied in Figures 1-6 and 1-7, several means are employed—the brush, a dash of pen or twig, a possible smear of the finger. In any event, one's choice of instrument is governed by the staining qualities of the medium to be used, and by the kind of imprint desired to shape the image. Let us put off discussing the peculiarities and merits of the various instruments until we come to the actual drawing exercises at the end of the chapter.

One of the first satisfactions gained from a serious involvement in the historic wealth of drawing and painting is the ability to recognize the work of a particular master. It is not necessary to look for the signature, for his or her name is written all over the image in every mark of the brush, pen, or pencil;

in every smudge of the finger, rub of the rag, or scrape of the knife. No two great artists execute the marks of a drawing in the same way. For if we accept that a configuration made up of points, lines, areas, and their tonal values constitutes an artist's graphic response to life's experiences, then we should expect to find that each mark applied reveals an individual and particular creative touch—a drawing gesture dictated by the intellectual and emotional charge driving the individual. (In music the factor of touch is just as important. Some people can recognize the pianist who is playing just by the performer's dynamics on the keyboard.) Touch and gesture thus constitute the kinesthetic factor in drawing. The nerve–muscle coordination operating throughout the whole body, and particularly in arm, wrists, and fingers, demands little conscious thought when the motivation to draw is strong. One sign of an inspired drawing is the apparent lack of struggle in the making of it—as if it results from some sort of spontaneous combustion springing directly from excitation or revelation. If problems of technique short-circuit the integration of psychological attitude and physical action, then the image does not convince. When working under your own steam you will be aware of this "body-in-action" problem; but one reason to practice is that ultimately, the less conscious a difficulty it will become. In the end you might be drawing as naturally as a dancer carried away by the music dances.

II
The Language of Graphic Marks: Natural Content

I have already used the phrase "the language of drawing" to suggest that a drawing evokes a dialogue between itself and the viewer. Becoming familiar with the physical structure of point, line, and area is like learning how to spell and pronounce a few essential words of a new language. You cannot really communicate in that language without knowing the actual and potential meaning each word carries. Consequently, we must now try to show that, as with words, graphic impressions bear a significance over and above their purely physical manifestations. This range of superior meaning is what I refer to as their "natural content." Now it is much easier to describe the physical aspects of drawing marks than it is to talk precisely about their built-in psychological referents—about the fact that points, lines, and areas of stain can convey the nature of thought or stand as a graphic analogy for states of feeling. It is this phenomenon which allows a drawing to reflect the state of mind of the person who made it, and thus to stand as a statement of human awareness and sensibility. When we describe a drawing as "powerful" it is a way of suggesting that the work has more to it than simply its formal, graphic nature; rather, that it is charged with meaning of one sort or another.

GESTURE AND CONTENT

Yet how can marks impressed on a surface communicate thought and feeling by themselves, without a word being spoken? This is a complex question and one with which we are dealing throughout this book. One answer is to be found in the kinesthetic factor in the act of drawing—that is, the body in action, moving in and out of the drawing with motions ranging from the spontaneous to the deliberate; applying different pressure touches from moment to moment, and generally putting the image together through the *gesture* of drawing. Think of it this way: A drawing is the graphic record of a series of gestures—the pen, pencil, or brush registering the direction, force of impact, speed of movement, and pressure applied, of each move. But this leaves us

nowhere unless one adds: *Given the drive to make a work of art, the dynamics of drawing action represents the external manifestation of our inner psychology.* The quality and intensity of mood and the substance of our thought automatically transpose themselves into what might be called the *creative gesture*. This is not a new idea. Both East and West have long subscribed to the belief that on those occasions when the mind is committed to absorbing imaginative activity, then the way the body moves in space is indicative of the state of the soul. In the choreographed bodily motions of ballet, for example, the dance form symbolizes thought and expresses feeling. And to lesser degree—because the whole body is not so involved—the tempo, weight, and pace of marks in drawing can help to communicate the nature of thought and the quality of feeling.

I am not trying to suggest that gestural drawing is a form of ballet dancing, or that the kinesthetic factor alone can carry the artist's intention; I am simply pointing out that physical movement and sensitivity of touch are both means by which internal states find an outlet and become shaped. *The act of drawing likewise involves the body's sympathetic response in terms of motion and touch.* So it is a good thing when drawing to give oneself over to the particular rhythms that arm, wrist, and body tend to set up for themselves, rather than to rigidly discipline one's movements in order to ensure a high degree of control. It is quite important to realize that the meaning and affect we find in a drawing is, to some degree, imparted through the artist's gestural action.

This, then, is what I mean by *natural* content: the ability of the drawing marks themselves to transmit, in part, the spirit and intent of the work. In lines consecrated to Rubens and written in 1876, Eugène Fromentin, in his book *Old Masters*, puts it this way: "If the hand did not run as quickly, it would be behind the thought; if the improvisation were less sudden, the life brought across would be less; if the work were more hesitant or less seizable, the work would become impersonal"

EXPRESSIVE AND CONCEPTUAL APPROACHES

Mindful of the danger in oversimplification, it is nevertheless helpful to classify the two major drives delivering content in the arts. These are commonly labeled the Expressive and the Conceptual. In the act of drawing and the graphic elements employed, these two modes are distinguished as follows:

EXPRESSIVE: seeks to express states of feeling—the intensity of the mood or the particular quality of the feeling.

CONCEPTUAL: seeks to render the nature of thought—the processes of intellect—in as clear and structured a way as possible.

Let us look at two drawings to see how the graphic treatment carries content. Delacroix admired Rubens, and his own drawing has much in common with that of the Flemish master. Study Delacroix's *Tiger* (Fig. 1-8) and see if you can "feel" Delacroix's vitality of touch in terms of the various marks employed. Can this graphic quality be described by words like *urgency, drama, menace, slinky,* and *predatory?* It would be easy to make a longer list, but these few terms will suffice, inasmuch as they all convey a certain suggestion of mood, a state of feeling. Yet, words aside, we can *see* that this is an *expressive* drawing: that the artist's feelings were aroused by the tiger, and that we can pick up the affect from the character of the drawing marks themselves. Although the *concept* of tiger as object in the physical sense, and as predator in the behavioral, is fully realized, in the final analysis it is the expressive nature of the drawing which dominates. Try to imagine Delacroix at work, hand mov-

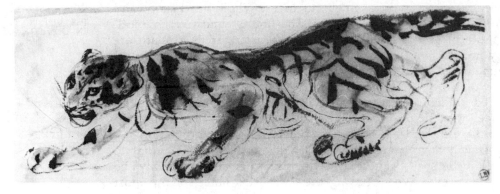

Figure 1-8
Eugène Delacroix. Tiger. *Pen and wash drawing.*
MUSÉE BONNAT, BAYONNE.

ing over the page as pressure is applied here, relaxed there, causing pen and brush to bounce and stroke their way over the ground with a linear energy at one moment curvilinear and sensuously relaxed, yet at another angular, pointed, and hesitantly anxious. The drawing gesture imparts both speed and stealth to the lines; the shaped areas of stain flow in sympathy with them. This, so far as I am concerned, is a visceral drawing—one in which expression prevails over concept.

What a change of emotional and kinesthetic pace when we come to Picasso's *Bull* (Fig. 1-9)! There is little doubt that Picasso enjoyed making this drawing. The concept is full of humor—puns on brawn and bullish masculinity delivered through a precise, geometrical treatment. But it is an intellectual kind of fun rather than the rib-tickling sort. This is why I refer to the work as a concept, an idea. Structure dominates—a deceptively simple structure—and one which is very cleverly put together. It is a carefully thought-out shape, beautifully controlled and regular in drawing, and showing the artist's ability to analyze the natural form of the creature before going on to invent his own.

Figure 1-9
Pablo Picasso. Bull 1946. *Lithograph.*
© 1983 S.P.A.D.E.M., PARIS/V.A.G.A., NEW YORK.

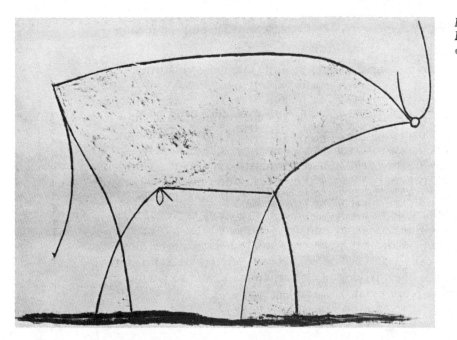

The graphic style serves the rational intellect's love of clarity, precision, and order, for control and deliberation rule here. The line is almost mechanical, resulting from uniform pressure and directional precision; areas of stain are avoided, thereby imparting a two-dimensional flatness to the image which severely limits animation and naturalistic vitality.

However, it would be wrong to assume that every drawing lends itself to such cut-and-dried categorization. All graphic marks can perform ambiguously. Lines of feeling-content are also structural inasmuch as they shape figure and space, and are therefore serving perceptual needs. Similarly, lines that structure concepts will have a greater or lesser degree of feeling-content to them, depending on the shade of accompanying mood which must always be present at some level, even when making the first visual notes for the most mechanical of engineering projects.

Therefore, while it is useful to keep the two general categories of content in mind—the expressive and the conceptual—we should also remember that the artist may ring the changes between these two extremes, varying drawing gestures to serve the dominant psychic power, be it thought or feeling.

One of your first exercises with the basic marks will be to try, quite deliberately, to make lines that carry feeling and idea. For this reason—and also because our approach to art throughout this book is oriented to studio practice rather than to the academic and theoretical—we should employ a terminology which relates to both the content desired and to the kind of drawing action required to produce it. Every experiment will call for different applications of the two drawing methods that you will be asked to try out. The first method I call *free-action* drawing—see Delacroix's *Tiger*; the second is the *deliberate-precision* method—Picasso's *Bull*. These terms literally describe the two most common drawing methods employed to produce the predominantly conceptual or predominantly expressive image. They are the way by which a certain rhythm of movement and sensitivity of touch deliver the desired image. As one first practices drawing freely, and then with more self-conscious control, it will become obvious that rhythm and touch sensitivity change to suit the psychic demands being made. Once this has been experienced it is easier to appreciate the relationship between drawing action, the appearance of the resulting marks, and the content they suggest. So, generally speaking:

FREE-ACTION DRAWING serves Expression—the release and shaping of feeling and mood.

DELIBERATE-PRECISION DRAWING serves Concept—the rational structuring of thought and theory.

Look for a moment at an expressive drawing. When confronting the dashing *Two Standing Figures* (Fig. 1-10), one can almost see the artist at work, slashing and parrying like a swordsman. At the same time one can distinguish between free-action lines and those of more deliberate precision, which impart a clarity of structure to the overall concept of two standing figures. So drawing is both expressive and conceptual. Which aspect would you say is dominant?

Obviously, there is less room for variety within the category of deliberate-precision markings than within that of free action. Precision, after all, means exactness; and this does not allow for much variation, whereas almost anything may go to serve the cause of free action. It would therefore be a difficult task to try to show examples of every kind of free-action mark, and so we must be content to provide some representative examples.

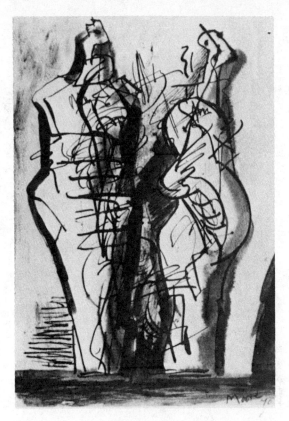

Figure 1-10
Henry Moore. Two Standing Figures No. XV *1970.*
Pen and wash.
COURTESY OF THE ARTIST.

Jackson Pollock's two drawings—Figures 1-11 and 1-12—give some indi-
cation of the free-action repertoire applied to non-objective or abstract im-
agery. (Abstract and representational art are discussed later.) For an example
of such graphic freedom at work in a representational drawing we have the
horse and rider in *Triumphant General* (Fig. 1-13), who seem to materialize from
a flurry of urgent lines and accidental blots of tone. This free and rapid draw-
ing action makes clarity of perception—and therefore of concept—difficult. It
is not easy to separate the figures from the spatial context they occupy; and
yet what is lost in this regard is amply compensated for by the dramatic inten-

Figure 1-11
Jackson Pollock. Number 10.
COLLECTION: ALFONSO OSSARIO, LONG ISLAND.

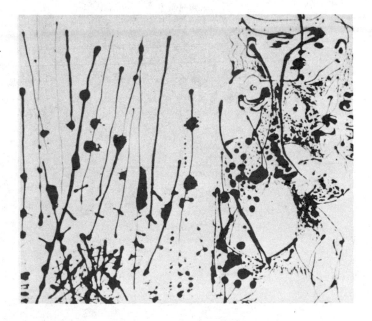

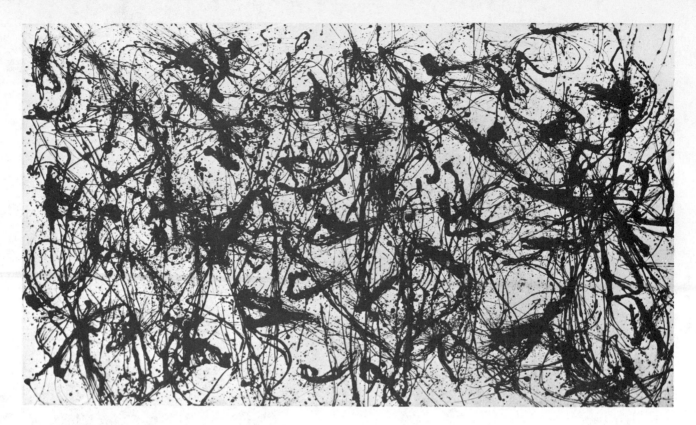

Figure 1-12
Jackson Pollock. Number 32.

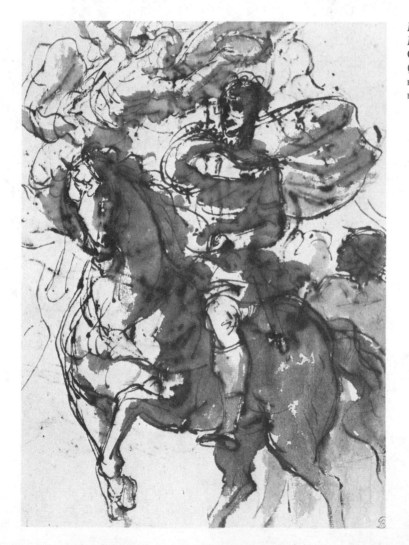

Figure 1-13
Italian Venetian artist. A Triumphant General
Crowned by a Flying Figure, *early 17th C.*
Quill and brown wash.

sity which is gained by such visual ambiguity. Also, such a graphic attack imbues the image with a great deal of energy. I am tempted to describe *Triumphant General* as a "symphonic" drawing because the light and shade contrasts produced by the rich areas of sepia tone, flooded so loosely against the white ground, produce the graphic equivalent of a blast of symphonic sound. This is an exciting drawing not merely because it depicts a victorious general in the story-telling sense, but because it is compelling and stirring as a work of lines and marks which, in their own right, excite and evoke an intense quality of mood.

But in Figure 1-14 we see the other side of the coin. In this drypoint etching by Takao Tanabe, the artist demonstrates how well suited the medium is for printing lines of calculated accuracy. For here is linear structure in direct contrast to that utilized by Jackson Pollock in his *Number 32*. Tanabe's drawing displays a full repertoire of deliberate-precision lines, each carefully controlled to proceed directly from point to point without wavering and with regulated changes in weight and tone value. Consequently the image grows through a rational application of geometric principles. Space is clean cut; lines are regular in length, and move parallel to each other in series as if made by a machine. Are we looking at a map, a blueprint, a layout . . . or a chart of refracted light? Yet despite the work's conceptual nature it is not devoid of mood. For a degree of feeling will be present in all but the most mechanical of engineering drawings; and here we cannot escape the realization that such precision and geometric order produces—almost as a by-product—an air of calmness and composure.

Figure 1-14
Takao Tanabe. Untitled *1972. Drypoint etching.*

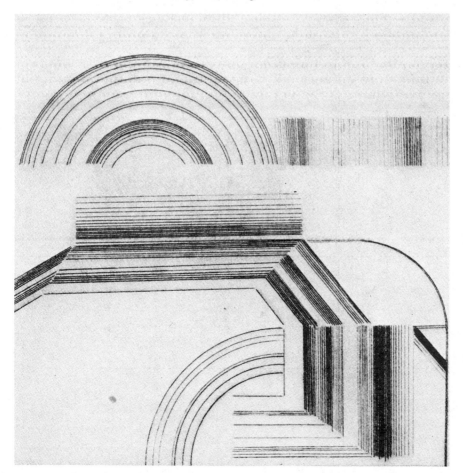

Figure 1-15
Juan Gris. Seated Harlequin. *Pencil on buff paper.*
© 1983 S.P.A.D.E.M., PARIS/V.A.G.A., NEW YORK.

Aware of this generalization, now observe that lines which are heavier in weight and darker in tone seem to project forward—they stand in a different plane to the thinner and grayer lines. Varying the weight and tone of the line is one way by which artists who favor the line of precision can create the appearance of depth.[1] (Also, such artists may give more volume to either figure or ground by exploiting the effect of light and dark values of tone, provided that such tones are applied with the same degree of precision, so as not to confuse the linear clarity already established.)

For an example of precision drawing in a work, we turn to Juan Gris' *Seated Harlequin* (Fig. 1-15). In contrast to Figure 1-13, Gris uses no superfluous lines or marks, no strokes which are not structurally essential. This work consequently lacks the graphic vitality and dramatic mood that free-action drawings tend to produce. Yet although a deliberate-precision drawing may not ignite us, it does something else. Through the regularity and accuracy of its line—the perceptually unambiguous quality we noted in Tanabe's etching—we are given precise information about the essential shape of figure and ground, and thus are able to clearly perceive the overall form of the image. The exactness of this kind of definition is plainly seen in Figure 1-15. And the absence of free-flowing, area spreads of stain which would confuse linear precision adds to the sense of order and regularity. Compared to the *Triumphant General*, this image appears flat. The lines seem to divide only regions of two-dimensional space, and this is characteristic of rigidly structured work in which the ground is devoid of tonal areas of stain. Yet, as in Figure 1-14, the heavier and darker lines project forward, thus creating some suggestion of depth and solidness.

[1]The linear structuring of ground in depth in discussed in Chapter 2.

Once again we have to admit that Gris' drawing, compared to Figure 1-13, is more an intellectual idea than a living event to which we respond with feeling. Hence its graphic style serves to shape a content which is much less expressive than it is conceptual. Even so, let us not overlook the dash of feeling which inevitably accompanies visual sensations of clarity and order—that brand of detached serenity which such unambiguous, clearly delineated images manage to elicit.

A NOTE ON ABSTRACT AND REPRESENTATIONAL ART

A full investigation into the respective merits of so-called abstract (non-objective) and representational (figurative) art is attempted in Chapter 9. But since we have been illustrating our discussion with works of both types, some explanation is necessary here.

The essential difference between abstract and representational images is clearly revealed in Figures 1-12 and 1-13. Jackson Pollock's drawing (Fig. 1-12) is abstract in the sense that it presents no recognizable object of perception; whereas the image of the triumphant general (Fig. 1-13) gives us several identifiable objects. We can discern the horse, the general himself, and the escorting angel. Simply put, the abstract artist invents his or her own configurations of figure and ground without utilizing things seen in the world. But in the representational—or semi-representational—drawing, we recognize objects and scenes which the artist has perceived and transformed in one way or another to form the image. Hence the terms non-objective, or non-figurative art are synonymous with abstract art.

There are certain advantages to drawing in a completely abstract vein. Because the artist is freed from the struggle—and it always is a struggle—to graphically recreate an object of perception, there are no representational problems in abstract free-action or in abstract deliberate-precision. So Pollock's drawing may be more expressively powerful than the Venetian artist's; and the totally abstract image of Tanabe (Fig. 1-14) more conceptually pure than the semi-representational work of Juan Gris (Fig. 1-15.)

However, whether a drawing be abstract or representational, it does not change the fact that *to draw* is to visually state a case—to find a form for what is going on in our thoughts and feelings.

THE WORKBOOK—A RECORD OF DRAWING EXPERIENCE

The experiments in drawing that you are about to undertake are designed to make you think in graphic, plastic terms. They translate what is said in the text into its visual equivalent, and thereby effect a synthesis between words—the most common means of shaping awareness—and the visual form we call art.

By keeping a workbook you will be competing against yourself in tackling a series of increasingly complicated ideas and challenges. The drawings, when complete, should stand as a graphic record of your learning and achievement.

The exercises for Chapter 1 provide a gentle initiation into the practice of drawing and allow you to see a theory in action.

The effectiveness of your efforts in the Workbook will depend to a large extent on how carefully you have read the entire chapter—not just the specific directions for drawing. An important part of this total involvement with the text is the visual reinforcement and stimulus provided by the masterworks. Therefore give yourself the time to be both intellectually and visually prepared before commencing the practical work. It will pay off.

After a while it will become obvious that your personal response to a given exercise differs graphically from that of your colleagues. The direction and in-

tensity of your thoughts and feelings are not likely to be identical, and certainly the kinesthetic tension you experience in your sense of touch to pen or brush, to staining medium and ground, will be your own. Some people are almost hypnotically relaxed in drawing, some are tense and tightly concentrating, while others are nervously agitated and bite their tongues and wriggle their bodies. For the artist drawing naturally in the studio, these responses are unself-consciously bound to mood and thought, to the mental activity which stimulated the need to draw in the first place. But for the student caught in the somewhat artificial situation of merely trying out the physical possibilities of line and mark structure, it may well be the kinesthetic difficulties of which you are most aware. In producing the lines, you will notice the resistance set up by the type of paper surface to the pen or brush, cut twig or pencil. How you react to this resistance will obviously play a part in determining the quality of your line. If you will mentally contrast for a moment the sensations you would experience in pushing soft charcoal over a coarse surface with pulling a hard, spiky nib over a velvet-smooth surface, you can almost feel the kind of line that will result without having to draw it. But as you begin to experiment with content, you may experience a more positive involvement with your own thoughts and feelings, and then the tensions of the psychological struggle to realize the right graphic marks will become apparent.

RECOMMENDED DRAWING TOOLS AND SUPPLIES

In almost every chapter you will need: a medium thick, felt-tip Paper Mate; a Pilot Precise Ball Liner; a Sheaffer Calligraphic Fount Pen; any type of hair watercolor brush, size 4; and two straight hardwood twigs cut from any brush or tree—one sharpened to a point, the other to a wedge-shaped tip. For the staining medium use either sepia or black Pelikan drawing ink, diluted as necessary with water. For the Workbook itself, use any general-purpose sketchbook; an approximate size of 12″ × 9″ is recommended.

As to which drawing instrument to use for each exercise, I do not want to be dogmatic about it. When the nature of the work demands either pen or brush, then such specific instructions are given. But it has been my experience that, when left alone, individuals experiment freely with all the materials suggested and produce some quite extraordinary results. It is better to have this freedom and to discover for yourself which marker works most effectively, and under what particular circumstances.

Although I have not included pencils (hard or soft), crayons (conté, pastel, or wax), or charcoal among my recommendations, this does not mean that you should not try any and all of them from time to time if you wish. My personal and professional opinion is that for the kind of drawing you are called upon to do here, these other media are somewhat too demanding. Yet if you are comfortable with an ordinary lead pencil—black and soft, preferably—then by all means try working with one whenever you feel inclined.

WORKBOOK

I-I. The Basic Drawing Marks

These assignments introduce the physical nature of various kinds of line, point, and area—using stain as diagrammatically presented in Figure 1-5. Until you become familiar with how this or that drawing instrument works with a particular stain, you may have to practice each exercise several times until you are satisfied. Initially, I suggest that you use one page for each exercise.

A. *Line—continuous and broken*

Work from the top down; it is usually easier, although you may certainly work from left to right, if you wish, in any of these drawings. Fill the space with a series of relatively straight *continuous* and *broken* lines. It does not matter how you mix them up, or whether you produce an arrangement which is more diagonal than horizontal. You can go vertically from left to right if you wish. Whichever way you feel kinesthetically more comfortable is fine. But you should try the whole range of drawing tools from the brush through the various pens.

First, fill about half the page with a series of freehand, *continuous* lines which move from top to bottom of the sheet. Once in motion do not remove the pen or brush from the surface—keep the line going. With some lines apply an even pressure throughout, but start others with a heavy touch and finish with a light one. Also, vary the speed with which you bring the drawing instrument down the paper, sometimes fast, sometimes slow. Study the variety of lines made by these three factors: type of instrument, pressure applied, speed employed.

Now to the *broken* lines. Again, using brush and pens, fill the remainder of the page with a series of broken lines. Start by nervously wiggling the drawing tool slightly from side to side as you descend the page, although at the same time never allowing its point to stay on the surface longer than a second or two. The first thing one notices about such fragmented lines is that the positive directional movement of a line is lost—the eye meanders with no particular end in view. Yet notice the gain in rhythmic energy such lines acquire. While making these continuous and broken lines, notice how each instrument produces its own kind of characteristic mark.

Contrast the decisive thrust and speed of the continuous line with the hesitancy of the broken one. Undeniably, the short, twisting, broken line is powerfully expressive in evoking feelings of uncertainty, anxiety, and restlessness. You will meet this "feathery" manner of drawing constantly, for it lends itself easily to the rendering of rapid impressions and quick-action studies. Such drawings are very lively, for line opposes line to give energy and a plastic tension to the image. (The three sizes of interchangeable pen-nibs which come with the Sheaffer calligraphic pen are useful here to give varying thickness to both kinds of line. Experiment by these means; ring the changes across the page.)

Figure 1-16 gives you some idea as to how the first page of your workbook may appear.

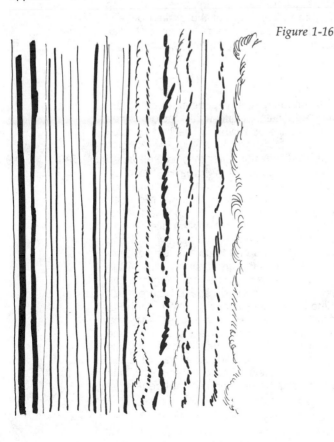

Figure 1-16

B. *Line—angular and curved*

A dual purpose is served in making this page of lines: first, to experience the different drawing gestures and touches which angular and curvilinear lines demand. This you will feel for yourself and learn to master as the space begins to fill. And second, to see the visual effect of what might be called angular and curvilinear, graphic counterpoint—the way one linear motion sets itself up against the other. We go further into this when we deal with the issue of content. At the moment it is enough to be concerned with the kinesthetic feel of angle and curve; the way each drawing instrument overcomes the surface resistance as angle and curve are negotiated; how it is necessary both to pull and push pen and brush . . . around curve and into angle, and to both feel and observe the graphic result. Once again, you should try several different instruments in order to produce graphic variations; and you should involve both continuous and broken lines in the experiment. I suggest that you again work from top to bottom—either vertically or on the diagonal—and alternate curved lines with angular ones, ringing all the possible changes of instruments and shifting from the broken to the continuous style to create yet further differences. The page, when complete, will probably look something like Figure 1-17—a graphic medley of linear curve and angle.

C. *Line—speed*

Our aim here is to produce a page of lines—both continuous and broken—which seem to alternate between fast and slow motion, as you see in Figure 1-16. Gesture and touch are all important, as is the choice of drawing tool. The brush will accelerate and decelerate more easily than the pen which, inevitably, encounters more surface resistance. But the sharpened hardwood twigs glide beautifully over a smooth surface. And a rough-surfaced paper will automatically produce a broken line of speed. Yet try more than one tool and find out for yourself. One thing you will discover is that the broken line occurs of its own volition once a speedy stroke is made, for the drawing point tends to bounce along the sheet. A study of Figure 1-18 will reveal that blobs or points of stain suggest that a line is either stopping or starting. And that as a line thickens to form a pool of stain, so the speed drops off. Conversely, as a line becomes *thinner and sharper,* so it accelerates away; and that the same effect is produced by broken lines when the space between the breaks lengthens. Figure 1-18 was produced by deliberately forming a few broader pools of stain, and then pulling the lines out from them at high speed, causing them to thin down as the tool was lifted off the paper. You can put the brakes on and abort such a takeoff, in which case the lines will thicken as you come to a stop. Notice also how they slow down on the curves, gather speed on the straight, and subside in the swells.

D. *Line–varying and constant weight*

You should have already noticed that it is difficult to maintain a constant touch-pressure in forming these lines—that some variation is a natural kinesthetic factor: When pressure is light, the line thins; and when it is heavy the line swells. The thin or thick nature of a line determines what is, in graphic terms, its *weight.* Now you are going to deliberately exploit the weight possibility. You will find that the brush, the chisel-ended twig, and the broad pen-nib of the Sheaffer calligraphic pen allow the greatest flexibility. Your drawing gesture should be deliberate and rhythmic—that is, the pushing down on the surface and the lifting away from it should be done to some kind of measured beat, because only then will the graphic change between thick and thin be well defined. Also, to impose such a beat forces a more precise control over the up and down movement.

With the chisel-edged twig or pen, learn to turn the instrument from narrow to broad sides as you move across the paper, in addition to applying up and down pressure. Similarly with the brush, although here you will undoubtedly find the greatest flexibility in the way the brush can be flattened against the surface to suddenly give great weight to the line. You should try both broken and continuous lines of the sort you see in Figure 1-19. Later on you will be relating the weight factor in line to that of its spatial position; but here, as you are concerned only with graphic or plastic properties, I would suggest that you observe how such variations immediately affect the velocity of the lines and at the same time create a visual play between major and minor linear themes over the page. Notice also how these weight changes become "accoustical"—suggesting changes of sonic quality . . . *piano, legato, vibrato, fortissimo.* . . . Anyway, experiment as you will. One other thought: Try using an inked finger, turning it to drag the nail; then you will really feel a tactile sensitivity to stain and surface.

Figure 1-17

Figure 1-18

Figure 1-19

E. *Line—value in terms of light and dark stain tone*

It is comparatively easy to lighten a concentrated black or sepia drawing ink by simply diluting it with water. This can be done by adding a brush load of concentrate to small pools of water laid out on a large piece of scrap paper, and then getting the right value of light or dark by experimentally brushing out with more water, or by the addition of a touch of pure ink. What you are to do here is simply cover the page with lines which vary in value from deep black (or sepia) to the lightest of tone possible to mix. There are many ways to effect these value changes in the line: It is possible to work directly from the ink bottle to the page, diluting as necessary from a saucer of water or from tones mixed on scrap paper. But I have seen the best results achieved by starting directly anywhere on the page with loaded brush, pen, or twig, pulling the line along an inch or two, and then dousing the moving end with a blob of water from a clean brush ready at hand. Immediately the line will diffuse and spread and the stain value will lighten. But do not stop there: Continue the movement by pulling the diffused stain out at the end of its run and then, reloading pen or brush, extend it once more as a solid line. You can repeat this process with the original line over the entire page. Or, blob a few brush loads of water at random over the surface and then pull a line rapidly through, and see what happens. Devise your own methods of interfering with stain value as a line moves; and ring the changes with all the drawing tools available. If you study Figure 1-20 closely you will be able to determine how the various light and dark values were achieved.

Figure 1-20

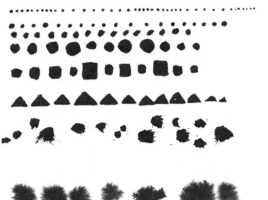

Pin points

Drawn round points

Drawn square points

Drawn triangular
points

Dab points

Wet free-form points

Expanding nucleus
points

Figure 1-21

F. *Point—physical characteristics*

Points—the marks initially formed as the drawing instrument touches the surface and is withdrawn without extending the marks into lines—set the pace of a drawing, regular or irregular, like a pulse. They also articulate and structure the shape of space in a figure-ground situation. When it comes to the gesture of drawing, point may result from either free action or deliberate precision. Both will be called upon in making the table of point marks which constitutes this exercise. Figure 1-21 illustrates seven graphic possibilities for point formation: the pin point, drawn round point, drawn square point, drawn triangular point, dry brush dab point, wet free-form point, and the expanding nucleus point.

The pin point is produced with either felt-tip or ball-marker pen; the remainder are all brush dabbed or brush drawn. The wet free-form marks and those of the expanding nucleus are made by applying ink in concentration to a predampened area of paper; the trick is to make sure that the surface has dried just sufficiently to allow a slight rather than runaway spread of the point concentrate.

Use Figure 1-21 as a guide in making your own table of points, adding any new categories you manage to invent. When your chart is complete, keep it for future reference. Some day you may wish to draw or paint as a Pointillist. Pointillism grew out of the Impressionist movement during the last years of the nineteenth century. It was a method of painting by which figure and ground were built up from a mosaic of brush-tip point marks, carefully modulated in terms of hue so as to produce gradual changes in chromatic value—light to dark. The points of color could be applied very mechanically to create a "tight" painting, or more loosely to achieve an altogether freer result. In the drawings we are now to attempt, a loose rather than tight pointillist technique is called for.

G. *Point—drawing with point alone*

Gather brush, twigs, pens, ink, and a cup of water. Have a large piece of scrap paper handy to dab off surplus ink or water from the brush. Use as much of the page as seems necessary once the work is under way. Remember, you are now to draw only with dots or points. Imagine a group of tall, thin saplings just coming into leaf and being blown from left to right by a gentle breeze. Using only a variety of points, try to form the image. Try, at all costs, to avoid overworking the method. Keep things open and loose, more just a suggestion than a firm statement, for it is the elusive and evocative aspect of such drawing that is its charm. Figure 1-22 is an example of such pointillist freedom. One minute the trees are there; the next they are not. Yet if you look through half-closed eyes, you can more easily discern their swaying movement. Anyway, see what you can do with your own mental picture of some dancing, lithesome trees on a spring afternoon.

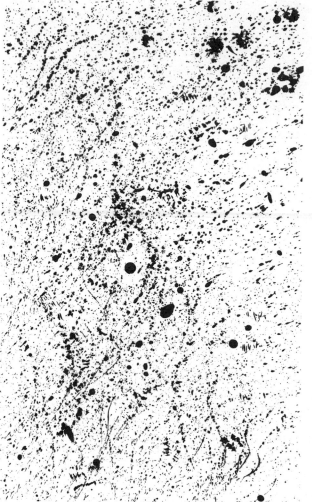

Figure 1-22

H. *Area and Stain—physical characteristics*

The final drawing in this series is a more difficult exercise than the preceding ones. In it you will try to consolidate all the characteristics of shape and stain that are shown in Figure 1-5. The best way to prepare for this work is to study Figure 1-23 in relationship to Figure 1-5. Strictly speaking, Figure 1-23 is more a painting than a drawing (remember how the differences were defined in the Orientation chapter?). This student drawing was made in response to the theme *Tree, Moon, and Thistleseed*—a subject matter which lends itself to the juxtaposition of skeletal and mass spread of stain; to the use of opaque, textured, and transparent surfaces; and to a dramatic deployment of light values in the stain itself.

Brush and twig were used to initially establish the principal areas of stain—those which determine the essential form of the work—but the tools which effected all the variations of surface quality, texture, and light value were two sponges, one wet and one relatively dry. The wet sponge was used to diffuse areas of dark stain, while the dryer one controlled the spread. By dabbing with the dry sponge, the edges of surfaces could be broken down and "feathered"; alternately stroking and dabbing stain over the surface with the edge of the damper sponge produced the textured sky-ground.

But verbal description is of limited use here. Study the image closely for yourself and decide how this or that effect was produced. And then experiment on several pieces of paper with brush and sponge, observing how the ink moves when water is applied, how to control its spread and so preserve white areas, and how to texture edges and surfaces, change values from light to dark, and so on. Start on your own *Tree, Moon, and Thistleseed* with a lot of confidence—or at least a spirit of genuine inquiry, curious to see what happens as you deal in light/dark areas.

Figure 1-23

THERE IS NO BETTER WAY TO CONSOLIDATE this work with line, point, and surface than to sum it all up visually, and acquire that immediate knowledge which the eye alone can give. For this purpose, examine Figures 1-24 and 1-25—two images which, appropriately enough, represent the work of master and pupil. (It was a tradition in Japan, particularly in the fifteenth century, that on the departure of a pupil, drawings should be exchanged.)

In Robert Kiley's *Chakra Suite 4* (Fig. 1-24) the plasticity and flow of brushed-in marks is thoroughly exploited to impart a symphonic range of graphic possibilities: Translucent and opaque surfaces, either light or dark in value; lines and edges varying in quality and speed, and points marking space or arresting and initiating motion are all delivered to the paper with a gestural certainty and economy of means which would please the swordsman's eye of a samurai. Study this drawing quietly; it is a masterpiece of kinesthetic sensitivity, a graphic experience in its own right, transcending subject matter.

Figure 1-25 is a drawing exercise carried out originally in the form of a hanging scroll. Unfortunately it cannot be reproduced here as such. Nevertheless, it is still possible to see the progression of the linear markings: the variations in touch and gesture; experimentation with thin and thick stain; and a thorough exploitation of the brush itself, causing it to deliver a repertoire of lines and edges, points and surfaces.

Such is the quality of gesture and breadth of understanding which these first exercises hope to engender; and they must be at the fingertips if one is to draw well.

Figure 1-24
Robert Kiley. Chakra Suite Number 4 *1982.*
Acrylic on paper.

Figure 1-25
Student drawing, courtesy
Professor Robert Kiley.

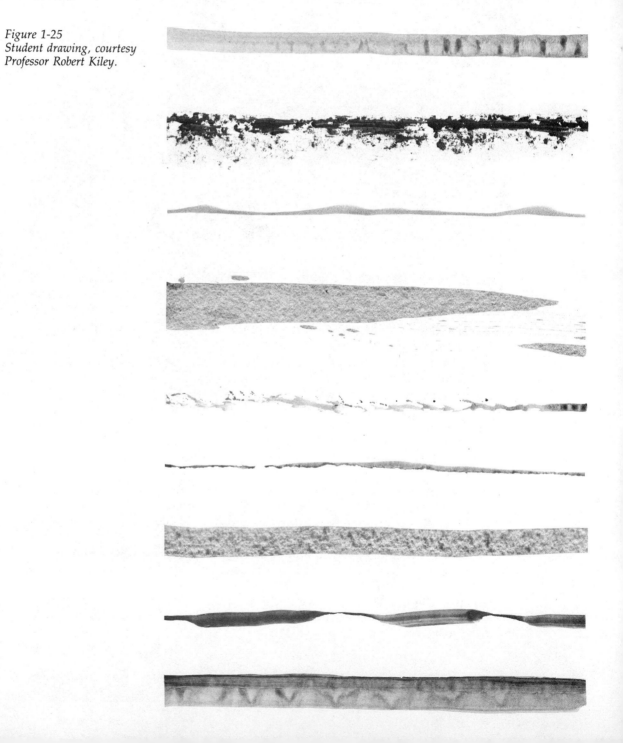

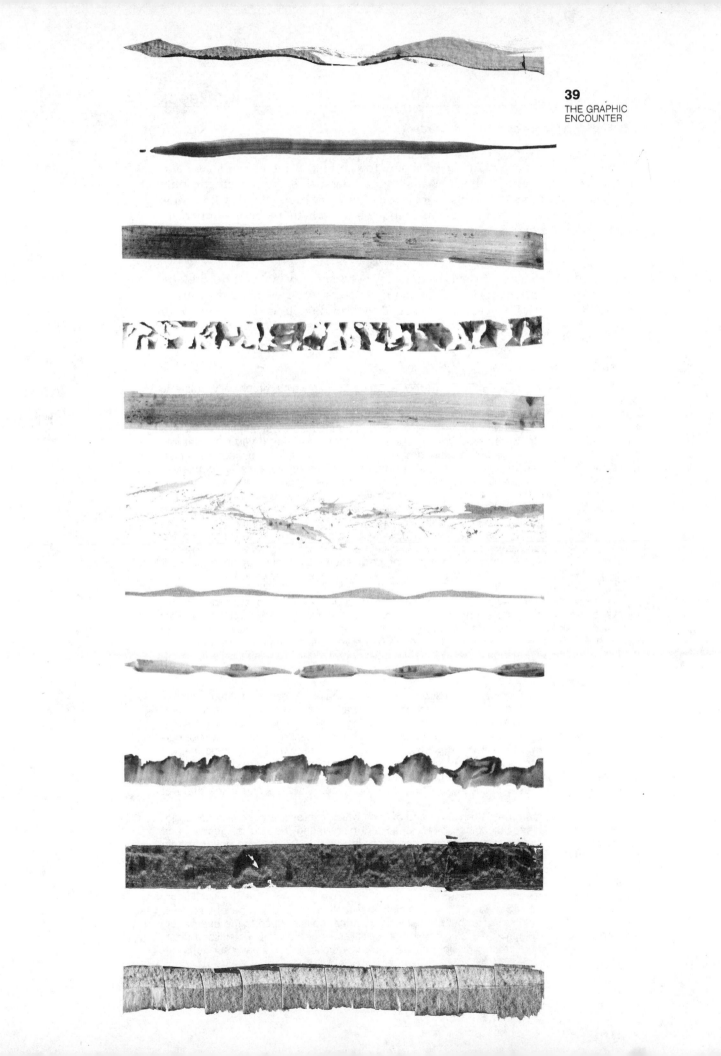

I-II. Drawing Marks and Natural Content

Our first set of exercises dealt with drawing techniques. Now we are to grapple with a much more elusive factor: how the graphic elements can shape and convey thoughts and feelings. With these experiments the kinesthetic phenomenon really comes into its own. For as the work proceeds, it will become obvious that even the slightest change in posture—whether it be the imperceptible shift of weight from one foot to another, or the release of muscular tension in the little finger—results in a drawing gesture which better serves in mind's intent.

Assigning a series of devised drawing exercises may not inspire the student to react in a personal way. In the normal course of events a drawing is the result of a private need. So at best all we can do here is try to whet your appetite.

A. *Free-action lines—Expression*

Now you will try to see if you can draw a series of lines which, graphically, relate to artificially induced, simple feelings. *Strong* feeling and *intense* mood are conditions which develop in the course of living, not when working through a textbook. So you will begin by trying to express mild emotions—ones which can be induced by attempting to identify with the particular feelings prescribed by each part of this exercise. If you can "get into the mood," so to speak, there is a good chance that your drawing response will, kinesthetically, correspond to your feelings. When this first series of drawings is complete—drawings in which you are shaping lines of sadness or of joy—then continue with the next exercise, which is intended to demonstrate the effects of creating in a situation in which the body will naturally be in motion. Most people find themselves moving to music, so you will try drawing to music. Then you will become aware of how spontaneity of feeling expresses itself in body movement, and of how such body movement translates into the kinesthetic aspect of drawing. Later, as more sophisticated drawings are called for, you will realize how difficult it is to keep some Expressionist content from creeping into a work of art, for feeling is usually present to some degree when one sits down to write, to make music, or to draw.

Because the first drawing sequence has familiarized you with various drawing instruments, it should not be necessary here to specify that a particular instrument be used for a particular exercise. Use pen or brush, twig or soft pencil, as the occasion seems to demand. But bear in mind that the direction in which you pull or push the drawing tool—vertically, diagonally, or horizontally—has a significant effect, in that each calls for a different type of kinesthetic action, of arm-wrist-hand movement, and of pressure of touch over the surface.

The nature of the work is as follows: You are to make six pages of lines, each of which is to convey a distinctive feeling-mood. First: Draw lines expressing *serenity*. Try to relax and keep the pressure uniform from the beginning to the end of each line. Avoid angular changes of direction so that the pen or brush movement follows a rhythmic, curvilinear flow. Figure 1-26 shows the regular and relaxed freedom of such lines in their unhurried undulations over the surface. These are what might be called even-tempered lines, each one showing a uniform thickness and tone value. They move across the page surely and without fuss, suggesting a tranquility of mood, a serene and blithe state of mind.

Now, in direct contrast, attempt a page of lines which express *anxiety*. It is no longer a question of relaxing, but of becoming tense and discovering the kind of gesture and touch which manages to convey such a condition. In Figure 1-27 you see how a felt-tip pen has jerked nervously over the paper, sometimes under intense pressure and other times not. The movement is angular, the flow disjointed, the rhythms irregular and unpredictable. All these kinesthetic factors and their graphic results are the very opposite of those we have described as serene.

In attempting to produce a page in which the dominant mood is one of *sadness*, which you should try next, note that the complexity of the feeling supports the use of varied instruments. In Figure 1-28 both brush and calligraphic pen have been utilized in order to produce the maximum possible contrast in the weight of line. Heavy surfaces (al-

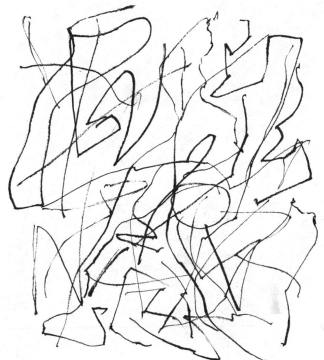

Figure 1-26

Figure 1-27

Figure 1-28

most non-lines) subside slowly and trickle out into thin veins of sharper pain. The movement is downward and horizontal. The lines—like the feelings—cannot rise.

However, it is a different story when it comes to shaping lines of *joy*. By varying the pressure on the brush (or pen) point, and by changing the angle of drawing, it is possible to make lines which start off delicately and then proceed to rise ecstatically, swelling and diminishing as they ascend. In Figure 1-29 you see lines of vertical energy—feelings bubbling and surging through sudden pools of intensification to reach peaks of pleasure. With lines like this, you should always be aware of the variations required in the tactile control of the instrument, and in the concentrated or diluted use of the stain. Touch pressures

Figure 1-29

Figure 1-30

and arm-to-wrist movements are constantly changing; the brush or pen will turn and twist as it moves over the paper. You might also discover that the normal, neutral pulse of your feelings shifts gear as, despite yourself, you begin to respond to the emotional uplift of the emerging lines. A visual comparison of these lines with those in Figure 1-28 speaks for itself. One says, "I'm feeling down"; the other, "I'm just up there today."

Finally, draw on two last pages, one again providing a strong contrast to the other. *Optimism* and *pessimism* are more difficult feelings to deal with, for the emotions involved are less pure, less immediate, than those you have previously been trying to express. Thoughts are also more directly involved; each experience becomes a complex attitudinal weave of both thought and feeling, which makes for a compelling and all-pervasive mood. Figure 1-30 shows a direct response to the challenge—to find the line of drawing which adequately expresses optimism. A very broad twig sharpened to a wide chisel edge was used. Dipped in the ink and starting its journey from the bottom of the page on the long, thin dimension, the twig was turned between the fingers to engage the full breadth of its width as it turned and looped. Alternately turning from thin to broad, it meandered in generous and expansive sweeps before tricking downward, only to start it seems, all over again.

Pessimism is expressed differently in Figure 1-31. Here, brush, pen, and blotting paper have been used to create a line which never seems very sure of itself—never completely gets going. As water is added to the line, it breaks up, loses impetus, and, for a moment, loses a sense of direction. The diagonal meandering and constant turning back onto itself suggest uncertainty—a wavering easily translated into the emotional despondency we call pessimism. Here is a case in which the lessons learned from the first drawing sequence are put into effect. The artist has experimented with both stain and instrument. By making a watery blob in the path of the line and then continuing through the damp area with the pen, by loading the brush with ink to make a line which passes

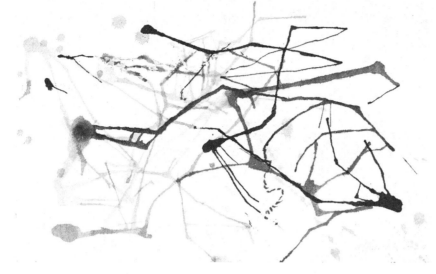

Figure 1-31

through a region dampened with a sponge, by sponging a line in order to diffuse the stain, and by having a dry brush handy to produce just whispers of a line a range of linear orchestration is achieved.

As you have hopefully observed while doing these exercises, the richer and more varied the graphic presentation, the more psychologically compelling in terms of content a work will be. Thus, you should continue to experiment and try new movements with the various tools. There is really no substitute for personal discovery. As your knowledge of stains increases—as you move, for example, from inks to pigments—and as you press new drawing tools into service, the curiosity to experiment and see what happens on the page is vital. This exploration of technique—in order to discover the best way to express feeling—is evident in all the examples shown. And although it seems very obvious, I still draw your attention to the fact that the *direction* in which lines travel has much to do with their expressive power: Vertical movement expresses a certain vitality of feeling; diagonal movement is less positive, fluctuating between the vertical and the horizontal; horizontal movement itself suggests the static and flat, an even emotional pulse; and downward movement implies weight and heaviness of spirit: a gravity of feeling.

Even more obvious, yet still worth mentioning, is the importance of the anatomy of the line: its skeletal curvilinear *or* angular structure. The serene range of feelings is served by the one; anxiety, stress, nervous vitality, by the other.

B. *Free-action lines—Heightened kinesthetic awareness of expressive content*

Free-action lines automatically evoke, in the mind of the viewer, an awareness of the kind of drawing gesture which produced them. As you look back on your own pages it will not be difficult to relive, in the mind's eye, the way your body responded to the stimulus of feeling offered by each exercise. The overt presence of this kinesthetic factor is part of the attraction of Expressionism. In the next few pages of the Workbook you will exploit the gestural element in drawing; you will self-consciously relate body language to stimulus and record it, like a seismograph, with pen, pencil, or brush.

A good way to do this is by responding directly, with the graphic line, to music. Figures 1-32 and 1-33 show two lines made in response to music. The even weight and regular horizontal flow of the monodirectional line in Figure 1-32 represents a drawing response to a few bars of Debussy's *La Mer,* a work in which the musical dynamics are relatively smooth and equable. But the multidirectional figure created by the line in Figure 1-33 was generated by listening to one of the more turbulent passages from Rimsky-Korsakov's *Russian Easter Overture.* Here the musical dynamics are anything but equable. The sound flares forth in great vertical crescendos only to subside in drawn-out horizontal quietness. The result is a line whose angles cause more abrupt changes of direction than its curves, and which ascends and descends—heavy, slow, and resonant here, but thin, speedy, and high pitched there. The interesting thing is to see how the dynamics of sound are faithfully translated into their graphic equivalent, which then becomes a visual experience in its own right.

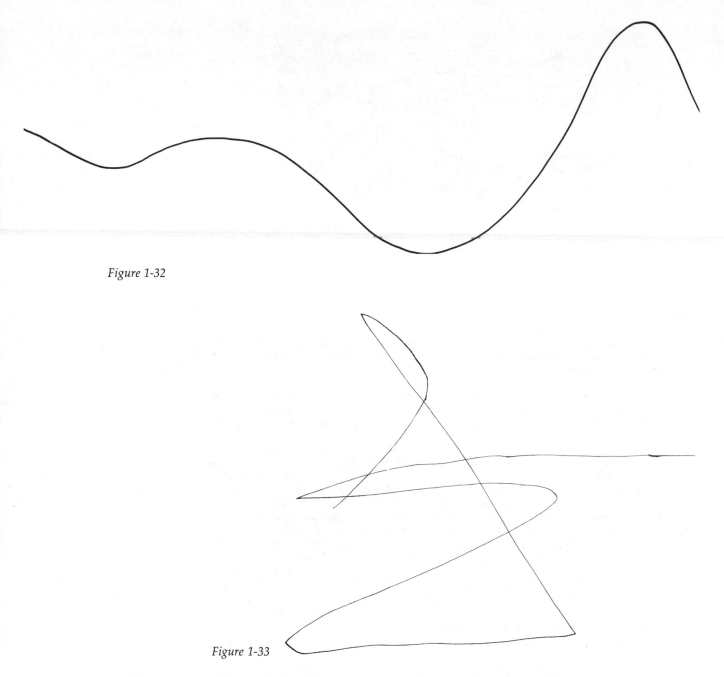

Figure 1-32

Figure 1-33

Play as many different kinds of music as you like, and give yourself over to the rhythm and mood while your hand—as your body's recorder—graphically traces on the page the kind of line which reflects your physical response. Figures 1-32 and 1-33 represent fragmentary responses to sound—a bar or two at most. But in Figure 1-34 you see the result of a 5-minute involvement with Felix Mendelssohn's *Hebrides Overture*. See how long you can sustain such drawing action before losing spontaneity of movement, or before overfilling the page.

C. *Free-action lines—Non-objective attack and expressive content*

Now let us move to the attack—and I mean this literally. The two extremes of emotional experience which most of us know in our lives are states of neutral, detached non-involvement and states of urgent involvement or passion. The preceding drawings have explored how physical action or touch produces lines that relate to feelings somewhere between these extremes. But you have not tried to stimulate an all-out attack—an action representative of intense and momentary feeling where the paper becomes the battle-

ground for such a catharsis. Of course, the artificiality of these drawing situations which we intend as exercises goes without saying. As I have said before, you are only going to experience the real catharsis of feelings into art when you are drawing freely and naturally for yourself, responding directly to life itself.

At any rate, try to work yourself up to produce a page of free-action lines which suggest the power and urgency of a compulsive passion. Think of this exercise as an "attack," because this is the only way to artificially stimulate such lines and marks. You can use brush, all the pens, and twigs, and your strokes can move across the paper from every direction. In drawing, contrast the directional thrust of line against line, of tense angles versus sweeping curves, and of nervously flickering dots and broken lines countering lines of continuous movement. The pressure that you bring to bear will relate to the strength of your emotional impulse; the speed of the line to the pulse of feeling; and the spatial intervals between the marks will proclaim the dynamic beat of the attack's rhythm. You should stop not when visually satisfied, but when, emotionally, you feel the action to be complete.

If you take this exercise seriously, the chances are that you will discover that every kind of line you have previously made is present in this drawing. The expressive power of such a non-objective image is inescapable. The extraordinary thing is that when you face it in Figure 1-35 you see that even the beginning student is unconsciously controlling pen and brush to make a range of lines which embraces the speedy, thin, and sharp, through to the ponderous, heavy, and blunt. The result is an explosion of graphic and nervous energy.

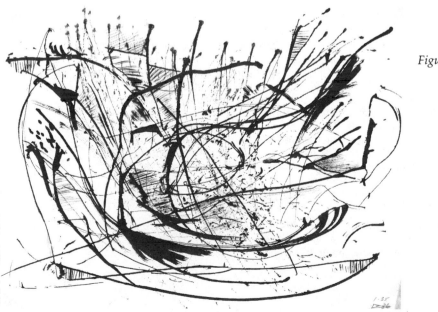

Figure 1-34

Figure 1-35

Figure 1-36

D. *Free-action lines—Objective attack and expressive content*

Now, for a change, let us move away from the theoretical and work from life—from a natural object—so that direct visual experience will provide the stimulus for feeling and attack. Select a tree that, in your view, has a lively shape, and sit yourself down before it. Study the tree for a few moments to get the visual "feel" of its structure, and then spring to the attack with ink, pen, and brush. You should try to work quite spontaneously, without deliberation or preliminary drawing, so that in about 3 minutes you have a drawing as free and as immediate as Figure 1-36. As you can see, the tree provides a certain objective stimulus, but really it is the action which is tree-like. Even so, this quick drawing, which makes use of many different kinds of lines and marks, is more graphically alive than the conventionally imitative, representational image resulting from safe academic techniques.

E. *Deliberate-precision lines—Concept and content*

All of the preceding work has involved a free-action drawing response in the attempt to portray a graphic equivalent of mood or a specific feeling. But now we come to the other side of the coin: to experience the linear discipline demanded when you wish to

shape thought or idea. When this is the aim, you must concentrate on physical clarity: on discovering the essential structural qualities which allow the image to display a form that is unambiguous and that is definite and exact. To do this, it is not necessary to have a theme, as such, in mind. Although it is perfectly possible to say, "I wish to discover the precise shape to suit my idea or concept of bird," it is also quite feasible to work with shape in the abstract with no natural object in mind—to find forms which fit in with your concepts of formness: structured shapes which your mind will accept as morphologically credible and interesting without needing to ask what it is they represent (form for the sake of form, if you like).

If you are, then, drawing to find shapes which thus appear distinctive to eye and mind, it is obvious that a degree of precision will creep into the kinesthetic process. As the form emerges so the lines will tighten to firm up the shape and to reveal the exactness of its structure so that the drawing can satisfy the mind's need for formal order. The shape should be cleanly delineated and the demarcation between figure and ground clearly determined. The finished drawing will have an "engineering" look to it—a structural clarification not present in more expressive work.

Your first page of drawings should be *objective*. That is, they should be based on ideas about, and visual experience of, a natural object—in this case, a bird. Note that you are not concerned here with the natural shape of a particular bird perceived at a particular moment in time, but with your mental realization of "birdness" in general—with the concept of what is essentially bird and with the translation of that concept into visible form through drawing. Look for a moment at Figure 1-37. The shapes are clear, the lines precise. The result is that the form is easily perceived; the form of bird is imprinted on the mind as shape. There is very little expression—a certain humor perhaps—but feelings are secondary to the formal concept.

Now, make your own page of bird forms. Do not just copy Betty Peebles' drawings in Figure 1-37, but structure your own concepts with lines just as firm, to arrive at shapes just as precise. Fill the page, allowing variations to occur as your ideas begin to flesh themselves out. As you draw it will become obvious that a conscious control is being exercised: arm and hand move with great deliberation, touch and pressure remain constant—all to ensure that the form is firmly and plainly delivered. It is difficult to use the brush for such drawing, for it is a tool more suited to the free action of expressive gestures. But the hard point of pen, pencil, or twig can render the line of deliberate precision most effectively.

Figure 1-37
Betty Peebles. Drawing *1973.*

For the second page of sketches you should deal with shape in the abstract, which requires no reference to natural objects. First divide the sheet into twelve or sixteen rectangles of reasonable proportions, and commence drawing in the top left-hand corner of the page. With a firm and even line start to spontaneously delineate a shape, angular or curvilinear or both. Once the line starts moving keep your eye on it like a hawk; you will have to make split-second decisions as to how the emerging shape should grow and how it should be formed so as to remain consistent with your continuing mental appraisal of its morphological credibility—that is, to hold your interest as shape. Stop when you are satisfied, when the shape itself matches your idea of what the shape should be. When this point is reached, shape has become form. Redraw this form in each remaining square; do not copy it, but modify and refine it as you go. The two most important aspects of this exercise are: (1) that the drawings are made—kinesthetically speaking—in a precise and deliberate manner; and (2) that the form which emerges in each rectangle results from a series of mental decisions as to the rightness or appropriateness of its physical character.

Figure 1-38, an excellent example of this sort of experimentation to find formalist content, originated as a series of drawings called *Ideas for Sculpture*. Throughout these sketches, Betty Peebles consistently explores forms which are, fundamentally, curvilinear and organic. Yet it may be that angular and more geometric structures hold your interest. Look for just a minute at the precise angular geometry and the structural ideas imposed on the human body by Villard d' Honnecourt in the thirteenth century. Observe the contrast between the organic and geometric (see Fig. 1-39). Note that you can attempt to create this same contrast in your own emerging style.

Now try a third sheet of drawings. Once again, aim to make between twelve and sixteen sketches on the page. This time, however, work deliberately with a combination of straight lines and angles and curved lines and circles. Just draw precisely to create a configuration of varied, overlapping lines in each rectangular space. Your drawing gesture should be controlled and firm on the surface; your decision making should be equally conscious. Constantly evaluate the visual interest emerging from the form of your bisecting lines, and the internal and external shapes and spaces they produce.

Figure 1-38
Betty Peebles. Drawing II *1973.*

Figure 1-39
Villard d'Honnecourt. Studies. *13th C.*

Figure 1-40
Betty Peebles. Drawing III *1973.*

Figure 1-41
Paul Klee. The Great Dome *1927. Pen and ink.*

Figure 1-40 illustrates another "working out" of visual ideas for two- or three-dimensional abstract images. However, as you can see, the artist has gone a stage further in these drawings: Area shapes and stain values have been introduced. In five of her sketches, Betty Peebles has chosen to emphasize certain parts of both figure and ground by applying varying values of stain, and I think you will agree that this results in a structural firming up of the form—in a further graphic clarification of the concept. Notice how the contrasting values of light and dark areas—in addition to line—help in the overall resolution of the image.

You should now try to accomplish the same effect. Select three or four of your sketches. Choose two or three areas in each and, with a soft pencil, make them into positive shapes by adding light or dark stain. The darker the stain, the more visually positive the area will seem to be in terms of the integral relationships of the parts. (We do not go into the spatial or volumetric aspects of such surface and light-value treatments here. These consequences of drawing are described in some detail in Chapter 2.)

For the final drawing in this series I leave you—more or less—on your own. Take your inspiration from Paul Klee's *The Great Dome* (Fig. 1-41). Study it closely to observe the sort of structural counterpoint that goes on between point and line as a linear pattern of architectural form is built up. Then close the book. Using pencil or ball-point liner, construct an idea of your own: Develop a concept with the help of points and lines of deliberate precision—one suggested by the title *Waterfront with Dome and Tower.*

F. *Area and Stain—Free action and expressive content*

This very brief exercise is intended to relieve the concentration on linear drawing by reminding you that the way stain spreads to produce areas also determines the content of a drawing. We have just seen, in Figure 1-40, how a carefully applied and even-toned pencil surface aids structural definition—helps supplement purely linear information—and thus enhances the design concept. Now let us attempt to handle areas of stain and the tonal values that may be employed to convey mood. Work these exercises together on the same page: use the top half for one, the bottom for another. In this way the visual comparison will be most effective. It makes little difference whether you work from a given theme or simply from the impetus of a feeling itself. Yet it may help you to relate feeling to a specific visual experience—for example, the sky. Thus, the two surfaces you are to stain would become sky on the page. Now for the feelings or moods: Let one drawing portray serenity; the other, anxiety. In order to avoid the intrusion of any linear element, work solely with brush, ink, and water. Dab or wipe with the sponge, take out stain with blotting paper—in other words, employ any means to direct the flow of the stain to become area and to contol its value from dark to light. A serene sky, or a threatening sky . . . that is what you are after. Can you identify which is which in Figures 1-42 and 1-43? They surely have no need to be verbally identified.

NOTE: Some of you may have recognized that—according to the distinction made between drawing and painting in the Orientation—this exercise is more a matter of making a painting than a drawing. And so it is. But I also suggested that such distinctions can become quite academic: useful categorizations to identify a particular way of working, and a particular kind of result: a drawing or a painting. In practice, the spread of stain and the positioning of point and line to fashion the essential form of the work is common to the making of both a drawing and a painting.

Figure 1-42

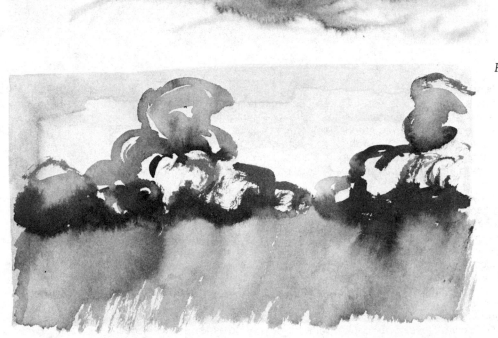

Figure 1-43

Figure 1-44
Pascal Tchakmakian. Brush Drawing
1976.

Figure 1-45
Henry Moore. Pen Exercise No. X *1970.*
COURTESY OF THE ARTIST.

G. *Calligraphic line—Freedom with precision, expression with concept*

Literally translated from the Greek, the word "calligraphic" means *beautiful writing*. The Greek and Arabic alphabets demanded letter forms which possessed clear and distinctive shapes, and which needed to be formed with skill. Penmanship then—in Arabic and Greek writing—and "brushmanship" in Chinese and Japanese—became an aesthetic exercise; writing became an art form. Masters were recognized, and the written page was appreciated as much for its visual elegance as for what the words had to say.

Nowadays when we describe a line as being calligraphic we mean that it has been rendered surely; is graphically "clean cut"; moves with curvilinear or angular grace; and reveals changes in weight from thick to thin as the drawing (writing) instrument utilizes both broad and thin aspects of its tip. This thick-and-thin character of the calligraphic line results from turning the brush or pen between thumb and forefinger as the directional formation of the letter (or figure) demands, and also from the amount of pressure applied. Heavy pressure ensures that the stain spreads to produce full lines; light pressure produces lines that are sharp and thin. In short, calligraphic line is characterized by frequent changes of line weight. These changes are distinguished because they are graphically elegant; the transitions are easy and flowing rather than awkward and "jerky."

Figures 1-44 and 1-45 are examples of calligraphic drawing. Pascal Tchakmakian gives us the calligraphic mark of the flat 1″ brush gyrating its way down the page under perfect control. Henry Moore shows us how changes in tactile pressure produce the swelling and diminishing of line when the pen is used. Note also the speed of the pen calligraphic line, and how damp and dry surfaces affect it. Such lines are expressive in their sensuous sway; they are also intellectually appealing, for they are elegant and represent perfect control.

This very simple exercise is intended to let you become actively familiar with this calligraphic quality. Choose the broadest pen provided with the Sheaffer calligraphic set, and use one or two pages of your Workbook to produce a series of lines which have the characteristics just described. You might also try the brush to extend the technique. You should aim for an elegant cursive flow and a sureness of touch: an easy transition in the swell of a line from thick to broad, achieved by rolling the pen or brush from its point to its side as direction is changed.

Compare your completed pages with Figures 1-44 and 1-45.

H. *Point, Line, and Area—A graphic potpourri of varied content*

The final drawing for this chapter represents a graphic summing up for which you should use every possible instrument, each to make its own distinctive kind of mark. For example, the pointed or chisel-ended twigs can make the most delicate or the widest of lines. They also possess the capability of producing interesting gray marks and textures once the ink has soaked into the wood. And they can be pushed around on the paper with more facility than a pen. Sponges, rags of various textures, and the finger (or finger-nail) itself all produce marks having particular qualities. Ink may be used "neat," or di-luted. The paper may be dry, damp, or wet. This exercise, therefore, demands experi-mentation with instruments and inks on dry or wet surfaces.

First assemble all your tools. Then you should draw uninhibitedly, yet with a great deal of concentration, employing both free-action and deliberate-precision gestures, to produce as wide a variety of points, lines, and stained areas as possible. The type of graphic tour de force that will result is illustrated by Figure 1-46. Study this drawing to ascertain how the various impressions were made. You see that some have been "printed"—that is, an instrument such as a ruler or sponge has been inked and then im-pressed once onto the paper—while others result from dripping ink over damp or dry areas. With experience you will be able to distinguish the lines drawn with a twig from those made with pen or brush. It is worthwhile to remember that every mark is capable of being used in more formal drawing. You should also make a mental note of those drawing tools that particularly suit you—those that produce a definite sense of control while you are drawing the line and those that allow you the greatest freedom of gesture as your feelings for the work ebb and flow.

In short, try to bring together on one page every kind of drawing mark which has been introduced in these Workbook exercises. And in doing so, organize their placement in such a way that the graphic personality of each mark is complemented by that of its neighbor. In other words, place the marks with an eye on contrast in order to heighten the individual differences of each.

When the work is physically complete—in your opinion—study it not only for the vis-ual richness of its graphic qualities, but also to determine whether it is primarily emotion-ally or intellectually satisfying. Of course, it does not have to be simply one or the other. Depending on the drawing gestures employed, some passages may express a quality of mood while others may be structured to clarify a particular thought concerning the cor-rectness of spatial balance or the proportions of a certain shape. But try to appraise your work for its varied content, and visually accept or reject it for its graphic physique.

Figure 1-46

W E ROUND OFF THIS CHAPTER with a few illustrations which exemplify some of the plastic aspects of drawing we have discussed, and which also embody the related content—conceptual or expressive. To make comparisons easier, all the works of art shown are drawings of the human body, and my comments appear with the figure captions. If you study these works you will become something of a connoisseur of drawing styles and their implied meanings.

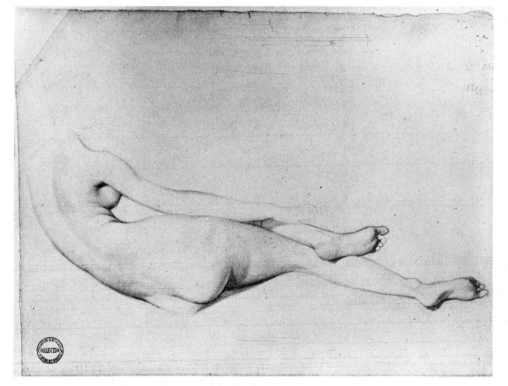

Figure 1-47
Jean-Dominique Ingres.
Study for La Grande
Odalisque.

COURTAULD INSTITUTE OF ART, LONDON.

COLLECTION: CHARLES MORGAN.

The flowing, continous line works to convey both feeling and idea. It carries a mood of relaxed serenity, while at the same time clearly defining a form which is nothing if not elegant—an ideal of feminine beauty. Area is but lightly indicated in terms of light and dark values, yet together with the swell of line, is sufficient to heighten the roundness and fullness of the volumes.

Figure 1-48
Henri Gaudier-Brzeska. Nude.

CROWN COPYRIGHT, VICTORIA AND

ALBERT MUSEUM, LONDON.

What a contrast to Ingres. The line moves forcefully in short bursts of speed; it is altogether more broken and angular. Areas are not treated by spreads of stain but by plays of short, stabbing lines which create abrupt transitions from black to white. Consequently, the mood is far from serene and relaxed: Instead it is aggressive and agitated. Neither are area contours rounded and gently flowing, but angular and abrupt. The idealized flow and clarity of Ingres is not present. All in all, the form of the drawing can be described as expressive distortion.

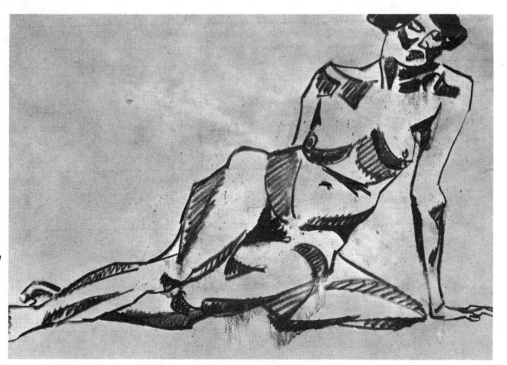

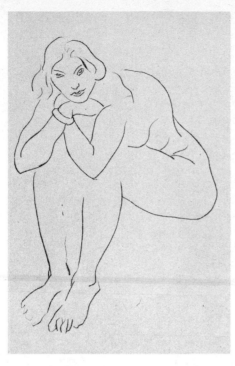

Figure 1-49
Henri Matisse. Seated Nude 1929. *Drypoint,*
printed in black.
COLLECTION: THE MUSEUM OF MODERN ART, NEW YORK.
PURCHASE.

Surety of touch, clarity and even flow of line,
and absence of stained areas make this an
extremely pure drawing: No anxiety, tension, or
passion prevail. The emotionally undemanding
image is calm and still. The line shapes the
overall form of the body simply, but clearly.
Without area tones of light and dark, and without
the swell of line, volumes are lost. The drawing is
therefore flatter than the Ingres or Gaudier-
Brzeska. Contrast it with the graphic treatment of
the Delacroix (Fig. 1-50). By now you should be
able to spot for yourself the physical differences
between the two works; counter the formal
simplicity of Matisse with Delacroix's dramatic
and loosely structured forms.

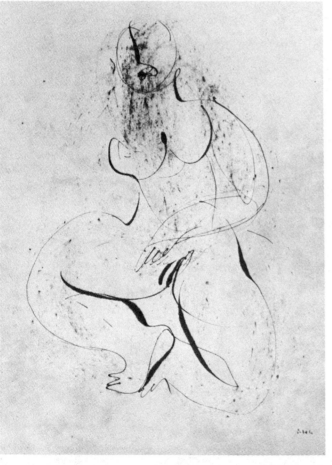

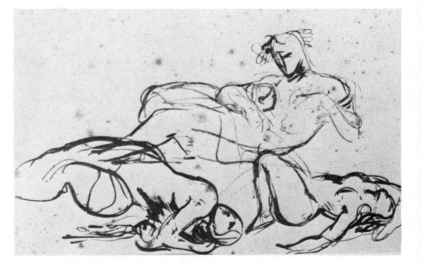

Figure 1-50
Eugène Delacroix. Studies for Sardanapalus.
COLLECTION: G. AUBRY, PARIS.

Figure 1-51
Jean Fautrier. Study for Bataille. *India ink and*
crayon.
HANOVER GALLERY, LONDON.

This India ink and crayon drawing illustrates the
calligraphic line in action. What conclusions would
you reach concerning the content of the work?

Figure 1-52
Henry Moore. Sketchbook study, Half-Figure Girl
1856. Pen and ink.
COURTESY OF THE ARTIST.

*The electrifying vitality of the short and almost
broken line here results from its changing direction
continuously and criss-crossing itself in a frenzy
of movement and animation. The expressive
intensity of such graphic force is overwhelming;
purity of form must suffer. Yet a Matisse-like
clarity of linear definition was not the artist's
intention. The urgency and immediacy of feeling
was—one assumes—spontaneous and dominant.*

Figure 1-53
Auguste Rodin. The Peach *1908. Wash drawing.*
COLLECTION: RHODIA DUFET BOURDELLE, PARIS, PHOTO BULLOZ.

*Now, for a change, line is subordinate to area. The
most obvious line of drawing is that created where the
area spread of stain stops. Notice how the subtle
values of light and dark gently round out the volumes
of the figure. The absence of dominant lines in this
limpid wash of stained areas allows the image to
materialize in a haunting way, unforced and poetically
appealing. This treatment imparts a most sensuous
mood of the image. The physical characteristics of
these lightly stained areas seen against the light
ground nevertheless shape the figure clearly—clearly
enough, at least, for us to grasp Rodin's concept of
the feminine as idea. Form and expression both are
well served in this drawing.*

GROUND
space perception and structure

*Spatial forces are thus operating as soon as any mark is seen, and these spatial forces become more apparent as we are able to experience differences amongst the elements which occur in the picture area . . .**

MAURICE DE SAUSMAREZ

THE CONCERN OF THIS CHAPTER is the inescapable presence of space—the fact that our perceptual awareness of it is as vital for the comprehension of a work of art as it is for our ability to recognize the characteristics of the physical world in which we live and move.

It will become apparent that, so far as eye and brain are concerned, space is not just nothing as much as it is *no thing*. Although this statement may seem obvious, its implications are far reaching when it comes to exploring how visual perception works: We must adjust our thinking to accept the fact that behind every act of perception lies our capacity to structure space as a positive entity—to shape it as clearly as any object. Equally important is the fact that even though we navigate through space daily and so are aware of the various shapes and proportions it assumes as a physical phenomenon, we are also strongly affected psychologically by its scale and by whether it is light or dark. We respond to the openness or the restrictions of space, its squareness or circularity, its verticality or horizontality. And as light needs space through which to travel, likewise the conditions of light in a particular shape of space can stimulate or repress creative thought and heighten or depress mood. (Think of the vital role played by the spatial, luminous, and accoustical qualities of religious architecture.)

The problems of treating such a complex subject as space adequately are formidable. But if it is to be attempted at all then let us try to identify essentials

*Maurice de Sausmarez, *Basic Design: The Dynamics of Visual Form* (London: The Herbert Press, 1964), p. 41, and Van Nostrand Reinhold, New York.

and concentrate the discussion around them—even if this results in some over-simplification. To this end, this chapter consists of three sections, each with its discursive and practical (Workbook) sides. They are:

1. Space and Figure-Ground Perception
2. Space Composition
3. Space as Positive and Negative.

I
Space and Figure-Ground Perception

We have already had to refer on several occasions to the fact that spatial situations are created by using a mark of drawing in a certain way. For example, we have seen that any line, moving in any direction, made an obvious two-dimensional division of space, vertically, horizontally, or diagonally. Also, we have seen that several lines together—or differing toned areas—created an illusion of three dimensionality, of space in depth. But it would have caused some confusion to have broken our concentration on the graphic aspects of drawing in order to then start explaining the spatial one; our perception of space, and response to it, are complex enough to demand individual and lengthy treatment.

In saying earlier that to draw is to make visible, I should have explained this statement by saying that drawing is a way of clarifying our visual perceptions and rendering them concrete. The psychology of perception is a relatively new field in which discoveries are continually being made, and with every advance it becomes increasingly obvious that dogmatic statements must be avoided. Nevertheless, despite the wide range of variables affecting perceptual experience, one truth can be stated which pertains, a priori, to everybody's visual awareness: *At any moment in perception there is a figure on a ground*—whether it be a twig against a sky or a line on a piece of paper.

Robert Nix's photograph (Fig. 2-1) of a single twig curving boldly into space provides a good illustration. Without the presence of the twig as figure, the rectangular area of the print would be just undifferentiated space—space with no focal point and no defined regions. But with the twig in position we can talk about the circular, top-center space; triangular, lower left-hand space, and so on throughout the picture, identifying shaped spatial regions which result from the presence and particular position of the twig. When this happens—when space assumes positive location and shape—then it may be justifiably termed *ground*. Yet, it is the *figure*, however slight, that by occupying space demarcates the region and thus gives mere emptiness both place and perceivable shape. The converse is also true. As you look at the twig in the photograph it is apparent that its physical personality as a material object—linear, curving, extending—is perceived because space, in contrast, is no thing: It is the void which starts where the twig stops and, as such, plays a vital role in our perception of the twig. Space acts as the surrounding, "cradling" matrix, thus allowing the twig itself to be seen clearly in relief.

Visual perception is thus dependent on our ability to mentally utilize this dual nature of the world outside ourselves: to comprehend space as an element without apparent substance, and then to attribute some measure of materiality—or "thingness"—to whatever we discern as possessing shape and standing in light or dark contrast against space. Thus, a vague, gray shape in a fractionally paler ground becomes object to be identified when intellect pro-

Figure 2-1
Robert Nix. Curving Twig.

cesses the given clues. During all our waking moments eye and brain are constantly engaged in attempting to separate the substantial from the insubstantial in the world around us. Visual perception, the process of "making sense" of the world, permits us to discern and locate tangible things in space and to identify them. Knowing this, Leonardo da Vinci's advice to painters who are at a loss with no subject to paint is to stare at a damp, stained, and cracked plaster wall. He points out that this will stimulate eye and brain to turn the inchoate surface of the plaster into a comprehensible figure-ground situation. With this accomplished, intellect will then do the rest by naming, identifying, what is perceived as figure, even if it must go to the lengths of projecting its own obsessive interests onto a shape which is really ambiguous and unrecognizable. So a particular stained area will become a horse; a series of linear cracks, a nude, depending on one's vital interests.

Refer again to Figure 2-1. The spatial regions I identified earlier according to position and shape—circular top center and triangular lower left—show no light or dark variations in tone value, and so stay on the same plane behind the twig. Given this unambiguous ground the twig is clearly perceived (1) as object in the world; and (2) as figure in the photograph. It is seen as a very positive linear shape, standing in strong tonal contrast to the spatial context, and so assumes physical tangibility. We then identify the shape as twig because intellect has filed away all previous experience of twig and "twigness," and immediately provides the information necessary for recognition. Yet although the ground seems to remain on the same plane in depth, the twig as figure does not: It appears to arc through both two- and three-dimensional space.

How does this happen? The photograph is, after all, a flat image. Two factors work to achieve this illusion: first, linear directional movement; and second, tonal contrast between figure and ground. In the case of the former, as the twig-line moves, it establishes the two-dimensional locations of left and

right, top and bottom—a normal occurrence with vertical and horizontal movement. But notice how a forceful diagonal maneuver suggests a cutting *into* the ground—the kind of penetration in depth strongly indicated by the two lower offshoots as they streak away into space. But it is the operation of light and dark contrast which significantly affects three dimensionality, and Figure 2-1 illustrates this phenomenon clearly. Which parts of the twig appear more distant and which more frontal? You can see that where the twig-line is light in tone, offering little contrast to the ground, it seems to be far away. Conversely, where it is dark, in maximum contrast to the ground, it jumps strongly forward. This leads us to conclude that figure assumes frontality in direct proportion to the degree of substantiality—mass or weight—it appears to possess; and that such physical credibility is achieved when its bright *or* dark tone is in *dominating contrast to the ground.* On the other hand, without contrast, figure appears insubstantial: lightweight and amorphous. This is so because when it shares reasonably similar tone values with ground, it merges with the spatial context, thereby putting in question its solidity, its physical actuality. When this is the case, figure recedes.

It is important to remember that these general rules of contrast still hold even were we regarding the negative of Figure 2-1. Then the whitest parts of the twig would take the frontal position when seen against the ground, which would be correspondingly dark.

Now let us move from the figure-ground of the photograph to that of a lithographic drawing. Kenneth Lochhead's *Outer Reach* (Fig. 2-2) reveals most forcefully how the graphic factors of line and area, employing strong tonal contrasts, can create a dramatic spatial situation. You can see that this represents a relatively simple treatment of the drawing surface: one line, one area of stain, and the white ground. It is a cunningly conceived image. The artist is playing with our perceptions. While the strongly contrasting black area becomes the material figure and therefore automatically assumes a frontal position, it cannot hold it. As you continue to study the work, the ground at far right will move forward to compete, not as figure but simply as advancing ground. Yet there is a way to ensure that the dark area stays in front. Simply cover up the curving line on the right. This line, as figure, contrasts strongly with the amorphous ground, being sharp, incisive, and black. As a cutting

Figure 2-2
Kenneth Lochhead. Outer Reach
1971. Lithograph.
COURTESY OF THE ARTIST AND
UNIVERSITY OF OTTAWA.

edge of stain it leaps stereoscopically forward from the pale and vague spatial context and manages to pull the whole of the ground with it, temporarily overcoming the frontal dominance of the dark area. Here we have an example of how contrast in terms of sharp-edged clarity, in addition to tone, can pull a figure strongly forward. What would happen in Figure 2-2 were the edge of the black area not diffused, but sharp?

The graphic structuring of figure and ground to create the illusion of depth on a flat surface seems, therefore, quite a simple matter if one follows the rules.[1] In Rembrandt's *Winter Landscape* (Fig. 2-3) we can see how it is done. Faced with lines which vary in thickness—at times almost becoming area—and which move in all directions (notice the diagonal), a few assorted point jabs, and an overall orchestration in terms of tone values, it is no surprise that the eye begins to differentiate both two- and three-dimensional planes of space. In fact, in this drawing the flat surface is, graphically, treated minimally, yet it manages to assume impressive three-dimensional credibility.

A strong figure-ground contrast is accomplished in Rembrandt's drawing by using lines and points heavy in weight and black in tone to establish the extreme frontal positions. The more delicate and gray lines offer less contrast and so fade into the distance. Notice how the directional movement of lines leads the eye across, up and down, and into space. Horizontal and vertical lines establish a two-dimensional orientation: left and right, top and bottom. But the diagonal lines of the fence appear to cut in and make a direct penetration of space in depth. Now notice the placement of lines and points. (Rembrandt does not really spread stain to form areas in this drawing.) Observe that the frontal position of the heavy black vertical fence pole is reinforced by being placed lower down in the rectangle than other vertical lines: We have become conditioned to associate the base line of an image with nearness, and the top line with distance. The lower down the picture plane are the marks, the nearer they appear to be; and the further up the marks, the further back they seem.[2]

Rembrandt's horizon is placed high in the drawing, and is composed of lines and marks which are light in both weight and tone. This high position, combined with light weight and tone, produces the illusion of considerable distance. But also notice that centrally positioned lines or forms tend to dominate and hold the eye, and hence stand out from the rest; therefore the central position of the heavy fence also helps to establish its frontal dominance. Something of a perceptual struggle is usually caused by placing a series of marks *across* the ground, for those which are central hold our attention so completely that it is difficult to see marks at left and right, except "out of the corner of one's eye." In the three-dimensional world, the bifocal nature of human sight inevitably brings us to a focal center in the visual field where objects are sharply defined in contrast to those that lie outside the bifocal cone of vision.

[1]Nevertheless, it must be pointed out that these rules are not absolute. Our visual perceptions may be strongly modified and influenced by our own subjective experiences in life—experiences which have colored the way we feel and think as adults, and thus ultimately influence the way we interpret our visual encounters with the world. (See definition of "gestalt" in Glossary.)

[2]This does not appear to be a guiding principle in the pictorial art of primitive societies. In Paleolithic cave painting, for example, space is often organized radially, and primitive space perception does not seem to depend upon establishing the nearness of things in terms of a fixed horizontal base, or their far awayness by moving them up a vertical axis. Oriental art has long made use of the up-down illusion of depth to which we are accustomed. By utilizing a picture-plane which is predominantly tall and narrow—the *kakemono* shape of Japan—the artist is able to divide the space into a series of superposed registers which correspond to a series of receding planes. Distant regions occupy the uppermost register, middle distance the center register, and the foreground the lower division. The sort of "aerial" space produced can be seen in Figure 2-4.

Figure 2-3
Rembrandt van Rijn. Winter Landscape *ca. 1648-52. Pen, brush, and brown ink*
on cream paper.
FOGG ART MUSEUM, HARVARD UNIVERSITY. CHARLES A. LOESER BEQUEST.

Figure 2-4: Kung Hsien.
Wintry Mountains. *17th C.*
John M. Crawford Collection.
From "Chinese Painting and
Calligraphy," ed. Wan-go Weng.
DOVER PUBLICATIONS INC., NEW YORK, 1978.

If we wish to see clearly the things situated at far left and right, we have to seek them out by the secondary response of moving our heads in their direction, thus making them the center of a new cone of vision. Consequently, at any moment of viewing, objects which are laterally far from the focal center are not seen clearly and so do not engage our full psychological attention.

The two most important factors, then, which produce an illusion of three-dimensional space when lines, points, or areas of stain are drawn on an empty ground are:

1. *Contrasting values* of light and dark to establish figure and determine position in space.
2. *Directional movement* in terms of horizontal, vertical, and diagonal inclination.

To these must be added two other factors which also play an important role in determining three dimensionality:

3. *Placement* of line, point, or area: the spatial implications that occur when the positions of top or bottom, left or right, and center are occupied by drawing marks.
4. *Quality of line*, which is determined by:
 (a) *weight:* thickness or thinness, suggesting spread or bulk;
 (b) *tone value:* range of tone from dark to light;
 (c) *constitution or build:* dullness and indistinctness, or sharpness and clarity. (Refer to the discussion of Fig. 2-2 concerning the effect of sharp-edged clarity versus edge diffusion and vagueness.)

TO STRUCTURE FIGURE AND GROUND there are three basic ways, each of which creates different perceptual problems. There is, of course, always a certain amount of perceptual stress involved when looking at a drawing or painting. The more abstract or non-representational the image, the more likely it is that the marks of drawing will work to create the straightforwardly graphic spatial situations I have just described. This is one reason for selecting the abstract drawing in Figure 2-2 as an illustration: the factor of association is less likely to influence perception. We cannot recognize familiar things and so

have no particular attitude based on past experiences to bring to bear; therefore our response to the figure-ground situation of the drawing as a graphic phenomenon is likely to be fresh and unconditioned. Yet there is always a degree of stress involved, for we usually try to translate from the graphic to the physical world—from the illusory two-dimensional surface to the natural context of real light and space, whether the work be abstract or representational.

A psychologist describes it in this way:

> The perceptual properties of figures and grounds have been extensively discussed in the psychological literature (especially by the Gestalt psychologist), and the nature of stresses induced by various patterns of figure and ground can be summarized—although it rarely is. Some painters show off a perceptual virtuosity by exploiting figure-ground tensions: Ben Nicholson in one way, Mondrian in another. One aspect of the struggle between the various "schools" of art opinion centers in the nature of the figure-ground relationship. The three fundamental ways to treat the figure-ground problem are as follows: (i) the more representational artists want the ground to stay in its place behind figure; (ii) the decorative artists like figure and ground to stay much on the same plane; (iii) others want a struggle in perception between figure and ground—what at one moment is figure, at another becomes ground; and vice versa. This shift produces a perceptual, and presumably an aesthetic (mental) stress.[3]

Let us examine three drawings of the human figure to illustrate the perceptual properties of figures and grounds which Miller described. In Figure 2-5 (a drawing by sculptor Henry Moore) the ground stays firmly in its place behind the figure. Miller ascribes this kind of figure-ground organization to the "more representational artists." But even though it is true that representational artists favor this treatment, it does not matter if the graphic-figure is recognizable as a representation of some known object or is totally abstract; in either case it is clearly separated from the ground in order that it may be distinguished as figure. A glance at Figure 2-5 shows that this is the case. All the marks of drawing are devoted to graphically realizing the human figure. The ground is untouched. All the graphic impressions—lines of weight and areas of dark tonal value—serve to endow the object (the human body) with substantial mass, and therefore with unmistakable frontality, thus ensuring that the thing of interest stands out challengingly. It is necessary, therefore, to leave the ground untouched.

In selecting an image where figure and ground stay much on the same plane, another sculptor's drawings come straight to mind. Certainly Figure 2-6 reveals a wonderfully ornate flow to William Thompson's line, an uninterrupted and joyous travel which is enhanced by the inviting flatness of a ground which presents no ambiguous spatial problems. Such a style in the hands of a lesser artist could easily appear superficially ornate and decorative in a pattern-like sense. Yet Thompson makes such subtle relationships between the flat shapes of the figure and the reverse shapes of ground, between their curving and countercurving, that our feelings are aroused by the very plasticity of these rhythms and their sensuous appeal. Thus a true aesthetic appreciation is aroused—one that transcends a simple visual, decorative attraction.

However, the artist makes no attempt to graphically work the figure so that it stands out from the ground like that in Moore's drawing. And although Thompson's line possesses a varied constitution—changes in stereoscopic quality and gradations in weight—figure and ground stay pretty much on the

[3]Robert Miller, in a letter to the author, November 30, 1965.

Figure 2-6
William Thompson. Figure Drawing 1972.
Pen, brush, and ink.
COURTESY OF THE ARTIST.

Figure 2-5
Henry Moore. Half Figure 1925–26. *Pencil, chalk, and wash.*
COURTESY OF THE ARTIST.

same plane. The ground flows evenly through the figure and so continues to compete as a flat, level surface. Just the introduction of a few lines, or areas of tone, modeling either figure or ground would be sufficient to separate one from the other in terms of volumes projecting or surfaces retreating.

The third category of perceptual experience with the image—the struggle in perception between figure and ground—is seen in Figure 2-7, another drawing by Henry Moore. Now one is forced to ask the question, what is figure and what is ground? It is immediately obvious that here the ground is not used as in the two previous drawings—as merely the field on which to draw the outline, or fill in the volumes, of the figure. Instead, Moore treats ground as figure by drawing into it with line, and by distributing areas of differing tone values which tend to repeat those of the figure itself. Therefore the shape given to ground competes with the shape given to figure, creating a situation in which both space and figure assume substantiality and are, as a result, perceptually ambiguous. The viewer must sort things out as best he or she can. Hence the perceptual stress. The aesthetic stress results from our unfamiliarity with the overall plastic and graphic character of the image, and from the fact that we must discover, and apply, new yardsticks of judgment as to its intellectual or emotional significance.

Figure 2-7
Henry Moore. Mother and Child *1942.*
Colored chalk and pencil.
COURTESY OF THE ARTIST.

PERSPECTIVE AS A WAY TO STRUCTURE FIGURE AND GROUND

So far we have described how visual perception operates through the ability to recognize figure-ground characteristics, and how personal inferences and associations can influence the outcome of any natural act of perception. But in any discussion of art and visual perception, some reference should be made to a drawing method of creating figure-ground depth known as *perspective*. This technique, which was developed largely in fifteenth-century Florence during the early Italian Renaissance, has dominated Western pictorial art until the beginning of our own century. The "science of perspective," as it is sometimes called, exploits the possibilities of movable horizons and multivanishing points, in order to assign a regularly diminishing scale to things as they are placed in positions which range from foreground to background.

As you can see in Figure 2-8, the illusion of space in depth produced by just a one-point perspective drawing is terrific. Much depends on the apparent space penetration of the diagonal line, and on reducing the scale of things according to their placement in the composition—large and dominant as near objects, diminishing in size as they move toward the horizon. Full use is also made of the frontal projection of marks achieved by weight and dark tone values. Perspective is a space-constructing system which relies heavily on the graphic factors we have discussed, particularly on the directional movement of line, and the up, down, and across placement of forms. Rembrandt's drawing in Figure 2-3 obviously makes use of a very free and unstructured perspective to assist the depth of the image. Yet we do not see the world in tight perspective. We cannot see in several lateral directions at once; neither can we ever see everything so completely in focus in the one panorama.

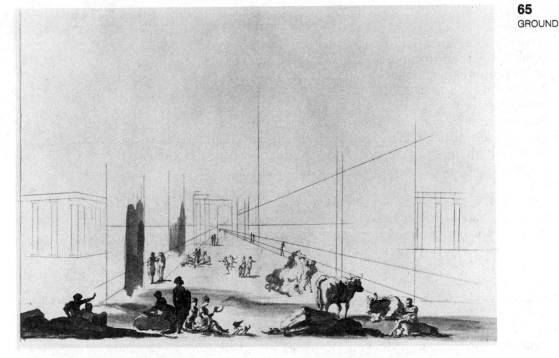

Figure 2-8
Gaetano Gondolfi. Figures and Animals in Deep Architectural View. *18th C.*
Sepia, gray wash, pencil, pen, and ink in one-point perspective.
LOS ANGELES COUNTY MUSEUM OF ART. LOS ANGELES COUNTY FUNDS.

Effective as perspective is in structuring space in depth, and as exciting as it can be to handle, it can also become a deadening influence on an artist's fresh way of seeing things once it is accepted as a system or as a mechanical formula. Fascinating as perspective is to employ, and important as it is in the historical sense, in your Workbook you should concentrate on less formalized systems to achieve space penetration. Nevertheless, the effect of perspective has been powerful enough to lead a great authority on Italian Renaissance art, the late Bernard Berenson, to proclaim the psychological importance of space composition in the visual arts. Inspired by the work of Perugino (1445–1523), the Umbrian (Central Italian) painter who was a master of perspective, Berenson wrote:

> Space composition . . . can take us away from ourselves and give us, while we are under its spell, the feeling of being identified with the universe, perhaps even of being the soul in the universe. . . . For those of us who are neither idolaters nor suppliants, this sense of identification with the universe is of the very essence of religious emotion—an emotion, by the way, as independent of belief and conduct as love itself. . . . The religious emotion—for some of us entirely, for others at least in part—is produced by a feeling of identification with the universe; this feeling, in turn, can be created by space-composition; it follows then that this art can directly communicate religious emotion—or at least all the religious emotion that many of us really have, good church members though we may be.[4]

[4]Bernard Berenson, *The Italian Painters of the Renaissance* (London: Phaidon Publishers, Inc., 1952), p. 122.

It is clear from this statement that the expansiveness of perspectivized space provides a mystical experience for Berenson. Yet would not the Japanese drawing we see in Figure 2-9 evoke a similar response? Granted that the space is much shallower than that in Figure 2-8; it is, nevertheless, more evocative. The space is mysterious and ambiguous; its depths are suggested but not visible. I find this misted and unstructured figure-ground treatment to be more powerful—in Berenson's terms—than the sharp lines of geometrical perspective which can produce such clean-cut, regularly diminishing spatial divisions. In the more loosely structured Japanese drawing, depth perception is evoked more realistically by the contrasting lines of differing weight; by their sharp or diffused quality; and by the play of dark and light tones of the various surfaces.

Nevertheless, with or without perspective, graphic space presentation can still evoke an emotional response. Space composition may especially yield this power when a concentrated focus on limitless space takes place within a small area. A work that creates an illusion of vastness within the physical limits of a piece of paper or a canvas is almost certainly going to push the viewer to experience a heightened perception of space.

Architects, incidentally, are the space composers par excellence. They are not restricted to flat figure-ground situations to create illusions of space; furthermore, they work with actual three-dimensional space to shape environments. The illusory space of a drawing, however evocative, cannot compete with architectural space—with, say, the vertical space and light of a medieval Gothic cathedral such as Amiens (Fig. 2-10).

Figure 2-9
Hagesawa Tohaku. Pines. *Detail from a screen, late 16th C. Ink on paper.*
TOKYO NATIONAL MUSEUM.

Figure 2-10
Choir vault, Amiens Cathedral *ca. 1247.*

PHOTO BY CLARENCE WARD.

In the twentieth century, painters and sculptors have experimented freely with the plasticity of space. A continuous line of artists from Paul Cézanne move through such movements as Futurism, Cubism, and Constructivism to the so-called Minimal painters of today. These latter artists try for minimum impressions of lines or marks on the ground—impressions which are barely perceptible—and which therefore result in highly ambiguous figure-ground relationships in which space, rather than figure, dominates perception. However, it was the Constructivist ideology of the 1920s, articulated so ably by Naum Gabo, that pronounced space to be a positive plastic element in art—an element to be used as definitively as the figure which occupies space. Since then it has been virtually impossible for the artist to regard space as merely background environment for a figure.

2-I. Figure-Ground Relationships

The following suggestions for drawing are intended to compel a conscious manipulation of two- and three-dimensional space, through the deliberate control of various figure-ground situations. Try to avoid a conscious use of perspective in making these drawings, and concentrate on developing space fields determined purely by the graphic and plastic characteristics of the drawing marks themselves.

A. *Area—Tone value and placement*

This is a simple but important exercise. The aim is to make a chart of tone values so that you can see for yourself where each area stands in space. Using black or sepia drawing ink, brush, and water, form a freehand series of small circles graduated in tone from black to light gray. Start each row with a different dark value on the left and try to get progressively lighter as you move to the right. Simply use water to dilute the ink and produce as wide a range of values as possible. Use a clean sponge to take off excessive water and also to lighten the value of a particular circle. The result should look something like Figure 2-11. Observe that each tone occupies its own region of space: Dark values come forward while lighter ones recede.

See also how such graphic qualities work perceptually by studying the spatial effects created in a fresh, brush-kissed drawing, *Persimmons* (Fig. 2-12). Mu-Ch'i uses differences in tone value to help fix the position in space of each fruit. Although five of the persimmons sit roughly on the same horizontal line, some appear to nose in front and others edge behind. Also notice that placement is exploited by the artist to further the three-dimensional illusion. The central persimmon dominates and its frontality is reinforced by its having the darkest tone. Similarly, the tendency of extreme left and right positions to fall behind is reinforced by giving these fruits a light, "airy" tone. It is also worth noting that the small persimmon which is placed lower down—and so should appear to be nearer—has a hard job holding a frontal position because the heavy, black, central persimmon intrudes so positively on our perception. Notice also how the weight and linear quality of the stalks cause some spatial tensions; they do not in every case occupy the same spatial positions as the persimmons to which they belong!

Figure 2-11

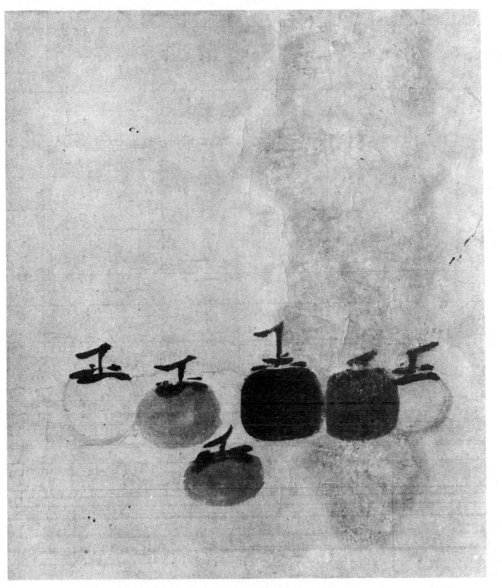

Figure 2-12
Mu-Ch'i. Persimmons.
Ink on paper.
DAIGO JI TREASURE HALL,
KYOTO JAPAN.

Finally, this drawing is also a good example of how associative and remembered visual experience can affect the way in which we perceive things in a two-dimensional image. The second fruit from the left, although light in tone, enjoys a strongly frontal place in the lineup that is not completely justified by its slightly lower position. It is achieved by the suggestion of a glistening highlight that reminds us of the light-catching frontal areas of real volumes in life; and thus we are led to assume that this fruit projects forward in the pictorial space.

B. *Line quality and placement*

Line quality is determined by *weight* (thick or thin), *constitution* (sharp or diffuse, continuous or broken), and *tone value* of the stain (light or dark). The purpose of this exercise is to discover how different kinds of lines, disposed over a flat surface, seem to occupy different regions of space in depth. The format for the work should be a rectangle about 7″×5″. Try a variety of drawing instruments from wood twig to dry brush—knowing, as you do now, the kind of line each will produce. Simply make a series of vertical lines which display as much variety in terms of *quality* (weight, constitution, and tone) as possible. Leave enough lateral space between the lines so that they may "breathe," and allow the illusion of their respective depth positions to operate.

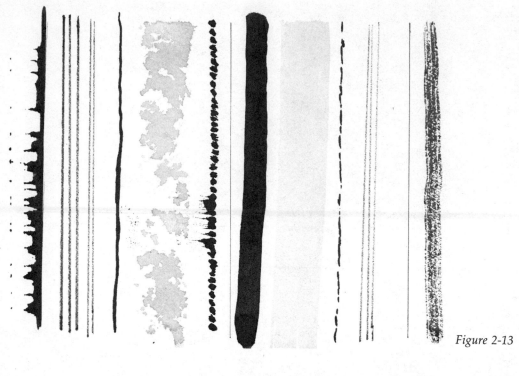

Figure 2-13

Figure 2-13 is a good example of the fight for spatial position that goes on when such variety of lines is placed side by side on the same ground. Notice here how textures and tone values—black versus gray—affect frontality or recession; how broken lines tend to recede; and how taut, sharp lines—however thin and light in weight—vie for a frontal position.

Remember as you work that this is not an exercise in forming various physical types of line—you have already accomplished that in Chapter 1—but in manipulating the illusory three-dimensional space of the ground. Study your results carefully. In the next exercise you will try to apply the knowledge gained.

C. Line and Area—Two- and three-dimensional space articulation

You are now going to make a deliberate attempt to articulate flat and empty space into lateral and vertical areas (up, down, and across) with depth (foreground, middle ground, and background). Begin the first stage of the drawing in a free, almost casual manner. Work within a rectangle no less than 7″×5″ in dimension. First work with brush and sponge by randomly applying three or four differently toned areas of ink wash to the ground. Go from the very dark to the very light. Lighten areas both by diluting the ink with water and by sponging it off. Aim to leave approximately *one-third of the ground untouched,* to stand as the lightest region in the rectangle. Patience is required throughout. Let each toned wash dry sufficiently to retain its shape and value before brushing in the next tone, otherwise the shapes will flow together and lose identity. For a textured wash, stroke a white candle loosely over the surface and then brush your ink solution over it. When complete, the image should consist of an almost accidental arrangement of free-form stains surrounded by the white shapes of the untouched paper.

Now take a sharpened, point-shaped twig and commence a linear doodle over the ground you have just created. (The advantage of doodling with the twig is that the wood has a nice habit of drying out quickly and imparting a grainy and broken line which, suddenly, retreats into the ground.) It does not really matter where you start or finish. That you will be doodling over an already-formed ground will undoubtedly influence the configuration your line will trace, because your eye cannot help but be involved with the shape of figure and ground now established. The doodling line will thus tend to complement and firm up the already-established form. This is the intention, so do not be concerned when you find it happening. Stop the line when it seems that the linear articulation has done its job.

The final phase of this exercise is a deliberate appraisal of both two- and three-dimensional aspects of the established image. You will do this by working over the lines already in position, with either brush, wedge-shaped twig, or razor blade. The brush and

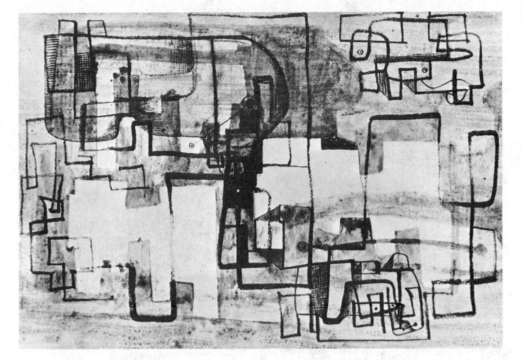

Figure 2-14
Henry Moore. Drawing *1935.*
COLLECTION: EDWARD CARTER.

wedge-shaped twig will obviously be used to increase line weight—to thicken up and therefore bring the line forward. The razor blade should be used to scrape the line out— to diminish its weight, change its quality, and brighten its tone, all with the effect of caus- ing it to recede.

First make a perceptual appraisal of the two-dimensional character of the figure- ground, and decide where to strengthen or weaken lines in order to clarify both the sideways and vertical spatial divisions that have already been tentatively established. When this is done, search for regions of maximum frontality and maximum depth, either in terms of what figure seems to have been established, or what particular regions of ground. Again, through a process of darkening and thickening a line, or scraping it out to weaken tone and sharpen quality, work to intensify perception in terms of foreground, middle-ground, or background regions.

Look at Henry Moore's 1935 *Drawing* (Fig. 2-14). The figure-ground situation created here is extraordinarily interesting. Study the work carefully. Notice that sometimes linear spatiality is at odds with the spatial position of a toned area; sometimes it is in accord. There is both clarity and ambiguity to the overall figure-ground form of the drawing: Graphic characteristics affect perception in one way, while personal associations with real-life visual experience affect it in another. Do you notice that little vista of rocky land- scape at right center in Moore's drawing?

D. *Line quality and placement—Objective space perception in landscape*

Now you are going to make some drawings based on a more objective situation. Move outside with a sketch pad and observe some tree formations. Using a broad-tipped felt pen, make some simple, line sketches of, say, half a dozen tree groupings. Select groups comprising up to seven or eight trees. Figure 2-15 illustrates a typical cluster. Ar- range the sketches in squares about 3″×3″. Draw quickly, without attention to detail. These sketches are not meant to become views of trees, just linear notations of spatial organization (see Fig. 2-16).

First appraise the lateral (sideways) distance between the trunks and then, observing the directional movement of each tree in terms of vertical and off-vertical growth, draw in single, one-time lines accordingly. Analyze your depth-perception instincts as you work: It will seem natural enough to place the lines representing more distant trees higher in the square—as you see in square *c*—and thus to produce the graphic suggestion of

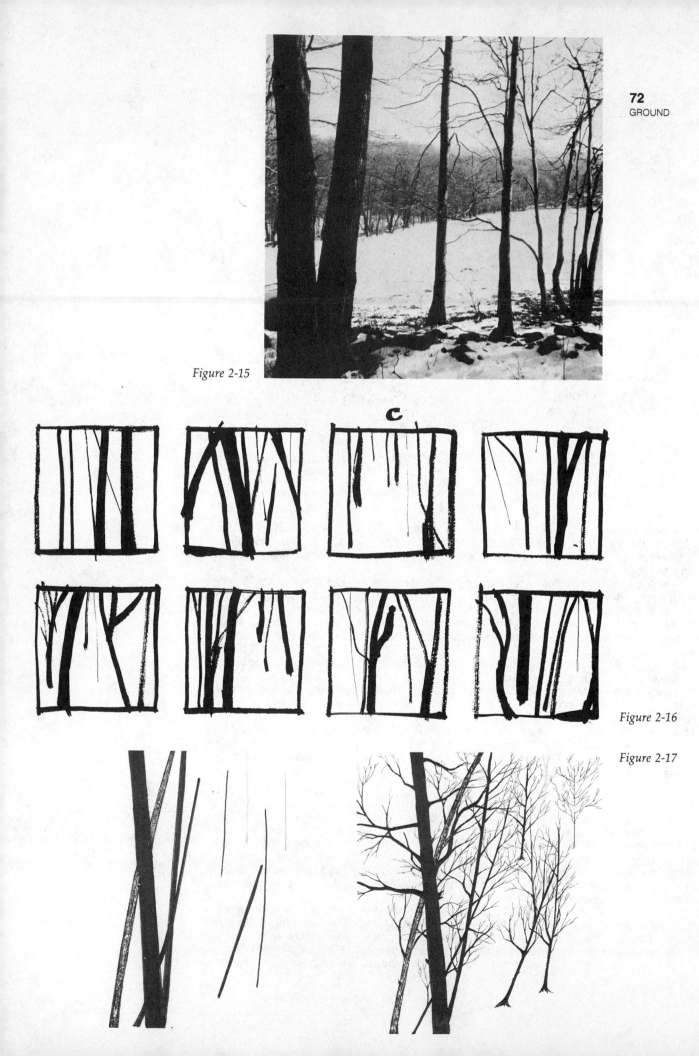

Figure 2-15

Figure 2-16

Figure 2-17

depth in the square. Finally, work over each square by making the following additions: Give the lines of the nearest trees more weight: Thicken them and make them as black as possible in order to emphasize their frontal position. This will leave the original lines in a middle-ground situation.

Later, further refine these sketches. Add one or two sharp, delicate, and light-weight lines to each square, and notice the extra suggestion of depth—whatever their position in the square—they manage to graphically suggest.

The final stages of this exercise are shown in Figure 2-17. These two drawings represent a more consciously developed organization of two- and three-dimensional space in terms of figure and ground. Select any one of the first tree-grouping squares—that which you think already is the most spacious—and enlarge it to an approximate size of 6″×6″. Using a combination of felt-tip pen and brush, reproduce this "sketchy" drawing as a more carefully controlled diagram: Noticeably diminish the weight of each line to force the eye to move rearward and search out the deeper space of the ground. The left-hand drawing in Figure 2-17 illustrates this diagrammatic treatment. When making this drawing, trees are no longer the subject matter. Instead, consider that you are forming a non-objective drawing of space-marker lines.

With the last exercise—the right-hand drawing in Figure 2-17—we return to nature. Simply take the left-hand "space diagram" and reproduce it exactly. But then add limbs and branches to each line. Make sure that the limbs are proportionately weighty enough to occupy the same space-in-depth position as the line of the trunk. The result should be a convincing rendering of "woodland space." But remember that it results from a diagrammatic appraisal of natural space, and an application of graphic figure-ground theory.

One final assignment: Take a razor blade and lighten the tone value of the line occupying the second most forward position, both in the linear diagram drawing and in the transformation back into the natural woodland. Notice the jump backward that takes place. And then, add one sliver of gray wash line high in the space, to demonstrate yet again what happens spatially as a gray tone fails to compete with black for frontal position, and stands higher in the rectangle.

Although tone values do not play a part in determining three-dimensionality in Parker Waite's *Trees* (Fig. 2-18), the placement of lines and their quality in terms of weight work most effectively to create the illusion of depth. Study the space composition achieved here in light of our discussion thus far.

Figure 2-18
*Parker R. Waite. **Trees** 1977. Woodcut.*
COURTESY OF THE ARTIST AND ANCHORAGE HISTORICAL AND FINE ARTS MUSEUM.

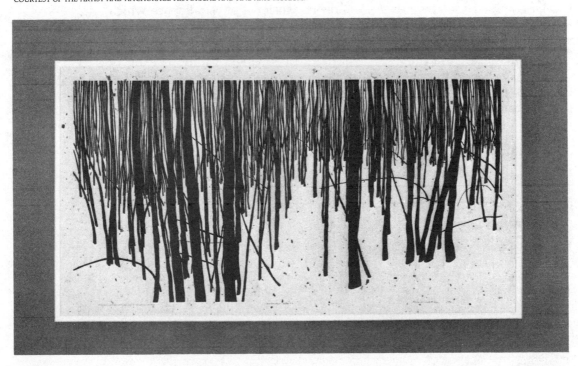

As we have seen, visual perception is dependent upon the presence of a figure on a ground. In Section I we examined the essential ways in which a graphic, two-dimensional figure-ground structure can appear perceptually three dimensional.

But even though the interplay between two- and three-dimensional space is illusory in drawing and painting, it is real enough in our perceptions of sculpture and architecture because actual, environmental space is occupied by such works. Consequently, the term "two-dimensional design"[5] is used to signify an involvement with figure-ground space in the graphic sense of impressing marks over a surface, while the term "three-dimensional design" indicates that the figure-ground problem is one in which real, environmental space is involved and becomes part of the piece, as in sculpture or architecture.

Our work here concerns two-dimensional design only: composing space on a flat surface using all the graphic experience already gained. Yet the experimental situations do present some novel problems in spatial dynamics, involving both active and passive possibilities. The aim is to provide some familiarity with space composition as such—to see some of the ways in which space may be structured to create figure-ground situations ranging from the vigorous to the static.

In order to consider the figure-ground situation in these more sophisticated ways—remembering that our chief concern at present is *not* figure as motif but rather figure in order to shape space—we must now be more specific in defining what, hitherto, we have simply called ground. Within the overall context of two- and three-dimensional design we can distinguish four categories of ground, only the first of which we have already discussed:

1. For the artist forming images through drawing and painting, ground is the two-dimensional surface on which marks are impressed.

2. For the sculptor, ground is the two-dimensional surface of the piece which can be graphically marked, *and* the three-dimensional physical space which it inhabits and shapes.

3. For the architect, as for both the painter and the sculptor, ground is the two-dimensional surface of wall which is to be marked by the placing of door, window, and cornice, and it is the three-dimensional space which the building—like the large sculpture—inhabits and shapes. But the architect's job in handling surface and space is compounded by the fact that it is as much an internal problem as an external one: Architecture demands that as much attention be paid to shaping interior space as is given to the two- and three-dimensional problems of designing the exterior.

4. For the rest of us, viewing the world on a day-to-day basis, ground is the all-pervading environment of nature's space, surrounding and penetrating natural forms, and thereby allowing us to perceive their shapes and their spatial dispositions.

[5]In current, popular usage, the term *design* denotes the drawing of visual layouts which have a commercial or industrial orientation: schemes for advertising, interior design and decoration, book production, machine illustration, and the like. The overall connotation is one of functionalism, of the organization of visual elements for a practical end. For the purposes of this chapter, it is appropriate to think of design in this way. We are, after all, organizing and manipulating space with a functional end in view—namely, learning how to structure figure-ground variations for this or that effect. In Part Two of this book the word *design* takes on added meaning, and signifies the attempt to visually form and communicate a state of mind. As might be expected, more is said at that juncture concerning the more profound implications of designing.

Why do we concentrate here on the range of dynamic possibilities in space composition? Because we respond to the spatial aspect of visual experience just as strongly as we do to the physical conformations of physical things, and our reactions to the shape of space, being relatively unconscious, do not receive the attention they deserve in studio training. Most of us have difficulty recognizing that an involvement with space composition is, for many an artist, the chief satisfaction gained from forming a work. This is particularly true today, because as I have said previously, the need to allow formed space to comprise the essential nature of a work has become a pressing concern.

Look for a moment at Figure 2-19, Paul Klee's *Portrait of a Scholar*, to see how, using brush and stencils, the artist has composed an image in which regions of space become articulated and formed to the extent that space becomes figure. Can you work out for yourself the ironic significance of the title?

It is worth pointing out that concern with space is a natural and vital aspect of ourselves as sentient beings, artists or not. Because of this, the content of the next few pages has as much to do with living satisfying and informed lives as it has to do with appreciating art. Space-time awareness is an integral part of human consciousness; it operates intuitively for most of us, but is deliberately cultivated by the artist in his or her role of space composer.

Figure 2-19
Paul Klee. Portrait of a Scholar *1930.*
Brush drawing with stencils.
© 1983. S.P.A.D.E.M., PARIS/V.A.G.A., NEW YORK.

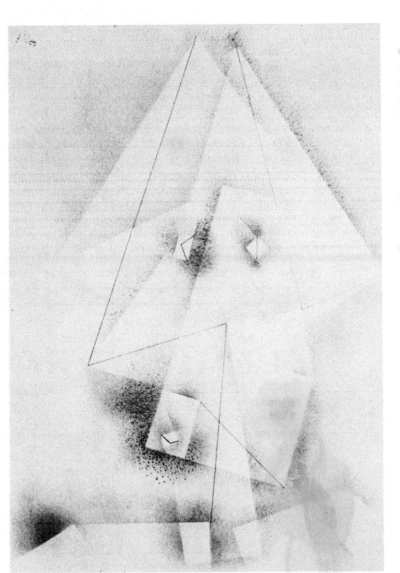

RATIONAL AND INTUITIVE RESPONSES TO SPACE are best thought of as two distinct types of mental activity, stemming from two "headquarters" which, between them, originate thought and feeling. These terms are not—as is sometimes thought—synonyms for thought and feeling. Instead, they refer to the *processes* which initiate thought and feeling and by which they reach consciousness.

In the preceding chapter I proposed that thought and feeling are the two fundamental constituents of consciousness which account for the basic duality of art—for content that is either conceptual or expressive. (But remember that I did not suggest that these two aspects of awareness are mutually exclusive. On the contrary, I indicated that both are present in any normal act of consciousness, though not always on equal terms, because one or the other often has the edge or may dominate strongly.)

The words "rational" and "intuitive" do not therefore describe aspects of consciousness such as thought and feeling, but indicate a modus operandi of consciousness—two distinct ways by which we think and feel. The simplest distinction between them is made very clearly in Webster's Dictionary:

RATIONAL: responding directly by conscious reasoning.

INTUITIVE: responding directly without conscious reasoning.

The implication is that the rational channel reasons things out logically in the face of fact or experience, and gives rise to feelings associated with what is happening. On the other hand, the intuitive channel can reach conclusions directly without going through the deductive processes of logical thought, and without necessarily confronting fact or event; also, it can give rise to feelings in the absence of any external circumstance. Consequently, one can experience rational or intuitive thought, rational or intuitive feeling.

This means that we have to take account of both process and result—of reason and intuition working to produce their own brands of thought and feeling—when it comes to setting up "training" situations as we are here. Ultimately, as I have said before, you will not be working so self-consciously.

DRAWING EXERCISES CONCERNED WITH STRUCTURING SPACE are more likely than any others to stimulate and to combine the intuitive and rational sides of our nature. An old proverb says, "Nature abhors a vacuum." We are not very happy with total emptiness—with space which is unmarked, thereby making it difficult to assign dimensions and to locate positions. We are not altogether comfortable in the dark, and downright uncomfortable when caught in a thick fog. A similar need to establish two and three dimensionality and to discover one's visual bearings seems to be present when facing the empty canvas or the empty page. And until this is done, any attempt to go ahead and develop a drawing is frequently inhibited. Consequently, in order to get started, the best thing to do is to make a mark—any mark, anywhere—lest we find ourselves in the situation described by Thomas Mann in *Death in Venice:*

The horizon was visible right round; beneath the sombre dome of the sky stretched the vast plain of empty sea. But immeasurable, unarticulated space weakens our power to measure time as well: the time sense falters and grows dim.

Any introduction to space composition—whether it be intended to aid in
the appreciation of space design when observing works of art or to assist the
beginning artist in his or her practice—should, then, stress the fact that,
whether we are fully aware of it or not, the imagination becomes very active
when we encounter the phenomenon of space. Rational and intuitive re-
sponses, thought and feeling, become inextricably mixed in our reactions
which, generally speaking, follow two courses. First, because space is there in
all its immensity by day and night, we seek to rationally comprehend it, to
discover whatever order we can through measurement. Second, we move in-
tuitively to identify with space, to project our more transcendent feelings and
thoughts on it. In drawing, the challenge of space perception and composition
often triggers one or other of the following responses: (a) an ordered and pre-
cise articulation of space in both two and three dimensions, or (b) a dramatic
and random use of line and point leading through galaxies near and far. The
first of these seeks to make the mind-boggling enormity of space rationally
comprehensible; the second to celebrate all the mystery and myth we intui-
tively attach to sky and deep space, to what we sometimes refer to as the
heavens.

The following comments by two twentieth-century artists, Naum Gabo
and Max Beckmann, illustrate the mix of feeling and thought operating both
rationally and intuitively in our space consciousness.

> The experience of space has been with us and with the artist throughout
> the whole history of art—a reality in our visions of the world—and its role
> was that it accompanied all objects and all events. . . . It is only with the
> appearance of the constructive ideology in art that . . . there was a clear
> call to the artist to use space as a new pictorial and plastic element . . .
> assigning to it the same importance that lines, shapes and colors have, as
> basic means in the structure of a visual image. . . . It is a concrete element
> of our vision . . . ever within our reach, and thus it carries an experience
> of palpability equal to any conveyed by the tactile sense.[6]

> Space, and space again, is the infinite deity which surrounds us and in
> which we are ourselves contained. . . . That is what I try to express
> through painting. . . . My dream is the imagination of space—to change
> the optical impression of the world of objects by a transcendental arith-
> metic progression of the inner being. That is the precept. One thing is
> sure—we have to transform the three-dimensional world of objects into
> the two-dimensional world of the canvas. If the canvas is filled only with
> a two-dimensional conception of space, we shall have applied art, or or-
> nament. Certainly this may give us pleasure, though I myself find it boring
> as it does not give me enough visual sensation. To transform height,
> width, and depth into two-dimensions is for me an experience full of
> magic in which I glimpse for a moment that fourth dimension which my
> whole being is seeking.[7]

You would certainly gather from these extracts that space has a definite "hold"
on us—that we are creatures of space in both a physical and psychological
sense. Artists or not, most people react consciously or unconsciously to, say,

[6]Naum Gabo, *Of Divers Arts* (Washington, D.C.: Trustees of the National Gallery of Art, The
Princeton University Press, The Bollingen Foundation and Pantheon Books, 1959), p. 99.
[7]Max Beckmann, *On My Painting* (lecture published in 1941 by the late Curt Valentin in New
York). Reprinted in *Modern Artists On Art*, Robert L. Herbert, ed. (Englewood Cliffs, N.J.: Prentice-
Hall, Inc., 1964), pp. 132–135.

their living-room or bedroom space; to forest, valley, mountain top, or city-street space. As the spatial context changes, so can our mood. Also, let us not forget that space is the arena for light, that the combination of space-shape and the play of light within it produces what we call the "atmosphere" of a place. How do you like your religious space: low, horizontal, and brightly lit; or tall, vertical, and dimly lit? Could you describe your own preferences in terms of religious space and light? What evokes a state of mind susceptible to religious insight? Consider, too, how accoustical possibilities suggest themselves: What sort of sound would be best suited to a particular context of space and light?

Visual awareness only exists through the perceptual complementarity of what is discerned as figure and what then as empty space. This phenomenon was described by a pioneer psychologist in the following way:

> Historically, the central problem of perception has been taken to be how we see depth and distance, the so-called third dimension of space. The psychologist and painter have been led to ask what the clues or cues may be for tridimensional perception as distinguished from bidimensional sensation. It begins to be evident, however, that the heart of the problem is not so much how we see objects in depth as how we see the constant layout of the world around us. Space as such, empty space, is not visible but surfaces are.[8]

For example, if you observe the outstretched fingers on your own hand, you perceive the intervals of space between the fingers as possessing proportion and shape because of the disposition of the finger surfaces. You are thus perceiving the layout of space, and in so doing become doubly aware of the mass and configuration of the finger itself. Now close the fingers—eliminate the clarifying space—and notice how less distinct the individual finger becomes.

Visual perception is apprehending the shape of space and the shape of physical things. Fundamentally, perception appears to be a recognition of the constant and fixed disposition of the surfaces of things in relationship to the spatial intervals which separate them. In perception, surfaces and the space they shape—and are shaped by—are indivisible. This is the gist of Naum Gabo's statement, and is indicative of our rational approach to space.

Now let us try to reinforce theory with some visual examples of space used as an element in its own right, working to heighten figure-ground perception or to obscure it, to create mood and to impart "atmosphere."

Wandering about in London's Tate Gallery one rainy Saturday afternoon, I came across a group of coal miners whom I followed for a while. They were a talkative bunch, but when they reached the great collection of J. M. W. Turner's oils and watercolors, their talk dried up; the knot of men dispersed as individuals suddenly found themselves preoccupied by this or that painting. Turner is a great master of space. Unfortunately, no black-and-white reproduction can do justice to the infinity of depth and energy of light present in Turner's finest work. But *Norham Castle* (Fig. 2-20), reproduced here, is the painting which seemed to generate the most interest—I might saw awe—that wet Saturday. I do not find this difficult to understand. The sheer physicality of space and energy of light present in Turner brings us to face the immensity and omnipresence of space in the universe, and the smallness of ourselves in comparison.

[8]James J. Gibson, "Constancy and Invariance in Perception," in *The Nature and Art of Motion*, Gyorgy Kepes, ed. (New York: George Braziller, 1965), p. 60.

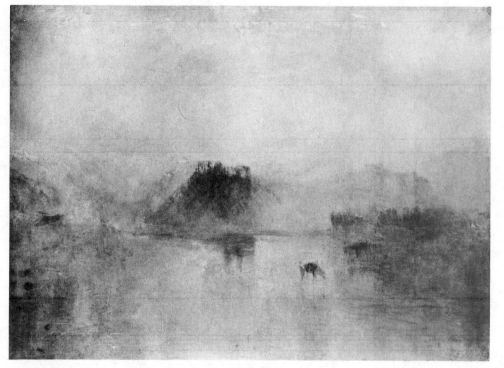

Figure 2-20
J.M.W. Turner. Norham Castle. *Oil painting.*
TATE GALLERY, LONDON.

Paul Klee's drawing *Forest Settlement* (Fig. 2-21) is an example of lines alone at work. Would you agree that it is as much a drawing of space as of physical forms? Certainly the trees and houses seem but insubstantial, open frameworks that serve, like a spider's web, to weave a design of space—a space screen through which the eye wanders, cutting into space from every direction. Do you see the lines of drawing as predominantly shaping space, or shaping houses and trees? To my eye, first impressions are of various spatial regions which thrust against each other, either horizontally, diagonally, vertically, or with a circular motion; some spaces appear tight and compressed, others more open and loose. Only after lines of drawing have produced this effect do I begin to discern insubstantial, yet recognizable, objects. Here the lines and marks of drawing work at least as much to shape space as they do to shape figure. Yet inasmuch as the result ensures a certain ambiguity to figure and ground—at the expense of rational clarification—we can also appreciate the "space poetry" the treatment creates.

Now look for a moment at Victor Pasmore's *Still Life with Bottle and Flowers* (Fig. 2-22) and observe how space invites the artist to shape and activate it. It is not difficult to grasp what is going on in this drawing. Every time a new mark is placed on the ground—whether it merely be a line indicating the edge of an object, or a more solid area of stain suggesting figure—new spatial regions are shaped. They come into being between the objects themselves, where they play such a positive perceptual role, and also in the peripheral ground, where they establish themselves as less involved, although still perceptually viable, regions. You can see from this drawing how Pasmore constantly probes and firmly establishes the spatial zones which the material areas

Figure 2-21
Paul Klee. Forest Settlement 1925. *Ink drawing.*
BENTELI VERLAG, BERN.

Figure 2-22
Victor Pasmore. Still Life with Bottle and Flowers 1947.
Oil on canvas.
COURTESY OF THE ARTIST. COLLECTION: ALAN ROSS.

Figure 2-23
Barbara Hepworth. Curved Form (Trevalgan)
1956. *Bronze.*
THE BRITISH COUNCIL, LONDON.

of figure have articulated. In fact, it takes only a moment or so of observation to realize that the drawing's spatial organization intrigues no less than the physical presentation of objects as such and that space composition in its own right has emerged as a response to the still-life theme of the work.

Sculptural surfaces work like architectural ones. To place Barbara Hepworth's *Curved Form* (Fig. 2-23) in a garden is, as you can see, to cut an empty corner of space up into variously shaped segments. Not only does the material presence of the sculpture itself engage our interest, but it creates a spatial environment which becomes significant in its own right.

And sort out for yourself the spatial illusions produced by the suspended construction of Victor Pasmore's *Environmental Painting* (Fig. 2-24). The play between black, gray, and white surfaces and between the "lines" formed where such changes in tone value occur—not to mention the positional changes in depth suggested by the variously toned line and point markings—all create an exercise in space perception in which figure seems to define a variety of spatial regions. Keep an eye on the baseboard of the room, in order not to get carried away completely by the mirage.

Chinese brush drawings (or, if you prefer, paintings) reveal notably refined sensibility to the perceptual interdependences of mark as figure, and space as ground. Study Figure 2-25 without considering the title; just regard it as a grouping of spontaneous brush marks. Each mark constitutes area and each area is characteristically rounded and pointed, moves in a particular direction, and has a particular weight. In addition, tone values run the gamut from black to gray, thus producing positions in depth. In putting all these facts together the eye distinguishes a pattern of both two- and three-dimensional space. It is a pattern of irregular interval, active in nature because of the general diagonal thrust and the forceful play between open and enclosed regions, and front and rear positions. The drawing appears remarkably unforced: a natural phenomenon of brush, hand, and eye.

Figure 2-24
Victor Pasmore. Environmental Painting *1956. Suspended construction at Hatton Gallery, University of Newcastle upon Tyne, England.*
COURTESY OF THE ARTIST.

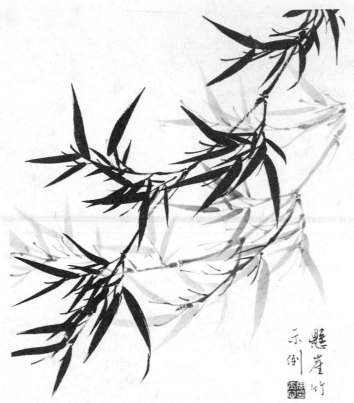

Figure 2-25
Johnson Su-Sing Chow. Composition of
Hanging Bamboo *1975.*
From the "Book of the Bamboo."
HO KUNG-SHANG, TAIPEI, TAIWAN.

One final point before proceeding to the Workbook: From time to time you will come across the expression "the dynamics" of art and design. The term has several interpretations, but the dynamics that concern us here—those of a drawing or painting—are fundamentally the outcome of its spatial organization. We have already seen that two extreme possibilities present themselves. One is illustrated in van der Leck's *Geometric Composition* (Fig. 2-26): Geometric order and precision distinguish the layout of figure marks, thereby imparting similar characteristics to the structure of space. However, Su-Sing Chow's *Leaves in the Snow* (Fig. 2-27) illustrates the opposite possibility: loosely and irregularly placed figure marks permit space to flow freely in an organic and vital fashion. A comparison of these two images clearly reveals the graphic extremes which may be exploited. In Mondrian's later years, the most significant aspect of his work was to rationally create spatial regions possessing a mathematical and geometric purity, the graphic equivalent of formal counterpoint in music where the regularity of interval and sound is not mechanical, but just sufficiently varied to give rhythmic vitality to the work. The Chinese artist, in contrast, celebrates a real asymmetry—a dash of the brush produces a series of irregularly positioned marks which let space flow freely in and out, expanding and contracting to no rules of mathematical counterpoint, but responding to a random kinesthetic rhythm intuitively generated by the artist's natural "space sensibility."

Between these two extremes we have just introduced—contained and static geometric space, and open, flowing, organic space—lie a range of "in-between" dynamic possibilities. Chapter 5 deals almost entirely with such varied possibilities in space dynamics. In the meantime, however, note that although we have been discussing such possibilities in terms of the graphic arts, the choice of static or active space is there for the artist to make in all the arts.

Figure 2-26
Bart van der Leck. Geometric Composition No. 2.
Oil painting.
COLLECTION: RIJKSMUSEUM KRÖLLER-MÜLLER,
OTTERLO, THE NETHERLANDS.

Figure 2-27
Johnson Su-Sing Chow. Leaves in the
Snow 1975.
*From the ''Book of the
Bamboo.''*
HO KUNG-SHANG, TAIPEI, TAIWAN.

83

Figure 2-29
Dominikus Zimmermann. Church of Die Wies,
West Germany, 1746–51.
PHOTO BY HIRMER.

Figure 2-28
Otto Haesler. Lobby of private residence, *Celle,*
Germany, ca. 1928.
COURTESY THE MUSEUM OF MODERN ART, NEW YORK. PURCHASE.

For example, observe the contrast between the tight, Mondrian-like space of Otto Haesler's lobby (Fig. 2-28) and the active, free flow of space in Zimmermann's church, *Die Wies* (Fig. 2-29). From these two photographs we see yet again how the dynamics of space composition are affected by the kind of figure which articulates the space. A rigidly rectangular enclosure of space creates a relatively static and tight environment; space which is enclosed by free-flowing, curvilinear figure forms appears altogether more active and vital.

WORKBOOK

2-II. Spontaneous and Deliberate Composition

Before you begin to draw, either spontaneously or deliberately, try to empty your mind. Relax and try to become "ideationless," to relieve the mental pressure of deliberate thought. Let the pencil or brush move freely, almost reflectively, as if it had a life of its own.

The aims of these first exercises in space forming are:

1. to show that a completely empty (unmarked) space field presents a perceptual challenge: that it invites and triggers an instinctive and unconscious need to articulate it—to impose a layout of marks (figure) which establish a formed, two-dimensional ground and create the illusion of a third in depth.
2. to show that one important response to the challenge offered is kinesthetic: that the *action* of drawing can take over and by establishing a particular bodily rhythm permit the free and spontaneous delivery of marks to the surface—a method which helps a "space intuition" to be realized.

A. *Spontaneous space structure using Point*

The first experiment is short and deceptively simple. You need a medium or large watercolor brush and a saucer of slightly diluted black ink. Open your sketch pad to a new page and prop it up on the table at about a 45° angle. Secure the page with paper clips. Load the brush with ink and proceed to dab (or jab) the paper with the brush point. Do not attempt to draw conventionally with the brush—rather, think of the brush as a rapier and attack the paper as if you were fencing. In fact, to achieve the best results, your body should move like that of a fencer in action as you lunge and withdraw to score hits on the paper. If you can relax both physically and mentally, having no ideas in mind as to how the pattern of marks should turn out, and let your body build up a rhythm as you move back and forth with the brush, then there is a good chance that this space experiment will work. The time to stop is when the *rhythm* begins to break down; when you find yourself having to force the movement, or to make conscious decisions about where to dab next.

This first drawing may only take about 3 or 4 minutes. When it is finished, start another, surrendering again to an ideationless and rhythmic body movement served by hand, eye, and brush. After this, do one more. The three works may look very similar if the brush marks take on the same shape, and the grouping of the dabs and the distribution of space they effect are not very different. On the other hand, there may be the world of difference between them. In the latter event, how much of such variation results from chance, how much from changes in innate kinetic sensitivity, and how much from sudden changes in mood is impossible to say. Different levels of intuitive space awareness can also be tapped when you work in this way.

Look, for example, at Figures 2-30, 2-31, and 2-32, three quite dissimilar results. Notice the difference in the shape of the brush jabs: The rectangular marks in Figure 2-32 result from flattening the brush onto the paper with some force and deliberation, holding it firmly in place for a second or so, and then letting it spring away to produce the tadpole-like tails which provide the horizontal and vertical emphases. In direct contrast, the marks in Figure 2-30 represent a delicate and ordered touch with the brush tip. The circular blobs and irregular blotches of stain you see in Figure 2-31 come from a brush loaded with a watery ink and splashed—almost flicked—onto the paper: It is the most spontaneous and "chancy" kinetic delivery of the three. By comparison, Figure 2-30 reveals a

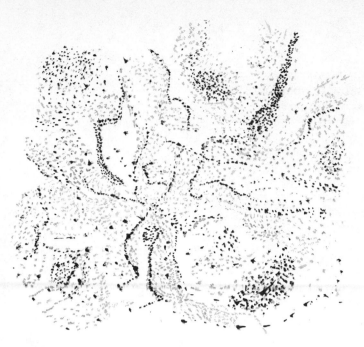

Figure 2-30

Figure 2-32

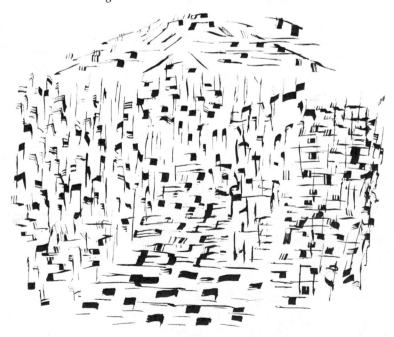

Figure 2-31

more controlled and regular timing governing the rhythm of the brush, and in Figure 2-32, the urgency and force of the brush's contact with the paper are balanced by a timing—and therefore spacing—which is relatively even in measure.

In all three cases the placing of the brush marks, their respective sizes, and their dark or light tone values tell us something about the kind of action involved, and this allows us to deduce the intensity of feeling present—its urgency or tranquility. Also, notice that a tendency for order and regularity in both placing and timing pulls in one direction, while a freer and more anarchic approach pulls in another.

It is difficult, if not impossible, to try to determine the mix of intuition and reason, or feeling and thought, present in these drawings. An intuitive drive to structure space does seem to manifest itself. At some point along the way, once a figure-ground situation is established, a rational, visual editing may occur. Such editing may impose order and regularity, or work in the opposite direction to enhance looseness and irregularity. The kinesthetic factor responds to whichever master is cracking the whip. The fundamental question to ask yourself as you regard these three examples is whether or not your dominant awareness is of the presence of space or of matter—that is, what makes the stronger visual impact: the shape and movement of the space *between* the brush marks or the disposition and physical shape of the marks themselves? Essentially, you must decide if you agree with the proposition that we perceive the form of space only when, and because, surfaces are disposed within it.

In the first part of this chapter we discussed how various kinds of graphic marks on a two-dimensional surface manage to impart the appearance of three dimensionality. Study Figures 2-30 to 2-32 in the light of that discussion. Notice how the tone value of the markings brings a region forward, or causes it to recede; how the weight of each dot affects spatial position, how such positioning—clustered or dispersed—creates suggestions of frontality or depth, and a sense of compression or expansion; and how the direction in which the brushed surfaces seem to be moving—diagonally, vertically, or horizontally—suggest to the eye a spatial penetration of these dimensions.

We have talked about the *dynamics* of space composition. After you do this work the term may begin to make more sense, because the spontaneity of approach we adopted guarantees a relatively loose structure of brush marks. Even Figure 2-30, which is the tightest—the most deliberately and self-consciously shaped—is still intriguing as a spatial design in which a variety of forces are present. Compare what happens, then, when the strictest of mechanical means is employed to mark empty space with the brush point. Look at Figure 2-33 in which precision, regularity, and uniformity in marking have been the aim, and consider the word "dynamic" in this context. Compare the spatial character of Figure 2-33 with that of the others. What do you see?

The photograph of Victor Pasmore painting a mural (Fig. 2-34) is an apt illustration with which to end this exercise. Articulating the empty space of the wall with a series of point-like surfaces, the artist, if not quite on the run, is obviously involved in a rhythm of movement which is responsible for the configuration of marks on the wall. With each additional dab, the hitherto blank, two-dimensional wall becomes a perceptually viable region—one assuming three dimensionality. Here we see the artist on the move, responding to the visual and psychological challenge to give spatial form to spatial nothingness.

Figure 2-33

Figure 2-34
Jon Pasmore. Victor Pasmore
painting a mural *1965*.

B. *Spontaneous space structure using Point and Line*

Drawing with only the brush tip in the previous exercise ensured a rhythmic "to-and-fro" movement. To have interrupted the back-and-forth nature of this action by demanding, say, that the side of the brush be used to stroke in a line here and there would have interfered substantially with the more spontaneous timing of intervals which the "point only" exercise permits.

Now you are ready to start a more complicated space experiment—one depending on a more intricate use of the brush and on a rhythm and timing altogether less basic. Therefore we introduce the brush *stroke* into the drawing action. In other words, you are to start off as before, building up a rhythm of brush-tip contacts with the paper surface. As in your first drawings, let the composition develop naturally, but from time to time break the tempo of the point movement by handling the brush to make broad sweeping strokes. I cannot suggest just when you should do this, or say how many such marks you should introduce. Let it happen when it seems right—when, intuitively, you move to define an area by the strong directional impetus offered by the flourish of brush and line.

With this exercise you are free to loosen up: to continue using whatever rhythms develop in the "pointillist" defining of space, and yet to slash and parry, cut and thrust, with brush strokes which may be dripping in ink or relatively dry. Black sweeping lines may merge into half-tone grays, run together, or pass over and under each other.

There is a danger in such free action: You might become carried away so that in the end it is not possible to see the forest for the trees. In other words, you must stop the action at just the right moment if spatial definitions are not to become so confused as to be lost. You must keep an eye out for this—that is, you must rely more on a conscious visual editing of the page than when you were utilizing only the point of the brush. At the same time, see if you can rely on intuitively knowing when to stop.

Figure 2-35 shows a drawing made in this way. In terms of the reaches of space it suggests, do you think it represents a happy balance in the use of jabbed points and stroked lines? Or would the space composition it represents be enhanced—become more dynamic and far-reaching—if more lines were present? Try to imagine the drawing without the linear strokes to determine whether or not they help to impart an extra expansive-

ness, or increase the dynamic momentum of the spatial situation. In any case, as you proceed in the Workbook, you will discover that the combination of point and line brushwork is constantly employed to form spatial situations in the problems presented.

The essential difference between Figure 2-35 and the first drawings lies in the sweep of area produced by the brush's flow across the paper—by the strong sense of directional movement as the curving diagonals penetrate the region, gathering space up and pushing through at speed. Yet within this stream of space, the dots and points still make their own tridimensional patterns of pulsating intervals. Consequently, when point and line (or brush jab and brush stroke) come together in the same drawing, two kinds of spatial dynamics may emerge: the *linear flow* and the *pulsating interval.* A vast variety of space-design possibilities exist for the artist who knows how to use them.

Do not forget the emphasis we have placed on the body in action, on intuitively fostering a rhythm of drawing through the perceptual challenge to articulate space. This "ideationless" activity, as I called it, is an important means to realize unconscious creative powers, but remember that it is not the only significant way. In the work which follows we try to harness the spontaneous to the deliberate, and to see if this alliance does not sponsor even more impressive space composition.

C. *Deliberate space structure on a Theme, using Point and Line*

Now you are going to work with a particular idea in mind. Rather than let the image take its own shape as a structure of space in the abstract, you are going to stick to a special concept of space—a concept which provides you with a subject. This does not mean that you have to reason the problem out and inhibit all spontaneity; but you should seek a balance between the intuitive shaping of space, and that which comes from rational thought and choice.

Using the knowledge you have gained from the last two exercises, put together the theme of *Garden Space.* What sort of space is garden space? What shapes does it assume; is it quick or slow space, heavy or light? Is it open and free, or compressed and captive? How should point and line be best combined to form it?

These are all questions which can be answered in many different ways, and they are only meant to help your own ideas mature. If you ponder them while regarding Victor Pasmore's *The Gardens of Hammersmith No. 2* (Fig. 2-36), you can see how this artist responded to them. Analyze the space composition for yourself, and study both Pasmore's pointillist technique and the graphic quality of his linear strokes. Do you like it? Or is your own concept of garden space quite different?

If you turn your attention to Figure 2-37 you will observe that the student who made this drawing did not "see" or feel the theme in the same way. This is not a combination of closed and open space, but a veritable thicket of space—a tangle of air.

Figure 2-35

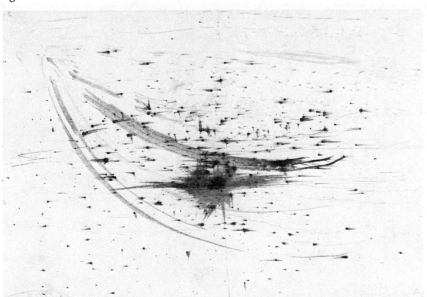

Figure 2-36
Victor Pasmore. The Gardens of Hammersmith No. 2. *1948. Oil painting.*
PRIVATE COLLECTION, ON LOAN TO THE CITY OF MANCHESTER ART GALLERIES, ENGLAND.

Figure 2-37

Now, set up a new page and start to compose your own idea of garden space. Remember to try to incorporate all the graphic techniques we have discussed, and to find a balance between spontaneity and deliberation in order to serve your idea of the space which is distinctively "garden."

D. *Deliberate structuring of space in Depth—Collage using newsprint*

The art form known as collage demands, through its very nature, a considered and deliberate buildup of parts—bits and pieces of various materials and surfaces, arranged and stuck down to produce a composite image. Consequently, no conventional drawing is involved. Figure and ground are created entirely by the adept juxtaposition of each selected component and by the way their various markings and spaces come together in terms of the overall design.

Assemble as many different examples of newsprint as you can find. Search for a wide variety of type faces in newspapers and magazines, and select specimens on the basis of type design, scale, and weight. Advertisements in particular employ dramatic changes in type in order to catch the eye. Also, be prepared to exploit the strong contrasts in tone which are produced by heavy and light letter forms: Heavy letters appear dominantly black, whereas those which are more delicate and slender seem to be altogether grayer. Make your selection by both tearing and cutting out from the page bits of random size. (You should notice, eventually, that torn, rough edges draw attention to themselves and thus appear frontal, whereas cleanly cut ones, merging with ground, recede.)

The job now is to begin arranging selected pieces onto a backing of stiff paper or light board approximately 12″ × 9″. Try to start non-deliberately: Take the first piece that comes to hand and place it without premeditation anywhere on the board—just wherever your hand happens to land. Do not, however, paste it down immediately. In fact, do not fix any of the components to the surface until, after much arranging and rearranging, you are satisfied with the result.

Remember that your object is to create regions of space—space in depth in particular—and that therefore you should be concentrating on what is happening spatially, as the collage develops, rather than on the kind of figure or object which the groupings of letter forms inevitably suggest. Your aim is to create two strong focal areas—one of space in depth, the other of space in close up (frontal space). Test your depth perception by concentrating on Figure 2-38, in which many regions of depth are suggested. Determine whether the image is relatively flat or persuasively three dimensional. If the former seems

Figure 2-38

Figure 2-39
Piet Mondrian. Composition with Lines *1917.*
Oil painting.
COLLECTION: RIJKSMUSEUM KRÖLLER-MÜLLER,
OTTERLO, THE NETHERLANDS.

to be the case then consider how it might be improved, and use this critical opinion to good effect in your own work. Also notice that the smaller and grayer the type fragment and the more empty the space surrounding it, the more distant in depth the area appears to be. And conversely, the more heavy and black the type of component pieces, and the closer together the pieces are placed, the more frontal such areas become. The advantage of collage as a method of working is that it permits a great deal of experimentation. You can try out various pieces from your newsprint collection, seeing how each works in one position or another in terms of spatial effect. Only when you have a result which achieves maximum frontality at some points, and maximum depth at others, should you glue the bits and pieces in place.

Finally, devote a little time to studying Mondrian's *Composition With Lines* (Fig. 2-39). Compare it with the newsprint collage and decide which image presents the stronger challenge to one's depth perception. The intention in developing the collage is to "do a Mondrian"—to heighten perception of space in all three dimensions, and especially in the third. Do you think that the formally drawn *Composition* is more "space effective" than the collage illustration?

E. *Deliberate space structure from two to three dimensions—Free-form space geometry*

The final project for Section II introduces you to the sensation of space which arises from what I call "differences in point dominance." In this exercise you are going to exploit the perceptual relationship between point and line without delineating objects as such. You will use points as space locaters only, and then see how they direct the eye to thread them together by means of an imaginary line.

For example, in Victor Pasmore's *Image* (Fig. 2-40), it becomes clear that a series of points or dots act on the eye in a certain way: They cause the observer to visually connect them together even though they are spatially separated. The closer they are, the more easily we "read" them as credible manifestations of a directional movement; the further apart, the less easily we discern such movement. But generally speaking, when several points are dispersed over a common ground, the eye will seek to thread them together. A dominant point is one that stands out, holds attention, and acts as a focal center in terms of attracting directional movement toward itself, or distributing movement away from itself. In *Image* the dominant point is easily discerned: it operates as a focal center and appears to be responsible for the movement of the other dots.

Figure 2-40
Victor Pasmore, Image,
1968–69. Relief painting.
COURTESY OF THE ARTIST.

COLLECTION: DESMOND MORRIS.

Obviously, points that occupy a frontal position in depth—points that are larger and darker in tone than others—tend to dominate focally. They catch our eye easily and establish the nearest positions in space, while the others then jostle for position behind. Points dispersed over a ground, therefore, affect space perception in two ways:

1. Depending on their loose or tight clustering they suggest a strong or weak *two-dimensional linear movement* in space.
2. Depending on their size and darkness of tone they take up near or far positions in space, and so suggest *three-dimensional linear movement* through space.

Notice how Vincent van Gogh, by using short linear brush marks to act virtually as points, exploits these two characteristics in *Garden in Provence* (Fig. 2-41).

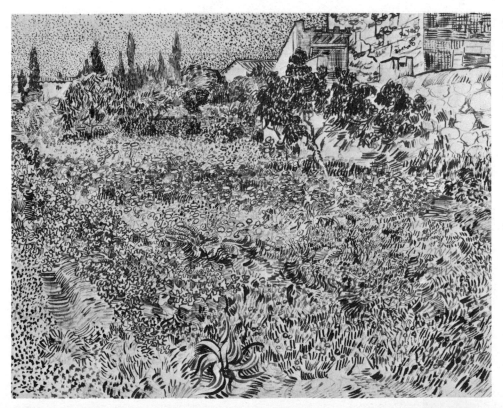

Figure 2–41
Vincent van Gogh.
Garden in Provence
1888. Pen, reed pen, and ink.
COLLECTION, OSKAR REINHART

AM RÖMERHOLZ.

WINTERTHUR, SWITZERLAND.

In order to get your first drawing—or diagram—under way, imagine that you are plotting positions on a homemade map. On a rectangle about 7″×5″, lay out about six major towns, eight or nine of intermediate size, and about fifteen or so small villages. Use large, medium, and small points respectively for each group. This layout can follow any imaginative configuration you wish. When the points are established, connect them with roads; thread them together as your eye sees fit. Your eye will tend to travel first between the large towns; as it does, make a strong linear connection using pen, ink, and ruler. Follow this by visually connecting those towns of medium size, and by graphically recording the link by thinner and weaker lines. Conclude by using only the most delicate of lines to thread together the villages.

Because the eye tends to travel directly over the shortest distance between dominant and then minor points, straight rather than curved lines preponderate. From time to time, however, bends in the road may creep in as the eye meanders over the longer distances. Figure 2-42 is an example of an imaginative map of this sort.

What you have now is basically a two-dimensional point-and-line diagram in which the points tend to perceptually dominate. Hopefully, while you worked you realized that the eye is always ready to be led from one dominant point to another, particularly when new and interesting changes of direction are suggested. Much of our visual perception consists of such rapid scanning of point extremities as we navigate ourselves through space. Equally important is that our eye is also led over surfaces through points of emphasis and points of directional change. This is as true for our perception of the world as for the surface of a canvas, or the wall of a building. Does your eye jump along the top of the window pediments on the wall surface of the Palazzo Farnese (Fig. 2-43), bridging the gaps between them and constructing horizontal "lines" which create proportionate divisions over the whole facade? Does your eye also travel vertically, moving up the pilaster-like columns which frame the windows, filling in the spaces between until finally halted by the projecting cornice of the roof? Thus, the wall surface becomes a vertical and horizontal grid, induced in perception through the layout of stone motifs and their visually challenging point extremities.

Figure 2-42

Figure 2-43
Sangallo and Michelangelo. Palazzo Farnese, *facade. Rome 1530–48.*
PHOTO ALINARI.

Now proceed further and try to give your more or less two-dimensional map the attributes of a three-dimensional point-and-line space structure. Take a tracing of your imaginary map but include only the towns and villages. *Do not record the connecting roads.* Then transfer the layout of points onto a new piece of paper, making sure that the point marks are exactly the same size as those in the original diagram.

As before, three different weights of line are to be used as connectors: heavy, medium, and light. This time, however, have no thoughts about maps in mind. Simply follow the instructions and watch what begins to happen on the page. First join all the *large* points together with a heavy ruled line—up, down, and across—irrespective of their "map-like" position on the paper. Proceed by making similar connections between all the *medium*-sized points, using a ruled line of only medium weight. Finally, join up all the smallest points with a lightweight, delicate line. In making these three types of connection move all over the ground: Do not worry about crossing any lines already in position. Move freely, concentrating on joining the particular group of points with which you are involved.

Figure 2-44 shows the kind of random, geometric space structure which results. This is a useful exercise not because it produces a figure of particular interest—although this might happen by chance—but because it illustrates how easily and naturally two- and three-dimensional perception is stimulated by points, and how to take advantage of this knowledge in drawing and design. We set out to graphically exploit points in terms of their strong perceptual dominance and attraction—their ability to suggest both two- and three-dimensional directional movement—and in so doing finish up with a space grid more complex than we might have envisaged at the outset. You can develop several variations of this exercise. For example, you do not have to rule the lines, nor do you have to use straight lines exclusively: A combination of straight and curved, ruled and freehand lines could produce a space model even more complicated and perceptually intriguing.

Figure 2-44

F. *Variation on the space theme*

For this drawing use three varying weights of line—heavy, medium, and light. Do not lay out points as such beforehand, but simply allow them to come about as the ends of lines or as the corners where two or more lines meet. The graphic quality of the lines themselves plays an important role. Study Figure 2-45 for a few moments. Notice that all the lines except one diminish in weight and tone value in the course of their travel, resulting in space penetration in many directions. The lighter and grayer the line becomes, the more distant it seems to be and the faster it appears to be moving. Also, observe that in addition to the variable weight of the lines, their length, angles of placement, and relationship to the edges of the paper all contribute to the spatial situation created.

Start by placing one heavy, black line in a semidiagonal position on the page. The weight and tone of this line should be constant throughout its length. Choose one end of this line from which to work: Decide on the angle and direction and put a second line down, diminishing its weight and tone as it progresses. Decide how far into the space you wish it to travel. Now start the third line away from the end of the second line; again you must decide the line's angle, direction, and length, and you must diminish its weight and tone as before. Make sure that your eye is appraising the space effect produced when lines approach the outer edges of the page, and when they stop well short.

Figure 2-45
John Flavin. Drawing 1963. *From "Basic Design: The Dynamics of Visual Form," by Maurice de Sausmarez.*
THE HERBERT PRESS, LONDON, 1964 AND VAN NOSTRAND
REINHOLD, NEW YORK.

With the introduction of these first three lines you have created a primary spatial situation. Now the question is where to insert independent lines, singly or in angle-making groups of two or three, in order to cut ever deeper into space. The relative weight and tone of these lines should vary according to how frontal or recessive you wish them to appear. No line should compete in weight or tone with the first strong diagonal.

The three-dimensional space sensation you are trying to develop depends for its effect on how well each line, or group of lines, functions as a unit—and on how these units overlap and interpenetrate over the ground. Analyze Figure 2-45 for yourself before starting on your own space structure, but do not imitate it. Be curious as to what you can do for yourself in this matter of creating space.

III
Space as Positive and Negative

In the context of drawing and design the words "positive" and "negative" do not carry normal, evaluative connotations: They do not imply that one is faced by a good spatial design as opposed to a bad one. Instead, they refer to the role played by a particular spatial region in serving as ground for figure. Briefly:

POSITIVE SPACE is perceptually inseparable from figure, and so becomes significant in its own right as distinctively shaped ground.

NEGATIVE SPACE is less perceptually integrated with figure, and less definitively shaped as ground.

Let us consider an illustration. Henry Moore's *Reclining Figure, External Form* (Fig. 2-46) is a sculpture which makes almost as much use of the element of space as it does that of bronze. The "holes"—the hollowed-out regions which penetrate deeply into the piece—are obviously an essential part of the sculptural concept, and they are integral to the overall form of the work. These cavities are shaped by the bronze surfaces; their presence permits the shape

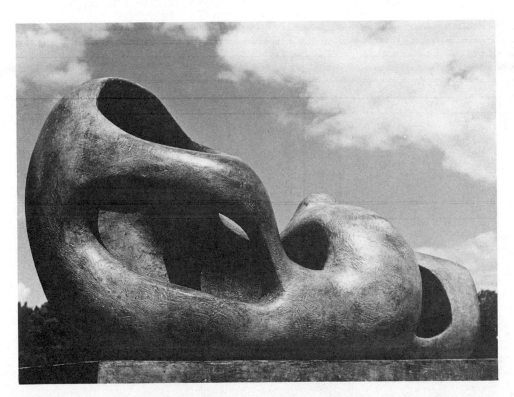

Figure 2-46
Henry Moore. Reclining Figure,
External Form *1952–53. Bronze.*
COURTESY OF THE ARTIST.
COLLECTION: MUSEUM OF MODERN
ART, ROME. PHOTO BY LIDBROOKE.

and flow of the bronze to be delineated more clearly and to be made more perceptible. In other words, when it is apparent that space is given a positive shape by a particular configuration of object or figure, and that same figure gains in perceptual clarity due to the distinctive space surrounding it, then we are justified in describing the spatial context as positive. Also, and equally important, is that such integral space functions as evocatively as the material structure of the work; it becomes aesthetically significant, and so once again justifies its designation as positive.

The French painter Henri Matisse considered space a powerful ally for the artist who wished to evoke mood and create images which become vehicles for feeling. In 1908, in *Notes d'un peintre*, he wrote the following:

> Expression to my way of thinking does not consist of the passion mirrored upon a human face or betrayed by a violent gesture. The whole arrangement of my picture is expressive. The place occupied by the figures or objects, the empty spaces around them, the proportions, everything plays a part.

Matisse is talking not so much about positive space acting to serve perception as he is about its ability to work expressively—that the shape and scale of space with which he surrounds his figures may work to impart the "atmosphere," the mood, he desires. Do you see what he is getting at when you confront *Joy of Life* (Fig. 2-47)? If you apply Matisse's statement to Moore's *Reclining Figure*, would you say that the spaces which are so integral to this work serve mood and feeling as well as perceptually endow the sculptural surfaces with a clear and precise shape? Space works for Moore the sculptor no less expressively than it does for Matisse the painter.

Figure 2-47
Henri Matisse. The Joy of Life. *Painting.*
PHOTOGRAPH © 1984 THE BARNES FOUNDATION, MERION, PA.

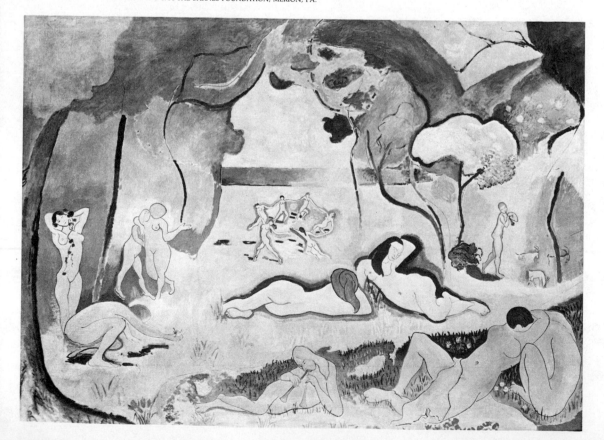

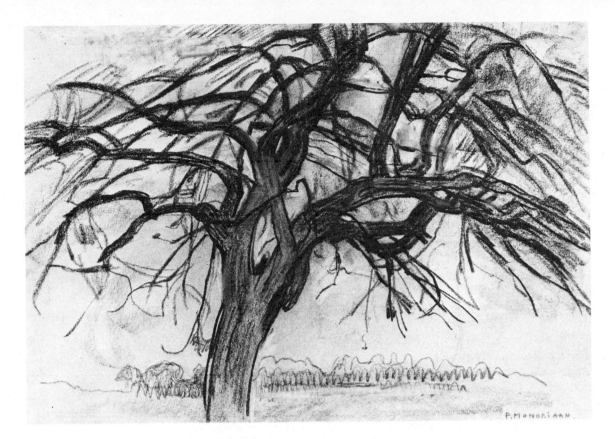

Figure 2-48
Piet Mondrian. Tree I. *1909–10. Black chalk on paper.*
ESCHER FOUNDATION, HAAGS GEMEENTEMUSEUM, THE HAGUE.

Even in photographic images we notice that a great deal of space is present which does not join forces in such an intimate and meaningful way with objects. This is the general context of space—the "outside" space, if you like—which surrounds all tangible things in the natural, three-dimensional world, and all graphic figures which exist on the two dimensions of the page. This ground of universal space is often described as negative space: negative because it is basically neutral—it is not experienced perceptually in direct relationship to the sculpture, nor does it contribute to the piece's aesthetic impact.

It is overly simplistic to just call all external space negative. If you study Figure 2-46 for a moment, it is obvious that exterior space *immediately surrounding* the sculptural surfaces follows the movement of those surfaces, and so appears to be shaped by them. As we have noted previously, it is this proximate space which serves perceptually as the matrix for the physical form it envelops. Therefore, in this sense, it is more positive than negative.

When we talk about positive and negative space, then, we must recognize that these are not absolute terms. The only truly negative space is that at some distance from the object, and which is formless in that it takes on no shape suggested by the object's presence. When we refer to positive space without making any qualification, it designates only those spatial regions which are unreservedly part of the object or figure both physically and aesthetically.

Mondrian's *Tree I* (Fig. 2-48) is a vigorous drawing that conveys the thrust and force of tree growth in a dramatic—that is, expressive—manner. However, this is not why I choose to show it. Rather than regarding it as an expressive (yet fairly naturalistic) drawing of a tree, what would you think if I suggest that it is as much a drawing of tree space as it is of tree? If you accept this—because the limbs define spaces which you perceive as being uniquely part of an overall "tree experience," then which spatial areas tend to be more "tree'd" than others? This is just another way of asking which spaces in the drawing

are unreservedly positive? My answer would be: those regions which are the more completely enclosed and which gather around the tree's focal center. Here, as for the hollows in Moore's sculpture, the shape of space complements the shape of tree and so becomes part of its form both aesthetically and perceptually.

But when your eye pulls away from these central regions to where limbs do not totally enclose space, and twigs (lighter and grayer lines) take over, space is more open and less strongly defined and thus less positive. In this drawing, because the tree fills most of the available ground, there is very little totally free, uncommitted space, and so it is difficult to find completely negative regions. Only in the extreme four corners of the page is the space so detached.

Now see what happens when the artist becomes as interested in drawing—that is, in structuring—the ground as in drawing the tree itself. In 1908 Mondrian had begun work on the series of tree pictures from which, ultimately, totally abstract images evolved. (Fig. 2-48, for example, was made in 1909.) In the process of being drawn and redrawn, the tree forms became more and more structurally precise as the natural growth pattern of limbs was transformed and simplified into an increasingly abstract design of linear rhythms which retain an organic credibility. In Figure 2-49, *Horizontal Tree*, you can see how far, by 1911, Mondrian moved in this direction.

The strong black lines which represent tree surfaces still dominate, but the lines of drawing which shape the space run them a close second. The ground has become "tree'd" to the extremities of the page. In this painting the question is no longer which spatial regions are positive or negative, for negative

Figure 2-49
Piet Mondrian. Horizontal Tree *1911. Oil painting.*
COLLECTION: MUNSON-WILLIAMS-PROCTOR INSTITUTE, UTICA, NEW YORK.

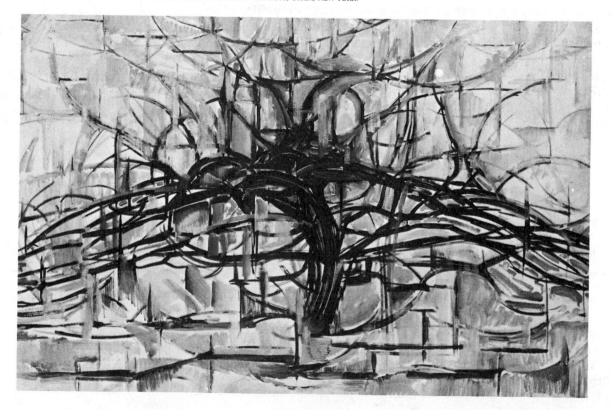

space does not exist in the conventional meaning of the term. Mondrian has continued the linear rhythms of the tree's skeletal structure outside the tree: horizontally, vertically, diagonally, and three dimensionally in depth. Certainly the central spaces, being focally commanding, are positive par excellence; yet even in the more distant corners where space normally goes entirely free, the vibrations of the tree's material presence continue, albeit somewhat less positively. One is inclined to wonder at what distance from the tree will ordinary empty, negative space resume.

We have previously discussed the graphic factors which may be employed to produce spatial illusions on a flat surface. The following aspects characterize Mondrian's "space technique":

1. Using heavy or incisive *lines* to totally enclose the most positive areas of space; and using lighter or duller lines to only partly enclose less positive, non-central regions.

2. Employing blue-black, dark *tones* in the painting for the most positive regions; and blue-gray and pink-gray for the lesser.

In comparing Figures 2-48 and 2-49 we realize that both treatments enjoy certain advantages. The more naturalistic, more conventionally positive to negative space of *Tree I* encourages us to perceive and identify with the reality of the tree in nature. But the relatively abstract configuration of tree and omnipresent positive space created by *Horizontal Tree* produces an architectural-like fantasy—a vaulting of space by tree limbs acting as ribs which serve to shape a concept, rather than a perception of the natural world.

The important lesson here is that space can become a plastic entity in its own right: that the artist can ring the changes between two spatial possibilities to suit his or her artistic intention.

WORKBOOK

2-III. Manipulating Positive and Negative Aspects of Ground

Tree and space—Determining spatial roles

Although we are going to borrow Mondrian's tree theme for this work, there should be no mere imitating of his results. We will adopt his idea of using tree limbs to break up space, but try to structure the exercise in such a way that a personal involvement is demanded. As only one drawing is called for, be prepared to treat it seriously as a comprehensive introduction to the effects of positive and negative space. Remember that the aim is to develop a regard for space equal to that we normally reserve for figure or object.

First, look around outside for some natural, twig-like object that is both interesting and skeletally complex. Figure 2-50 shows the kind of twig linear system that will work well; the wild garlic stem you see in Figure 2-51 might be even more suitable. The important thing is to select a specimen that cuts cleanly through space, and in so doing produces a variety of open and closed regions of ground. If you place your example on a piece of white paper you will be able to see more clearly how the ground behind it is partitioned by the limbs, and perhaps at this point you will recognize positive and negative areas. Now remove your "found object" from the paper, but keep it in one hand for observation. Pencil it in as it was arranged on the paper, using a single strong line to represent the primary limbs, and successively lighter lines to stand for the more delicate limbs remaining. At this juncture it might be necessary to do some editing—to eliminate those detailed aspects of the specimen which simply clutter and confuse the spatial layout as it develops on the page. (This would obviously be necessary in using a twig such as that shown in Fig. 2-50, but not necessary at all if working with one like the wild garlic stem.)

With this accomplished you are no longer primarily interested in the linear aspects of the drawing, but, instead, must perceive the overall form of the image: the relationship of limbs to the spaces they define, and vice versa. Therefore look hard at your drawing to

Figure 2-50

Figure 2-51
Robert Nix. Wild Garlic Stem.

appraise the spatial situation. Decide which of the areas are positively defined by which limbs or lines, and are therefore visually inseparable from them. Perceptual recognition of these regions produces a heightened awareness of the material surfaces which shape them. Positive regions of space tend to be fully or partially enclosed by strong lines of forceful movement over the page. Also, they usually occupy a focally central position. Nevertheless, an incisive, biting line representing the end twist of a secondary limb may suddenly curl and define a circle of space which intrudes positively upon one's perception, even though it might be out toward the edge of the page.

Now you will need brush, pen, and ink to continue the exercise, and also a saucer of water for ink dilution, in order to use a range of tone values from black to gray.

The process is now one of "toning in" both limb and space. Commence as follows: Work on the assumption that when a dark or black-gray tone is washed over a region of white ground, that region will dominate perception by standing out in contrast. And conversely, when a light, pale-gray to white tone is washed into a region the area will not immediately engage the eye but will be perceptually unobtrusive because of lack of contrast.

Select the region which you see as the most positive space and lay down a dark wash of ink. Avoid using a dead, heavy black: Dilute the ink a little to give it some transparency and just flood it in on the brush. Do not overwork it by trying to smooth it out to produce a uniformly flat tone. Leave the wash to flow in its own way. If more than one spatial region dominates, give all the same tonal treatment. Now proceed down the scale of perceptual predominance. Decide which regions are next in importance in terms of catching the eye and in being part of the image's overall form, and wash in a lighter tone of gray. Repeat the process for any tertiary spaces you discern, merely lightening the gray tone of the wash. Finally, let the white paper itself represent the lightest possible tone, and so remain untouched in the areas you determine play the least important role in shaping the overall form of the drawing, or in contributing to its dramatic interest.

It is possible to go further and to emphasize the spatial differentiation which the toned washes of ink have produced. Study the penciled-in lines or limbs first put down, which may now, in parts, have become lost in the washes of tone. In those instances where they are part of a positive spatial region, work them over with a brush and dark ink. Treat lines which relate to secondary regions in the same way, but give the brush line less weight and use a lighter tone of ink. Then look for any line which was originally incisive and sharp, and determine if you should restore its keenness with a stroke of the pen, and what would happen to the immediate region if this were done.

Finally, you could work in the opposite way and take out lines which are too visible and which occupy spatial positions at variance with the spaces to which they relate. Do this with a razor blade: Gently scratch out such lines until they are spatially compatible—that is, possess the right degree of negativity commensurate with the region. Figures 2-52 and 2-53 illustrate two graphic resolutions of this positive-to-negative space experiment. Which one do you think is the most effective in terms of accomplishing the spatial differentiations the exercise sets out to achieve? Which image do you consider integrates space with figure not only for perceptual reasons, but for expressive or dramatic ones as well?

When this drawing is complete, the result should not simply be an image of a twig-like figure drawn on a white piece of paper. The organization of the ground should have made it as perceptually vital and as aesthetically interesting as the skeletal object itself. The significance of such figure-ground totality in a drawing is a completeness which is best described by the word "form." If form is to be achieved in a work of art, recognition of the positive and negative roles of the contextual space plays an important part in the process of designing.

Figure 2-52

Remember that the work we have described here is merely an exercise. As you continue to work for yourself there will be no need to go to such formal "black-and-white" extremes in determining the interplay between figure and positive to negative areas of space. The kind of relationships achieved so analytically—and with such graphic force in Figure 2-53 particularly—should ultimately come about naturally in the normal process of drawing.

IN CONCLUSION, we have seen in Chapter 2 how space, when it functions as ground in an act of perception, becomes an element to be no less seriously treated in art than the figure which occupies it. From now on, we should remember that when talking about a work of art—or even about general visual experience—we are referring to the totality of *figure and ground*.

FIGURE
basic structural characteristics

> *The observation of nature is part of an artist's life, it enlarges his form-knowledge, keeps him fresh and from working only by formula, and feeds inspiration . . .*
>
> <div align="right">HENRY MOORE</div>

WE HAVE TALKED at length about lines and other marks, and the physical surfaces they represent on the page; we have also described surfaces which are more concrete—those of sculpture, for example. And we have described both configurations—the graphic and the material—as constituting the formed motif in art known as *figure.* But we have said comparatively little about the structure or design of such figures as objective presences. Instead, we identified figure in order to discuss space as a perceptual reality in its own right, to recognize that space is as much a constructive element at the artist's disposal as is physical surface, graphic or otherwise, which becomes figure. By the end of Chapter 2, this concentration on the use of space in art led us to examine its positive and negative aspects in both two- and three-dimensional art.

Now we must redress the balance and turn to scrutinize figure. We start by looking more intently at things in the world of nature—at the infinite variety of shapes and sizes which should attract your curiosity and interest; we then consider how "the observation of nature is part of an artist's life . . ." Implicit in Henry Moore's statement is the suggestion that a knowledge of natural objects inspires the creation of art forms: that the artist's imagination is fed by his or her visual and mental involvement with natural phenomena.

Note, before you proceed, that throughout this discussion the terms "figure" and "object" are used more or less interchangeably. The distinction that is made between them is that *object* refers more specifically to a thing in nature, and *figure* to that which is formed as a motif in art.

The aim of this chapter is to stimulate and develop your observation and analysis skills: to teach you how to look intently rather than casually at a variety of objects, and then to reveal through drawing, the structural principles which determine their shapes. Although some artists would not consider observation as crucial to the work of mature painters or sculptors, a capacity for observation is vital for students. It is, however, also relevant for mature artists, because the memory of things seen constitutes a repertoire of visual experience on which the imagination constantly builds. Even abstract non-objective artists depend on a knowledge of physical forms gleaned from the visual memory.

There are many ways of regarding an object, from a superficial glance to a penetrating scrutiny—casually and disinterestedly, or with intent and involvement. When we look with intent we try to see beyond the immediate, apparent shape of the object into its true and essential structure in order to understand *how* it is made. Looking with intent also yields an understanding of *why* something is, what its function and meaning are, and what part it plays in its particular setting. It is this type of looking which allows us first to reveal in drawing the fundamental physique of a thing, and then, perhaps, to move on to produce the kind of statement which shows the object transformed: modified to shape feeling or stand as a symbol for an idea.

Obviously, external appearances do not tell the whole story about an object. Asked to describe a tomato, the average person would say that it is a small, round, and reddish object. Some might go further and describe its softness to the touch, but relatively few would cut it open mentally and describe its internal cross section. Yet the tomato's cross section is as much an aspect of the tomato as its roundness and redness and softness. When purchasing a new automobile, few people decide to buy solely on the basis of the *looks* of the car; they want to know how it performs and perhaps how well it is built. Similarly, to make a significant drawing of any object, one should know about its essential structure and function as well as about its external appearance.

Leonardo da Vinci is the exemplar of this attitude to drawing. He pursued structure ruthlessly, stripping away externals until the bones of the physical form were laid bare. The drawings in his *Notebooks* are masterpieces of structural statement, whether they be of flowers, rocks, or human anatomy. Leonardo's eye was like a microscope. Do not be deceived by the apparently easy beauty of such paintings as *The Virgin of the Rocks*, or the famed *Mona Lisa*. Beneath that soft patina of the face, Leonardo reveals all the structural thrusts which shape and form the skull. And the detail of the landscape indicates a laboratory-like study of structural minutiae. Observe his drawings of the shoulder in Figure 3-1, a part of his anatomy studies. Leonardo writes in his *Notebooks:*

> The painter who has acquired a knowledge of the nature of the sinews, muscles, and tendons will know exactly in the movement of any limb how many and which of the sinews are the cause of it, and which muscle by its swelling is the cause of this sinew's contracting, and which sinews having been changed into most delicate cartilage surround . . . the . . . muscle.

Before we can expect our looking "with intent" to reach this level of knowing, we must train ourselves in the more elementary aspects of visual analysis, in such concerns as proportions, the directional movements of surfaces and their rhythms, the pattern of organic growth, and the mechanical forces that operate. In so doing we are led inevitably to evaluating the structural reality of the object. All the drawings suggested in this chapter are designed to initiate you into the processes by which an initial observation of structure can grow

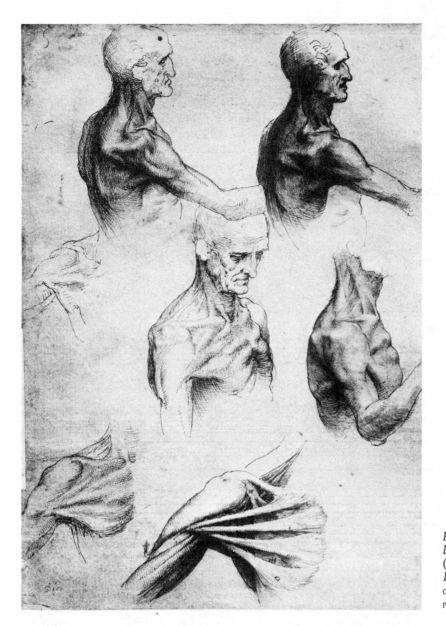

Figure 3-1
Leonardo da Vinci. Anatomical Drawing
(Shoulder).
Ink and Chalk

into a more meaningful perception and perhaps, finally, into the full imaginative experience that later in the book is called "vision."

WE CLASSIFY THE VARIETY OF SHAPES we confront into two simple and very general categories. We do this by virtue of the way their *surfaces extend into space.* Consider a visual example. Constantin Brancusi's *Muse* (Fig. 3-2) and Laszlo Moholy-Nagy's *Dual Form with Chrome Rods* (Fig. 3-3) represent two extreme possibilities in terms of the way material surfaces can occupy space: They might be informally described as bulky or massive on the one hand, and skinny or thin on the other. The surface flow of *Muse* is expansive—that is, its amplitude or area spread is the dominant physical characteristic. Therefore let us assign it, together with all other figures or objects whose spread of surface is the commanding physical trait, to a morphological family called *mass* types. (The term "mass" does not necessarily connote weight or

Figure 3-2
Constantin Brancusi. Muse 1926. *Bronze on stone base.*
PORTLAND ART MUSEUM, PORTLAND, OREGON.

Figure 3-3
Laszlo Moholy-Nagy. Dual Form with Chrome Rods *1946.*
THE SOLOMON R. GUGGENHEIM MUSEUM,
NEW YORK.

heaviness: It is more indicative of volume suggested by the expansion of surface. Such volume, as we see later, may comprise heavy material or it may simply contain space.)

In contrast to *Muse,* however, the material surfaces of *Dual Form with Chrome Rods* do not flow as volumes. Although they extend to define space as volume, they themselves remain thin and attenuated, presenting an overall figure shape the very opposite to that of Brancusi's sculpture. Therefore let us consider Figure 3-2 as representative of a second morphological group of shapes called *skeletal* types, distinguished by linear rather than mass characteristics. We discuss skeletal types in Section I of this chapter and mass types in Section II.

Many physical forms are quite homogenous—totally one type or the other—as is the case with Figures 3-2 and 3-3. Brancusi's *Muse* possesses no skeletal qualities; and the surfaces of Moholy-Nagy's chrome rods encompass minimal volume. However, mass and skeletal types are also not mutually exclusive. Objects may very well embrace both possibilities in their structure— think of the physical form of a spider, for example, or even the human body, with torso as its mass and arms and legs as its more skeletal limbs. Conversely, even the most skeletal of attenuated surfaces possess volume—a strand of hair, for example—but we are hardly aware of it because of the surface's preponderant linearism. The categories of skeletal or mass physique represent the two essential properties of just about every visible object. If we look at things with this in mind, our visual analysis of physical forms becomes more critical and more acute. Such knowledge then allows us to draw any object convincingly, notwithstanding the complexity of its mass and/or skeletal composition. When the human eye encounters an object possessing such a dual nature, the dominant configuration—mass or skeletal—wins, and we then conceive the object as belonging to the appropriate family even though physical ambiguities are present. Therefore when we describe something as mass or skeletal, we do so because one or other quality is preponderant.

I
Skeletal or Linear Qualities

Let us discuss skeletal forms by referring to some pertinent visual illustrations. Inevitably, as we have seen, skeletal surfaces are less substantial than those of mass: They move out thinly into space, and so by their very nature break space up into positively and negatively defined areas. This is not the case with objects of mass which, unless they are penetrated by hollows and cavities, present solid, spreading forms which effectively eliminate the possibility of shaping space save around their immediate edges. To gaze at a watermelon is to gaze at a solid, heavy watermelon, and to be aware only vaguely of the oval definition of space made by its contour. But to gaze at a hand with fingers outstretched is to perceive, equally strongly, the finger surfaces *and* the triangles of space between them.

One of the most important characteristics of skeletal forms, then, is that their attenuated surfaces not only produce a structure with a particularly linear, dynamic quality, *but they also create a pattern of space—a ground—enjoying equal perceptual status with the figure and affecting the viewer no less significantly than the form of the extended limbs themselves.*

Look, for example, at Figure 3-4—a wire sculpture whose physical surfaces as such are reduced to minimal volume, appearing like lines in a drawing. Yet this treatment allows the "limbs" to move through space most cleanly, each

Figure 3-4
Harry Kramer. Torso
1964. Wire.
TATE GALLERY, LONDON.

moving at its own pace in its own particular direction, yet all combining to form the single, dynamic, linear phenomenon called *Torso*. But is it not true that our perception is almost equally involved with the mosaic-like pattern of space, with the flowing and interlacing volumes so clearly structured by such slender wire surfaces? Kramer's *Torso* certainly represents an extreme case of skeletal form; even so, such positive space definition is also attributable to Henry Moore's *Double Standing Figure* (Fig. 3-5) and Theodore Roszak's *Rite of Passage* (Fig. 3-6), sculptures whose surfaces are far more substantial.

In these two works we see also how the type of surface displayed by the limbs can produce different skeletal effects. The smooth, semirounded, and cleanly edged linear forms of the Moore stand in sharp contrast to the rough, angular, and broken-edged physique of Roszak's piece. It becomes obvious that these differing treatments affect both the dynamics—the rate and flow of linear movement—and the expressive or emotional force of skeletal forms. The limbs of *Double Standing Figure* appear to flow evenly into and through each other, giving an organic credibility and permanence to the work; also, these linear rhythms impart a generally relaxed and serene air so far as its expressive impact is concerned. On the other hand, the coarser and irregularly edged surfaces of Roszak's piece appear to move through space more erratically—now quickly, now slowly—due to the angular and jointed limb connections. Consequently, the figure appears altogether less equilibric, less permanent than the Moore; its expressive power, however, is more dramatic, restive, and uneasy, indicating a volatile sculptural presence with its attendant mood of mystery.

The dynamic capabilities of skeletal forms are best shown in Victor Horta's ironwork balustrade shown in Figure 3-7. The international style known as Art Nouveau, which swept through Europe and America at the turn of the nineteenth century, thoroughly exploited all the visual excitement offered by sinuous sweeps of line and the spatial flow that complements them. The élan and exuberance, the sheer curvilinear vitality of Horta's design is echoed in Figure 3-8, a graphic Art Nouveau creation which exploits a similar sense of linear animation and corresponding skeletal vigor.

Yet it is not necessary to use only the highly stylized images of Art Nouveau to illustrate the ways in which such linear or skeletal emphases work. In Li K'an's extraordinarily naturalistic drawing *Ink Bamboo* (Fig. 3-9), we see structural, spatial, and expressive qualities shown off to perfection. If we briefly contemplate the skeletal object in nature, and the use of the skeletal principle in architecture, we see yet again the strong articulation of space which results, and we feel the expressive vitality of such a figure and ground combination.

Figure 3-5
Henry Moore. Double Standing Figure *1950.*
Bronze.
COURTESY OF THE ARTIST.

Figure 3-6
Theodore Roszak. Rite of Passage *1953.* *Steel, nickel, and copper.*
COLLECTION: MR. AND MRS. NED L. PINES, NEW YORK.

Figure 3-7
Victor Horta. Balustrade of the Solvey
Residence, *Brussels, 1895–1900.*
PHOTO COURTESY OF THE DEUTSCHES MUSEUM, MUNICH.

Figure 3-8
Gerrit Willem Dijsselhof.
Title page of Kunst en
Samenleving 1900.
Private collection, Amsterdam.
From "Flowering of Art
Nouveau" by Maurice Rheims.
HARRY N. ABRAMS, NEW YORK.

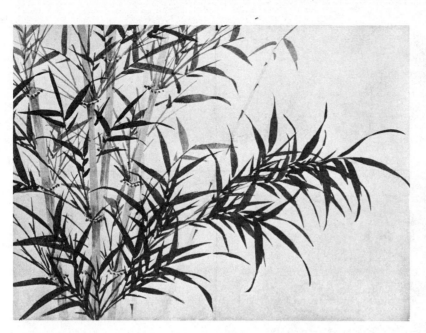

Figure 3-9
Li K'an. Ink Bamboo. *Ink on paper; handscroll dated 1308.*
NELSON-ATKINS MUSEUM OF ART, KANSAS CITY, MISSOURI, NELSON FUND.

Figure 3-10
Robert Nix. Mimosa Branch.

Study Figures 3-10 to 3-13 as a series of photographs which show the strong visual affinities between skeletal structure in nature and that in architecture. The mimosa stem (Fig. 3-10) forms a cage that cradles space like an architectural ribbed vault. In the drawing for the *Sternkirche Project* (Fig. 3-11), the linear framework defines space in a similar way and indicates how the thrust of such limbs will provide the building's stability. In the magnificent fan-vault of King's College Chapel, Cambridge (Fig. 3-12), it seems that the ultimate sophistication of the linear or skeletal form has been reached. Like a great web in stone, the architecture's linear flow of column and rib is dramatic in itself, yet at the same time it causes space to follow its movement and rhythms. Structurally each stone strand of the web provides the thrust and counterthrust that defies gravity and determines physical equilibrium.

Figure 3-11
Otto Bartning. The Sternkirche Project 1921. *Cross section.*
From "Modern Architecture and Expressionism" by Dennis Sharp.
LONGMAN GROUP, LONDON.

Figure 3-12
King's College Chapel, *Cambridge, England, 1446–1515.*

The stem, the rib, the line—all attenuated surfaces—have the potential to cut through space—perhaps it would be more descriptive to say dance through space—in a way that forms belonging to the family of mass cannot equal. Herein lies the skeletal expressive and space-defining capability. Look at David Herschler's *Spiritual Flight* (Fig. 3-14) to see if you agree. Then try to imagine what the architectural effect would be if the skeletal ribs of Niemeyer's cathedral design (Fig. 3-13) were modified to take on the sculptural quality of *Spiritual Flight*.

Earlier in the chapter I talked about structural principles being related to the type of surface spread—skeletal or mass—which dominates perception of figure or object. The structural principle inherent in skeletal configurations is that of the cage or frame—the underpinning to any skin-like spread provided by a hard or "bony" framework in which each linear element is thrusting against another, rib against rib or girder against girder, to provide a box-like rigidity. Thus, in George Stubbs' *Anatomical Exposition of a Tiger* (Fig. 3-15), we see the rib cage revealed, the bones and sinews of the legs indicated beneath the surface of the skin. Is it going too far to suggest that Stubbs' drawing has something in common with the photograph of the church you see in Figure 3-16? I ask you to make the comparison because the skeletal frame of the ar-

Figure 3-13
Oscar Niemeyer. Cathedral, *Brasilia. Commenced 1959.*

Figure 3-14
David Herschler. Spiritual Flight *1972. Steel and chrome.*
COLLECTION: MR. AND MRS. J. CONSTANCE, MONTECITO, CALIFORNIA.

115

Figure 3-15
George Stubbs. Anatomical Exposition of a Tiger. *Pen, pencil, and wash.*
CROWN COPYRIGHT, VICTORIA AND ALBERT MUSEUM, LONDON.

Figure 3-16
Wallace Harrison. Presbyterian Church, *Stamford, Connecticut, 1961.*
PHOTO BY ANTHONY MAUER.

Figure 3-17
Alberto Giacometti. Man Pointing 1947. *Bronze.*
TATE GALLERY, LONDON. PHOTO BY ERNST SCHEIDEGGER.

chitecture serves like the skeletal rib cage of the tiger: It is the linear framework providing the rigidity of thrust and counterthrust, over which or in which the skin of glass (or any other material) may be placed.

We have seen that the expressive vitality of skeletal forms is basically two-fold: Space is effectively shaped to convey feelings that may run the gamut from repose to urgency, and linear surfaces themselves move forcefully through space suggesting different degrees of both vigor and speed, thus also heightening the dramatic possibilities.

"Thinness" itself carries expressive suggestions. Just think of the emotional connotations in language of the words "gaunt," "wasted," or "thin." Feelings of sympathy, worry, concern, solitariness are almost automatically aroused when such words describe people; when they pertain to things these words give rise to similar responses—although perhaps less intensely—which spring from an awareness of fragility, impermanence, and vulnerability. When Alberto Giacometti treats the human figure in the stick-like way you see in *Man Pointing* (Fig. 3-17), human physique is immaterialized to a skeletal line. There are only a few occasions in the history of art when the human form has been pared down to this degree. Even though Etruscan sculpture of the seventh and sixth centuries B.C. employs a similar distortion—as it does when treating the idea of ghost or spirit rather than the body as such—the work appears more substantial than Giacometti's *Man*. Consequently, feelings about metaphysical problems are more naturally expressed by the skeletal form than by that of mass. Look again at Roszak's *Rite of Passage* in Figure 3-6 and try to imagine its effect were it filled out and substantial.

Before proceeding to the search for, and selection of, the skeletal specimens with which you are to experiment in the Workbook, you should familiarize yourself with some basic features of the figures and objects that we classify as skeletal types:

1. A skeletal object, unlike an object of mass, consists of a limb or series of limbs whose surfaces are sparse and attenuated as they extend linearly into space.

2. In the case of a multilimbed object the connections may be jointed in what might be called an "articulated system," or bifurcated in a free-flowing "continuous system."

3. The linearism of the object defines the occupied space with great clarity through the extension of its limbs. Consequently, form and space are in a positive complementary relationship in the skeletal object, for we perceive the figure in order to comprehend the space, and perceive the space in order to comprehend the figure.

4. An object with a skeletal structure can be initially analyzed through drawing, using an X-ray-like system of lines to represent proportionate lengths, changes of direction, type of movement, and the manner of their joining.

5. Complete regularity in a skeletal form tends to produce a static and mechanical-looking structure. On the other hand, when the parts possess enough diversity to tilt the balance a lively and organic structure, which holds the interest of eye and mind and arouses feeling, results.

6. We recognize a structural unity to the form when we realize that each individual limb is totally part of the whole; when we are not aware of an alien element in matters of proportionate rhythms, directional movements, or joining systems; when the object has apparently *grown* that way, rather than having been contrived artificially from a series of parts.

3-I. Visual and Graphic Analysis of Skeletal Form

Perhaps the most important part of this work lies in the looking and selecting rather than in the drawing. The first thing you must do is to search around outside and collect five or six objects which possess skeletal structures. Once you start, you will be surprised by the variety of available specimens that have either angular and jointed or curving and bifurcated formations: grasses of all kinds, twigs, seed heads, thorny or smoothly curvilinear bushes, leaves, feathers, and the bony skeletons of small animals and fishes. But select only organic objects. A plastic comb, skeletal though it may be, does not support the kind of visual analysis I have in mind here.

Look, for example, at Figures 3-18 to 3-24. Commencing with the depiction of a single twig of thorn, the specimens are arranged in order of increasing skeletal complexity; the arrangement concludes with an illustration of the delicate, linear intricacies of the bladderwort. Give yourself some time to search for the most interesting and unusual examples available, such as those pictured here. Bear the following definition in mind as you make your selections:

SKELETAL FORM is that which comprises one or more limbs whose linearism is the dominant physical characteristic in one's perception. They may be joined in either an angular and jointed system, or in one which employs a more continuous, bifurcated flow of parts.

Figure 3-18
Robert Nix. Honey Locust Thorn and Shadow.

Figure 3-19
Robert Nix. Mimosa Leaf.

Figure 3-20
Robert Nix. New Briar
Shoots.

Figure 3-21
Robert Nix. Common Thistle.

Figure 3-22
Robert Nix.
Saw Briar
Tendrils.

Figure 3-23
Robert Nix. Clematis.

Figure 3-24
The Bladderwort Plant, *mounted on paper.*
DIVISION OF LIFE SCIENCES, UNIVERSITY OF CONNECTICUT.

Your purpose in making these drawings is to pick out the discernible basic skeleton of each specimen—and to do this by making an X-ray-like diagram which reveals how the limbs or tendrils join together to compose the overall form. You should not be concerned with representing an item's natural appearance, as you might be in making a straightforward sketch. The principal objectives of these first drawings are:

1. *Proportion and rhythm.* To accustom the eye to different kinds of skeletal movement: angular and jointed or curvilinear and flowing. To follow this up by assessing the proportionate factor: the varying lengths of linear travel between sudden changes of direction in a jointed system, and the more gradual directional changes in a bifurcated one. Such assessment fosters awareness of the differing linear and spatial rhythms of skeletal structures.

2. *Morphological types.* To expand your knowledge of basic shapes through analytical involvement with objects of the skeletal family.

3. *Structural principles.* To point out that skeletal systems produce the structural engineering of thrusting and supporting ribs—the skeleton as such, which carries the surface "skin" in both organic and mechanical things.

4. *Time and space.* To show that it is the special ability of skeletal form to decisively cut through space; and, in so doing, to precisely define the spatial context. Also, to demonstrate that such structures suggest varying rates of linear motion between points, and therefore inevitably involve a sense of time.

A. *Skeletal Analysis*

For this exercise, you need a black grease pencil, a broad felt-tip marker with a chisel point, a broad-nibbed drawing pen or number 4 watercolor brush with black ink, and a precise ball liner, depending on the heavy or delicate nature of the example you plan to depict.

Work first with the more angular and jointed specimens you have collected, using whichever drawing instrument you deem appropriate. Visually analyze each object in order to determine its fundamental skeleton and to thus eliminate secondary features and details, for we are less concerned with a naturalistic treatment than with a diagrammatic one—an X-ray approach, if you like. The aim is simply to reveal the linear directions, rhythms, proportions, angles, and curves of the specimen under scrutiny. A glance at Figures 3-25 to 3-28 shows how such diagram-drawings should appear. Varying degrees of angularity are displayed in these four illustrations, together with varying degrees of diagrammatic simplification. All except Figure 3-26 distinguish between principal and secondary skeletal limbs by using heavier and lighter lines—that is, they represent the primary stems or ribs by thicker, and possibly blacker, lines than those used for secondary ones. Also, notice that three of the drawings utilize dots or points to indicate the presence of a definite joint as a new limb moves off in a different direction. When dealing with angular specimens it is useful to use points in this way: They allow you to both visually judge and graphically shape linear proportions and directional changes; they also help ensure that the subtleties of the various angles are appreciated.

The drawings so far, as we have described them, are of positively jointed skeletal systems. Now we move on to deal in a similar way with skeletal objects which are more curvilinear, and whose changes in linear direction result from curvation rather than from jointed terminals. In representing such continuous skeletal flow, there is obviously no need to show directional changes by means of dots; the lines flow rhythmically and freely. Yet you can still use lines of differing weight and tone value to indicate primary and secondary limbs.

Figure 3-25

Figure 3-26

Figure 3-27

Figure 3-29

Figures 3-29 to 3-31 are analytical drawings of curvilinear skeletal objects in which confusing detail has been eliminated. In Figure 3-29 the chosen sample combines both joints and curvations in its overall skeletal structure and movement. The weed represented in Figure 3-30 is similarly hybrid in structure; curvilinear shoots spring angularly from a central stem. The limbs (or lines) in Figure 3-31, however, flow continuously; joints as such do not seem to exist. Consequently the drawing is a good example of a purely curvilinear skeletal figure.

In comparing all of these drawings, it is pretty obvious that each specimen has yielded a different type of skeletal diagram—one indicating the particular growth pattern of each object. Notice how much less "tight" is the movement of non-jointed skeletal forms as seen in Figure 3-31—not merely the linear organization itself, but also the spatial regions, which are altogether less static than those defined by angular systems. Compare Figure 3-31 with 3-26, for example. Even within the range of jointed forms, marked differences of this sort are evident. The almost mechanical regularity and rigidity of Figure 3-25 do not emerge from the freer and more delicate tracings of Figure 3-27.

In fact, skeletal objects can display a range of configurations, from the symmetrical and tight to the irregular and loose. Their very linearization also gives rise to such extreme possibilities in the composition of figure and ground.

Figure 3-31

Figure 3-30

B. Skeletal Form—Free drawing

For this exercise select the most interesting of the objects you have gathered—angular or curvilinear—and study it closely in order to imprint its form firmly on your mind. This is to be a spontaneous sketch. It should be naturalistic enough to capture the "likeness" of the specimen, and to emphasize the particular character of the object's skeletal structure. However, it should not become a painstaking, objective study. Instead, try to work freely, letting hand and eye work together to size up the essential character of skeletal form. The work should be lively in terms of graphic vitality, yet also convincing in the way it renders the specimen's structure. You should find it relatively easy to achieve this effect after "plotting" the first X-ray, diagrammatic drawings, for there is now a good chance that you can gauge linear proportions intuitively as you sketch. After all, your approach is based on knowledge: You are aware of skeletal space division and of essential skeletal figure characteristics.

Figure 3-32 is an example of a "warming up" exercise for this work; it is a series of quick familiarization sketches of spiky and angular twig sections. Figure 3-33 shows the thorn-like specimen complete and put together, after the artist had gained confidence from making the preliminary studies. In contrast, Figures 3-34 and 3-35 show a somewhat more precise approach to depicting the structures of a feather and grass stem respectively. Even so, they are lively and free drawings concerned with imparting structural credibility in terms of the objects themselves.

Finally, I include the drawing you see in Figure 3-36 for but one reason: The artist has used the outline to probe structure. Notice how the outline stops and starts as proportionate lengths are intuitively assessed, and how quick changes of direction follow the underpinning of bone. The outline is an investigative line which, although it does not shape the skeleton as such, is nevertheless aware of its structural underpinning as it draws the human figure.

Figure 3-32

Figure 3-33

Figure 3-34

124

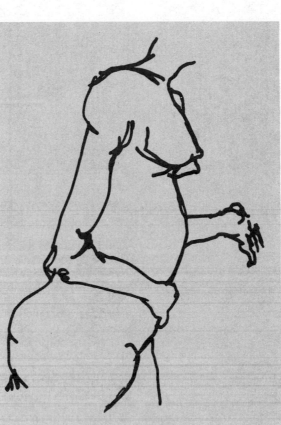

Figure 3-36

Figure 3-35

C. *Skeletal Form—Imaginative composition*

At this juncture let us see if the experience you gained in the last two exercises can assist in the creation of an imaginative skeletal form. Try to visualize a skeletal structure comprising a web-like organization of filaments—the kind of configuration that can result from the wholesale erosion of porous materials such as limestone, or from the intricate linear buildup of twig-like limbs (see Figs. 3-37 and 3-38). Just let yourself go and invent a skeletal fantasy. If it helps to think of an eroded rock, weathered by wind and water, then do so. Perhaps it might be useful to have in mind a multidimensional web—an intertwining structure of tendril-like threads woven by some exotic spider. In any event, this exercise should intrigue you with the possibilities of skeletal design, and give you a chance to graphically exploit some of the "skeletal skills" you have acquired. Figures 3-39 and 3-40 show the response of two students to the challenge.

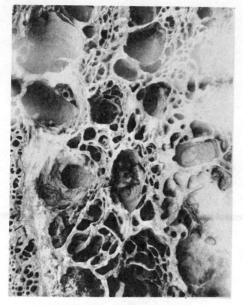

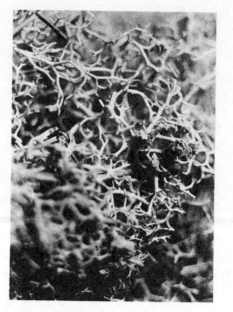

Figure 3-37

Figure 3-38
Robert Nix. Skeletal form of dry moss.

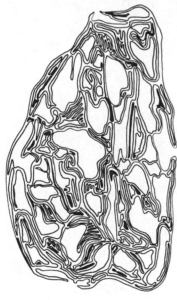

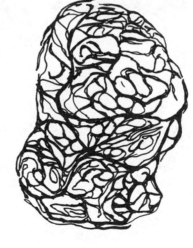

Figure 3-39

Figure 3-40

WE CONCLUDE THIS SECTION with a visual rather than a verbal state-ment. The detail from Victor Pasmore's painting, *The Bird Garden: Winter Morning* (Fig. 3-41), sums up everything I have said about the physical move-ment, the figure-ground definition, and the expressive force of skeletal design. When the artist makes use of line—the graphic equivalent of the physical limb in nature—in the way you see here, then the artistic potential of linearism is fully exploited.

Figure 3-41
Victor Pasmore. The Bird Garden: Winter Morning *1944–46. Oil on canvas.*
COLLECTION: THE HON. COLETTE CLARK. COURTESY OF THE ARTIST.

II
Mass: The Structure of Solid and Spatial Volume

SOLID VOLUME

The second family of objects to concern us differs radically from the skeletal forms we have just discussed. The structural cohesion of skeletal things is relatively easy to determine: we can see where the limbs go, how they join together, and what the shape of their spatial context is. However, objects whose surfaces are expansive rather than attenuated cannot be said to possess limbs. The onion shown in Figure 3-42, for example, has no discernible skeleton and thus belongs to a second family of object types, called the *mass* group. Mass objects are not made up of a series of jointed or bifurcated limbs, and consequently both their structure and the shape of their spatial context are less clearly articulated. It is not easy to perceive the structural principles which determine the shape of the onion, nor to decide how to reveal such characteristics in a drawing. It is much easier to do this with a twig. But let us not forget that all substantial things have mass—even the most slender twig which, although predominantly linear and skeletal in appearance, will reveal mass if its cross section is cut through and exposed. However, the reverse is not true: Objects of mass do not automatically have skeletons. What, then, is the point

127

Figure 3-42
Robert Nix. Onion.

of dividing objects into two families if fundamentally they all possess mass? The reason is that we want to emphasize the dominant physical characteristic. As I have said before, if you hold a hair in the palm of your hand, you will not find yourself concerned with the surface spread of its mass. No: Your dominant perception is of its length and directional linear movement. Thus the division of objects into two morphological families is based on our perceptions of the particular physiques possessed by the objects we observe—whether linear and skeletal or massive and voluminous.

The basic characteristics of non-skeletal objects are their mass and space displacement, which we perceive through the expansion of their plane and curved surfaces. In fact, it is the movement and spread of their larger surface areas which first intrude on our perception. If you look at the massive expanse of surface presented in Figure 3-43, you will realize that your sense of greater or lesser mass is dependent upon the relative expanse of surface area presented, and on the degree of continuity of surface flow. These characteristics are the antithesis of skeletal ones; therefore, in order to render mass it is necessary to find a way to structure *surface spread* rather than to simply line in contour or edge. In this section, then, we set out to find a way to draw such surfaces and thereby to find a graphic means of also shaping and structuring mass and volume. Most artists dislike systems and methods which suggest "how to do it" and in discussing the following suggestions this is not what we are trying to do. Instead, we want to introduce a graphic system which will help sharpen your *perception* of this family of objects, and thus expose you to the possibilities they present for imaginative exploitation.

The graphic system for drawing or structuring mass which we are to follow arises, naturally enough, from perception of such objects—perception which results because our eyes primarily "read" surface rather than edge. In so doing they are assisted in comprehending three-dimensional amplitude in two ways. The first way is by any linear relief or indentation formed by grooves or channels which follow surface flow, such as you see in Figure 3-43. These linear formations move over the object delineating the curves and planes of the mass. As they run around and under the form, suggesting the presence of the other side, they increase our appreciation of the three-dimensional solidarity of the object. (Note how the linear markings of the onion skin

Figure 3-43
Henry Moore. Two-piece Reclining Figure No. 2. *1960. Bronze.*
COURTESY OF THE ARTIST.

in Figure 3-42 work in this way.) The second way is by the variable tone values of light and shadow that move over and around the object and aid perception of mass in the same way. The highlights and shadows that course over the fragment of melted glass in Figure 3-44 provide an excellent example of this. Here no lines help the eye—only the movement of light and dark tell of advancing and receding planes and curves, and thus bespeak the mass of the piece.

Figure 3-44
Robert Nix. Fragment of melted glass.

129

Figure 3-45
Henry Moore. Four Gray Sleepers. 1942. Ink drawing. Collection: War Artist's Committee, London.
COURTESY OF THE ARTIST.

It is eminently feasible for you to make similar use of line and light to dark tones when drawing an object of mass. A line that continuously traces the angular or curvilinear expansiveness of surface, that seemingly comes into view from one side and disappears out of sight to the other can shape mass. We call such a line *the continuous surface directional line*. Light and shade—light to reflect from the nearer parts, and shadow to indicate the underneath, otherside, or more distant parts—also shape mass. We call such a graphic combination of tonal values *continuous surface directional tone*.

You may use these two techniques separately or together. Henry Moore makes use of both the surface directional line and surface directional tone in *Four Gray Sleepers* (Fig. 3-45): What a heightened suggestion of bulk and weight these figures take on as a result! These lines move almost without any break over and around the surfaces, constantly describing the mass. Where they are closeknit they form dark tones of shadow which help to recede the surface into three-dimensional space. In contrast, the light gleams on the forward-thrusting surfaces. The technique used by Moore in Figure 3-45 aids the perception of mass in the same way as does the visual assistance given by the lines and grooves of the sculpture, and by the highlights and shadows playing on the melted glass. For an example of how surface light and shade alone reveal the solidity of form, look at Rodin's watercolor drawing *The Peach* (Fig. 1-53). No surface directional lines are used to mar the smooth and firm volumes of this

figure. Although the values of Rodin's light and shade are not as extreme as those we see in the highly reflective surfaces of the glass fragment (Fig. 3-44), his more opaque and less contrasting wash tones follow the surface direction of the figure's swell and work in the same way to enhance our sense of mass.

As I have said, these graphic practices are closely tied in to our visual experiences of objects possessing positive mass. As the eyes follow the visual clues of linear markings tracing the run of surface, together with highlights and shadows which follow suit, we imagine the path of these clues even when they have passed out of sight. There are also occasions when the tips of our fingers can become sympathetically involved, seeming to actually "feel" the three-dimensional spread of surface, even though we are merely intensively looking, not feeling. The tactile sense is very strongly linked to the visual when mass is thus emphasized.

In fact, an important aspect of "drawing in the round" in the two ways I have described is that it helps artists to respond tactilely to the solidity of mass, enabling them to mentally "feel" weight and volume and so impart a greater phenomenological credibility to their drawing.

SPATIAL VOLUME

Up to this point we have been describing mass in terms of the expansive spread of material surfaces, and the solidity and weight which necessarily accompany such amplitude. The term "volume" is generally used to denote these characteristics of mass.

However, volume may also refer in a general sense to regions of space: to the multidimensional vastness of it. Bearing this in mind, we are also going to use the word with reference to space, but much more specifically. In employing the expression "spatial volume" my intention is to identify those particular regions of space which *may be present in an object of mass*—space which is positively shaped by surrounding surfaces and so becomes an interior volume, a hole if you like. Therefore, from now on, we must be careful to make the appropriate distinctions and talk about either solid volume or spatial volume.

For example, we perceive the pebble shown in Figure 3-46 as an object of mass pierced by three holes. In studying the holes we tend to automatically gauge their volumetric capacity—the shape and quantity of air mass contained.

Figure 3-46
John Albaugh. Pebble with Holes.

The presence of such spatial volumes, though they exist as a perceptual reality in their own right, also allows us to see into and through the solid volume of the material object, and thus gives us direct visual information about the extent and solidarity of its mass. Space volumes that are integrally part of an object or figure may function perceptually in a complementary way, articulating the solid material to show off the extent and nature of its massive nature. At the same time they can work aesthetically as "space shapes" on their own account.

The question then is: How can we graphically structure spatial volume? And the answer: by using the *continuous surface directional line* and *continuous surface directional tone*—the same two methods we employed to describe solid volume.

Look at Henry Moore's ideas for sculpture, *Reclining Figures* (Fig. 3-47), and observe that he structures both hole and solid, space volume and solid volume, together in the same object. To achieve this Moore uses both surface line and surface tone values to shape the concave and convex aspects of mass *and* the space volumes which form the cavities or holes. It is obvious from these drawings that without the contrast between highlight and deep shadow, and the continuous surface line which works its way around the cavity walls, neither hole nor solid would be so well realized. Certainly the continuous surface line alone can construct recessions and projections, but the addition of light and shade is an important aid to perception.

Now look at Andreas Feininger's photograph of a much-weathered tree form (Fig. 3-48), and observe how the hole is structured by the strands of wood which, acting almost graphically like a continuous surface directional line, delineate the cavity walls. Also notice how the play of light—bright on the projecting edges and darkening as the hole's depth increases—also reinforces the perception of the space. A graphic representation of this object would follow, line for line and tone for tone, what the eye sees in the photograph.

If you compare this photograph with Henry Moore's drawings of *Reclining Figures*, you will note that the sculptor is employing a graphic technique which keeps faith with normal perceptual experience. The continuous surface directional line graphically traces out the walls of the sculptural cavities, and thus structures their internal dimensions, while light and shade work to suggest frontality and recession: the lighter the hole the shallower it is, the darker it becomes the deeper it seems to go. In solid volumes light and dark tones work in the same way: Brightness suggests forward-projecting parts of an object or figure, darkness, the parts more distant from the source of light. Notice in *Reclining Figures* how this general rule is exploited. When the artist wants a hole to go right through to the other side—as in the lower figure—then we see "light at the end of the tunnel," so to speak. Yet the chest cavity of the figure is a hole where darkness rather than light is finally encountered, thereby imparting—at first glance anyway—a greater depth to the space.

I drew your attention, in Chapter 2, to the psychological factor operating in perception, to the difficulty of postulating cut-and-dried rules to explain visual awareness. So much depends on the context of each encounter and on past visual experience. But generally speaking, when perceiving objects or figures, we associate dark values with the distant or underneath sides that are away from the light; this helps us to recognize both three-dimensional solidity and the depth of space. Also, and almost as a bonus, dark tones help to impart a dramatic emphasis to an image, because we link darkness with the unknown; while weightiness itself has expressive significance. Conversely, we associate strong highlights with nearness, because the convex rather than the concave

Figure 3-47
Henry Moore. Reclining Figures 1942. Chalk, pen, and wash.
COURTESY OF THE ARTIST.

Figure 3-48
Andreas Feininger. Tree Form.
From "Forms of Nature and Life" by Andreas Feininger.
THE VIKING PRESS, NEW YORK.

surface is brightly illuminated, and therefore assumed to be physically close. (Yet, we must also remember that in purely graphic situations, when we are concerned with frontality or recession, it is the factor of *contrast* between light and dark which plays the important role. Then, a strong light *or a strong shadow* will come forward if it is sufficiently saturated in tone and thus appears intense in contrast to the general tonal context.)

Look again at the solid object in Figure 3-47; it is not easy to assess the depth of the middle hole in this stone. Reason tells us that it is probably not a deep as the bottom hole, which we can see goes right through. Yet, as we have already said, darkness suggests the presence of regions where light cannot reach—places which must, therefore, be "in," "under," or "behind."

To summarize, then, the graphic ways by which the structure of space volume (as well as solid volume) can be convincingly effected are:

1. *The continuous surface directional line*, a relatively simple process of closely tracing the external planes and curved surfaces of mass, on the one hand, and of its internal space volumes, on the other.
2. *Continuous surface directional tone*, a more complex and ambiguous process which employs light and shadow to shape the external form of mass in terms of near and distant parts, and to create the deep or shallow cavities which comprise its spatial volumes.

3-II. Shaping Solid and Spatial Volumes

Lines that are continuously exploring either solid or spatial volumes demand free, unforced movement. The whole arm, rather than just the wrist or fingers, must move, and a rhythm should be built up while drawing. Your first drawings may look a little disheveled as you try to achieve this *continuous movement of a free-flowing line,* but do not worry about this. Ultimately you will find yourself drawing more tightly without any loss of rhythm and linear continuity.

A. *Free drawing of elliptical volumes*

This is essentially a familiarization exercise intended to get your arm moving in a continuous rhythm of drawing. Elliptical volumes invite a continual drawing motion—a line moving around and around without pause—unlike angular forms, which demand sudden changes in direction and rhythm.

Using a fine ball-point or felt-tip pen, start anywhere on the page and put together a series of balloon-like volumes. Just let your arm move freely and naturally to delineate these ellipses, using a circular motion which, in the mind's eye, describes a solid volume by going all around the form. Allow one ellipse to flow into another to produce the kind of composite design you see in Figure 3-49—not in any calculated fashion, but by allowing the rhythm of movement to follow through of its own volition and to thus establish new oval volumes—without pause and without removing the pen from the paper.

The important lesson to learn from this short exercise—which a study of Figure 3-49 will confirm—is that instead of merely producing the outline of an ellipse, your line has been shaping the curving expanse of its mass. Instead of just lining in the apparent *edge* of a solid oval form, which is a common kind of graphic delineation, your continually moving surface directional line has been grasping the spread of mass from the center, and has thus been imparting a sense of weight, overcoming the flatness inherent in drawings concerned simply with outlines.

Figure 3-49
Betty Peebles. Drawing: Oval Volumes.

Figure 3-50

B. *Objective drawing of solid volumes*

Now you are going to work with the solid volume of a natural object, employing the technique just practiced. Find a small rock or stone which has a positive mass—that is, a well-developed three dimensionality in terms of projecting and receding surfaces, curved or angular. Use any of the drawing instruments previously recommended, but remember, do *not* start with an outline. Instead, study the spread of the object's surface at its approximate center, and put down a series of directional lines which faithfully represent the flow. Continue by working left and right with as continuous a run of line as possible, bearing in mind that your rhythm will not be as regular as when you were making the first drawing of ellipses, because you will be closely following the changing surface characteristics of your model as you work out from the center. This is the most difficult part of the work: relating the movement of one surface to that which is alongside, so that any angular or curvilinear transition is convincingly realized by your line, which is "feeling out" the various faces of the rock.

At this point you should have a drawing that looks something like those in Figure 3-50, or, if your specimen possessed a more square and angular form, like that in Figure 3-51. (Note that the gray wash applied to the ground in Fig. 3-50 is not intended primarily as a means of imparting light and shade to the drawing, but as a ground "coloration" attractive in itself to work over. The dark and light values, where they occur, are accidental.)

When you study these drawings, the important thing to realize is that the contour or edge of the shapes have come into being by virtue of the directional surface lines' running together as they begin to disappear around the other side of the stone. As a result, the edge of the drawing is not presented as a rigid line that flattens the form on the paper, but simply as the place where the solid surface simply disappears from view. The mass nature of the object is thus more credibly represented.

C. *Supplementing line with the continuous directional surface tone*

We have seen how lines, closely following the contours of surface, convey the solid nature of an object. But in order to realize the full sense of mass, line drawings must be supplemented by the addition of highlight and shadow.

Place your stone in such a position that light falls directly onto it from one side, and then observe closely how the pattern of light and shade is distributed. Using pen or pencil, "feel out" the various movements of surface by means of the directional line, just as you did in exercise B. When this is done then introduce differing tone values. Where the highlights are strongest, leave the white paper to represent these values; then work through the intermediate range of gray tones before you finally build up the darker blacks.

Figure 3-51

You can do this by filling in between the existing lines with others moving in the same direction, until ultimately the tone value of the area reaches the desired degree of grayness or blackness—the fewer lines, the less dark the shadow; the more lines, the darker it becomes. In this way you can work from the white of the paper to the deep black of an area containing a multitude of lines.

Figure 3-52 shows a pen working over a form in this way: The lines both shape the volumetric spread of the mass and create areas of light and shade according to their density on the paper. If you are working with a pencil, you can achieve similar results. In Figure 3-53 the spines of this particular wood piece are shaped and lit, as are the convex and concave surfaces and the deeper holes.

It is, of course, possible to use a brush and dark or light washes of ink or paint to achieve similar degrees of shading. In fact, you can create such effects if you apply the tones over existing surface directional lines, as you see in Figure 3-54.

In addition, if you wish to dispense with lines as such, and to rely entirely on the values created by brush and wash, this is also quite admissible—even though the added three dimensionality offered by the continuous surface line may be missed. In Figure 3-55 you see the result of some very fine brushwork. Working with a dry brush and an equally dry scumble of black tempera watercolor, the artist has modeled the rock's mass most effectively, even to the extent of revealing the slight ridging of the lower surfaces. Notice also how the white paper has been used to provide the highlights where necessary.

Figure 3-53

Figure 3-54

Figure 3-52
Betty Peebles. Mass Forms.

Figure 3-55

D. *Practicing holes and projections*

The intention here is to produce a single sheet of random sketches, each one the result of experimenting with the continuous surface directional line and the appropriate tonal values. The aim is to cause solid projections to rise from the paper, and holes to sink deeply into it. Look at Figure 3-56 to see what I have in mind. Pen, pencil, and charcoal have been used to draw both revolving lines *and* revolving tones; the strongest highlights result from leaving the paper (or ground) untouched. Notice how the forms of both solid projections and spatial holes are made by graphically tracing the relevant surfaces—walls coming out for the one; walls going in for the other. Both projections and holes appear to be "threaded" as solid and spatial volumes are defined.

Figure 3-56

Try to develop these linear and tonal characteristics as you experiment freely and quite randomly on the page. Discover for yourself where to leave highlights and where to impose shadow in order to intensify the illusion of projection and recession. Practice of this sort will reinforce our thesis that a graphic structure can be applied to the representation of mass, and that it can be effective in forming solid volumes and, when necessary, the spatial ones which may also be present.

E. *Transforming the flat to solid and spatial volumes*

One of the most satisfying aspects of drawing is seeing the form of a work grow and develop under one's own hands—a process that involves the "fleshing out" of one's initial graphic marks until the image stands fully modeled to one's personal aesthetic specifications. This is precisely what we are about to do in this exercise.

First you must establish a flat, two-dimensional design. The best way to accomplish this may be by allowing your pen or pencil to wander, in a doodling kind of way, and to thus create five or six free-form shapes which are complete in themselves—that is, the lines join up with themselves to leave no loose or open ends in the shape delineated. Let this be an *expansive* doodle: one which defines broad and clearly discernible areas, rather than tight and cramped ones. Imagine that you are drawing non-objectively in order to discover ideas for sculpture—combinations of surfaces and spaces which would lend themselves to development "in the round." This will help to keep your drawing from becoming cramped or overly fussy and detailed.

Figure 3-57 shows some excellent examples of this kind of free, exploratory drawing. Also notice how the initial, linear models are transformed from two-dimensional flatness, into three-dimensional mass. Following the example of the artist, Betty Peebles, select two of your original images for development, and then proceed to round out their various parts, deciding how massive they should become and in what directions these new, expanding areas should flow. At the same time, you should be looking out for holes—for those parts that invite penetration as opposed to those that obviously should extrude as solid volume. Notice in Figure 3-57 how the artist has made use of surface directional lines and tones to model the spread of the solid and new sculptural form; how light and shadow take the eye over and under the spread of area to impart a sense of bulk; and how the holes or spatial volumes take on depth and penetrate the piece.

Figure 3-57
Betty Peebles. Graphic Development of Volumes—Mass and Space. *1972.*

As you work over and into your initial and relatively insubstantial shapes, your eye should begin to discern the transformative possibilities. More important, perhaps, you now have a genuine opportunity to make a few mental leaps and envisage new and original three-dimensional structures. You must build imaginatively from even the sparest of visual hints. There is a real challenge here to "go to town" in employing the graphic techniques we have been describing: to experiment enthusiastically and test out the ability of directional surface lines and tones to transform the flat into the solid.

F. *Structuring solid and spatial volumes—The natural object*

Finally, let us use these graphic systems freely and confidently to make a really grand drawing—one in which the sense of mass is intensified by the rendering of expansion and surface flow, and by the structuring of holes which penetrate to reveal the extent and depth of solid material present.

First look around to find an unusual and interesting object. Driftwood, gnarled and twisted roots, strangely weathered parts of dead trees, bone formations, shells—these are the kinds of things that will test your drawing ingenuity. Give yourself a day or two to search. It is unlikely that you will find an attractive shape in 5 minutes—something as challenging as the seabird's skull in Figure 3-58 or the rotted-out section of tree trunk in Figure 3-59.

When you have your model, decide which drawing instrument and medium—or which combination of instruments and media—will serve best to bring out the volumetric character of your piece. By now you must certainly have developed preferences, and so will be able to select the most suitable tools for the job at hand.

Enjoy this drawing. Bring to bear all the knowledge you have gained about the graphic structuring of mass: about the use of line and tone to follow the "ups and downs, ins and outs" of surface movement. Let the line flow, the highlights gleam, and the holes and recessions become dark and resonant cavities. Take inspiration from the drawing in Figure 3-60 of a very interesting bit of wood. Most of the work was done with a ¼", flat, one-stroke, sable brush applying Indian ink that had been allowed to become very dry and so produced the series of broken lines which, as you see, are very effective in delineating surface configuration. Solid black shadows contrast with ridged highlights. A ballpoint liner and a black felt-tip pen were used to pull things together—to emphasize and clarify the more complex parts of the form.

Figure 3-58

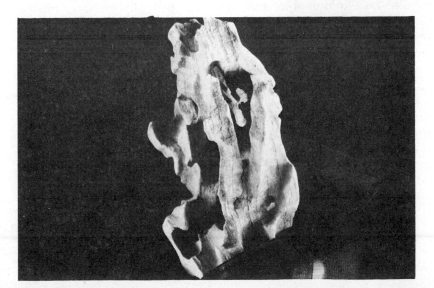

Figure 3-59
John Albaugh. Weathered Wood.

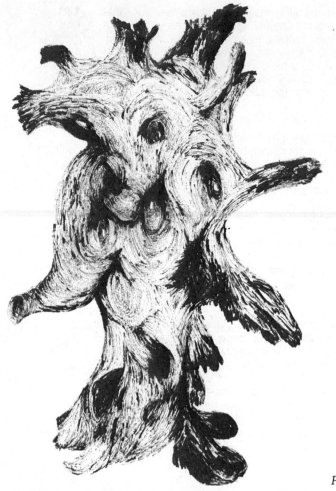

Figure 3-60

T O CONCLUDE THIS SECTION, it is worth reiterating that in discussing the physical nature of skeletal and mass objects, we have stressed the importance of first visually analyzing their structural natures, and of then discovering the best graphic means of imparting commensurate structural credibility in drawing them. To draw in this way helps to ensure that both figure as motif and ground as a plastic element in its own right, assume a cohesiveness and a certain visual authenticity.

Eugène Delacroix, one of the great French masters of nineteenth-century art, wrote in his *Journal*, "*. . . ne pas prendre par la ligne, mais par le milieu,*" which may be freely translated as, "take hold of objects by their center, not by the lines of their apparent edges." The obvious implication is to treat objects as masses. There are undoubtedly two ways of drawing visible things—by using outlines to define them precisely, or by treating the planes and curved surfaces of their masses. We have previously suggested that skeletal forms, not having any dominant mass, may be treated linearly, in an "edge" fashion. But in this chapter we have taken the view of Delacroix, using a multiplicity of surface directional lines and tones to shape mass and volume. We have discussed how objects which are uniformly outlined on the paper tend to lie flat on the ground and do not reveal their volume. The dominant idea behind Delacroix's drawing is to use lines to express masses, not edges: to take the fundamental volumes and planes of an object first, when making a drawing, and to come to the contour edge last. In so doing, he was also concerned with a gradation of

lines in terms of weight and quality, in order to bring some masses forward and cause others to be less distinct. And this, after all, is how we perceive solid objects.

Consider Figure 3-61, a brilliant example of "taking hold of objects by their centers," as Delacroix put it. This is one of a series of drawings of a single elephant skull made by Henry Moore, and results from a rapid "feeling out" of elephant skull landscape. The freedom of the drawing is all the more remarkable if you imagine the artist drawing directly onto a copper plate with an etching needle, for the image you see here is a dry-point etching, an intaglio print from the plate. Notice how—automatically it seems—the flurry of lines lay out the principal planes and curved surfaces, indicating their directional flow and the fit of one part to another. Moore draws to delineate the surface of mass, attracted by the plasticity of volumes—massive or spatial—captures the sense of weight and solidarity of such a skull, and renders it by means of a graphic technique with which we are now familiar.

In contrast to Moore's exploratory and energetic lines, those in Norman McLaren's drawing (Fig. 3-62) are deliberate and calculating, and they leave no visual doubt as to how the surface moves. Notice that there is no need here to draw an edge as such: The surface directional lines end with such clarity and precision that the eye follows them down and makes its own edge to the shape. We see in Chapter 5 how continuous surface directional lines, used with ultraprecision, can create strange optical illusions because they impart such a heightened rate of flow to surface movement.

Figure 3-61
Henry Moore. Elephant Skull *1968. Drypoint etching.*
COURTESY OF THE ARTIST.

Figure 3-62
Norman McClaren. Stress 1971. Silkscreen.

Composite Organization: The Organic Union of Parts

Every object we can think of is basically a composite form, deriving its shape from the union of several parts. Even a stone which we can see and handle as something very much "in one piece" is composed, albeit invisibly, of atomic particles. And although the common orange handles like a stone and visually appears to be monomorphic, the parts that comprise it are revealed once we open it up and see the organization of the internal segments.

In this section we focus attention on those objects which can be clearly seen, from an external viewpoint, to be *not* one-piece forms like an orange, but made up of several units or parts. Such composite figures tend to be in the majority, whether we are regarding plants, animals, insects, or furniture; it is obvious that their physical natures are determined by the shapes and proportions of their parts and by the ways in which they join together.

Observe the plant photographed in Figure 3-63; notice the pattern of leaf units, and how they radiate from a tight grouping at the center to a more open and expansive flow at the outer extremities. If you follow up on this initial visual discovery, you will see that these concentric bands of leaves are arranged in a certain way: The point of one leaf is always positioned dead center of the two leaves juxtaposed in the bands behind or in front. This rotational 2-to-1 symmetry is particularly satisfying visually, because it imparts a regular yet *variable* rhythm to the design that would be lacking were the leaves positioned uniformly in a 1-to-1 system. Thus, total uniformity is avoided and a harmonious vitality gained. This kind of balance appeals strongly to our sense of order and reason: While appraising the whole we remain very much aware of the shape of each part.

Figure 3-63
Robert Nix. Hen and Chickens Plant.

Figure 3-64
Leonardo da Vinci. Star of Bethlehem and Other
Flowers, *1505–1508. Pen and ink with red chalk.*

Nature provides an unlimited variety of shapes ranging from the near symmetrical to the asymmetrical. Part of the appeal of nature's composite structures is that they engage the eye in this same way: at both macro and micro levels, challenging us to study the structural relationships between the parts, to judge the effect of symmetrical or asymmetrical organization or curvilinear or angular movement, and generally to come to terms with the diversity yet unity of their overall shapes. Many artists have studied and drawn botanical specimens. Leonardo probably heads the list of such artists, which also includes Jan van Eyck, Albrecht Dürer, Peter Paul Rubens, Rembrandt van Rijn, Antoine Watteau, Paul Klee, and Piet Mondrian, among others. Figure 3-64 shows the care that Leonardo takes to distinguish the flowing movement and scale of each individual leaf unit, and how his drawing represents more than a general visual impression of the plant. By analyzing the form of each part and by grasping how the parts are collectively structured to create the radial swirl of the complete object, Leonardo produces a drawing which is organically credible.

The word "organic" has many connotations, notably those involving biological and chemical phenomena. But it is used in our context to mean a particular physical quality: namely, the coherent union of parts invariably found in natural objects, but not always in those that are man-made. Most artists would agree that the creative mind is attracted to things organic. In fact many amass large collections of "found objects" which they constantly use as

sources of inspiration. Why is this? There is a "rightness" inherent in the structure of natural things. That is, whether the shapes are regular or irregular in their configurations, an overall physical homogenity manages to persist. They may be unbalanced, asymmetrical, and bizarre—altogether "unbeautiful" in a conventional sense—yet they still appear to be entire and whole in the rhythms, proportions, and directional movements of their various parts. There is a "fitness for purpose" about them which imparts a visual credibility to the form. These organic qualities, in other words, represent a design standard we seem to recognize intuitively as visually satisfying and functionally genuine. If a particular example is "classically" pleasing—that is, if it kindles our appreciation of an ordered and logical arrangement of parts in the way that the radial symmetry of the plant in Figure 3-63 does, this is but one aspect of organic credibility, albeit one which gets high marks because such order and intelligibility appeals to reason.

On the other hand, we are surrounded by natural objects whose composite structures are anything but symmetrical and logical, and which possess a disproportionate and erratic grouping of parts that is the antithesis of classical balance and systematic juxtaposition. The thistle you see in Figure 3-65 is such an object. Although just as organic (in the sense of the just-proposed definition) as the more regularly ordered plant in Figure 3-63, it attracts for quite different reasons. Its very irregularity, erratic movements, and proportions give it a restless and vital plasticity, a physical unpredictability which renders it exciting and mysterious. To use another descriptive label, we might call it "romantically"—as opposed to classically—pleasing.

Figure 3-65
Robert Nix. Common Thistle, *Detail.*

Figure 3-66
Samuel Colman. Analytical Plan and
Elevation of the Milkweed.
From "Nature's Harmonic Unity," by
Samuel Colman (1832–1920).
G. P. PUTNAM'S SONS, NEW YORK AND LONDON.

Note that an artist's interest in one of these two basic types of composite structure found in nature does not preclude an attraction to the other. Both regular and irregular organic structures appeal in their own right. However, a seeming paradox does exist: Creative minds often show a built-in tendency to "tidy up" nature—to simplify and reduce organic vitality in all natural objects so that they conform to the intellectual theories of mathematics and geometry. It is as if this endows them with a purity and consistency which nature itself lacks. Such an idea—or ideal—seems to be part of a general artistic impulse. For example, South American Indians strive for geometrical precision in painting designs on their ritual drums, apparently in the belief that the purer the design, the stronger the magic. Consequently I think we must accept the fact that art frequently tries to organize nature. Writing about art in Classical Greece, Aristotle remarked that, "the purpose of art is to realize nature's unrealized ends." Such a statement expresses the essence of Greek aestheticism.

Look for a moment at Figure 3-66, in which the common milkweed is rendered in both plan and elevation, and notice how mathematically exact the plant's configuration becomes in such a diagrammatic treatment. Such geometrical exactness tightens up the looser plasticity of the plant in life, irons out the subtle irregularities of even nature's most regular creations.

We can, then, expect a wide range of artistic response to the stimulus provided by nature's variety of composite shapes. And the problems of designing—of organizing the layout of the several parts which make up the total work of art—reflect the diversity of choice: Following nature, the artist might favor the more symmetrical and regular type of structural organization found in Figure 3-63; or the artist might prefer the irregular, unsystematized, yet more vigorous and dramatic physique of the common thistle in Figure 3-65. Here lies the central issue for the artist-designer: What sort of composite "personality" does he or she envisage for the piece he or she is making? It all de-

Figure 3-67
John Hildred. Table Study Lamp. *Photo.*
COURTESY THE DESIGN COUNCIL, LONDON.

Figure 3-68
Unknown designer. Lamp in
Glass and Bronze, *ca. 1900.*
Photo courtesy R. B. Fleming
& Co., London. From
"The Flowering of Art Nouveau."
by Maurice Rheims.
HARRY N. ABRAMS, NEW YORK.

pends on the homogeneous or heterogeneous nature of the parts, on whether they lend themselves to a regular or freer type of grouping, and on his or her personal preferences and taste at the time.

The two lamps shown in Figures 3-67 and 3-68 illustrate this point. Although lamps require similar parts—base, stem, holder, and shade—such parts can vary greatly in shape and proportion; and they may be combined in different ways to form two quite dissimilar objects. One is classical, if you like—symmetrical, carefully proportionate, and logically integral part to part—whereas the other is romantic in its overall asymmetry, its curvilinear freedom, and the almost accidental—as opposed to planned—union of parts. You should have no difficulty in identifying the more organic of these two examples. If you do, then apply the acid test and ask yourself: If it were possible to plant a "lamp seed," which of these two examples is the more likely to have germinated from it? And the question that then follows is: Given my ideas about lamps and their function, which of these two composite structures do I like the most? Ultimately, you would probably touch on fundamental issues in such designing—namely, does the structure of the piece work to aid function; and does it visually satisfy as "lamp form"?

Both these lamps represent the visual consciousness of their period: that shown in Figure 3-68 was made at the turn of this century (about 1900) and

belongs to the style known as Art Nouveau, a very organic style as you can see; the other lamp came out of the 1950s and exemplifies what we think of as a more "modern" approach, a technical, machine-age style which turns away inevitably from the extremes of organicism to the logic of geometry.

The principal reason for drawing your attention to composite structures in nature is to introduce the important aspect of artistic awareness called *organic sensibility*. That such sensibility recognizes a wide range of organic possibility from the most unruly to the rhythmically regular is a measure of its importance and relevance. One thing which irks many a good artist, poet, or composer is compositional dullness or sameness: a perfectly static, mechanical arrangement of parts. But as soon as the sort of radial variability you see in Figure 3-63 is introduced—each second row of leaves ringing a positional change—then even the more apparently geometric objects in nature are relieved from absolute regularity and its consequent "woodenness." Organic sensibility in the life of an artist represents both an aesthetic need for, and a response to, the kind of rhythmic and subtle transition from part to part that allows the natural object to attain a vital plasticity; and ensures that the object is seen as an entity, rather than as a grouping of structurally disassociated parts.

Keeping this definition in mind, we are then justified in talking about the organic quality of a painting when the relationships between colors and between shape and scale of parts of figure and ground—and the "rightness" of their juxtaposition—suggest a natural (non-mechanical) growing together. Such a quality may also be found in the design of machines, articles of furniture, and buildings; in the composition of photographs, interior design projects, and so on. And when it is present, the work seems to possess a vital physical life of its own, almost as if it has qualified to become a work of art. Figure 3-69 satisfies these criteria. Linda Lee Shimmin's drawing *Mountain*

Figure 3-69
Linda Lee Shimmin. Mountain Forms *1981.*
"Graphite, pen, and ink.

Forms shows a most skillful combining of skeletal, mass, and space-volume physical characteristics—not easy qualities to unite convincingly in one image. Yet the structural union of the parts in this work is completely credible. Why? Because the fusion, the flow, and the organization of space and tone values produce a composite figure-ground design which is "all in one piece"—which, given the content of the work, is *organically* thoroughly convincing and satisfying.

The Workbook exercises which follow have, therefore, one main purpose: to ensure that, through the selection of a few composite objects which you subject to both visual and graphic analysis, you glean a thorough appreciation of organic quality—across the board, from the ordered to the disordered.

WORKBOOK

3-III. Structural Integration

This Workbook segment demands that you look for and select a few easy-to-handle, natural objects—specimens composed of several units or parts. You may search in gardens, parks, flower shops, tree-lined streets, or country lanes for everyday things: the complex seed heads of dandelions or thistles, fir cones, wild or cultivated flowers both before and after turning to seed, even the linear, composite skeletons of small fish and animals. For example, a single flower composed of several petals, pistils, and stamen enables you to see well enough how the parts combine to form the organic whole. Figures 3-70 and 3-71 (in addition to 3-63 and 3-65) are photographs which show the range and variety of such complex, yet everyday, natural structures. Find something which, as a shape, genuinely intrigues you: Then your drawings are likely to be more convincing. Analyze whether you tend to favor symmetrical or asymmetrical combinations.

Figure 3-70
Robert Nix. Queen Anne's Lace.

Figure 3-71

A. *Visual and graphic analysis of part formation*

Examine the first specimen before you closely in order to recognize those parts which constitute its overall form. After this visual examination, start dissecting one part from another in a surgical manner, using a sharp razor blade when necessary. Your aim is to make *one* sheet of drawings—using pencil, felt-tip pen, ball-point liner, or sharpened twig and ink—which records the results of the dissection. How much you should draw and how much you should just observe are decisions for you to make as you work. You should proceed freely to draw the parts that most interest you and that are obviously essential to the general configuration of the object. However, when you reach a point in the study at which the original object stands "naked and revealed"—when sufficient bits and pieces have been removed to expose previously hidden structural details—then make a drawing of the composite object as you now see it. Figure 3-72 shows the salsify seed head analyzed in this way; Figure 3-73 treats the breakdown of Queen Anne's Lace in drawings *a, b,* and *c.* Both of these figures illustrate the kind of graphic search for structural information you are to endeavor here. Ideally, your page of drawings should turn out like Figure 3-74, in which Leonardo was working at the same task.

Figure 3-72 Figure 3-73

Figure 3-74
Leonardo da Vinci. Viola Odorato: Spikelet of Graminacea. *Pen, ink, and brush.*
GALLERIE DELL'ACCADEMIA, VENICE.

B. *Dissection and organic reconstitution*

To work this sheet of drawings effectively, make the project very specific. Obtain a flower—not a simple daisy-like plant—but one with somewhat more detailed and complicated parts, like an iris, rose, geranium, or lily. Now perform exactly the same process as in the previous exercise: Separate the flower into pieces and draw each important part. But now go further. Reassemble the parts *to form a completely new plant,* to make what botanists would call a mutation or variant. Obviously this will mean that you must put together the various elements of the petals, stamens, pistil, stem, and leaves (if any) in a different way than that of nature in the original. Put your imagination to work. The test is not to see how fantastically imaginative you can be, but to see how imaginative you can be *commensurate with organic credibility.* That is: How believable is your newly constructed flower in terms of the living and rhythmic integration of part to part—the flow and transition between the units which seems to result from biological growth, as opposed to a contrived and mechanical "nailing together" of the parts?

After reading the preamble to these Workbook instructions and gaining some understanding of "the organic" with your first dissection drawings, you should create a mutation that is convincing as a true biologic fact. Figure 3-75 shows a page of such drawings. A wild poppy, drawn in at the top, right-hand corner at *a,* was the chosen flower. The sketches at *b, c,* and *d* reveal stages in the separation of the petals to disclose the pistil at center. The drawing at *e* represents the first stage of the reconstitution: The petals are assembled horizontally rather than vertically, and assume an open rather than closed position. At *f* the new trumpet shape of the plant, standing horizontally off a hairy stem, is in marked contrast to the clustered verticality of the original poppy. Does the mutation work organically? Yes, almost. But there is a weak spot in the design: The attachment of stalk to trumpet does not convince. There is no natural growing together at this point and the flower seems to be merely tacked onto its stalk. However, try the project yourself, and decide how you would describe the structural principles which determine the nature of organic, as opposed to mechanical, objects.

C. *Application of organic principles*

Now you are going to try to create a new organic form without going through the laborious process of physically dissecting a specimen. Instead, you will assemble a new composite form by *mentally* appraising the unit characteristics of the model, and by applying the visual knowledge you gain directly to the design of an invented object—in this case, a drawing for sculpture.

Choose a plant, vegetable, or other natural object made up of several parts whose form seems particularly sculptural—that is, suitable for three-dimensional exploitation as a work of art. Set up the object where you can study it from several positions and begin to get a "feel" of its sculptural possibilities. Determine, in your mind's eye, the character-

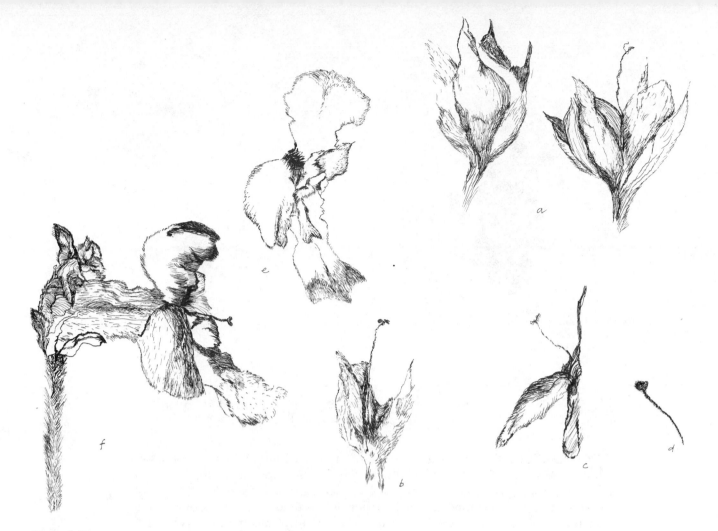

Figure 3-75

istic parts you will use in the drawing to form the new sculptural piece. Then, as you start to draw, realize that you are free to modify the shapes of the parts to suit your imagination as the design begins to evolve. The way in which you assemble the parts on the page must also result from your intuitions as to how you want the piece to ultimately appear in three dimensions.

To help you visualize how to structure your work, look at Figure 3-76, a photograph of a warty gourd, and Figure 3-77, which shows how its sculptural possibilities have been exploited. Notice the simplification of the warty parts that has occurred in the drawing; also notice how, in their new sculptural role, the parts are articulated much more cleanly in the way they join together. Yet the organic vitality of the natural gourd is not lost in the translation to sculpture. In fact, some would say it has been intensified. Would you agree?

Figure 3-76
John Albaugh. Warty Gourd.

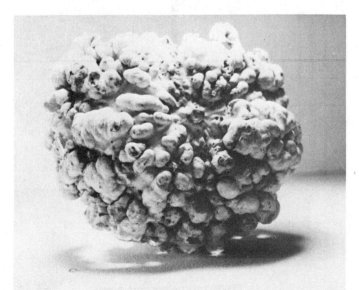

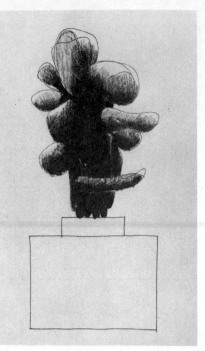

Figure 3-77
Betty Peebles. Composite Form—Idea for
Sculpture 1972. *Pen, ink, and pencil.*

TO CONCLUDE this brief discussion of organic quality, let us compare Figures 3-78 and 3-79. Both are linear sculptures made up of a number of limbs or parts. It is perhaps unfair to place professional and amateur work side by side, but it is justified if the juxtaposition provides the kind of contrast which finally—and completely—illustrates the point. Which piece in your view is organically more credible?

Figure 3-78
Ernest Mundt. Tree Broken by Storm
Decides to Live *1951*
Nickel and brass.
COURTESY OF THE ARTIST.

Figure 3-79

THE TEXTURAL WEAVE
figure and ground

Here are cool mosses deep,
And thro' the moss the ivies creep,
And in the stream the long-leaved flowers weep . . .
TENNYSON

ONE OF THE ATTRACTIONS of music is the rich texture of sound it is capable of presenting—the interplay of strings, brass, woodwind, and percussion; variations in the pitch of notes, and in their loud and soft values; and in the fast or slow rates at which the sounds and their accompanying spatial intervals are delivered. Music as an accoustical-time-space weave is a complex auditory experience.

As I write, I am looking out into a corner of woodland filled with magnificent thistles coming into seed, spaced at intervals against a ground of grasses, leaves, and thin branches, and wrapped in the heavy, warm air of a summer afternoon. So I find myself visually involved with a material weave of texture no less complex or rich than the musical kind of texture which engages the ear. Figure 4-1 is a small detail from a photograph of this scene. Figure-ground perception in such surroundings obviously depends a great deal upon the textural differentiations—on the nature of each material surface involved, on the ways they physically engage, and on the spatial intervals (rhythms) created by the weave.

This observation introduces an important issue for artists who must make perceptual, technical (graphic), and creative decisions concerning texture once they start fashioning figure and ground in an image. Obviously, much depends on the medium being used. Sculptors, architects, and those who favor the collage buildup technique all handle solid materials with which they work to produce a variety of textures, or which already possess positive, natural textures. But a graphic artist working on a two-dimensional surface must exploit the possibilities offered by the medium employed: Oil pigment, for example,

Figure 4–1: Thistles.

can be used very thickly to build a surface in relief, but watercolor remains thin and flat, and if the artist desires a relief surface he or she must use either a technique that suggests the illusion, or a coarsely textured paper or board to physically provide it.

Tactile, Spatial, and Expressive-Conceptual Aspects

The principal aim of this chapter is to stimulate your interest in both the variety and visual richness of individual surfaces, and in the ways they mesh together to form a large-scale weave. Webster's Dictionary defines texture as, "the arrangement of the particles or constituent parts of any material, as wood, metal, etc., as it affects the appearance or feel of the surface . . ." Apply this definition to the surfaces of bark, fungus, grasses, and toad shown in Figure 4-2. Each has its own special appearance—a quality of surface which invites the sensation of touch. For textures, when keenly perceived, trigger an imagined awareness of their feel. Think of the *tactile* aspect, therefore, as the "touch quality" of a surface: rough or smooth, wet or dry, hard or soft, sharp or blunt, and so on.

However, it is necessary to go a little further than the dictionary definition and to qualify the rather nebulous word "appearance." There are three important aspects of texture—in addition to touch—which play significant roles in visual perception and in art. These are the ways in which surface texture works *spatially*, *expressively*, and *conceptually*. Texture, then, should not be regarded as mere surface decoration, because it plays a vital role in figure-ground perception and in stimulating the imagination. There is little need to say much more about the *tactility* of various surfaces: The connection between the visual sense and that of touch is so immediate and so innate as to require little further description. Merely by looking at the surfaces presented in Figure 4-2 you know automatically how each will feel.

Figure 4–2
Robert Nix. Textures—Bark, Fungus, Grass, and Toad.

Furthermore, because there is such an intimate relationship between eye and touch where textures are involved, textural *variety and richness* in any visual situation can serve to intensify the experience: This automatic, mental stimulation of the sense of touch that accompanies looking can be thought of as a bonus. Two senses are actualized for the price of one, so to speak. Refer to Figure 2-41 and see how Vincent van Gogh capitalizes on this in *Garden in Provence*. In this drawing virtually no aspect of figure or ground is left untextured: Even sky and air take on a surface quality and invite touch. Such all-over textural treatment engages perception at two levels which, in itself, makes a drawing luxuriant and memorable. As a result, the work becomes graphically forceful, holds the viewer's visual attention by virtue of the sheer profusion and variety of marks, and so inevitably evokes the tactile dividend.

But the *spatial* characteristics of texture are also well realized in this drawing: Various kinds of surfaces, employing varying values of dark or light tone, occupy different regions of space. It should not be difficult for you to analyze how this works in *Garden in Provence* if you remember our discussions on figure-ground perception and space composition in Chapter 2.

Let us now look at textures qua textures, in order to see how surface qualities can operate independently in taking up spatial positions. Figure 4-3 is a photograph of deformed steel, highly magnified, which presents three types of textured surface. Nine out of ten people, when shown this photograph and asked to assign spatial position in depth to each texture, say that the top-left

Figure 4-3: **Deformed Steel**—*magnification 12,500 times.*
Electron microscopic photograph by K. Evans for Boeing Aircraft Company, Seattle.

surface is frontally dominant; that the surface at bottom-left follows a close second; and that the right-hand side area appears the more distant.

Can we explain why this might be so? Using Figure 4-3 as the example, here are some suggestions in tabular form:

SPATIAL POSITION	TEXTURAL QUALITY	LIGHT–SHADOW CONTRAST
Frontal	Compact intertextural surface High relief Point projecting—eye catching and strongly tactile	Multiplicity of highlights and darks, making for many strong contrasts
Middle ground	Open intertextural surface Less relief Flat projecting—less obvious and less tactile	More even flow of light and dark; contrasts less pronounced and fewer in number
Distant	Little intertexture of surface Little relief Smooth—minimal projection	Comparatively little light and dark contrast; more even, overall tone value

Note that one further fact affects the ability of *light* to play its vital role: Some natural surfaces reflect light, whereas others absorb it. If you refer again to Figure 4-2, you can see that the porous, soft texture of fungus absorbs more light than it reflects, whereas the opposite is true for the tightly compressed, hard surface of the grass. The former texture therefore retreats while the latter advances.

An extremely revealing example of the startling effect of texture versus non-texture in drawing is George Wray's *Wrapped Neon One* (Fig. 4-4). The sack-like texture of the wrapping material falls into a modeled and open (as opposed to compact) relief, and produces fairly strong light and dark contrast. Yet this textural tangibility is so opposite to the flat, even-toned ground that the sacking jumps stereoscopically forward. Were the sackcloth texture to be more compact and to present a higher relief, thereby intensifying the light and dark contrasts, then the illusion of frontality would become even greater.

Look again for a moment at *Garden in Provence* (Fig. 2-41). Notice how the scene breaks down visually into distinct textural regions occupying different positions in depth, in very much the same way that the textured surfaces in Figure 4-3 assume individual spatial locations. Then refer to the preceding table of spatial positions and textural qualities, and determine whether the suggestions made there are relevant—whether the graphic textures developed by van Gogh fall into the categories described and work in the same spatial way.

Let us now talk briefly about the ability of certain textures to function *expressively*, to provoke strong feelings, as well as to stimulate the viewer *conceptually* and cause questions to arise about the artist's intention, idea, or concept behind the work. When feelings are aroused, the question "why" is often hot on their tail, demanding some comprehension of what is going on.

Figure 4-4
George Wray.
Wrapped Neon One *1977.*
Ebony pencil on paper.
COURTESY OF THE ARTIST.

Many of the textured surfaces we visually encounter in the world are evocative—they can occasion strong, emotional reactions and set us thinking about the significance of an experience. Some people, for example, find themselves attracted to cold, smooth, dry, and reflective surfaces, while actively disliking those which are warm, rough, damp, and opaque. Softness and furriness are anathema to some but pleasurable to others. Silks and satins can create one kind of mood or ambiance; coarse wools and sackcloth another. Would you pick up a smooth stone half covered with moss by grasping the stony half or the mossy half? How do you feel about sinking your teeth into an apple which is smooth and shiny outside, but soft and pulpy within? And what about drinking milk from a fur-lined bottle . . . ? Obviously, then, feelings may be directly aroused by the texture of substances—feelings that comprise, for example, elements of desire, pleasure, uncertainty, fear, hate, comfort. And with each feeling, should it be powerful enough, intellect will sooner or later attempt to conceptualize what is going on.

Let us see how this expressive-conceptual function of texture operates by referring to two works of art which significantly exploit textural possibilities: Meret Oppenheim's *Object* (Fig. 4-5), and Michelangelo's *Saint Matthew* (Fig. 4-6).

Oppenheim's piece speaks for itself. We may respond with feelings of amusement or indignation, attraction or repulsion, but the chances are that we will respond emotionally to some degree. Furry things are pretty powerful in stimulating feeling of one sort or another because they possess such distinct touch quality. Furry surfaces may be called dramatic because people rarely feel neutral about them; feelings for or against are usually strong, and strong feelings are the essential stuff of dramatic experience. On the other hand, when familiar objects like cup, saucer, and spoon are given an unfamiliar and dramatic texture, the bizarre effect violates our normal perceptions of such things

Figure 4–5: Meret Oppenheim. Object 1936. *Fur-covered cup, saucer, and spoon.*
COLLECTION: THE MUSEUM OF MODERN ART, NEW YORK. PURCHASE.

and jolts our established views of "reality." Faced with such a work of art we must expand our thinking about what is real, put perceptual reality against imaginative reality, and try to grasp the concept behind the piece. Whether or not we are unnerved by fur, feel eerie when hard metallic or ceramic substances are given a furry surface, most of us will, nevertheless, find reason offended and wish to know what was in the artist's mind when he or she made the work.

Oppenheim's *Object* belongs to the movement in art known as Surrealism, and one of the ways the Surrealists challenge sensory reality is through such metamorphosis of surface texture. For Surrealist art seeks to question the infallibility of sense impressions in order to lessen our total dependence on a purely rational approach to the true nature of things, and to suggest that absolute reality may lie beyond our normal perceptions of physical appearances, time, and space. In his early years as a sculptor Michelangelo polished the rough and semiopaque marble with which he worked to a smooth and reflective patina. But in midlife he fashioned rough and dull, smooth and shiny surfaces to work together, as is evident in the sculpture *Saint Matthew* (Fig. 4-6). The strong contrasts he achieved heighten both the composition's perceptual impact and its dramatic mood. Look at the variety of textures enlivening the surface. The smoothed and polished areas catch and reflect the light, and when seen against those which are rough and shadowed stand forward and provoke a greater sense of mass. The various textures of the rougher surfaces produce a broken quality of light and shadow which acts as sculptural chiaroscuro and suggests various levels of relief as light flickers animatedly over the pitted and lined marble and pools of shadow form in the undercut valleys. Notice also how the claw chisel has cut lines of drawing over some regions; these are continuous surface directional lines (see Chapter 3), which help to shape the volume of limbs and torso. The contrast of this linear treatment with the pitted textures made by the heavy point chisel aids in perceptually separating figure from ground. All these factors enhance and intensify the sheer physicality of *Saint Matthew* as a sculptural presence.

But equally important, such textural vigor with its accompanying range of light and shadow, acts expressively to create a mood of emotional and spiritual intensity.

Figure 4–6: Michelangelo.
Saint Matthew. *Marble.*
GALLERIA DELL'ACCADEMIA, FLORENCE

WORKBOOK

Drawing Textures with Various Media

The aim of the exercises which follow is twofold: to direct your attention and interest to the richness and complexity of surface quality, in both nature and in art; and to give you the chance to unearth the special, individualized fascination characteristic of drawing or otherwise fashioning textures. Sometimes, a response to a particular type of surface can go beyond the visual: The feel and even smell of the texture may also be involved.

A. *Montage of textures made from rubbings*

For the first part of this exercise you need a large, soft drawing pencil or a large, black grease crayon, together with some small sheets of tracing paper. (Any reasonably strong semitransparent paper will do.) For the next hour or so, attune your eye toward a sensitivity for surfaces, both indoors and out: wood, metal, plastic, concrete, textiles, bricks, rocks, leaves, skins—any surface that excites the eye and imaginatively activates the touch sense. Make a rubbing of a small area (about 3″ × 3″) of each surface. To do this, place the tracing paper over the surface selected and rub gently or vigorously (depending on the delicacy or firmness of the texture). For intricate textures use the lead

159

Figure 4-7

pencil; for bolder ones use the grease crayon. The intention is to graphically simulate, by rubbing, the material's surface characteristics.

When you have about ten or fifteen of these rubbings, lay them down at random on a large sheet of white paper. Now decide which to use: Which of the samples will, when trimmed and juxtaposed, complement the others' textural qualities and allow each to show to the best advantage? Try a number of different groupings until you are satisfied that you have the best possible arrangement. Then, using scissors, trim each rubbing, if necessary, to fit with its neighbors and produce an interesting overall shape. Then use rubber cement to glue each piece down. The results should look something like Figure 4-7, which is a particularly attractive montage.

Save this completed sheet of rubbings to use as a visual "reference library" of textures. Refer to it to make the drawings which follow.

B. *Drawing textures from observation*

Look first at Figure 4-8, which depicts a variety of textures which have been drawn directly "from life"—that is, the student worked on the spot observing and graphically recording the nature of each particular surface. Study these fragments in order to ascertain how each surface is produced. Transparent washes of ink, smoothly applied with a brush, suggest metallic and reflective surfaces. Ink used dryly and stippled on with the brush point produces a coarse, brick-like texture. Linear cross hatching with the pen is responsible for the sack-like surface at bottom right; and speckling a darker and more opaque ink wash with sharp black points produces the pitted texture of cork. The grainy surface of wood is easily identified; so is that which is scaled and shaped distinctly in pencil.

What kind of natural surface do you think is recorded at bottom left? A dryish brush is responsible for the finely grained gray areas which are overlaid in parts by black stippling with the brush point. Is the surface dry or damp, hard or soft, rough or smooth? Can you pick up any smell associated with it—musk perhaps, an outdoor, garden odor of some sort? This is a rendering of the top surface of a large mushroom.

Now find your own textural examples and render them similarly.

Figure 4-8

C. *Utilizing textures for spatial effect*

Refer to your textural montage. Look over the whole sheet carefully to determine which rubbings seem to occupy frontal regions of space, which stay in the middle ground, and which tend to remain in the distance or to actively recede.

Now select three or four textures which perform spatially in these different ways, and reproduce them graphically in a rectangle about 8″ × 5″. Place them in such a way that their space-position characteristics can work to full advantage. Try to work in the manner of the student who made the drawing in Figure 4-9. Each of the four textures was reproduced separately on a different piece of paper. Pen and ink were used to create the two surfaces on the left, and the edge of a sponge was employed to dab light and dark tones of ink and to form the textures on the right. The important aspect of this exercise is for you to use any instrument that comes to mind to apply the stain to the ground, or any media or combinations of media—grease crayon, pencil, charcoal; or brush, sponge, rag, or finger—to apply dry or watery ink or paint. Experiment and discover what will do what in order to emphasize your chosen surfaces.

Figure 4-9

Now cut each texture to a particular shape and scale such that all the pieces fit together when you cement them down onto a new white sheet of paper. Be sure to leave a region of white ground untouched to contrast with the textured regions. Organize the arrangement of the four areas in the new empty rectangle to suit yourself aesthetically, but remember that a free-flowing design may fit the demands of this exercise better than a rigid, geometric one. In working on this problem, the student responsible for Figure 4-9 organized the design to suggest a landscape, and was successful inasmuch as the surfaces fall into place spatially, and suggest the texture of rock, soil, grass, and so on.

This kind of work can be executed in a more sophisticated style if you use many more textures in a combined drawing and collage. You could also use some of the actual rubbings you previously made, together with drawn and simulated textures. Remember that artists reproducing textures will choose both instruments and media for the natural textures they know will result. When painters apply watercolor with silky sable-hair brushes, they want the limpid, transparent softness of stained surface that occurs; on the other hand, if they apply dry and opaque tempera paint with hog-bristle brushes they know they will achieve crumbly, non-transparent stained surfaces. And, of course, by selecting smooth or rough paper or board on which to work, they also effect variations in texture.

D. *Drawing textures for tactile quality*

In making this drawing you should decide which media to use and how to apply them. In fact, it would be wise to experiment with sponge and rag, bristle and hair brushes, lead and grease pencils, and to try the ink concentrated or diluted, even breaking it up with a drop of glycerine or oil. Or see what happens when you wax an area by rubbing a white candle over it before you apply the stain, or when you deliberately roughen the paper with a razor blade, or when you close the grain by rubbing hard with the smooth side of a ballpoint pen. In every case a different surface quality will result as you draw. When you have a couple of pages of such trial runs, then decide which results to exploit for the present purpose: to produce touch quality by means of a drawn texture, to try to heighten the feel of a material substance simply by virtue of its graphic, textural credibility.

The object you use for this exercise is a bone. Beef shin and knuckle bones for making soup are available from butchers, and you can clean them up at home to enhance their bony smoothness. Select a bone with a bold, positive shape: it will provide a more expansive surface with which to work. The problem is straightforward: You are to make two drawings, one which attempts to emphasize the *hard* and *smooth-dry* quality of bone as material; and another which reverses these characteristics in favor of a *soft* and *fungoid-like, damp* bone substance.

If you are successful in creating these textural differences, the effect will be quite startling when the drawings are placed side by side, as they are in Figure 4-10: The hard boniness of one is intensified by the bizarre rubberiness and soft, rotting material of the other. Also, when you view the result, the touch sense should be stimulated almost as much as the visual. You may even smell the bones. To do this experiment well, you must be prepared to try out all sorts of textural possibilities beforehand. This demands that you be inventive with both stain and methods of applying it.

E. *Drawing textures to aid expression and concept*

This drawing is an attempt to effect a transformation, to change the surface character of a familiar object to arouse a new level of feeling, and to shape an innovative idea or an unfamiliar concept.

Select an object, either man-made or natural. Figure 4-11, for example, shows a transformed strawberry, apple, and egg; Figure 4-12, a plate, knife, and fork. By now you have had enough practice with textures that images should come readily to mind—images suggesting strange and mysterious transformations of familiar objects with unfamiliar textures. The results—as you can see in Figures 4-11 and 4-12—appear incongruous and even disturbing: As we have discussed before, when normal, perceptual experience is violated we are aroused to strong feeling. The spore-like texture of mold transferred to a plate, or the hard scales of a reptile imposed on a strawberry, intrigue, attract, repulse, sicken, or otherwise affect us.

Think of an object yourself—one which will surprise, even shock, those who see it. When you are off and running with the idea, and find feelings rising, remember that the effect for which you are striving depends upon your skillful and convincing simulation of textures using all the graphic means you now have at your fingertips.

Figure 4-10

Figure 4-11

Figure 4-12

163

F. Drawing textural weave in landscape

Finally, let us return to the multitextured world of nature. At the beginning of this chapter we talked about the overall weave of surfaces in space, of that richness and variety of texture that at times permits airy space itself to show off its brittle transparency or soft and opaque haziness, even, on occasion, to become cross hatched with twig lines so as to appear like regions of sackcloth.

This assignment is straightforward: Look out into a grouping of saplings and trees and make a drawing which concentrates more on the weave of surfaces than on the naturalistic rendering of the scene. Turn what you see into a tapestry of hatched textures, using any combination of instruments or stains you like. Manipulate the stain with sponge, dry brush, glycerine on a paper towel, or in any other way you may have discovered, to produce a result as effective as those you see in the fine drawing by Raphael Sloane (Fig. 4-13), and in Figure 4-14.

An alternative way to do this exercise would be to search out an intimate corner of forest or garden and, instead of taking a grand landscape view, to observe the warp and weft of textures existing more at ground level: roots, grasses, leaves, petals, bark, fern, rock, soil. Again, choose a medium or range of media which will allow you to graphically express such variety. In fact, you might try working on scratch board for this particular drawing. But as before, pay more attention to producing a pattern of textures than to being representationally accurate. *Balsam Root* (Fig. 4–15) by Constance Speth, although botanically precise—a characteristic not demanded here—is also a graphic weave of textures which shows how exotic nature's surfaces are at the most intimate levels.

Figure 4-13
Raphael Sloane. Wild Growth *1971. Ink on paper.*
COURTESY OF THE ARTIST.

Figure 4-14

Figure 4-15
Constance Speth. Balsam Root *1978. Multi-media.*

T O CONCLUDE the case for texture in drawing let me reiterate the follow-
ing points:

1. The world is rich in textures, and our acuity of visual perception is en-
 hanced when we are fully aware of them.
2. To recognize textural possibilities in drawing challenges graphic invention,
 inviting experimentation with instruments and media which can enrich
 both the visual and psychological appeal of the work.
3. A sure way to create a dreamlike or surreal image is to graphically change
 the natural texture of things.

DYNAMICS

dual forces in art and nature

*The elementals, the rock ribs, the cold root-nourishing stones jut free through the cap rock . . .**

LOREN EISELEY

I
Equilibrium / Turbulence, Stability / Motion

ENERGY AND THE ART OF COMPOSING

The art of composing, simply defined, is that of organizing a variety of elements into a coherent whole, into an entity possessing an overall form. In one way or another this is what we have been discussing throughout the book. But in this last chapter dealing with figure and ground we confront the *dynamic* possibilities inherent in such composing—the stable or restless nature of the forces which the figure-ground situation suggests are present.

There are many figure-ground variables that determine compositional vitality. Here we focus on the two dominant manifestations of energy or "life" occurring in both nature and art—equilibrium and turbulence—and, when possible, we rely on visual examples to speak for themselves.

Let us start this discussion by considering two illustrations. Figure 5-1 is a snapshot taken on a Puget Sound beach the day after a big storm; Figure 5-2 is a drawing entitled *Abstract in Black and White* by Victor Pasmore. The first shows a three-dimensional situation for which nature is responsible, the second, fundamentally a two-dimensional and abstract image. Nevertheless, both the objects in nature and the figure elements in the drawing occupy positions in space which produce a certain sequence of interrelationships. In the photo-

**From "Men Have Chosen the Ice," Notes of an Alchemist. Copyright © 1972 Loren Eiseley. Used with permission of Charles Scribner's Sons.*

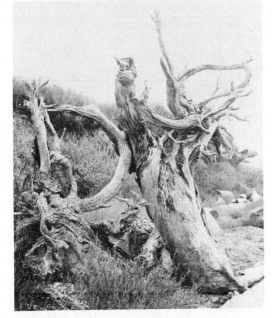

Figure 5-1

graph these interrelationships are between the objects themselves, and between them and the spatial regions which are shaped by their presence and disposition. The same is true for the drawing, except that we refer to figure instead of to object.

In both cases the result of these interrelationships is to invest the scene with a particular degree of liveliness: of actual movement seemingly taking place, of potential movement about to take place, or of no movement occurring at all as forces are totally contained.

To determine compositional force (in art or nature)—the degree of active or potential movement which is apparently present—the nature of the clues in a particular scene must be analyzed: How do compositional factors imply the operation of certain kinds of force or energy and thus endow the situation with a particular measure of vitality?

Figure 5-2
Victor Pasmore. Abstract in Black and White
1960.
COURTESY OF THE ARTIST.

In order to initiate this kind of analysis you should make an intensive study of Figures 5-1 and 5-2, for although one represents a natural setting and the other an abstract and invented one, they display their energy in similar ways. You can learn a great deal by merely comparing these illustrations. To help you, I have set out the basic compositional principles pertaining to dynamics under three main headings: placement, shape of objects, and shape of space. See if you can apply this information to both the Puget Sound photograph and to Victor Pasmore's drawing, in order to account for their particular dynamic characteristics.

Compositional Principles Affecting Equilibrium and Turbulence

PLACEMENT OF OBJECTS AND SPACES

Distance Factor
When objects and separate regions of space almost *touch* each other, the physical encounter suggests the operation of some degree of force or energy, thus creating dynamic tensions of motion rather than stability. Mere *closeness*, however, diminishes these tensions in favor of stability. *Remoteness* decreases the tensions of motion still further, helping to create a more inert equilibrium.

Angles of Juxtaposition
When objects and sparate regions of space confront each other at steep angles (45° to 90°), motion and turbulence are implied. Forces of gravity and weight are suggested or, conversely, an energy which defies gravity by moving things vertically or diagonally away from the horizontal. *Vertical and diagonal* angles of juxtaposition therefore suggest dynamic tensions of movement and speed. Confrontation at 180° angles—*horizontal* juxtaposition—intimates gravitational stability; even though there may be implied movement left and right, equilibrium seems less threatened. Vertical and horizontal angles coming together make for a balance of forces.

CRITICAL SHAPE OF OBJECTS—MASS OR SKELETAL

Relationship Between Shape of Object and Pressure-Force Exerted
When the shape of an object seems to push against its context, *mass shapes* seem to exert a surface swell in all directions; whereas *skeletal shapes* are seemingly point-loaded and energy travels in a concentrated, linear fashion. Such pressure dynamics can contribute substantially to the equilibric or turbulent nature of a visual situation. Generally speaking, surface-swell pressure is relatively even and well dispersed, less a threat to stability until expansion reaches bursting point. Point-loading pressure, on the other hand, suggests a powerful concentration of energy at work, moving in a particular direction. Here, thrust must be met by equal thrust if equilibrium is to be achieved.

CRITICAL SHAPE OF SPACE

Spatial Shape and Energy
When spatial regions are totally *enclosed* they appear compressed, and thus dynamic in the sense that although energy is constrained it could well burst out. *Partially open* regions, however, suggest not potential but actual movement, as space flows freely in and out. In contrast, *wide-open* spaces seem to be dynamically neutral in terms of pressure forces at work. Space which becomes *angled* and narrowed assumes the energy capability of the point-thrust—a threat to stability. Mass, or *rounded* regions, in contrast, appear to exert more generally dispersed and even surface-swell pressure—altogether more benign, less turbulent.

For additional evidence of how images seem to be more stable or more active, we turn to the three diagrammatic examples in Figures 5-3 to 5-5. These quick sketches are intended to illustrate the compositional principles presented.

Figure 5-3 presents a collection of random mass and skeletal shapes which indicate, by a general scattering of arrows, the ways in which their sides, points, and corners thrust into space. Different pressure loadings are suggested when the surface swell is convex, concave, or quite flat. It does not take

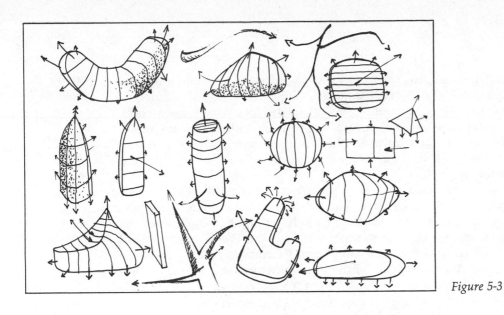

Figure 5-3

Figure 5-4

Figure 5-5

169

much imagination to visualize what an array of forces is brought into play when mass and skeletal objects are juxtaposed.

Figure 5-4, on the other hand, indicates the energy potential possessed by space or ground when it is shaped in a certain way. As with object or figure, the two basic pressure characteristics are those of swell (volumetric expansion) or linear point thrust; but, as you can see, they can take on many different energy manifestations.

When you have compared the space and object dynamics—of Pasmore's drawing in particular—with diagrams 5-3 and 5-4, and have identified the forces at work, then spend a few moments studying Figure 5-5. These little sketches of mine attempt to isolate some of the ways the French painter Paul Cézanne treated the natural forces of landscape. Cézanne aimed to dispense with the clutter of detail and to discover the basic structural shape of all within the cone of vision. When he thus reduced trees, rocks, houses, topographical and other characteristics—*including* spatial regions themselves—to their essential shape characteristics, he could not help but expose their forceful natures. All the object to object, object to space, and space to space interrelationships seem to become *crystalized* in Cézanne's drawing or painting. There is a strong sense of interlocking forces, of the fundamental equilibrium that persists despite the day to day, season to season changes of weather and growth. Cézanne's space ceases to exist as emptiness, and assumes shape and pressure interacting with all the objects present in the composition. Figure 5-5 illustrates how the theoretical diagrams shown in Figures 5-3 and 5-4 come to life in the work of an artist like Cézanne.

Now examine Cézanne's *Mont Sainte Victoire* (Fig. 5-6), a favorite subject, and notice how Cézanne transcends the momentariness of fleeting visual impressions by constructing an image of elemental and enduring stability.

Figure 5-6
Paul Cézanne. Mont Sainte-Victoire Seen from "Bibemus" Quarry. *ca. 1898–1900.*
Oil painting.

Figure 5-7
John Piper. Bullslaughter Bay *1951. Ink, chalk, and wax resist on paper.*
COURTESY OF THE ARTIST.

What happens dynamically in a drawing when space is left to roar restlessly through the image? In John Piper's *Bullslaughter Bay* (Fig. 5-7) the rock forms are enormously forceful: Angular and point thrusts are on the rampage, their energy uncontained by any positively shaped spatial pressure. Only where the two great holes loom in the rock do we see space shaped and boring in, a spiral of energy that fills the cavity and extrudes into the outside air, thus creating two concentrations of force in the work. The result is a drawing in which movement and energy triumph. Here we see the formative processes of natural energy still going on—geological forces heave and strain and wind and weather whittle away in a scene charged with movement and change. There is no stability like that achieved by Cézanne.

We are now ready to formulate definitions:

EQUILIBRIUM is the stable situation achieved when forces are in balance, when energy is contained and some degree of permanence is implied. Such a situation possesses vitality when the balance achieved is delicate and tense; it moves to a condition of inertia when balance is so solidly locked in that the potentiality for motion is lost and tension between forces accordingly disappears.

TURBULENCE is the unstable situation resulting when forces are not in balance and energy is on the move, producing change or the strong likelihood of change. Turbulence may be weak or strong: a condition just energetic enough to be non-equilibric, or so total that chaos reigns.

Let us verify these definitions by once again seeing how they work in the presence of two specific illustrations, two landscape drawings in which compositional forces shape the dynamics of equilibrium and those of turbulence. Samuel Palmer's *Valley with a Bright Cloud* (Fig. 5-8) is an example of the first; John Piper's *Slopes of Tryfan* (Fig. 5-9), an example of the second.

Nature is perpetually active: Tree roots pull down, branches push up, trunks lean and ultimately fall; rocks roll down angled slopes and stop when they meet an obstruction; winds blow, cause things to bend and to move about; buds open and leaves spread in the air; oceans advance and retreat, shaping sand and rock in the process; rivers flow and shape their courses; glaciers erode while geological forces push up and gravity pulls down; and sun,

Figure 5-8
Samuel Palmer. Valley with a Bright Cloud *1825. Wash and ink.*
ASHMOLEAN MUSEUM, OXFORD.

Figure 5-9
John Piper. Slopes of Tryfan *1950.*
Ink, chalk, and wax resist on paper.
COURTESY OF THE ARTIST.

172

wind, rain, and frost wear away at everything. In time all things change, nothing remains the same. Yet although motion and change can be violent and occur as one watches, it may also take place so gradually that one is not aware of it, as Cézanne's particular brand of equilibrium shows. *Valley with a Bright Cloud* shows nature basically at rest in a state approaching equilibrium. Bushes and clouds swell grandly into space but their volume bespeaks an equally strong gravitational force at work. Trees push upward in vertical point thrusts, but are anchored solidly in the horizontal ground swells. Here nature is relatively stable and benign—its forces are contained. How is this achieved? *Volume*. The surface-swell pressures of volume—as opposed to the linear force of the point thrust—appear to be generally stable in that they seem to be slower acting and often weighty. The massive, heavy log in the foreground lies solidly on the countering, heavy swell of earth; and the well-rounded clouds do not scud across the sky but seem to move ponderously, imperceptibly. When shapes are predominantly volumetric, and when, in terms of placement, they are organized in a dominantly *horizontal* composition, separated by regular intervals, and do not lean off the vertical away from or toward each other, then a general sense of stability, and a relative degree of permanence, result.

However, in *Slopes of Tryfan*, such is certainly not the case. We seem to be present at the birth of a mountain range. As a drawing, this work is a fine example of how turbulence and movement can be realized. It combines diagonal composition, a non-vertical (less stable) angular dynamic, and shape characteristics which favor the point-thrust pressures of skeletal form rather than the surface swell of mass—all guaranteed to create a sense of turbulence.

The eminent French historian and philosopher, René Huyghe, made a compositional analysis of several paintings by Rubens and Delacroix by imposing lines over photographs of their work to indicate the directional grouping of the shapes (objects) which constitute figure in each picture. The results are interesting and bear out the points we have discussed concerning artistic composition and energy potential. Following are four of Professor Huyghe's "diagrams":[1]

1. Delacroix's *Chess Players in Jerusalem* (Fig. 5-10). René Huyghe makes the point that, "after 1830 and the visit to Morocco, Delacroix's composition became more balanced, and verticals and horizontals were brought into play." Balance is synonymous with stability—a stability achieved by 90° horizontal and vertical forces in a state of containment.

2. Delacroix's *The Massacre at Chios* (Fig. 5-11). The horizontal line occupied by the foreground figures is not lined in here; even so, it remains a dominant compositional force imparting a basic stability to the scene. But the diagonal impetus of the twin triangles rising asymmetrically constitutes a turbulent threat in the overall dynamics of the painting. Is the horizontality of the horizon capable of calming things down again? Delacroix makes the most out of the tension created by this duality of forces present in the one work.

3. Delacroix's *The Death of Sardanapalus* (Fig. 5-12). A tremendous energy force is present in this painting. The combination of a diagonal point thrust and the curvilinear swell of pressure exerted by the arched body of the nude concubine in the foreground presents a force that seemingly cannot be contained and is capable of leading only to disintegration, which is exactly what Delacroix wants to suggest. The palace is under attack and the insurgents are about to break through to the royal chambers.

[1]René Huyghe, *Eugène Delacroix* (New York: Harry N. Abrams Inc., 1963), pp. 121, 175, 290, 232.

Figure 5-10

Figure 5-11

Figure 5-12

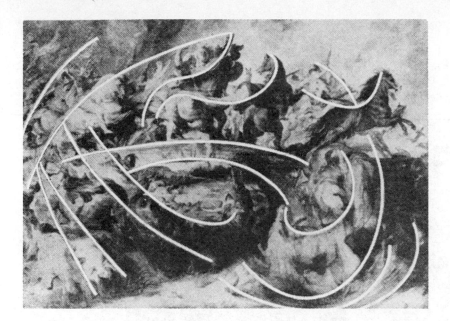

Figure 5-13

4. Rubens' *The Battle of the Amazons* (Fig. 5-13). Here we have a swirling composition of horses and riders, producing both linear point thrusts of energy and the swelling pressures of mass shapes. The result is a situation of great flux—the very opposite of stability. It is as energetic a design as you will find, with everything going on at great speed and the situation changing second by second.

Remember, however, that although equilibrium represents stability, stability itself does not necessarily imply a dynamically dead or inert situation, but rather one in which an "energetic calm" prevails. When forces are contained and a balance achieved, a certain kind of tension is present—the tension of balance, one might call it—for there is always the realization that it could take very little extra force to produce imbalance and with it an aesthetic and physical breakdown. It is not a contradiction in terms, therefore, to talk about *equilibric vitality*. At times, such a tension of balance is even more forceful—the contained forces being so potentially powerful—than the more obvious and outright dispersal of energy described as turbulent.

COMPOSITIONAL FORCES APPLY UNIVERSALLY throughout the visual arts, in the two-dimensional fields of drawing and painting as well as in the three-dimensional areas of sculpture and architecture. To assess the nature of the forces involved in the following three-dimensional examples, refer again to the various diagrams and drawings we have already discussed, and decide how many of the points listed as compositional principles seem to apply.

Stephen Gilbert's *Structure 14C* (Fig. 5-14), for example, possesses both mass and skeletal shape characteristics, pushes against space by means of surface swell and linear point thrust, and shapes space to become part of its overall form and to assume its own energy potential. The point thrusts stretching the mass of Donald Brown's *Untitled* (Fig. 5-15) are almost unbearable. The surface tension is so great that collapse seems imminent. Obviously the surface-swell pressure of mass, when subjected to attack by the concentrated linear force of the point thrust, results in a most forceful and energetic situation, one in which the plasticity of material is tested to its limits. This work is an excellent example of how tautness of surface intensifies the sense of stress and violent motion rather than stability.

Figure 5-14
Stephen Gilbert. Structure 14C.
1961. Polished aluminum.
TATE GALLERY, LONDON.

Figure 5-15
Donald D. Brown. Untitled 1976.
Epoxy and glass fibre.

Now consider architecture: Compare Le Corbusier's *Philips Pavilion* (Fig. 5-16) with Buckminster Fuller's *Kaiser Aluminum Dome* (Fig. 5-17), and decide which is more vigorous and which more stable, and why this is so. What energy characteristics are displayed in the space volume shown in Figure 5-18? Even a simple article of furniture can be designed with a particular energy dynamic in mind. How do the parts of Dan Cooper's *Butterfly Table* (Fig. 5-19) push and pull together in terms of their shape characteristics?

176

Figure 5-16
Le Corbusier. Philip's Pavilion
Brussels International Exhibition, 1958.
PHOTO: ARCHITECTURAL REVIEW, LONDON.

Figure 5-17
R. Buckminster Fuller. Kaiser Aluminum Dome, *Honolulu, 1957.*
LECE PHOTO SERVICE, NEW YORK.

Figure 5-18
Stairway in Berlin.
COURTESY ULLSTEIN, BERLIN. PHOTO BY FRITZ ESCHEN.

Figure 5-19
Dan Cooper. Butterfly Table 1942.
Knock-down furniture ("Pakto")
designed for housing projects. **Exhibition:**
Useful Objects in Wartime under $10.00
THE MUSEUM OF MODERN ART, NEW YORK, DECEMBER 1942.

Up to this point we have discussed the dynamic possibilities of equilibrium and turbulence in terms of the landscape or the drawing seen as a whole. Now let us examine those individual aspects of composition which contribute significantly to the "life" of a work. These are:

- Space energy as determined by shape: open or closed; two or three dimensional.
- The enlivening of space by drawing marks.
- The energy of line in drawing.
- The energy and structure of planes and curved surfaces.
- The energy potential of area stain.

SPACE ENERGY AS DETERMINED BY SHAPE initiates this part of our inquiry into compositional forces. In Chapter 2 we talked about space perception and composition; we discussed ways in which the treatment of space contributes to the kind of vitality possessed by a work of art. Empty space begins to assume varying shapes once lines of drawing appear and establish basic horizontal, vertical, and diagonal formulations. Figure 5-20 is a simple diagrammatic rendering showing the fundamental ways in which space be-

Figure 5-20

comes shaped and so vitalized by such rudimentary line placement. In column *A* the space (or ground) thus shaped is totally enclosed; but in column *B* the intruding line stops short before reaching the rectangles' boundaries, leaving each region of space open. As a result, there is a flow of space between the regions which causes these simple sketches to appear more active than those in *A*. Also, because the unconnected lines suggest to the eye that it can go around and *behind* them—that depth is attainable—more active and varied movement is evident. The space-shaping examples under *A* are thus more limited and two dimensional whereas under *B* we can see three dimensional possibilities and a far greater energy potential.

Diagrams 1 to 4 go several stages further in that they incorporate horizontal, diagonal, and vertical space formations in each image, show space open and enclosed, and substitute the angular slope of line for the vertical and curved lines for straight. In diagram 1, although depth is suggested by the diagonally opening "window," space is enclosed and all is stable. But the following three diagrams show situations of increasing motion and instability. Study these to see how the energy factor increases once space is opened and firm connections with the border are broken; when leaning-line space replaces vertical-line space; and when curved-line space supplants non-curved space.

While you are examining Figure 5-20 also notice another aspect of horizontal, diagonal, and vertical space shape that profoundly affects perception of such compositional characteristics. We associate such divisions of space with our overwhelming visual familiarity with the layout of things as they appear in the world, and with the cone of sight through which we see into the world. (We look out into the world with two eyes, and thus with two sight lines that come together at the object on which they are focusing as they diagonally converge, and so form what is commonly termed the "cone of vision.") Hence the horizontal line suggests the stable horizon of space, dividing things into up and down, sky and earth; the diagonal line implies the slope of space seen against the mountainside or abutting the angular form of objects, and so is associated with obtuse or acute energy movements; and the vertical line connotes the motion of space away from earth to a weightless and energy-possessed region escaping gravity. We cannot help but carry these existential associations with us, however abstract the images in which such space shapings appear. You can see how conditioned we are by these associations when, as in diagram 1, diagonal lines are inserted into the flat rectangle and, because we are accustomed to seeing the world by means of a diagonal cone of vision, the once-simple rectangle now assumes a "window-like" function and becomes a way of perceiving space in depth. Once imposed in the previously empty rectangle, the diagonal space line in diagram 1 acts like a natural sight line cutting through space. We also perceive an implied instability in diagram 4, when diagonal space penetration becomes *bent*.

The shapes of space which appear in Figure 5-20, and which suggest stability and motion are:

- Horizontal and vertical space shapes for stability; diagonal and leaning for motion.
- Enclosed space shapes more two dimensional and stable; open ones more three dimensional and active.

To see the application of these theories, look at Figures 5-21 and 5-22. How would you describe the space in Ben Nicholson's 1947 *Still Life—Odyssey* (Fig. 5-21)? What kind of energy does it bring to the image? Is the work spatially

Figure 5-21
Ben Nicholson. Still life—Odyssey *1947*.
COLLECTION: THE BRITISH COUNCIL, LONDON.

Figure 5-22
Victor Pasmore. Line and Space
1964.
COURTESY OF THE ARTIST.

vigorous two or three dimensionally? Do the forces at work appear at rest or in motion? The answers to these questions, with regard to the Nicholson, become all the more obvious if you ask them again of Victor Pasmore's *Line and Space* (Fig. 5-22). Surely these two examples speak for themselves in terms of space energy. Figure 5-22 in particular is an excellent illustration of how lines, when not tied in to other lines in a closed space system, permit the space they shape to assume depth and to become active, free to move from region to region.

E̲NLIVENING SPACE AND GROUND by applying stain and marks is, for some artists, a natural thing to do when drawing. In Chapter 2 we discussed that unmarked regions of empty ground can challenge an artist to make that ground more perceptually specific and thus "navigate" through it, so to speak. This inevitably enlivens the ground. Refer again to the Workbook drawings concerned with space composition that you made in Chapter 2. Particularly compare those exercises in which concentrated brush-point jabs created certain regions of turbulence, and those in which widely dispersed jabbing marks had the opposite effect.

To treat ground in this way—to graphically mark it with line or point or smudges of stain—is to endow space with a volumetric vigor (nearness and distance), as well as with the vitality of things on the move in a three-dimensional situation. On the other hand, leaving the virgin ground untouched maintains a two-dimensional flatness, allows space to function as an empty backdrop, and thus permits figure to assume clarity and dominance. How the artist treats the ground all depends on what he or she wishes to achieve.

Refer to Figures 5-23 and 5-24. Once again we have a photograph next to a drawing in order to reveal the difference between what the camera *records*, and what the artist *does*. John Albaugh's photograph of a distant Mount Rainier frames space in much the same way as Victor Pasmore's drawing, *The Window: Garden in Spring*. But whereas the space in the photograph is untouched, static, and tranquil, and—despite the mountain's distant position—relatively shallow in depth, the space in the painting is marked everywhere with point and line and is seething with movement and light energy. Skillful employment of light and dark hues, concentrated and dispersed points, and incisively drawn fast-moving lines activate space in this drawing to become a significant element in its own right.

Figure 5-23
John Albaugh. Mount Rainier, *Washington.*

Figure 5-24
Victor Pasmore. The Window: Garden in Spring *1947.*
PRIVATE COLLECTION. COURTESY OF THE ARTIST.

The general tendency of the beginning artist to think of space as mere background—as a neutral backdrop against which objects are to be seen—should be countered as soon as possible. One of the best ways to do it is to emphasize the forceful possibilities offered by the various graphic treatments of ground, as we are doing here. Remember, however, that the artist always has the choice to treat space and ground graphically or to leave them alone. If the former, then any or all of the marks in his or her repertoire can be employed to imbue the space or ground with depth and with the contrasts of dark and light, and to show movement occasioned by radiant or physical energy forces. If left alone, space will remain at rest, a two-dimensional plane.

LINE IS THE MOST EFFECTIVE WAY to impart energy in both figure and ground. Let us pursue some of the possibilities that line affords, and in so doing reaffirm its importance as both a shaper and an energizer of space. We have certainly seen enough evidence in the diagrams and illustrations introduced thus far to appreciate line's effectiveness.

Once again let us turn to visual evidence; and once again the art of Victor Pasmore provides the most striking examples. In *Linear Motif* (Fig. 5-25) a single and pure—that is, regular and clean-cut—line indicates the firm and unambiguous path of a point in motion. In the *Linear Motif* of Figure 5-26, on the other hand, the reverse is true; there is a multiplicity of lines of irregular thickness, length, and tone value, tracing relatively uncertain paths in space. What is the result in terms of each drawing's vitality?

Figure 5-25
Victor Pasmore. Linear Motif *1961*.
COURTESY OF THE ARTIST.

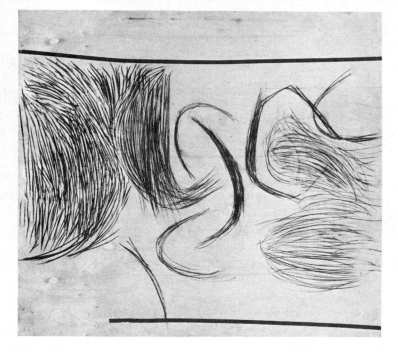

Figure 5-26
Victor Pasmore. Linear Motif *1961*.
COURTESY OF THE ARTIST.

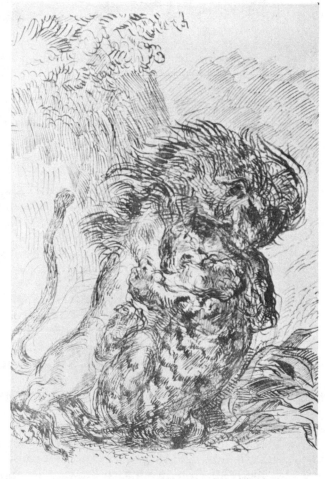

Figure 5-27
Eugène Delacroix. Lion and Tiger
Fighting. *Ink drawing*.
GRAPHISCHE SAMMLUŃG, ALBERTINA, VIENNA.

184

Kurt Badt has written extensively on the drawings of Eugène Delacroix. Following is what Badt says about the difference—in terms of vigor and forcefulness—between single, pure lines and two or more uneven lines:

> . . . One can draw a line in such a way that the eye is induced to follow its direction, the rhythm of its curves, and the elegance and beauty of its movements. Such a line has the character and value of a pattern, but, in itself, has "no significance." . . . On the other hand one can draw lines—not just a single one; two are almost necessarily required for this purpose—related to one another, in such a way that the eye has to interpret them as the bounds of a corporeal, a plastic form situated within them. To put this another way; these coupled strokes are drawn in such a manner that the eye is prevented from following them lengthwise, but must apprehend them in a direction independent of their own. It must proceed beyond the flat sheet of paper on which they lie, and to which they are tied down, in three dimensional space. In this case, the lines have a "significance" beyond charm of their own lead and their descriptive capacity; they signify spatial extension, and are at the same time expressive, demonstrating by means of their forms the inner tension, the lively vigour of the body which they make apparent.[2]

He goes on to say:

> Delacroix was unable to do justice to the value of these lines (single lines) because they play no part in expressing *active* life. On the contrary, they are opposed to it, tending to *restrict* the richness, vigour and abundance of living forms. Ornamental line (the single line) has no "significance" for him because it achieved exactly what his own art never aspired to; it stills life, reduces its fullness and curbs its vigour. . . . By means of . . . the ornamental line an artist dominates life, by soothing and purifying it and setting it in an emphasized order. . . . By means of the second (a multiplicity of coupled strokes), an artist dominates life by extolling its power, expressing its vigour, and implying its volume and richness. . . . Between these two alternatives the art of drawing swings. There is no third, unless, indeed, one be arrived at by the synthesis of the former two. Such synthesis, uniting calm and purity with power, vigour and the richness and volume of Life has been rarely achieved, and by very few masters.[3]

In the light of such commentary, now take another look at Pasmore's two *Linear Motifs*.

As Delacroix's style has been the subject of comment and an example of vigorous and lively work, let us now examine a typical drawing of his. *Lion and Tiger Fighting* (Fig. 5-27) gives you some idea of what Kurt Badt is getting at when he says that "by means of . . . a multiplicity of coupled strokes . . . an artist dominates life by extolling its power. . . ." This point becomes even more obvious when you study Delacroix and then look back at Picasso's *Bull* (Fig. 1-9), a lithograph in which one line creates the form. However clever and humorous the Picasso concept may be, it nevertheless lacks "the richness and volume of life" found in the Delacroix drawing. To see how a veritable deluge of lines can suggest voluminous waves of energy, study Leonardo's *A Storm of Water and Rocks* (Fig. 5-28), in which we see an irresistible force breaking down the hitherto immovable rock. Finally examine Georges Mathieu's *Painting* (Fig. 5-29), which must surely stand as the pièce de résistance of linear energy, and

[2]Kurt Badt, *Eugène Delacroix Drawings* (Oxford: Bruno Cassirer, 1946), p. 48.

[3]Ibid., p. 51.

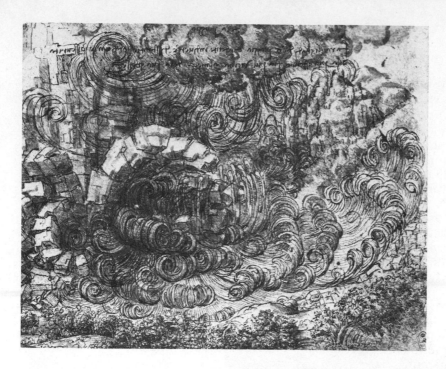

Figure 5-28
Leonardo da Vinci. A Storm of Water and Rocks.
Bistre over black chalk.

Figure 5-29
Georges Mathieu. Painting 1952. Oil on canvas.
THE SOLOMON R. GUGGENHEIM MUSEUM,
NEW YORK.

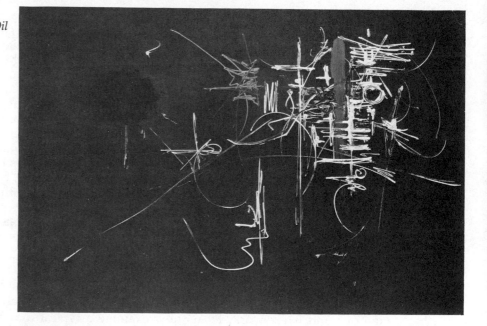

Figure 5-30
Bernard Vonnegut. Lucite subjected to ion implantation. *From "Structure in Art and Science," ed. Gyorgy Kepes.*
GEORGE BRAZILLER INC., NEW YORK, 1964.

186

Figure 5-31
Betty Peebles. Drawing of Linear Flow.

in which you will find all the forceful characteristics of line we have described, activating both potential figure and actual space.

Any one line, or many lines, may suggest the conveyance of energy. In Chapter 1 we described line as a point in motion, and motion is, after all, energy on the move. Look at the linear flow revealed in Figure 5-30, a photograph showing the pattern of electrical breakdown in a plate of transparent lucite, charged by ion implantation, and discharged through a single point.[4] When we use *lines* to draw we are registering the transmission of force no less credibly than nature itself. Let us, therefore, now talk about and look at some basic types of linear energy, which, inevitably, determine the dynamic quality of any drawing.

One drawing by Betty Peebles—Figure 5-31—serves to illustrate the fundamental energy characteristics I wish to single out:

a. The direct linear thrust;
b. The meander;
c. The curvilinear swell.

Each of these categories carries connotations of *direction*, *rate of motion*, and *force of motion*; and is easy to identify visually in every line of Figure 5-31. The direct linear thrust is provided by the completely straight lines, moving in any direction, yet not dissipating energy or speed by angular or curvilinear changes in direction; these are fast lines of concentrated energy. The meander, on the other hand, turns and twists, slows and speeds up, and carries a relatively relaxed energy charge. The curvilinear swell arcs into space at an even sort of pace, conveying a sense of a bulging area of pressure, rather than that concentrated in a point of movement and proceeding in a straight line.

[4]Cyril Stanley Smith, *A Search for Structure* (Cambridge, Mass.: M.I.T. Press, 1982), p. 62.

Each line of this drawing "reads" in a different way in terms of the energy patterns just described. Different time rates are involved, different accelerations and slowing downs, and varying outputs of energy. When the line goes up and down, diagonally or horizontally, these factors undergo change. And when one linear direction is set against another, tensions result as these differing energy patterns interact.

Remember, however, that the *graphic* quality of a line—its tone value, smoothness, roughness, heaviness, lightness, brokenness, continuousness, or sharpness—also plays an important part in determining linear vitality. Such physical characteristics of drawing marks were discussed in Chapter 1; and the results, in terms of linear motion and forcefulness, were visibly evident. Can you recall, for example, the energy qualities of the calligraphic line? Obviously we cannot repeat these aspects of Chapter 1 here. But in order to fully understand the dynamic possibilities of line in drawing, it would be useful to turn back to Chapter 1 to refresh your memory and to complement the discussion of linear energy here. You will thus be in a better position to account for what happens in Figure 5-31 when the weight of line changes, when tone value varies from dark to light, and when a broken line replaces a firm one.

Following are a few individual examples from the notebook of Betty Peebles:

Figure 5-32: an example of the strong pressure forces of the curvilinear swell. The energy is intensified as more than one line is involved.

Figure 5-33: an example of direct and semidirect linear thrusts.

Figure 5-34: an example of the weaker forces of the meandering line, called aptly by the artist "a waft of lines."

An illustration of sheer graphic energy in which force is allied with speed is Reg Butler's *Brush Drawing, Series 1* (Fig. 5-35). Decide for yourself how the graphic quality of the linear thrust intensifies the sense of force.

Figure 5-32
Betty Peebles. Drawing of Linear Flow II.

Figure 5-33
Betty Peebles. Drawing of Linear Flow III.

Figure 5-34
Betty Peebles. A Waft of Lines.

Figure 5-35
Reg Butler. Brush Drawing *(from Series 1).*
THE HANOVER GALLERY, LONDON.

189

Figure 5-36
Robert Kiley. Water Suite No. 4.
1982. Pencil.

To conclude, here are two complete drawings in which you can see these linear characteristics working to fulfil the artist's intention and convey a particular type of force. Robert Kiley's *Water Suite Number 4* (Fig. 5-36) is concerned with two levels of energy: an upper and a lower, different in kind and in intensity. Study the drawing and decide for yourself the nature and intensity of the forces at work. How turbulent is this *Water Suite* study? Umberto Boccioni's *Study for Dynamic Force of a Cyclist* (Fig. 5-37) speaks for itself. As you study it and gain a "feel" for all the forces involved, and understand how they are graphically conveyed, notice how easily curvilinear lines which continu-

Figure 5-37
Umberto Boccioni. Study for Dynamic Force of a Cyclist II. *Pen, ink, and wash drawing.*
YALE UNIVERSITY ART GALLERY, NEW HAVEN, CONNECTICUT. GIFT OF SOCIÉTÉ ANONYME.

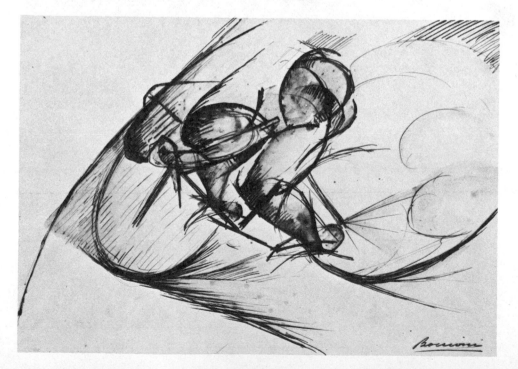

ously turn in on themselves can become spiraling lines of energy. This almost happens once or twice in Figure 5-37. (Note that I have not included the spiral as an independent line of force in my list, because I prefer to regard it as an extension or development of curvilinear, swelling lines of force.) Umberto Boccioni, incidentally, was an important member of that group of Italian writers and painters known as the *Futurists* who came to prominence in Paris in 1909. The manifesto of Futurist poetry extolled the beauty of speed and aggressive movement, and vowed to destroy museums, academies and libraries as representative of a decadent past.

THE ENERGY AND STRUCTURE OF PLANES and curved surfaces help to determine the dynamic nature of things—the liveliness or stillness we perceive the object to possess. We have already touched on this kind of "shape energy" in both discussing and presenting diagrammatically the way in which shape characteristics appear to pressure space and to reveal the force of internal and external pressures which have worked on the form's material substance. But here, we focus on the movement and organization of *planes* and *curved surfaces*—the two fundamental types of surface—to see how lines describe them and reveal the forces involved. To do this, we will move from the graphic art of drawing to the three-dimensional one of sculpture.

Pablo Picasso's *Woman's Head* (Fig. 5-38) and Henry Moore's *Composition* (Fig. 5-39) obviously represent dynamic opposites: One is angled and thrusting, the other round and swelling. Although lines of force are discernible, the overall *movement of surface* determines the kind of degree of vitality possessed by each piece. With sculpture we face a true multidimensional plasticity in real, three-dimensional space. Lines in sculpture are formed as a result of plane meeting plane and are, therefore, structural manifestations of three dimensionality. When a surface is composed of flat planes, arranged in strong convex to concave opposition, angles become acute and form lines—or, more strictly speaking, edges—which carry the thrust of the force; the skeletal-like lines of edges you see in the Picasso represent the pressure of subcutaneous bone at forehead, nose, cheek, and chin jutting against flesh. But this energy of angle and line is present only in the face. As the hair masses high on the head it falls into the gentler waves natural to fibrous materials, and curved surfaces fold and flow into each other, suggesting less severe energy forces.

In the Moore, planes and their angles have almost disappeared altogether and consequently acute angle lines that convey the sense of force are not in evidence. Here the forces are not those of skeletalized mass but of swelling mass volumes; the dominant lines we see are of curvilinear swell that form the apparent outline of the piece, even though they are not really there at all. They are simply the apparent edge of the object as surface turns and disappears around the other side, out of sight.

Once we start to deal with the dynamic aspects of three-dimensional objects—as evidenced by Picasso's bronze sculpture and Moore's stone carving—we see that while lines of drawing do not exist as such, the edges of the various surfaces, which appear as lines, do; and that because of this, the linear aspect of surface configuration continues to convey the forceful nature of the works. If an object presents a surface made up of juxtaposed concave and convex planes, then the forces at work are concentrated in angle lines of direct thrust. But if the form offers an uninterrupted flow of rounded volumes, then such forces become perceptually manifest by the curvilinear swell of their apparent contours—the line of curvilinear swell.

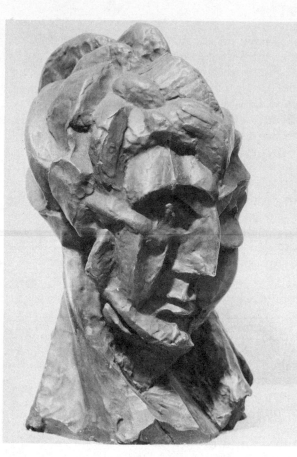

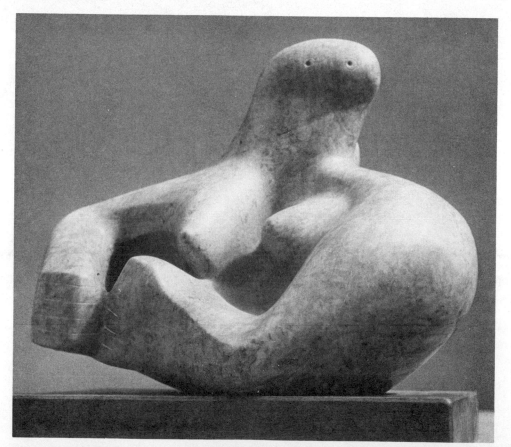

Figure 5-38
Pablo Picasso. Head of a Woman (Fernande) *1909.*
Bronze.
COLLECTION: THE MUSEUM OF MODERN ART,
NEW YORK. PURCHASE.

Figure 5-39
Henry Moore. Composition *1931. Stone carving.*
COURTESY OF THE ARTIST.

192

We perceive the structure and force loading of solid objects through their surface shapes and motion; thus, the apparent lines formed by organizations of planes or representing the contours of curved surfaces carry the same connotations of force and energy as are present in the graphic lines we employ in drawing. But—and this is readily evident from even a quick look at Figures 5-38 and 5-39—the kind and degree of vitality possessed by solid form is conveyed more by the plane or curved nature of surface areas and their juxtapositioning than it is by the linear "reading" we take. Yet obviously, a complex series of planes will create an abundance of force lines (edges seen as lines), whereas curvilinear regions, exerting pressure via surface spread rather than by a succession of skeletal edges, will not produce such a linear impact.

These sculptures are examples of the two basic force systems found in three-dimensional design—that of curved surfaces producing swelling volumes, and that of concave and convex thrusting planes creating angular ones. Each possesses its own dynamic character; each can move from a condition of equilibrium to one of turbulence; and each shows matter subject to differing orders of force working both internally and externally. In *Composition*, internal forces swelling outward seem to be more than a match for external forces pushing inward—a characteristic of such volumetric expansion. In *Woman's Head*, on the other hand, there are regions where external pressures—seemingly of the point-thrust variety—determine the structure of the form as much as do those pressures exerted through the extrusion of the mass itself.

THE ENERGY POTENTIAL OF AREA STAIN can become a compositional force in drawing. Two examples demonstrate this. The first is *Chakra Suite Number 4* (Fig. 5-40) by Robert Kiley. Many of the figure-ground events taking place here have been the subject of previous discussions—for example, the illusion of space in depth created because differing tone values take up different positions; also, the effectiveness of point in punctuating space and so establishing a scale of distances. Therefore, although we should be aware of this dynamic interplay between figure and ground, let us concentrate here on the sheer joyousness of brush movement and stain flow which animates this drawing and imbues it with energy and sensuous grace.

Figure 5-40
Robert Kiley. Chakra *1982. Acrylic on paper.*

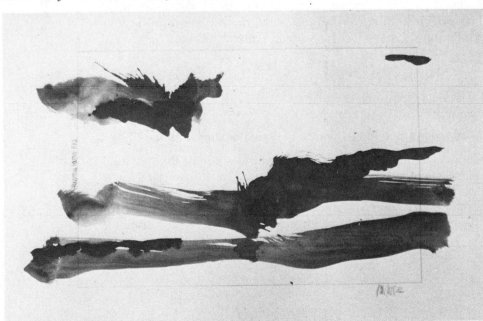

Difficult as it is, try to avoid any visual associations which lead to ideas about galloping animals, and just experience the sensation of a rush through space for its own sake. Then consider these five principal ways by which the artist has achieved the exciting vitality we discern in the drawing:

- The use and exploitation of a staining medium capable of sustaining considerable fluidity while the brush is in motion, yet also able to dry rapidly once it is touched down.

- The application of stain: the controlled, sure sweep of the brush across the paper, producing both an immediate crispness and diffusion of "drawn" edge to an area which suggests, in itself, alternately fast and slower rates of speed.

- The use of differing touch pressures in the brush's travel over the paper, constantly intensifying and lightening the deposit of stain. This results again in a change in tempo; dark areas tend to slow up, lighter ones to speed away. Also, as the tone value changes back and forth, a wave-like effect is produced, again indicating an area in motion.

- The placement of dark and light areas, causing the lighter stain to appear as a dispersal of stain from the black concentrations. The resulting implication is of the distribution of energy; the darker area is seen as the energy source, bleeding out through space into lighter, more distant areas of tone.

- The shape of stained areas, which also results from the touch pressures of the brush. Where the brush lifts delicately off the paper, a delicate tipping concludes the mark of stain, thus suggesting point thrusts of energy. Consequently we see left and right movements vying with each other in the overall energy tensions present in the image.

Let's refer back to John Constable's drawing, *Trees and Water on the Stour* (see Fig. 1-4). Composed predominantly of brushed-in areas of stain, it is a powerful image in which the forces of wind, water, and light are graphically realized in the spontaneous and free handling of the brush. Yet if we were to explain how Constable conveys nature's elemental energies through such an apparently easy-going rendering of simplified light and dark areas, the five points made in reference to Figure 5-40 would, for the most part, apply also to this landscape study. But decide for yourself how the forcefulness of *Trees and Water on the Stour* differs from that of *Chakra Suite Number 4*: What does the "rougher" technique of Constable achieve in comparison with the sophisticated brushwork of Robert Kiley?

Whatever you decide, remember that force and movement may be strongly communicated through the fluidity of staining medium and through the way the medium responds to an artist's touch and technique.

WORKBOOK

5-I. The Enlivening of Ground and the Dynamics of Figure or Object Shape

The work which follows is designed to introduce you to some of the essential principles which govern the plasticity of a work of art. The plasticity factor is the formative factor: It is the way in which the parts, or aspects, of the created image are brought together to impart a particular dynamic quality to the form, the "plastic life" of the work, as it is sometimes called. We have seen some of the results of such composing, ranging from the sort of vitality that produces equilibrium to that resulting in turbulence.

We work here with line and other marks of drawing, with space, and with the shape characteristics of figure or object, in order to deliberately compose images which possess a particular dynamic character.

A. Using line and open or compressed space

Work on a rectangle approximately 8″ × 7″. Use any combinations of felt-tip pens, ball-point liners, and brushes with ink to make a particular line or lines. The top third of the ground should represent sky, the lower two-thirds should represent land. First, using lines alone, enliven the land region by employing the various kinds of force lines we have discussed and presented in diagrammatic form. Use point thrusts and curvilinear swells, placed horizontally, diagonally, or vertically, to structure the shape characteristics of the terrain, and in so doing *graphically describe the nature of the subterranean forces and pressures which have shaped the land.*

Remember that the space element is also involved. As space becomes compressed so the sense of concentrated energy becomes stronger; the more open the space, the more dispersed and accordingly less active and visible the energy factor becomes.

To activate the area of ground that is to become sky, select lines and place them in such a way that *energy movements through space are indicated.* Clouds, wind currents, and thermal movements of air are all systems which naturally determine the dynamic life of space—a life which you can transfer to the page by purely graphic means, and in so doing bring life to the drawing.

If you wish to treat this exercise more diagrammatically than pictorially, then do so. On the other hand, should you get carried away with the pictorial possibilities, then let the drawing develop in this way. Figure 5-41 is an example of the diagrammatic approach. And surely it would be difficult to find a drawing with more pictorial vitality—more graphic exuberance of linear swell and thrust—than Vincent van Gogh's *Starlit Night* (Fig. 5-42).

Figure 5-41

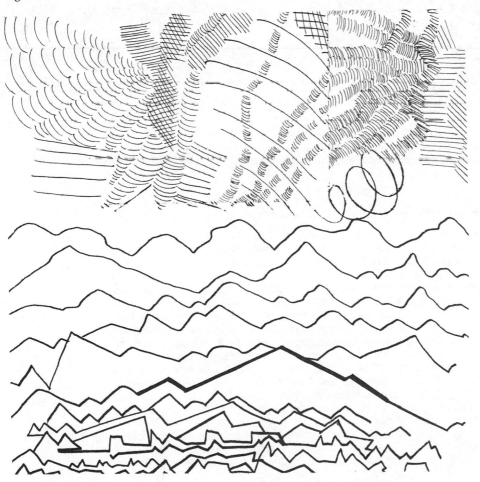

Figure 5-42
Vincent van Gogh. Starlit Night *1889. Pen, brush, and ink.*
THE KUNSTHALLE, BREMEN.

B. *Using line and point to show contrasting treatment of spatial dynamics*

For this exercise work within a rectangular region about 12″×8″. Use the space horizontally. Again, make your own selection of drawing instruments and again, think of this drawing ground as sky. (This association makes it easier for the visual imagination to conjure up energy movements in space.)

The aim is to place linear, point-thrust systems of energy side by side with ones suggested by point clusters; roughly half the region should be enlivened by line, the other by point. Work a variety of vertical, diagonal, and horizontal lines which culminate at fixed points, over the ground. Make them speed to their destinations and in so doing penetrate space in what appears to be a series of overlapping planes. In the remaining ground, however, activate an energy movement through space by dispersing point marks. Where such points are concentrated energy will be strong; where spaced out, energy will appear to be weaker. The closer the points are together then the faster the force will seem to travel, and the more easily its path can be traced because the eye can connect such dots more easily. Conversely, when the points become more spread out, the pace will slow and its direction will be less easy to discern.

When the two halves of the ground are thus treated, you should have an interesting comparison between different kinds of energy movements, different speeds, different penetrations of space, and differing strengths of force. In Figure 5-43, the artist chose to work

Figure 5-43

over a washed-in gray ground. Such an initial treatment is not necessary unless you consider it to aid the spatial illusion.

C. *Dynamic implications of skeletal and mass shape characteristics*

The work described here is intended to call upon all your inventive resources; it will also utilize the knowledge you have already gained about the pressures and forces which are implicit in the configuration of skeletal and mass structures.

Try to visualize the most ferocious and forceful *claw-like* shape imaginable. In terms of both definition and function such an object is essentially skeletal, and calls to mind pincer movements of great thrusting power. The lines of drawing you employ should convey this kind of force—the angle of thrust and the swell of closure and grip. There should be a turbulent quality to your drawing; you should be able to feel the strength of its piercing grip merely by looking at the work. You may use any combination of media and drawing instruments. Also, if it comes naturally in the process of drawing, by all means complement the linear structure by letting the ink (or whatever medium is being employed) spread to form areas of stain.

Paul Edmonston's *Organic Forms* (Figs. 5-44 and 5-45) show skeletal characteristics exploited to their maximum in terms of thrusting, grasping energy. The drawings are so physically and psychologically powerful that it is difficult not to be overly influenced by them. But do try to invent your own version of a sharp and clasping form.

After grappling with the linear and angular thrusts of claw-like forms, then move to the opposite kind of dynamic shape: that of the swelling pressure forces of mass and volume. Again, you should trust and enjoy your own imaginative responses; experiment freely, first with line alone and then by combining line with area stain.

An apt expression to describe the shape that may result here is *embryonic cluster*. An embryonic cluster is a grouping of egg-like, oval configurations which are bound together dynamically into some kind of composite form. You can imagine—without visual reference—how such a structure will differ in its physical appearance and its energy characteristics from that of a claw-like figure.

The problem here, then, is to construct an embryonic cluster—a mass, composite form—in such a way that the general sense of "oval pressurization" is credible as a force: one which basically is contained and therefore relatively equilibric, even though the overall dynamic is one of strong pressures and near turbulence. Start by working with line alone. Through their expansive turning in space, lines of curvilinear swell represent the contours of oval volumes. Relate oval to oval in such a way that they comprise an organic whole: graphically in terms of linear continuity, as part overlaps or interlocks with part; and dynamically in terms of a balance of pressures as embryonic segments cohere to form the cluster. Do not be surprised if from time to time in the process of designing, point

Figure 5-44
Paul Edmonston, Organic Form 1972. Pen and ink on paper.

Figure 5–45
Paul Edmonston, Organic Form II, 1972. Pen, brush, and ink on paper.

Figure 5-46
Betty Peebles. Studies 1973. Pen and ink on paper.

Figure 5-47
Paul Edmonston. Organic Form III, *1962.*
Pen, ink, and brush on paper.

thrusts and angles appear as you explore, in drawing, the possibilities of shape interlocking with shape. This is inevitable as lines of force carry through from curve to straight in the structuring of the cluster. Fill a page with such visualizations: drawings which, like those you see in Betty Peebles' *Studies* (Fig. 5-46), have an engineering-like, exploratory precision to them.

. Now go a stage further and attempt to intensify the dynamic tensions suggested by the word "clustering." Study Paul Edmonston's *Organic Form* (Fig. 5-47) as an example. The force which binds the embryonic units together—or, conversely, may force them apart—is suggested in two ways: first, by introducing a slight spatial separation between the oval units; and second, by turning a pure line drawing into one in which area spreads of stain add three-dimensional weight to each part and three-dimensional depth to the ground. With the spread of stain—as a wash—tonal values are thus introduced into the drawing—a factor which aids substantially in increasing the sense of weight and volume.

The simple lesson to be learned from this is that when figure assumes weight, and grounds takes on depth (as a result of developing area and tone value), the dynamic impact of the drawing is strengthened. This is because mass and space volumes are, in themselves, forceful and energy-laden (as opposed to flatter shapes that are simply outlined against a flat, toneless ground) and so artists will impart an overall "weightiness" to figure and ground when they desire a dramatic and powerful effect.

Select one of the embryonic shapes from your page of drawings and intensify the stress factor by redesigning it in the ways we have just discussed: by amplifying the volumes of mass and space.

D. *Dynamic implications of the shape characteristics of planes and curved surfaces*

Earlier in the chapter we discussed how the structural layout of an object's surface—plane or curved—suggests the nature of the active forces and pressures responsible for its shape. Now you are going to directly visually encounter the dynamics of surface.

Take a sheet of aluminum foil and by alternately crumpling and folding it model it to resemble a mountain range. Aluminum foil is extremely pliable, and thus lends itself to the formation of both angular planes and swelling curved surfaces. When you have finished you will no doubt be aware of the types of force you yourself brought to bear in

order to create the form: Pinching and poking with the fingers produces thrusting points, angles, and planes, whereas stroking distributed over an area results in a curved and swelling surface. The forces at work on the land are essentially the same and result in similar surface variations.

Figures 5-48 and 5-49 are photographs of modeled foil—one taken from a distance and deliberately slightly out of focus—which show how easily the aluminum model can become a dramatic range of mountains with a complex surface configuration.

First create the model; then transform it, through drawing, into a whole mountain range. This is painstaking work, for the drawing must show how keenly you have analyzed the relationship between surface structure and the types of force that have produced it. Angles and planes should be organized around the dominant points of thrust; and curved surfaces must fit coherently into place, indicating in graphic terms the positional impact of the different sort of pressure which produced them.

Figure 5-48
Ruth Carpenter. Crumpled Aluminum Foil.

Figure 5-49
Ruth Carpenter. Crumpled Aluminum Foil.

Figure 5-50

Work to make your drawing a dynamic tour de force—an image which bears witness to the power of natural forces and to the plasticity of the land. Hopefully, your model will be dramatic enough to inspire a really powerful "force drawing" in which each plane and curve carries a dynamic charge of thrust or swell. Use either pencil, or pen and brush with ink—instruments which permit a detailed analysis of surface organization as you draw. The effectiveness of the image—as you see in Figure 5-50—depends on maintaining a clarity of surface structure.

E. *Reducing the forces in landscape to linear systems*

This exercise is quite brief. First you must find a small-scale but interesting region of landscape—one in which the topography is rolling or "up and down"; where rocks abut, break through the earth, or are piled; where trees or bushes lean against the wind; or where streams course. In other words, find an intimate corner of dynamic interest, perhaps something like the situation you see in Figure 5-51.

Take pencil or pen and sketch the scene quite naturalistically, as if you were out with a sketch book to make a few quick landscape notes for future reference. When you return to the studio or to your room, study the drawing you have made and reduce it, in your mind's eye, to a *diagrammatic presentation* of the forces and pressures which are responsible for the overall "design" of the setting. By now you should be familiar with the repertoire of lines which indicate the principal types of forces and pressures at work, and so it should not be difficult to create a linear abstraction which relates to the "force structure" of the corner of landscape observed. You should, of course, take into account in this linear interpretation the forceful shape characteristics of objects no less than the topographical dynamics of angle and swell in the land itself. Do not forget the motion through space of storm, tempest, and light. Figure 5-52 shows an abstract image derived from an analysis of such landscape forces.

Figure 5-51
John Albaugh. Dynamic Equilibrium.

Figure 5-52

F. Landscape in transition—Struggle between equilibrium and turbulence

Now call upon your powers of imagination. Following up on the previous landscape exercise, let us see how you can apply abstract and diagrammatic theory in a creative way by making two drawings in which the force factor is almost "electrically" alive.

Using a horizontal format, and drawing with pen, sharpened twig, or brush and ink, invent a landscape in which every dynamic possibility is present. Structure the topography and the growth patterns of living things in such a way that the landscape appears to be trembling with an energy so vital that you would only step into it with the greatest care— and hasten through it before its fragile equilibrium is lost. Employ every graphic means you now have at your disposal to try to achieve this result.

Then make a second drawing. This should not simply be a variation on the first, in which the same landscape is shown, but is subject to different forces. Keep the same horizontal format, however—it allows you to work with a greater spread of land—but now conjure up a new topography: one in which stability has given way to turbulence. Imagine that a combination of volcanic, electrical, and atmospheric energy systems have ousted harmony and balance, and that everything is on the move. The situation your drawing should describe is one of landscape in transition: an old organic order giving way to a new.

Again Paul Edmonston's drawings illustrate the variations in compositional vitality just described. Study his two landscape drawings—Figures 5-53 and 5-54—to gain a little inspiration before embarking on your own voyage of graphic discovery. Should you need to see a landscape drawing in which relative equilibrium and stability are achieved—in order to learn from the contrast—then look at Edmonston's *Rock Landscape* reproduced in Figure 5-55.

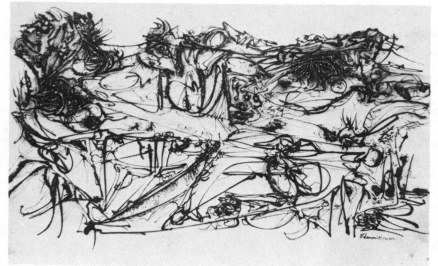

Figure 5-53
Paul Edmonston. Landscape 1972.
Pen and ink on paper.

Figure 5-54
Paul Edmonston. Landscape
1966.
Lithograph.

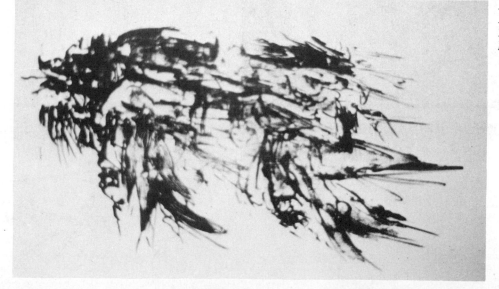

Figure 5-55
Paul Edmonston. Rock Landscape *1965. Pen and ink on paper.*

Figure 5-56
Paul Edmonston. Organic Landscape *1969.*
Pen, brush, and wash on paper.

Figure 5-57
Paul Edmonston. Falling *1962.*
Pen, brush, and wash on paper.

G. *Landscape in transition—Stability and instability of stratification forces*

These drawings can follow any format and be to any scale you wish. The choice of medium or media is also yours. Consider using a combination of line and stained areas with their tone values to provide the right sensations of mass and weight.

Simply make two drawings based on the phenomenon of geological stratification—one stable, the other in the process of collapsing. In other words, imagine a section through the earth made up of layers of rock, loose stones, boulders, deep-thrusting tree roots, gravel beds, and so on. Let the first drawing show a design which is essentially stable in that all is firmly held in place. But let the second drawing introduce weaknesses and flaws in the pressure relationships, causing the stratified structure to collapse and the land to fall.

Paul Edmonston's *Organic Landscape* (Fig. 5-56) and *Falling* (Fig. 5-57) provide strong examples of how changes in the angular juxtaposition of the various units, and in spatial composition, create such dynamics of stability and instability.

Produce these two drawings in any way you wish, and to any scale. The situation is as follows: Suppose you are a professional artist called upon to produce two set designs for a contemporary operatic production. The first of these is to set the scene for the act which takes place in the underworld—the kingdom of the dead, the shades, over which Pluto reigned. The second set is to represent the intermediate region between the underworld and earth—a place where the hero must rest on his return if he is not to be destroyed, and where the spirits of the dead must now leave him to find his own way. Which of the two scenes will be best served by a design in which thrusting points and angular planes predominate; and which one where sweeping curvilinear pressures and curved surfaces prevail?

With this problem we now encounter a new aspect of compositional dynamics: the balance of equilibrium and the stresses and strains of turbulence, while being perceived as physical states, also work expressively to stand for psychological ones. Hence, the choice of point or curve dominance in the design of a set will determine the emotional quality of the particular act—the mood and feeling which is part of the drama. Bear this in mind when you make these drawings. Once more, turn to Paul Edmonston to see the physical dynamics of curve and point in action, and to pick up the mood engendered by his two untitled drawings shown in Figures 5-58 and 5-59.

Figure 5-58
Paul Edmonston: Untitled 1972.
Pen, brush, and wash on paper.

Figure 5-59
Paul Edmonston. Untitled 1962. Charcoal.

Figure 5-60
Claude Lorrain. View from Monte Mario *ca. 1640. Brush and brown wash.*
THE BRITISH MUSEUM, LONDON.

I. *Visual Immediacy of area dynamics—Calm or storm*

Look immediately at two drawings (monochromatic paintings, if you prefer) which reveal the two basic ways in which stain may be spread to form area. Figure 5-60—the work of a seventeenth-century master of landscape, Claude Lorrain—is created almost entirely by the brushing in of areas. Figure 5–61. is a student's drawing made as a response to this exercise.

As you can see, composing by area as opposed to composing solely by line produces a strong and immediate visual impact. As we have noted previously, an area spread of stain endows both figure or ground with a degree of volume, and this in itself imparts the suggestion of weight and three-dimensional tension to the image.

In *View from Monte Mario* (Fig. 5-60), the rounder tree volumes occur where both light and dark values are present in a stained area. Space itself will also assume a three-dimensional vigor when tone values are strongly contrasting.

All the characteristics of area stain we have previously mentioned are present in both drawings. But in Figure 5-61 the long, angular thrusts of stain push diagonally to disrupt vertical-horizontal stability. Whereas in Figure 5-60 the stained areas form rounded swells of tree, and tend to follow a more stable, horizontal organization. See what other compositional principles you can discover to account for the calm or stormy character of each image.

Having thus briefly analyzed these two works, now make two drawings using brush and ink in varying concentrations. Areas of stain alone should form the composition. Do not use conventionally drawn lines; merely let the edges of brushed stain act as line and edge together.

Use the theme "Trees and Reflections." One drawing should represent calm, the other storm.

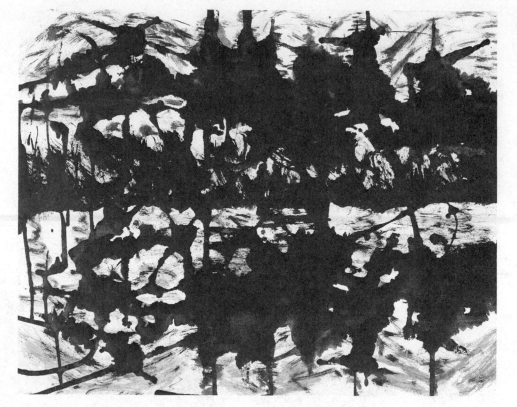

Figure 5-61

IN CONCLUSION let me present a "homemade" triptych—three of Edmonston's drawings reproduced as a single panel in Figure 5-62. These are images signifying the *Energies of Growth,* the *Irresistible Force,* and the *Motion of Flight,* subjects you might wish to use for future drawing of your own. But here they comprise a visual postscript—a final reminder of how alive a work of art can become when the plasticity of figure-ground composition is understood and brought into play.

Figure 5-62
Paul Edmonston. Triptych 1972. Varied media.

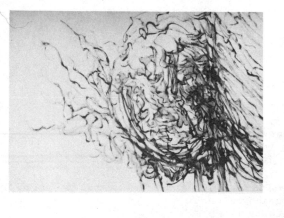
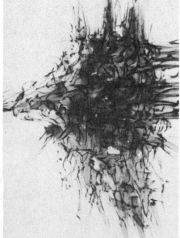
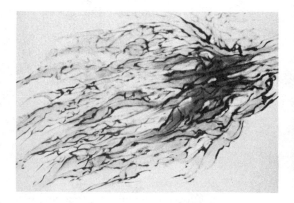

II
Optical Dynamics and Illusions

This section is a brief introduction to a particularly energetic form of art known as Op (short for Optical) art. Op art is a style which thoroughly exploits the mechanics of visual perception and the fact that visual awareness depends upon a clear recognition of what is figure and what is ground. Look at Figure 5-63, Bridget Riley's *Current,* to see what I am getting at.

Obviously, some strange things happen when a figure-ground situation is cleverly manipulated to confuse the eye. In this case, the grand illusion is that we are facing a surface which seems to be permanently in a state of motion—up and down, side to side, and in and out: a true, tridimensional vitality. How is it achieved? The eye is given a little too much to do because a great deal of figure-ground activity is concentrated in the space available. Knowing that our eyes have a strong tendency to follow the run of a line—and also to string points mentally together to form a line—Riley gives us a multitude of lines to follow. Knowing also that the longer and more unbroken the line, the more hypnotically the eye will follow it, she ensures that her lines possess this quality in order to help us become optically mesmerized. In addition, remember that when the linear flow is strictly vertical and horizontal, we basically have only to cope with two dimensions of movement; but when a diagonal direction

Figure 5-63
Bridget Riley. Current *1964. Synthetic polymer paint on composition board.*
COLLECTION: THE MUSEUM OF MODERN ART, NEW YORK. PHILIP JOHNSON FUND.

Figure 5-64

Figure 5-65

is taken, the sensation we receive is of the line cutting *in* or pushing *out*. This intensifies the sense of energetic movement in space, producing the seemingly concave troughs and convex ridges which Riley causes to appear in Figure 5-63.

Another compositional factor adds to this optical alchemy—that of fitting the marks of drawing tightly together in the kind of close parallelism you see in *Current*. The result of this technique is to further render the figure-ground situation ambiguous. What is figure and what is ground? Because of the uniformity of black lines and white spaces, we cannot tell which is which. Because we cannot cleanly separate figure from ground the eye—doing its best to visually clarify the situation—finds itself dazzled by the complexity of surface movement; by the shimmering effect seemingly given off by the image. In fact, the movement or pulse we perceive in the drawing represents the movement of the eye itself as it focuses and refocuses, trying to clarify things and present a clean-cut figure-ground situation.

Op techniques permit the artist to go beyond the dynamic possibilities made available by the compositional and graphic means we have been discussing throughout this chapter. They do this by causing the eye to work overtime and to transmit its own activity to the page.

Try one final drawing: an attempt, using Op methods, to set a page of your sketch book in motion. First analyze how the two student examples reproduced here—Figures 5-64 and 5-65—produce their three-dimensional pulse and, though not as frenetically active as the professional work of Bridget Riley, do, nevertheless, cause the eyes to tire rapidly with prolonged scrutiny. Then set to work.

THE HUMAN FIGURE

structure
and action

It is true, that it is inexpressive minutiae of execution and false nobility of gesture which pleases the ignorant. The crowd cannot understand a daring impression which passes over useless details to seize only upon the truth of the whole.

AUGUSTE RODIN

THE HUMAN BODY is an amalgam of parts which are determined by the major skeletal divisions of our structure and which work and flow together in our perceptions as a *whole*. Drawing the human figure—the nude—thus presents some special problems. It is all too easy, for example, to do one of two things: either to become slick in the use of drawing marks which, although sensuously pleasing in themselves, are inadequate in revealing the *overall* structural rhythms and the interplay of the parts; or to become obsessed with detail and to tighten the whole drawing up and thus loose the flow of the whole.

The most common difficulties experienced in drawing the nude seem to be:

- In grasping the relationship between the body's *volumes* and their skeletal underpinnings, so that the various parts come together in drawing to convey the sense of an organic, structural whole; and
- In rendering the complexity of body movement as trunk, limbs, and head turn through 360°, while at the same time maintaining a plastic credibility and imparting a life to the image which convinces both aesthetically and organically.

Any brief introduction to figure drawing must, therefore, concentrate on describing how an artist can realize broad structural principles while beginning to experiment with all kinds of bodily movement.

Several pictorial diagrams here illustrate a way to begin life drawing (figure drawing). The system is based on two assumptions:

210

1. That the body can be treated as a series of simple, elliptical volumes of varying proportions which reflect anatomical fact; and

2. That just about every body movement can be represented in drawing if the "hinging" method by which each volume may move independently is understood.

Figures 6-1 and 6-2 are diagrammatic representations of this simplified anatomical system seen from the front and from the side. Three principal trunk regions are defined: the bony mass of the pelvis, the rib cage, and the shoulder mass. Limbs, in the form of arms and legs become simplified into two elongated ellipses, each of which follows general anatomical proportions. Read the explanatory notes that are part of each diagram, and try to memorize these basic body shapes. It is important that they be imprinted on your mind, for they constitute our anatomical "grammar." The large dots represent the main pivotal points of the body. The spine is, as you can see, the articulated system on which the head and upper torso depend for any movement. To draw the figure in action—running, jumping, sitting, or just lounging—you turn any one of the body parts at these hinge points, through the illusory 360° of space offered by the ground.

Now let us turn to Figure 6-3. Here you see in motion the basic body volumes which were relatively static in Figures 6-1 and 6-2. Notice both the off-vertical and off-horizontal tilting that takes place as each body part swings on its pivotal point or points. Note also that the bony pelvis mass is the body's sheet anchor: the ultimate center of gravity. It remains fixed, the fulcrum for all upper and lower bodily movement.

One other important matter is illustrated in Figure 6-3—namely, the problem of *foreshortening*. As the body moves through 360° of space, so trunk and limbs change their shapes according to the positions in which they are seen. Consequently the simplified elliptical parts which we are adopting here must follow suit, if we are to draw the body convincingly in any conceivable position. When seen in a standing figure the thigh, for example, becomes a lengthy, elliptical volume: When positioned in such a vertical plane, with its full length exposed, we see it from top to bottom. But if the knee is brought up, this length disappears and we find ourselves regarding a thigh as a compacted, oval, almost circular volume. Such a change in elliptical character occurs because the thigh no longer occupies a vertical plane, but occupies space in depth. Once a limb penetrates three-dimensional space—which happens when it is no longer absolutely vertically or horizontally positioned—then its elliptical form becomes foreshortened. The degree of foreshortening depends upon the angle of space penetration. If the figure is immediately in front of us when the knee comes up, then the compacting of the thigh volume is total and we see it as a circular mass; but if we move to the side, so that we observe the new position of the thigh from a 45° angle, then the original ellipse will appear more oval, say halfway between a sausage and a circle.

You can see how this foreshortening works in Figure 6-3 where the foot and lower right leg are obviously moving backward in space. This effect is created not only by placing the foot itself higher up on the page, and thereby seemingly further back, but by foreshortening the ellipse of the lower leg. The limb here takes on a more oval shape, is positioned on the diagonal, and so apparently occupies space in depth. Notice also that siting the foot on a diagonal plane, and foreshortening its normal "triangularity," further the illusion of body movement in three dimensions. Similarly, by employing this technique, the right arm in Figure 6-3 pushes backward in space, while the left arm comes forward on the same angle of depth penetration.

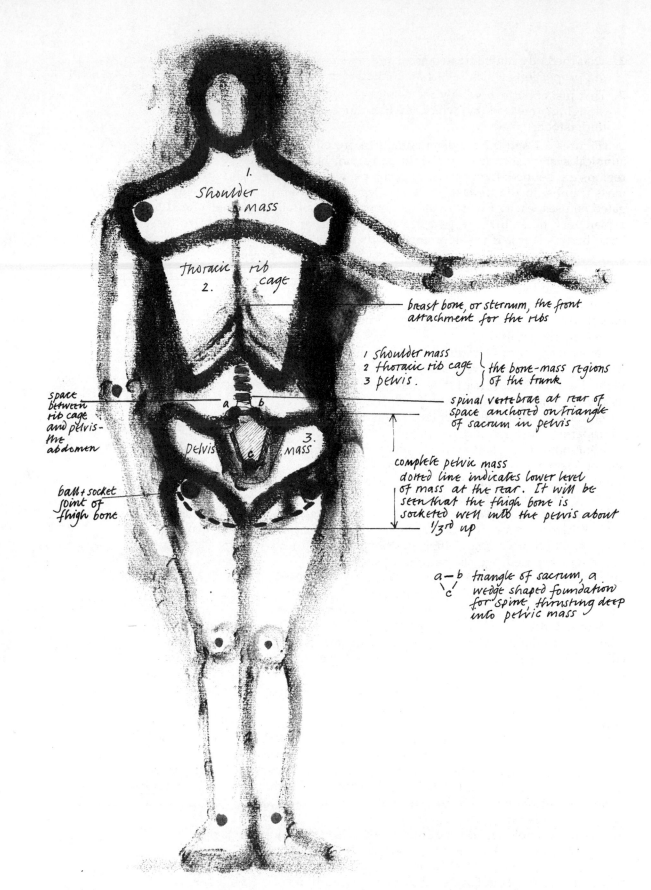

The labels and annotations within the figure are:

1. Shoulder mass

Thoracic rib cage 2.

breast bone, or sternum, the front attachment for the ribs

1 shoulder mass
2 thoracic rib cage } the bone-mass regions
3 pelvis. } of the trunk

space between rib cage and pelvis- the abdomen

a b

Pelvis 3. mass

c

spinal vertebrae at rear of space anchored on triangle of sacrum in pelvis

complete pelvic mass dotted line indicates lower level of mass at the rear. It will be seen that the thigh bone is socketed well into the pelvis about 1/3rd up

ball+socket joint of thigh bone

a—b triangle of sacrum, a
 \c/ wedge shaped foundation
for spine, thrusting deep into pelvic mass

Figure 6-1
Simplified Anatomical System: Front view.

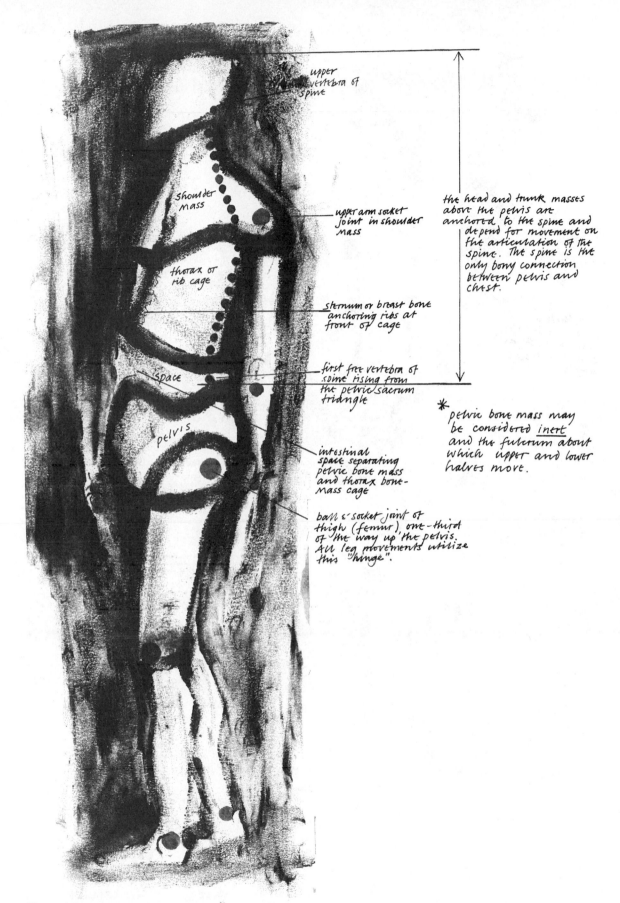

upper
vertebra of
spine

shoulder
mass

upper arm socket
joint in shoulder
mass

thorax or
rib cage

sternum or breast bone
anchoring ribs at
front of cage

space

first free vertebra of
spine rising from
the pelvic sacrum
triangle

pelvis

intestinal
space separating
pelvic bone mass
and thorax bone-
mass cage

ball & socket joint of
thigh (femur) one-third
of the way up the pelvis.
All leg movements utilize
this "hinge".

the head and trunk masses
above the pelvis are
anchored to the spine and
depend for movement on
the articulation of the
spine. The spine is the
only bony connection
between pelvis and
chest.

* pelvic bone mass may
be considered _inert_
and the fulcrum about
which upper and lower
halves move.

Figure 6-2
Simplified Anatomical System: Side view.

final vertebra of spine meeting bony mass of skull at rear of head.

upper arm joint in shoulder mass

the spine, taking with it the thorax and shoulder mass and head can move in any number of ways about its fixed point at the sacrum triangle

foreshortening throughout this line due to 45° penetration of depth

block of hand appearing large because of 45° head-on view

slight change of direction by lower arm at elbow

sacrum triangle, fixed part of pelvis.

bony mass of pelvis remains *fixed* – other parts of body move from it.

ball & socket joint of thigh bone in pelvis

NB. Points 1 and 2 represent two prime articulation joints in the body's skeletal frame

angle of foot determined by ankle joint

pelvis

head of thigh bone (femur) with neck and ball socketing into pelvis as at 1 above

Figure 6-3
Simplified Anatomical System: In motion.

Now move to Figure 6-4 in which the basic anatomical regions undergo further simplification into purer elliptical volumes, and in which the rib cage and shoulder mass are combined into one broad shape to facilitate rapid sketching. The pelvis becomes a circle, and the overlap between it and the unified upper torso relates to the abdominal cavity beneath the sternum or breastbone. The reason for "tidying up" the body in this way is simply to permit you to more easily put together *the figure in action*—to provide you with a system by which you can treat the body as an organic whole, and at the same time capture its spatial maneuverability. Drawing the figure in this way, using

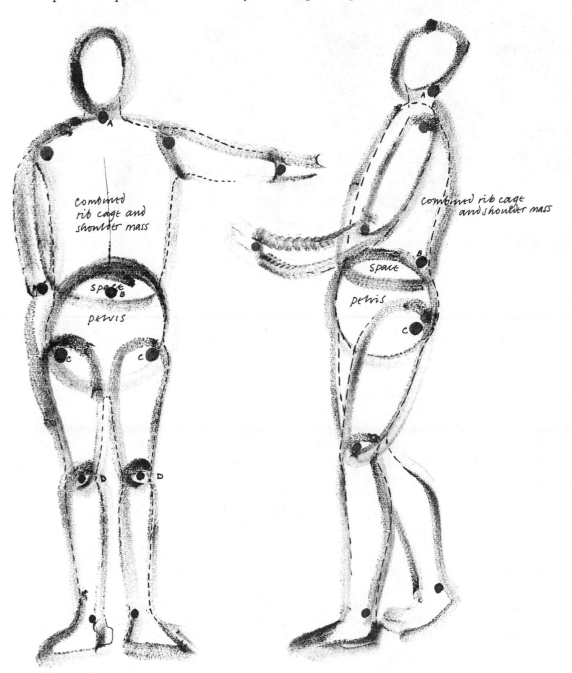

Figure 6-4
The anatomical mass regions reduced to rapid-sketch forms. Four major points of articulation and movement are: A—neck and upper vertebrae; B—pelvis and trunk; C—thigh bone (femur) forming ball and socket joint with pelvis; and D—knees.

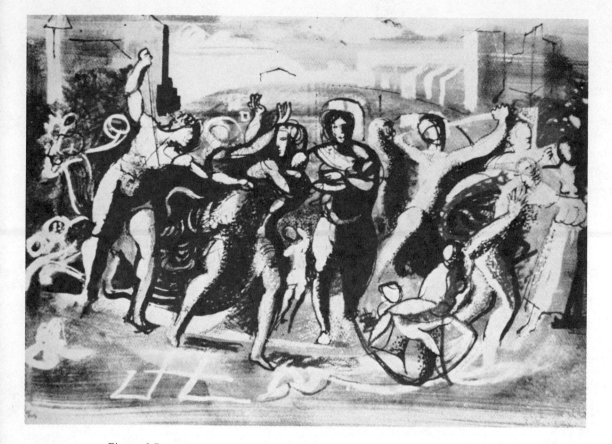

Figure 6-5
John Piper. Raphael: Massacre of the Innocents *1951. Ink and wash.*
COURTESY OF THE ARTIST.

elliptical or quasielliptical formations, allows you to overcome the two funda-
mental difficulties mentioned previously—namely, maintaining the unity of
the body's structure and rendering the subtlety of its motion.

Study John Piper's *Raphael: 'Massacre of the Innocents'* (Fig. 6-5) to determine
for yourself how this artist has made use of the simplified anatomy of vol-
umes. The overly diagrammatic separation of parts we employed has, of
course, no place here. But the figures are put together, and their violent action
realized, through the expressive and skillful application of elliptical volumes
similar to those we have been discussing. Rodin's "daring impression which
passes over useless details . . ." applies completely to Piper's ink and wash
drawing.

WORKBOOK

For this chapter, simply explore the possibilities of drawing the human figure for your-
self and discover how you can make the system described work to your own satisfaction.

Be prepared to use many sheets of paper. The only way you are going to develop
facility and freedom of expression is through practice, practice, and more practice. It may
be necessary to draw fifty figures in the beginning in order to get one that satisfies you.
In trying to learn and assimilate the correct "formula" here, constant practice works best
to help you grasp the technique.

You should, then, just go ahead and draw. Cover numerous pages with figures in
action, exercising your imagination to discover all the possible positions into which the
human body can get. Do not be concerned with producing any particular order on the

page itself, although you may find that, automatically, the figures group themselves—in the way you see in Figure 6-6, a sheet of quick studies prepared to illustrate this point. The important thing is to really experiment in throwing the body around, as you see in Figure 6-7. Try to get the hang of foreshortening thigh volumes when the figure is sitting, or limbs and head when they are moving in planes in depth and are not strictly positioned on vertical and horizontal planes.

Scrutinize these rapid little sketches thoroughly to determine where movement in depth has occasioned the foreshortening of a volume. Use any drawing instrument and medium you wish; or, alternatively, experiment with a variety of combinations. Various sorts of pens and brushes have been employed in the chapter illustrations you have observed. In some cases a finger simply smeared with black tempera paint was successful; as a finger glides over the paper it can make incisive definitions, and often in the right places!

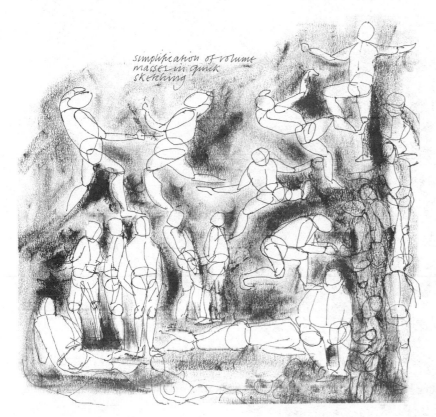

Figure 6-6
Diagrammatic studies of figure in motion.

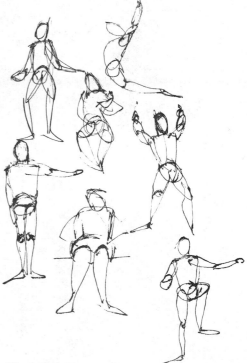

Figure 6-7

IN CONCLUSION look at Figures 6-8 to 6-10. These three drawings are the work of students who commenced drawing from a live model after spending only a couple of hours on theory—that is, after working with the simplified anatomical volumes introduced in this chapter. Although all three draw in a very personal way, and employ different means and media, nevertheless you can see that they have all grasped the essential structural unity of the body. In Figure 6-10, the simple outline employed takes the configuration you see because, in the mind's eye, the artist was perfectly aware of the *volumetric* masses her line was describing.

Figure 6-8

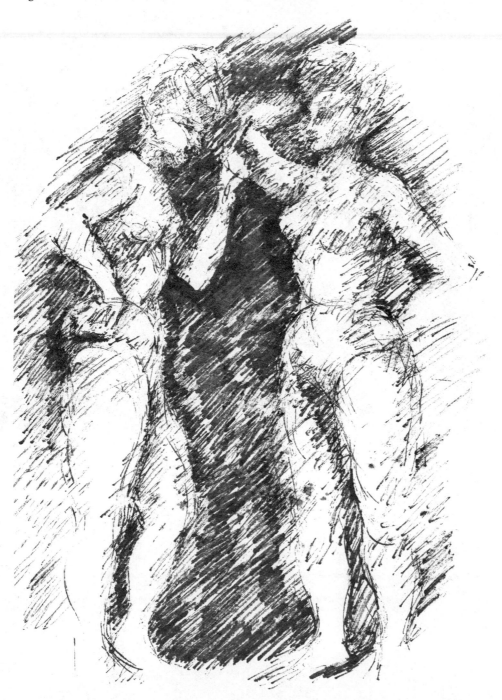

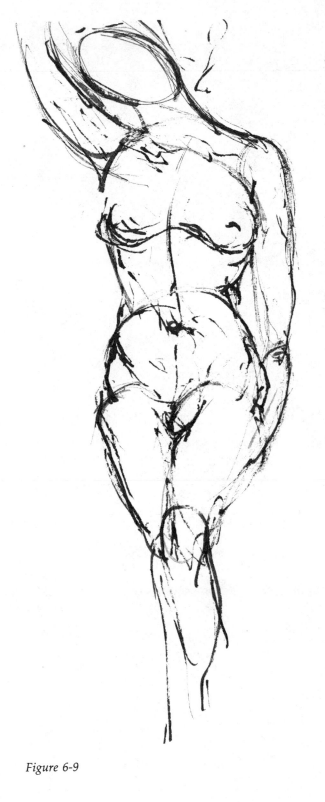

Figure 6-10

Figure 6-9

VISION

the creative factor

PART TWO

The study of nature is not a necessity, though the love of nature may be such. Nature is for the workman simply a dictionary, however well beloved and inspiring, to which he may go for reference when necessary or when he chooses . . . It behooves the workman therefore to beware of making things which savour not of the mind but of the senses . . .

ERIC GILL

A WORK OF ART is the means by which we recognize the person, the artist who is in the work, the shape of his or her mood, anxieties, joys, hopes, and intuitive insights. My old friend, the late English art critic Eric Newton, often used to talk about "la vie intérieure" (the inner life) when discussing the wellsprings of creative experience. In his novel *Mes Haines* (My Hates), Emile Zola wrote: "In the picture (the work of art), I seek, I love the man, the artist. . . ." All of these comments simply stress the importance of an artist's personal *vision*.

We use the word "imagination" a great deal in this second part of the book, but we use the term "vision" in the title because—although it is practically synonymous with imagination—its semantic implications are more focused. Vision connotes those occasions in ongoing imaginative experience when a creative breakthrough occurs: when we find ourselves caught up in the fervor of discovery and aroused by the insights gained.

Central to our understanding of the visual arts is the realization that such images do not exist merely to replicate the visible world, but also to manifest a new kind of graphic or sculptural reality—a handling of elements (as we have seen) which produces the physical character of the painting or of the sculpture. Perhaps the most important factor responsible for the design of this new and created form is the attitude of the artist—the way this particular human being feels and thinks about his or her existence in relationship to life's events.

Nowadays we believe that the cave paintings and sculpture of the Old Stone Age introduced a magical element into life. The artists were actually *re-creating* objects and events of a hostile world that were of supreme importance to survival; in so doing—as artists, hunters and shamans—they inevitably invested the images with a human imprint: the hopes, fears, and needs of the community. In this way, the practice of art allowed people to participate in the life of nature—not as victim or outsider, but as a force influencing events. This was achieved because the works of art represented *transformations* of the natural scene brought about because nature became modified into forms shaping human needs. The life of the animals became subject to human aspiration—to the psychic energies of feeling and thought which drive the imagination. Through art a new and more complete way of life came into being: the individual as subject and nature as object.

It is thus not difficult to understand why the practice of art as an outlet for the forces of mind would be considered magical. It was probably the first tangible way in which concepts and feelings were recorded and exercised in a positive manner. As painting—so we think—became a ritual, a performance carried out by the wisest of hunters or shamans in secret and sacred places, then human sentiments and ideas took on a particular authority: They became means of seeing "into" and affecting the very forces behind the object-facade of life. When a Paleolithic artist caused an animal to materialize on the cavern wall, expressively vitalizing stance and movement, the creature was under the artist's creative sway; and when it came time to hunt, the transference of that power to the chase must have given the hunter much-needed psychological confidence. After all, in forming the animal's likeness the artist-hunter had controlled its every movement, had thus possessed it, and in so doing had commanded life itself.

This *participation mystique*, probably the principal reason for making those powerful Paleolithic animal paintings, shows how persuasive were the forces of mind even thirty thousand years ago. To talk about the imagination, then, is not to refer simply to odd flights of fancy—a connotation that seems to have developed in today's suprarational climate—but also to the activity of an inner mental life which is always with us: our "felt thoughts" as Herbert Read put it—that process of imagining by which we determine what is important and what is not; and by which we come to assess the "reality" of the world. Cave art is the earliest record we possess of the human imagination in action in this way; many thousands of years passed before such expression took the form of written statements.

Like our Paleolithic ancestors we still live by force of imagination. In so doing we recognize that creativity is a subjective process which, at its most effective moments is, in the words of Carl Jung, capable of "giving shape to a secret." The odd thing is that the secrets revealed are sometimes so universally relevant that they surpass their personal origin and have significance for us all. These secrets are nothing more or less than our deepest thoughts and feelings.

It is not strange, therefore, that although we live in "modern times," we recognize certain Paleolithic paintings as masterworks. This is not because they are superbly executed, or display the keenness of eye and sureness of hand which you can see if you turn back to the frontispiece. We demand more of art than this. What essential quality is it, then, that we, so much more advanced in time and in technological—as opposed to psychological—"magic," recognize?

We must attempt to answer this question—however superficially—because the aim of this second part of the book is to encourage you to cultivate and trust your own feelings and ideas, and to use drawing as the vehicle for shaping them. It is easier to do this if you are aware that both a cave painter and a Rembrandt have one thing in common: their work carries a personal stamp, the conviction of a personal attitude to life, put down with certainty and confidence. You can learn to *exercise* imagination—to listen to yourself and thus to become aware of the emotions and thoughts running in your consciousness. You should gain the confidence to do this if you realize that even though the content of your work is determined by such personal attitudes, the rest of us can still experience its effect, across time, because to some extent we share common aspects of the human condition. Given the extraordinary range of forms with which art presents us, we have ample evidence to show how actively personal imagination has driven artists throughout history. Yet, we know too, that we have been able to relate to such varied images on a number of different levels, not the least being the fact that we catch a glimpse of another human being's response to life.

Part One stressed that any act of visual perception depends on the presence of figure on ground; and that when we create a drawing we start building a figure-ground situation with the impression of the first mark. All our earlier work was designed to promote familiarity with the formal elements which fashion the graphic image: the characteristics of basic drawing marks and staining media as well as the compositional problems that evolve as the figure-ground phenomenon develops. The emphasis was almost entirely on how to handle the *formal structure* of a drawing. Now we are going to concentrate on the imaginative *content* that such structure manages to embody: on the personal nature of the artist's statement.

Works of art are often divided into two distinct parts—*form* and *content*. But form is the shape taken by content as it is tangibly embodied in an image. Even when we find ourselves responding to a piece because we are taken by its physical appeal—its purely visual qualities—we are actually responding to the way the artist's intentions (the content) were served by the configuration. A work of art transmits on two levels—the sensuous and formal, and the imaginative and psychological. It is difficult for the observer to tune into one without receiving the other. Any image transmits on both levels simultaneously, although one signal may be stronger than the other, depending on whether the artist has concentrated on the shapeliness of the work—shape for the sake of shape, if you like—or has urgently conveyed content at the expense of formal clarity.

Therefore, although we now turn the spotlight full onto content and meaning in art, and try to both discover and apply one or two "laws" of visual imagination, we are not about to turn our backs on the formal aspects of figure-ground composition. Obviously, the physical organization of drawing as we have been describing it constitutes the vital means to the end: It carries the content.

Picasso's toad (Fig. II-1), emits equally strong signals of both form and content. The sensuous textures and oval, linear rhythms, visually intriguing as form, hold the eye as new musical rhythms and textures hold the ear. The viewer becomes tactilely involved, imagines feeling the toad. But at the same time the viewer also becomes aware of a less tangible quality—an elemental grandeur of "toadness"—as if Picasso has discovered the archetypal toad from

Figure II-1
Pablo Picasso. Toad *1949. Lithograph.*

which all other toads are descended. Obviously, imagination is at work, triggered by the nature of the formal design; the viewer shares some of the artist's obvious fascination for the bejeweled, slimy creature he has invented. This toad is eerie testimony to the mutability of living things and the mystery of time's span. Was all this going through Picasso's mind as he made this lithograph? We really cannot say. To some degree, then, content lies in the mind of the beholder. Often the artist prefers not to talk about content, and understandably so. He or she can become too cerebrally introspective, and intuitive inspiration can dry up. Then it is not a matter of vision but of self-consciously struggling to be original.

This, of course, is the problem we face from now on. What we depend upon words and contrived situations to initiate here should eventually happen naturally. Ultimately, you should draw because you feel a *need* to draw, and your images should materialize of their own creative volition.

Look again at Picasso's toad, and notice one final point: The toad in nature has undergone considerable transformation to become the toad in the drawing. The remaining chapters try to explain how and why transformation of one sort or another invariably occurs when a natural object becomes the inspiration for a drawing.

Finally, in Chapter 9, we must examine the genesis of totally abstract images which, apparently, owe little to the presence of natural objects. Here we have to suggest that the imagination works more independently, that perception of things in the world plays less a part than an internal capacity for free, visual invention.

IMMEDIATE AND DEVELOPMENTAL VISION

7

It should not be hard for you to stop sometimes and look into the stains of walls, or ashes of a fire, or clouds, or mud or like places, in which . . . you may find really marvelous ideas.

LEONARDO DA VINCI

I
The Momentary Recognition of Subject

How many of us would notice the strange face emerging from the bark of an oak tree, as it appears in Figure 7-1? The configuration you see in the photograph is a considerable magnification of the area originally observed—a region of only about 3 square inches, lost in a surrounding sea of bark. Its discovery by photographer Robert Nix provides an excellent example of what we call here the *recognition of subject*.

We spend our days taking in a great deal of visual information. In fact, about 70 percent of our behavior with regard to the world in general is in response to visual experience. Nevertheless, we take it very much for granted, using our eyes solely as fact finders rather than as the means to discover how the diversity and richness of the world affects us imaginatively.

Leonardo would have approved of Nix's use of the camera to aid such searching, because of the camera's ability to focus on, and then record, the fragment of bark which the artist's eye had discovered in the first place. After all, the photographer was following Leonardo's advice to "stop sometimes and look . . . [and] find really marvelous ideas."

But what exactly is Leonardo talking about when he suggests that a painter, with no particular subject in mind, might discover a theme by regarding the random form of clouds, or stains on walls? He is simply recounting the sort of experience that, nowadays, is sometimes described as "moments of heightened perception." The photograph in Figure 7-1 represents such an occasion.

226

Figure 7-1
Robert Nix. Fragment of underlayer
of oak bark, *enlarged.*

Moments of heightened perception are not always with us. Most of the time we are content to observe things simply to identify them, position them in space, act with regard to their presence in such a way as to satisfy prevailing existential needs, and then file the information away. Such is the nature of a normal act of perception. But moments of heightened perception seem to occur when we are *unusually* mentally receptive, ready (consciously or unconsciously) to exercise our imaginations and to advance a little further in understanding ourselves in relation to the world. When these internal conditions apply, our senses seem to become keener to serve; and the visual sense in particular is likely to regard the world more acutely, and to discover aspects of it which suddenly assume significance. These new vistas—whether minute or on a grand scale—are significant for one, fundamental reason: They present an external form into which we can imaginatively project ourselves. They have the capacity to not only invite imaginative response, but also to shape it:

> . . . I have always paid great attention to natural forms, such as bones, shells, and pebbles, etc. Sometimes, for several years running I have been to the same part of the sea-shore—but each year a new shape of pebble has caught my eye, which the year before, although it was there in hundreds, I never saw. Out of the millions of pebbles passed in walking along the shore, I choose out *to see with excitement only those which fit in with my existing form-interest at the time* . . . [Italics added.]

Earlier in the same essay, the sculptor Henry Moore writes:

> The observation of nature is part of an artist's life, it enlarges his form-knowledge, keeps him fresh and from working only by formula, *and feeds inspiration . . .* [Italics added.][1]

The experience of heightened perception is as Henry Moore describes it. When one is on the lookout, certain forms stand out from the rest. Their shapes assume physical significance because they act as catalysts—they arouse those "felt thoughts" which comprise the substance of the imagination. An interesting question now arises: Do such perceived forms become important because they embody an idea which is already present in mind, yet not quite at the conscious level, and therefore, by their presence bring it fully to consciousness? Or do they, by their very "shapeness," cause a totally new mental insight to spring into being? When Henry Moore talks about fitting in with an "existing form-interest at the time," he is suggesting the former; but when he says "feeds inspiration," he implies the latter.

Yet it really makes little difference in the long run which way the process works, for in the end the result is the same: a new level of thought and feeling which becomes shaped as a work of art—Leonardo's "marvelous ideas." What is the difference, then, between the experience of heightened perception which brings a subject to mind, and the imaginative phenomenon described as "vision"? The matter is one of both *intensity* and *quality*: the degree to which one is moved by the insights gained, and how significantly one regards the new train of thought. The painter and critic Roger Fry considered that moments of vision give access to "the substratum of all the emotional colors of life . . . something which underlies all the particular and specialized emotions of actual life."[2]

When an event takes on such intensity and quality, consciousness can be completely taken over and the artist can be driven relentlessly to action under the complete influence of vision, or what Henry Moore describes as inspiration. (In my view, the terms are synonymous.) Strictly speaking, therefore, although moments of heightened perception represent a positive gain in sensibility, and permit one to recognize the *potential* importance of a theme or subject, they do not necessarily reflect the deep insights which drive the artist to create the appropriate form—the inspirational condition Michelangelo described as "a creative fury."

We are not going to reach such levels here. We discuss the phenomenon of vision in general terms, and examine a visual example of how such inspirational activity manifests. Then we demonstrate the link between seeing and imagining—or imagining and seeing—at the lesser levels of heightened perception. After all, to discover that feelings can be aroused and trains of thought set in motion by a visual stimulus is perhaps the first step in attempting to encourage and develop the full imaginative potential of vision.

Figure 7-2 is an outstanding example of creative vision. Not only is the painting visually compelling, but the circumstances which led to its materialization—and to others like it—are well known to me from firsthand contact with the artist. Some years ago, the artist, the late British painter Graham Sutherland, experienced a situation very similar to the kind of thing we have been discussing—an event that led to the now famous series of Thorn Tree images. One day a common thorn bush, which the artist had passed by with-

[1]Henry Moore, "Notes on Sculpture," *The Listener*, 18, 1937, 449.
[2]Sir Herbert Read, *The Meaning of Art* (London: Faber & Faber, 1946), p. 64.

Figure 7-2
Graham Sutherland. Thorn Trees 1946. *Oil painting.*
COLLECTION: THE BRITISH COUNCIL, LONDON.

out notice on numerous walks, detached itself from its surroundings and demanded the painter's attention. (A sudden "stepping forward" from its context by an immediately perceived and newly significant object is a mark of heightened perception.) For the first time, Sutherland found himself examining the thorn's structural complexity, the sculptural precision of its parts, and the weave of space shaped by its limbs and spikes. He made many exploratory drawings to analyze and understand each important physical characteristic. At the same time he was aware of other, sympathetic sensations: He felt the sharpness of the thorn without having to touch it, as well as a more general physical pain, as if he were trapped in the bush. Also, a chain of thought was set in motion: He formed associations of ideas concerning thorns which ranged from mental images of the shrike—a bird which impales its victims on the thorn—to crowns of thorns and crucifixions. He finally came to reflect on the constant presence of pain and suffering in human life.

In this way, the long unnoticed thorn bush became the catalyst by which dormant and powerful sensibilities were aroused. The series of paintings which followed caught the public imagination and set Sutherland on the road to international fame. It would be useless for any other artist to take up the thorn motif without experiencing, for him- or herself, the inner meaning residing in the thorns. Such work would, more likely than not, become merely a picture of a thorn bush.

What do *you* make of Figure 7-2? As you see, the artist has reconstituted the thorn bush to suit his own ideas; it is no longer the natural object. In so doing he has created a puzzling image, thus forcing the viewer to ask ques-

tions about the meaning of the work. Is Sutherland telling us that life is an archway of thorns? Does the white, bone-like structure—weathered by time—indicate the age and indestructibility of the thorn and, by metaphorical allusion, the persistence of pain and suffering? This is the kind of thinking aloud that goes on when one faces an image of symbolic significance, which is what we face here. (We discuss symbolic transformation more fully in Chapter 8.)

At this point I would like to make a simple proposition: *Any act of heightened perception not only provides us with detailed visual knowledge of the form perceived, but inevitably ensures that we gain knowledge about ourselves due to the compelling nature of our response.* The last verse of William Wordworth's well-known poem, *The Daffodils*, illustrates what I mean. After three verses in which the poet provides the reader with a great deal of information about his encounter with the daffodils—their location, the state of the weather, and even their number ("ten thousand")—the fourth and last verse tells of the effect on the subjective life of the poet:

> For oft, when on my couch I lie
> In vacant or in pensive mood,
> They flash upon that inward eye
> Which is the bliss of solitude;
> And then my heart with pleasure fills,
> And dances with the daffodils.

Figure 7-3 is not a photograph of stained walls or of clouds; nevertheless, as a photograph of a cave wall it possesses all the features which Leonardo suggests will help to discover a subject. The markings are random, the figure-ground situation ambiguous. Despite the presence of point, line, area stain, tone values, and textures, it is still difficult to separate figure from ground and to identify things. Yet just take two or three minutes to stare fixedly at the rock

Figure 7-3
Paul Zelanski. Rock surface.

wall in Figure 7-3, and see what begins to emerge. You may discover animals, faces, the human figure, or you may conclude that you are looking down on the Snake river from 10,000 feet. The fact is that when the figure-ground situation does not yield immediate recognition of objects and spaces, we *mentally* impose recognizable forms on the vista presented. In the haphazard configuration of marks we find shapes, objects, and spaces that have meaning for us. (Consider the well-known Rorschach test. Faced with a series of accidental and meaningless inkblots, viewers are asked to state what they see. If they keep naming the same object the testing psychiatrist concludes that it, or something for which it stands, must be very much on their minds.)

When Leonardo says that "really marvelous ideas" may emerge from ambiguous visual situations of this sort, he is implying that our own subliminal passions and interests take form and so become recognized when we project them onto a figure-ground situation which, in itself, makes little sense. It is reasonable enough to suggest that when thus faced by our own intimate concerns, we find the ideas and feelings they embody to be marvelous.

What, then, do *you* see in Figure 7-3? How successful are you in imaginatively projecting yourself into the image? If you find forms there which provide a subject—whether it be a line of dancing figures or a couple of grazing animals—and if the subject is one with which you find yourself thoroughly involved, then you would be justified in describing the experience as one of heightened perception.

However, we should recognize that to rely on a photograph for this is somewhat limiting. Moments of heightened perception occur when the "timing" is right for an individual—when the mind has something to reveal and is seeking the form through which to say it; that might not be at this very moment. Also, the greater the variety of things seen, the better chance of discovering the significant motif or detail that stands out—like the face in the oaktree bark—and sets ideas and feelings running.

A lesser form of heightened perception is that which comes about through a relatively straightforward association of shapes—one thing visually reminding the observer of another. For example, Auguste Rodin's wash drawing, *Birth of the Greek Vase* (Fig. 7-4), shapes the female torso in such a way that the similarity between it and the amphora you see in Figure 7-5 is fairly obvious. The implication of Rodin's title is that the Greek potter found inspiration for this classical vase shape in the body of a woman. Yet we might argue that Rodin is the one who saw the formal relationship through an act of heightened perception, and shows it to us in his drawing. In any event, the two objects do show a common "shapeness." If it is necessary to go a stage further and demonstrate yet another "shape association" inspired by the vase—to architectural forms this time—then look at *Les Vases Doriques* by Amédée Ozenfant (Fig. 7-6).

Mary La Porte's *Rumination 9* (Fig. 7-7) provides an excellent example of how such shape associations work. Here is a swag of material, convincing in its highly realistic treatment, straddling what at first glance appears to be a cleverly structured spatial context. But is it? Does any particular subject come to mind once the figure-ground situation is visually clarified? We frequently make such associations, perhaps without being particularly aware that we are doing so. Nevertheless, such imaginative transference from one object to another can lead to amusing and bizarre results, as you see in Kurt Seligmann's *Ultrameuble* in Figure 7-8. The Surrealists, who were interested in showing how easily the reality of the everyday, familiar world can give way to the realities offered by the imagination, made good use of the mind's ability to associate one thing with another in this way.

Figure 7-5
Greek amphora *(675–650 B.C.).*
COLLECTION: THE METROPOLITAN MUSEUM OF ART,
ROGERS FUND, 1911.

Figure 7-4
Auguste Rodin. **Birth of the Greek Vase.** *Study for a kneeling female figure. Wash drawing.*
COLLECTION: THE METROPOLITAN MUSEUM OF ART, NEW YORK. GIFT OF
THOMAS F. RYAN, 1913.

Figure 7-6
Amédée Ozenfant. **Doric Vases** *1925. Oil on canvas.*
COLLECTION: THE MUSEUM OF MODERN ART, NEW YORK.
ACQUIRED THROUGH THE LILLIE P. BLISS BEQUEST.

Figure 7-7
Mary La Porte. Rumination 9. *1981. Pencil and wash.*

Figure 7-8
Kurt Seligmann. Ultrameuble. *Assemblage. Shown in the International Exhibition of Surrealism, Galerie Beaux-Arts, Paris, 1938. Destroyed in hurricane, Sugar Loaf, N.Y. 1949. From "The Art of Assemblage" by William C. Seitz.*
THE MUSEUM OF MODERN ART, NEW YORK, 1961.

233

7-I. Recognition of Subject

As you work through—or select from—the following drawing assignments, remember that at best they represent a contrived attempt to engage the imagination. Yet even if they are no substitute for "real-life" experience—for those moments of visual and mental receptivity when one encounters the myriad of stimuli the world has to offer—at least these exercises can be considered as studio practice to prepare eye and mind for the real thing. As Delacroix put it, talking about studio practice: "I am very sure that if Rembrandt had held himself down to this studio practice, he would not have either that power of pantomime or that power over effects which makes his scenes so genuinely the expression of nature."

Figure-Ground Discovery

Preparation of an active and variegated figure-ground situation is the most important part of these exercises. You are more likely to discover a subject when strong tonal contrasts are present, and when many diverse shapes of either ground or figure occupy the eye. With a page thus prepared, the process of discovering a subject becomes a matter of time and patience. Once you have identified the subject matter, adding the few marks of drawing required to cause the perceived form to fully materialize is not a difficult job, although it still must be accomplished with some finesse.

A. Random configurations using ink, glycerine, brush, and sponge

There are many ways to haphazardly produce a formation of marks on a blank page, and later you should experiment freely to see how diverse a random figure-ground image you can produce. But for this first attempt work with the equipment and materials listed in the heading. Use both concentrated and diluted solutions of black or sepia ink, and have a small saucer of glycerine on hand. Glycerine is a water repellent, so ink washes break up as they are applied over "glycerined" areas, and produce textured and odd runs of the stain. You need very little glycerine to do this—merely a light film on the edge of the sponge.

Work over an area of paper approximately 15"×11". Start by dabbing a "glycerined" sponge here and there on the paper, and from time to time wipe the glycerine over larger areas of the surface. Do this quite unthinkingly—on impulse—but avoid over-application. Leave at least two-thirds of the surface untouched.

Now pour a large pool of concentrated ink anywhere on the page to cover an area no smaller than 3"×3". Encourage the ink to run by tipping the paper in one direction and then in another. Take the largest brush you have and steep it with the diluted stain. Then use it to pull or push the large, dark pool here and there over the page. Just use the space available without having any specific design in mind. But remember to *leave about one-third of the page white,* for contrast. Keep everything as damp as you can at this stage. (The glycerine will also retard the drying.)

Certain dark and light tones should already have formed, but you can achieve a further breakdown of the stain by again using the sponge to *wipe out* certain areas, and to break others down with a fresh application of glycerine. Also, you may achieve additional disintegration by spreading a clean, white sheet of paper over the developing figure-ground and by rubbing vigorously and randomly over it, before peeling it away to observe the result. Sometimes, the imprint which is left on this rubbing paper is more varied and interesting than the original one. If such is the case, then use this image.

You can incorporate all kinds of refinements and modifications into this process, and you should employ any that suggest themselves as you are working. The object is to produce as diverse a series of areas, lines, and points as possible, over as broken a ground as possible, showing as much tonal contrast as possible. Any means of creating such a result is therefore justified.

Figure 7-9 is an example of the effect produced by manipulating stain in the ways just described. If you study the Figure closely you will see where the sponge has been used to fade out tones and to impart broken textures, and also, where the loaded brush has pulled, pushed, and dabbed.

Figure 7-9

At this stage you should study the image patiently. Turn it in order to observe it from every position. At some point, hopefully, you will begin to see things. If not, then you must make another image and attempt to produce a different configuration that might lead you to discover a subject. The author of Figure 7-9 described the subject she found there as "coyote overlooking gazelle and peacock." You may or may not see this scene; you may see something quite different.

But although the artist has named her subject, she has not yet drawn into the raw figure-ground situation in order to firm up the form, cause the objects to materialize, and thus separate figure and ground more completely. This is the next step in the operation, and it is shown in Figure 7-10. Here, a minimum of brushed-in marks—line and point principally—have clarified the previously ambiguous, randomly formed, configuration of blots and sponged half-tone areas. Notice that this additional drawing does not appear forced or superimposed over the original, but blends in with it as if it was there in the first place. Such subtlety, or finesse, is very important. If the final result is to convince, the drawing must appear to be "all of a piece" from a graphic point of view. The clarifying marks of additional drawing should possess similar graphic qualities, and should flow from and blend into the form of the design originally established. What did the artist find, and ultimately shape, in Figure 7-10?

Figure 7-10

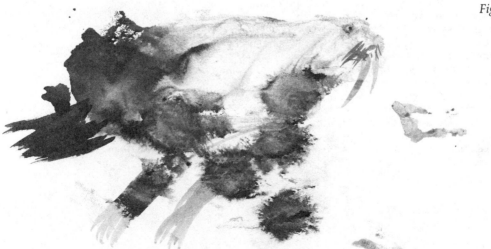

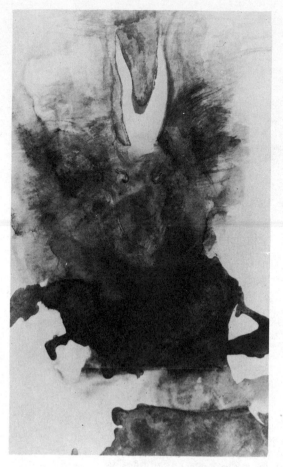

Figure 7-11
Victor Hugo. Satanic Head. *Wash drawing.*
PHOTO COURTESY THE MUSEUM OF MODERN ART,
NEW YORK.

Victor Hugo's *Satanic Head* (Fig. 7-11) provides a further illustration of subject materializing from an amorphous spread of stain—the face seen in the clouds or the smoke. Observe how skillfully the clarifying lines of drawing are made to homogenize graphically with the general spread of stain.

B. *Random configurations—The monoprint*

Figure 7-12 is a monoprint: the one and only print taken from an inked glass slab. The monoprint generally provides a very effective means of graphically producing a ready-made figure-ground state. Such a print is usually strong in graphic contrasts and is therefore particularly evocative. The method used to make monoprints is particularly suitable for our purposes because it permits rapid and experimental working. The inked surface, glass, is wonderfully slippery on which to draw; and you can get carried away with the ease with which marks register on it. Also there is a strong element of surprise when you pull the print: Even though you impress all kinds of marks in the ink, and wipe the ink away here yet intensify it there, your visual perception of what is happening is minimal.

To make a monoprint, you need a glass slab, say 15″×12″, and a large tube of black, *watercolor* block-printing ink. Usually a brayer is used to apply the ink to cover the glass slab, but you can obtain good results by simply smearing the ink out with a flexible knife blade, a wooden ruler, or the palm of your hand. However you do it, cover the glass well with a strong film of ink. (If the application is uneven, do not be concerned. This can add unexpected tonal contrasts to the printed image.)

With the slab thus inked you now need a small sponge and a clean rag to wipe and dab the glass to remove ink, and to thus produce the white and gray regions you see on the print. Dabbing with the sponge imparts texture to the ink film which shows up as such on the printing paper; wiping firmly with the rag clears the ink off thoroughly, thus creating regions of pure white on the print. You can use just about any instrument for marking (drawing) in the ink. Razor blades can turn and twist, twigs can scratch and line in, finger

and finger nail can travel over the glass to good effect—there is no limit to the tools which you can use to mark the ink in unique ways. Adding a little glycerine to the ink in spreading it, will retard its drying and give you the opportunity to work back onto the plate *after* the first marking and wiping session. In this way you can *add* ink in the form of textures, points, or lines for richer graphic effect. This additive process accounts for the dotted texture you see in Figure 7-12.

Remember as you are working that every mark you make in the ink will print as white, and that over the larger wiped or dabbed regions, it is possible to produce a range of grays in printing by not wiping the glass completely clean. Also, splashes of water applied to the slab from time to time will produce interesting and quite random results.

When you are satisfied with your efforts on the glass, spread a sheet of fairly thin absorbent paper over the slab. Holding the paper firmly in position, rub over it with the palm of your hand, ensuring that all of the paper comes in contact with the glass. By rubbing strongly you will take a strong impression from the glass; by applying less vigorous pressure you will produce a fainter result. When you have worked over the paper thoroughly, and have checked underneath to see that the ink has not dried too quickly to register, then peel the paper away and study what you have created. There is something addictive about the monoprint. When you see your first result and realize how faithfully the print picks up the graphic characteristics created by every interference with the ink, you will probably experience a strong urge to try again. So continue and learn more about the process with each attempt. Finally, select the print which offers the greatest possibility for development—the one in which, after viewing it from every angle, you find a ready-made subject.

Now you should proceed as with the first drawing of this series. Using brush or twig, sponge or rag, draw *onto the print itself* in order to more firmly delineate or fill in the subject matter you dimly perceive to be present in the raw print. Remember, though, that whatever "touching up" you do to the print should be so sensitive that it appears to have been there from the very beginning.

This final, clarifying stage was not accomplished in Figure 7-12. The print came "hot off the press," so to speak, as an example of the monoprint technique. If it were yours, how would you complete it? What do you see there? Would you agree that the photographic negative-like effect of the print presents such forceful graphic contrasts that the mind's eye is easily stimulated to discover a subject?

Figure 7-12

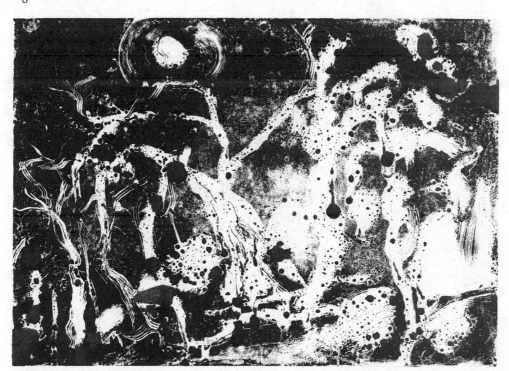

C. *Random configurations with string, wax resist, and ink*

Figure 7-13 results from yet another randomly formed figure-ground condition. Study it carefully before starting your own drawing, to determine how the graphic quality of the various lines and areas was achieved—how the wax as well as the ink were manipulated. The following exercise will familiarize you with the techniques used to make this example.

To begin you need a large sheet of paper—about 20″×15″. Make a strong solution of ink in a large soup bowl sort of dish, for this is where the lengths of string are to be dipped and thus saturated with stain. Using ordinary white, household string, cut three lengths of about 15″, three about 9″, and three about 6″. You also need one ordinary white household candle.

Again, proceed as instinctively and as freely as possible, with no particular "design" result in mind. Using both the end and the side of the candle, wax over randomly chosen regions of the paper, covering about one third of the total area. You should lay down some solid areas of wax, some more broken, and also, from time to time, some *lines* of wax (draw them with the candle's edge). These waxed places will, to greater or lesser degree, resist the ink which you are going to overlay.

Now, using both a sponge and the largest brush you can find, make a couple of large pools of a strong ink solution anywhere on the surface. (Each should cover an area at least 6″×6″ or 8″×4″, respectively.) Move the paper around so that ink can trickle or flow from these regions of strong stain. Just before these stains are dry, take a grayer dilution of ink and brush it all over the paper's surface—over *all* the existing stained and waxed areas. The only white paper remaining after this should be where the wax has resisted the various ink applications the most effectively.

With this accomplished, turn to the string. Take any of the various lengths which come to hand, and after soaking it in the bowl of ink just drop it anywhere on the paper. Leave it for a second or two so that it leaves a firm imprint on the surface, and then repeat this performance with different string lengths. You should continue long enough with the string to build up a complex linear design over the whole paper area. After the first

Figure 7-13

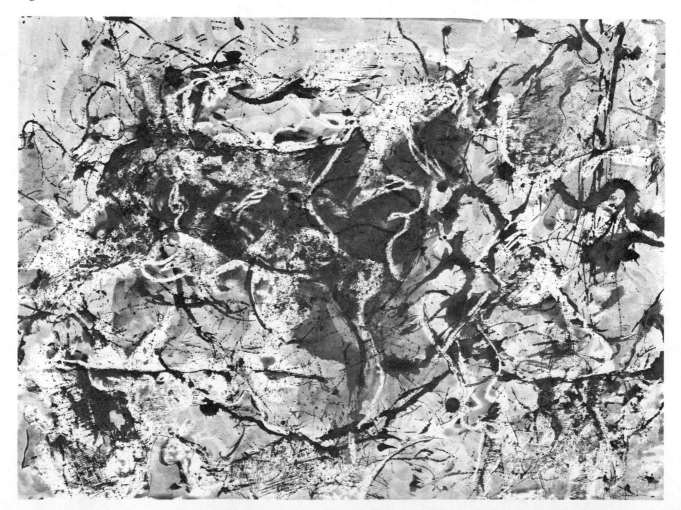

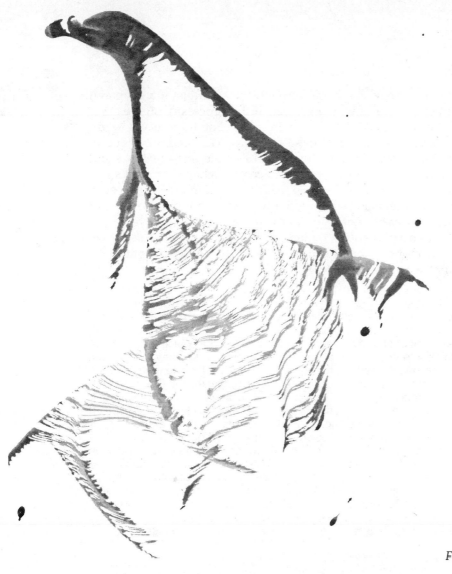

Figure 7-14

string imprint, do not be content with simply dropping the lengths here and there: Start throwing them down so that the string recoils and splatters ink as it strikes the paper. Do this with your eyes closed, if you like, just to ensure the haphazard buildup of the image. Stop when you are satisfied with the visual richness and diversity of the string, wax, and ink configuration.

Once again, survey the sheet from every position to see what you can find. When you have discovered the subject, take the usual steps to clarify figure and ground and so cause it to materialize more distinctly.

In order to present a completely homogenous image, these final drawing steps in Figure 7-13 were made not with pen or brush, but with string. The artist trailed ink-loaded string where it was necessary to shape the horse more positively. At the same time he firmed up some figure areas by sponging in darker solutions of stain where, in his view, they were required. Finally, he took a razor blade and scraped carefully over the waxed regions. This had the effect of cleaning them up—of removing some of the speckled grains of residual ink to produce a more strongly contrasting area of white. But he took care not to do this everywhere.

Figure 7-14 illustrates a developed string drawing in which no wax or randomly laid down areas of stain were employed. Using one long and one short piece of string, the artist started to work very mechanically, and very methodically, laying the string down— not dropping it—to produce the ordered formation of linear imprints you see in the figure. Very early in the process he knew he had a penguin, and quite deliberately he placed a long piece of string in position to mark the line of the back and head. Then he used a smaller piece to delineate the neck and beak. Then he simply took a brush loaded with a diluted ink solution and quickly brushed these last two lines out to form the linear areas of wash which come together to form the head and beak. As I watched this artist working, I wondered if he could have produced such a personal image of "penguin" if he had been restricted to more conventional drawing methods. What do *you* think?

Instead of seeking to discover a theme through the stimulus of a prepared figure-ground situation, we are now going to see if the process of shape association will work in the same way. The old saying that "one thing leads to another" is particularly true in terms of visual awareness. The tangible shape of something seen can trigger a wide range of mental associations—feelings and thoughts of past experiences and of those still to come—while the mind's eye conjures up forms related to what is being perceived at the moment. Because ideas so readily transfer themselves to specific physical configurations, and physical configurations so easily generate ideas, the artist does not have the time to decide what, at any particular moment, is doing what. Let us see if we can set this process in motion here—or at least provide a little insight as to how the process might work in "real life."

D. *Found object*

Before you attempt this exercise, you must spend some time searching for the right object. When you discover something which attracts you, the word "found" possesses connotations of surprise, almost of a revelatory confrontation with that which is perceived. Such a discovery is unlikely to occur in an urban environment, and you may have to get away to the woods or beaches to start searching seriously. Going for a long walk is the most likely way to come across an unusual piece of wood, a weathered stone, a seed cluster, an animal bone—something that stands out from its context and demands further examination. You may find several such forms, but one will most likely engage your interest more than the others. This is the object to use for drawing.

Figure 7-15 is a photograph of such an object. Half in and half out of the ditch, shining in the rain, it caught the eye and was carried home. In this photograph you see it in roughly the same position in which it was found. Figure 7-16 shows the object from the ditch photographed in the position in which it assumed maximum significance for its finder. Figure 7-17 shows the lighting conditions under which the artist discovered the subject *The Family*. Drawing after drawing was made to shape this theme—drawings in which the original wood form could still be recognized despite the transformation that took place to convey the idea. Figure 7-18 is just one of these exploratory drawings.

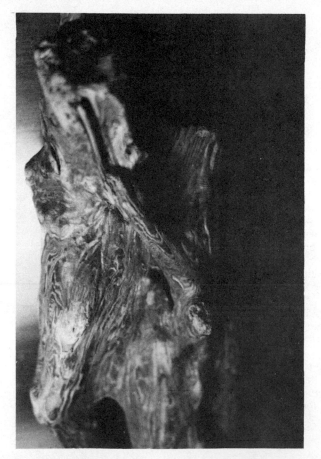

Figure 7-15
Ruth Carpenter. Found Object.

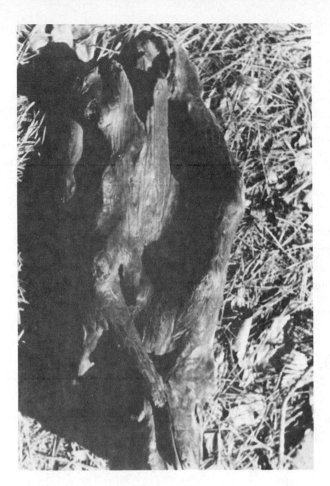

Figure 7-16

Figure 7-17

Figure 7-18

241

This exercise consists of a similar series of moves from the moment of first discovery to the moment of final recognition of the imaginative possibilities. Figures 7-19 to 7-21 show three stages in this kind of imaginative development: A chosen object, by virtue of its physical "personality," becomes something else. Betty Peebles made these drawings for me one day, after we had been talking about bones—bones in the butcher's shop and bones in the field. We said enough about bones for Peebles to go away and work with some of her specimens in the way I have just been describing. Figure 7-19 is a drawing of two similar bones side by side. Peebles tried the bones in many positions before selecting this one. In Figure 7-20 the drawing has already become looser because the idea of, and feeling for, *dancing* forms has evolved; and in Figure 7-21, the dancers in the Ballet of the Bones appear.

Now try the process for yourself. Examine your found object from every conceivable position, and under different conditions of direct and indirect lighting. At some point in the process you will discover the aspect that appears to be particularly significant. You will be reminded of other forms, other times, other places, other events. More than likely, this will also be the view of the object that you like best—the position in which its physical characteristics appeal the most strongly. And there is a good chance that now feeling and thought are heightened through these varied stimuli, and that you are ready to develop one or another possibility through drawing. Do it!

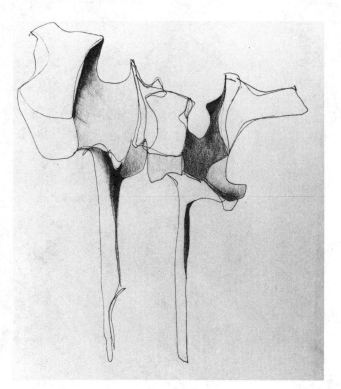

Figure 7-19
Betty Peebles. Bones I. *1972. Pen, ink, and pencil on paper.*

Figure 7-20
Betty Peebles. Bones II. *1972. Pen and ink on paper.*

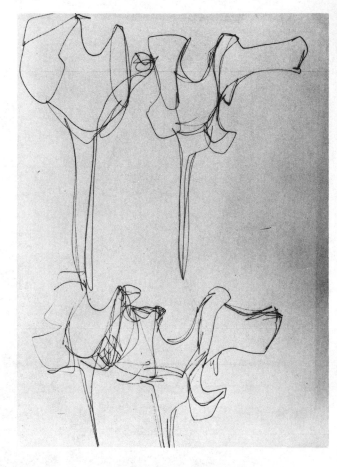

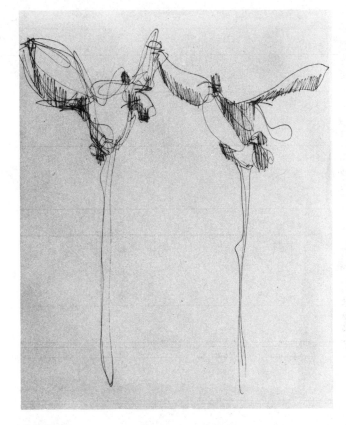

Figure 7-21
Betty Peebles. Bones III. *1972. Pen and ink on paper.*

E. *Found object and assemblage*

No drawing is involved in this exercise. You simply select and arrange various objects in order to construct a composite figure from them. Although this is a simple enough experiment in imaginatively developing the associative possibilities between object shapes, it does demand that you utilize both your visual and ideational faculties, in choosing the objects as well as in assembling them.

The art of assemblage has become very popular in this century, whether assembling bits and pieces of wrecked automobiles and calling it sculpture, or, like Picasso, putting bicycle handlebars and saddle together to suggest the head of a bull. Such statements can be witty and illuminating (Picasso's head of a bull really makes one aware of the essential, simplified form of the object) or they can be boring, mechanical operations in just putting pieces together. Your composite form, when complete, should be identifiable and not entirely abstract. Because this is a training exercise, more visual imagination will result if you are limited by the requirement that you keep such representational associations. Figure 7-22 illustrates what I have in mind. In this case the artist chose to start with a corkscrew, followed up with the nut crackers, added the scallop shell, and finished everything off with the onion.

Look around the kitchen for suitable shapes. There you will find an amazing variety of both mechanical and vegetable objects. Start with one object—a wire whisk, for example—and proceed from there to build up a complete assemblage. Try all kinds of combinations until you have one that you think is "clever": amusing, startling, innovative, perhaps even pleasing in the way a new form satisfies in terms of its proportions, rhythms, and homogenity of materials involved. Finally, in lieu of drawing, photograph the grouping from several different angles and using different lighting treatments. If you like the assembled object well enough, you might attach the parts permanently and mount the work for display—a testament to your powers of perception and originality!

Figure 7-22
Ruth Carpenter. Assemblage.

II
Discovering and Developing the Motif

The emphasis in this second section is not on the immediate—or relatively immediate—discovery of a ready-made subject: one stimulated by an ambiguous figure-ground situation, or by shape association. Instead, our concern is with the other side of the coin of imagination: the developmental process of *composing* an image—of putting it together part by part. Furthermore, we are to be involved with a particular kind of composing: that which comes from discovering and developing a motif.

What is meant by the term "motif" in this context? A motif is something seen, in whole or in part, which interests one by virtue of its physical nature and by its ability to engage new levels of thought and feeling. A particular quality of light and air, the juxtaposition of one color to another, a shape, a texture—anything perceived, in fact—may become a motif if it intrigues and if it is recognized as a visual theme to be *elaborated on or developed in the form of a work of art*. The words in italics are important. A motif, when thus acknowledged, represents but the nucleus from which the image to come will be derived—the physical nucleus which will determine the ultimate configuration of the work; and the mental nucleus from which the work's final emotional and intellectual impact evolved.

When the painter or sculptor selects, from the vast repertoire of things seen, this or that thing or event to become the driving force behind the creation of a work of art, he or she is aware of that thing's potential, of the fact that the imagination is inevitably going to be engaged to realize the full creative significance offered by the thing as motif.

Earlier in this chapter we discussed Graham Sutherland's encounter with a thorn bush, and Figure 7-2, which shows one of the paintings which resulted from the confrontation. But even years after this series of Thorn Tree paintings was complete, the artist was still exploring new possibilities in thorn compo-

sition and was developing images no less powerful and significant than the earlier works. In fact, the physical and psychological influence of the thorn as motif influenced the form and content of Sutherland's work to the end. Such is the hold on the imagination exerted by a true motif.

Let us consider a visual example. Look at the photograph of the common thistle in Figure 7-23, and compare it with Sutherland's *Thorn Cross* of 1955 (Fig. 7-24). It is not difficult to discern their common thorniness. But at the same time you can see that *Thorn Cross* is a distinctive image in its own right—the thorn *motif* can be recognized as the nucleus of the completed drawing, but a nucleus that has undergone considerable development and transformation: a process of transformation which, in 1955, had in fact been going on for seven or eight years.

Figure 7-23
Robert Nix. Common Thistle.

Figure 7-24
Graham Sutherland. Thorn Cross 1955. Lithograph.
From "*Graham Sutherland—The Graphic Work,*" by Roberto Tassi.
EDICIONES POLIGRAFA, BARCELONA.

The drawings in Figure 7-25, called *Leaf Figures* by their creator (sculptor Henry Moore), represent a series of experimental variations based on leaf motifs. Although the discovery of the figure as leaf, or leaf as figure, is largely due to shape association, the leaf form nevertheless goes through enough modification and change before becoming the sculpture you see in Figure 7-26 to be justifiably termed a motif. Since this artist constantly and keenly surveyed the world around him, collecting those things which fitted in with his "form interest" at the time and thereby took on the role of motif, perhaps a leaf something like that in Figure 7-27 triggered the *Leaf Figure* drawings.

A final example of the discovery and development of a motif is Sutherland's *The Egg* (Fig. 7-28). (Note that this is actually a gorgeously colored lithograph, but even in this monochromatic black-and-white reproduction it serves our purposes well.) The egg is the motif, and is found in one guise or another throughout the image. Notice how convincingly Sutherland incorporates its shape into the overall design, and how each repeat conveys a different suggestion of "eggness" in terms of varied graphic treatments and carefully chosen positionings. Because we see eggs almost every day, we might not con-

Figure 7-25
Henry Moore. Leaf Figures *1951. Pen, crayon, and watercolor.*
PRIVATE COLLECTION.
COURTESY OF THE ARTIST.

Figure 7-26
Henry Moore. Leaf Figure No. 1. *1952. Bronze.*
PRIVATE COLLECTION.
COURTESY OF THE ARTIST.

Figure 7-27
Robert Nix. Spathephyllium Leaf Unfolding.

Figure 7-28
Graham Sutherland. The Egg 1975. Lithograph. From ''Graham Sutherland—
The Graphic Work,'' by Roberto Tassi.
EDICIONES POLIGRAFA, BARCELONA.

sider them as a very promising motif for a major work of art. Yet here we become aware of the significant role their shape can play in the purely plastic rhythm of a drawing, and of how the artist's vision can turn them into embryonic time capsules which cause us to reflect on the origin and gestation of botanical and biological life.

Such is the way the motif takes over, lends itself to variation after variation, and finally shows the original nucleus fully realized—plastically in terms of composition, and mentally in terms of the artist's evolving thoughts and feelings.

WORKBOOK

7-II. Discovering and Developing the Motif

It is difficult to put together the kind of drawing exercise which really does clarify motif as it has just been discussed. So much depends upon individual interest, choices, ways of working—outlook on life, almost—that a rigidly de-

fined exercise will work against rather than for the sort of imaginative freedom we are trying to develop. Therefore I make suggestions here—rather than give instructions—to help the one drawing you are going to make become the kind of creative exploration that attends the discovery and development of a motif.

The Repertoire Approach to Potential Motifs

This method depends upon amassing as large a repertoire of visual "motif references" as possible. To do this it is necessary to spend time constantly looking and constantly drawing. The results will *not* be immediate: This is a long-term project demanding a certain amount of patience. You should nibble away at it daily, collecting visual "data" as you move routinely from place to place and as you make special forays into the world just to see and draw what you find. Then be prepared to browse through, and reflect on, the images you have made, before starting to compose a motif-inspired drawing.

Carry a small, pocket-sized sketch pad with you at all times. Always be on the lookout for any object or part of an object that catches your eye and, using pen or pencil, brush and a diluted ink solution, or any other instrument and medium you choose, make a drawing in the sketch pad. The sketch should be more than a quick impression: Its effectiveness later will depend on clarity and firmness of shape, and the graphic vitality it possesses on the page. Henry Moore stores all the interesting things he finds in specially built sheds. Then he returns to them at his leisure and examines them as actual, physical specimens. Your sketch pad is to be the storage equivalent of Henry Moore's sheds. But, as drawings, your specimens lose their three-dimensional physicality, and you must make up for this by forcefully drawing them, if their potential use as motifs is to be maintained.

Choose all sorts of objects to record—from animate to inanimate things and organic specimens to mechanical ones. Figure 7-29 shows a typical page from one student's sketch pad. This large flying insect was found dead on the patio one morning. It was promptly drawn, both whole and in part, and so became part of a repertoire of potential motifs. Another student began to examine, through drawing, the motif possibilities of an orange (Fig. 7-30).

Figures 7-31 to 7-34 are photographs of four interesting shapes, the sort of organic and mechanical configurations which stand out and seem worthy of scrutiny. Figure 7-32 in particular is an example of the kind of interior space containing internal forms which has always been of such interest to Henry Moore. The bone in Figure 7-33 lends itself to exploration through drawing and to imaginative development.

Figure 7-29

Figure 7-31
John Albaugh. Worm-eaten Wood Form.

Figure 7-30

Figure 7-32

Figure 7-33
Robert Nix. Cow Vertebra.

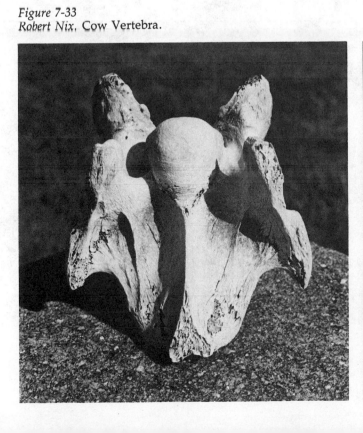

Figure 7-34
Robert Nix. Mechanical Form.

Figure 7-35

Figure 7-36

Figure 7-37
Carrie Mullen. Untitled 1982. Pen, ink, and pencil.

When you have a good-sized collection of possible motifs, browse through the sketch pad to see which drawing interests you the most, both with regard to its present form and to the significant variations you discern would be relevant. When you have made a choice then work out the composition. This, in itself, will take time. You must determine the scale of motif and variations—as Graham Sutherland did with the egg forms—and decide where they are to be placed relative to each other, and by what kind of context they are to be formally and rhythmically supported, as well as helped to gain in meaning. You must be prepared to work through several designs before the form that carries all your evolving ideas and satisfies as figure-ground organization in its own right comes into being. Do not be satisfied with your attempts to discover and develop a motif until you feel you have thoroughly exploited all the possibilities your sketch-pad repertoire offers.

Figures 7-35 and 7-36, two shells, illustrate how a particular motif can inspire. Just about everybody returns from the seashore with such things: shapes discovered on the beach which attracted and demanded to be touched, examined, and ultimately possessed. Shells come in a great variety of shapes and sizes and seem to have a particular appeal. Although I am not sure what motif played what part in stimulating Carrie Mullen to make the drawing *Untitled* (Fig. 7-37), I nevertheless use her work as an example of a motif-inspired composition. The major theme is of the sea: sea forms, sea ideas, sea feelings. Yet if you look closely at the drawing, the minor theme of shell and variations becomes all pervasive. Large and small, either whole or in part, the shell motifs determine both the form and meaning of the developed image.

Now see what motifs you can develop.

THE MINIMAL MOTIF

Throughout this chapter we have been talking about those motifs which are recognized as objects in their own right: thorn bushes, pebbles, daffodils. But the imagination can also be stimulated by much less complete configurations: by even a detail such as the particular line of curvature taken by a rock's edge, or by the shape of a bright spot seen against a dark ground. In fact, the thing perceived does not have to be three dimensionally real at all. An unusual movement of line arcing its way across the page, or the pattern on a turtle's

shell can, for example, stimulate the creation of a fully developed work whose complex composition was inspired by a simple visual unit.

In the course of his work, Victor Pasmore has used and reused the spiral as a motif. The spiraling line has served him well, giving rise to themes entitled *Inland Sea, The Wave,* and other names of similar implication. Figure 7-38—*Spiral Motif: The Wave*—is a typical example of such an image: one in which the simple spiral has become a labyrinthine complex of currents and forces which provokes the viewer to think beyond the fact of the wave itself and to travel in more mysterious regions into the underworld of the mind.

A spiral, in this context, would be called a *minimal motif*. So when involved in the search for motifs, bear in mind that a detail might serve as well as the complete form; be visually prepared to recognize the truth of the saying, "less is more."

Figure 7-38
Victor Pasmore. Spiral Motif: The Wave *1949–50. Oil on canvas.*
THE NATIONAL GALLERY OF CANADA, OTTAWA.
COURTESY OF THE ARTIST.

CREATIVE TRANSFORMATION

order, expression, and symbol

> . . . the idea of the artist is form. His emotional life turns likewise to form: tenderness, nostalgia, desire, anger are in him, and so are so many other impulses, more fluid, more secret, oftentimes more rich, colorful and subtle than those of other men . . . He is immersed in the whole of life; he steeps himself in it. He is human . . . But his special privilege is to imagine, to recollect, to think, and to feel in forms . . .*
>
> *HENRI FOCILLON*

THE QUOTED STATEMENT by Henri Focillon gives the theme of this chapter in a nutshell. If you understand it as written, then there is no reason not to proceed directly to the Workbook. Yet, of course, we must expand on Focillon's words in order to drive home the profound aspects of art and imagination in textbook terms—a treatment which, inevitably, must try to both simplify and explain complex subject matter.

The creative imagination which gives rise to works of art—and theories of science—is a complex phenomenon; and yet there is some justification in delineating *three* basic directions taken by the creative mind in the visual arts: order, expression, and symbol. I use these terms not for their historical or critical connotations in the literature of art, but simply to distinguish the three most constant ways in which the imagination shapes itself through our abilities to visualize and make works of art.

We have been constantly involved with thought and feeling as two streams of consciousness, and we have tried to show that they are not mutually exclusive ways of knowing but work as a team, with one or other mode dominant. The last sentence in the quotation from Focillon aptly sums up what we have been saying. Focillon emphasizes that it is the special privilege of the artist to imagine; and then he says what such imagining is: the power of recollection, the force of thought, and the capacity to feel, all of which becomes embodied in the form of art. There is really very little to add to this. Although

*Henri Focillon, *The Life of Forms in Art*, 2nd ed., trans. Hogan and Kubler (New York: Wittenborn, Schultz, 1948), p. 47.

it would be possible to write volumes on the complex interaction between rational and intuitive ways of thinking and feeling, and on the interplay between the mental images of oneself as subject and the world as object, here we try to keep the discussion on imagination relatively simple without, hopefully, becoming simplistic.

We will attempt to achieve this by examining the creative responses described as the art of order, of expression, and of symbol, and by providing examples of their appearance in drawing. In each case we will find ourselves involved with varying degrees of interaction between the mental forces of thought and feeling; and we will see once again how closely these two operations of consciousness work together. Although it might be the intellectual constructs we call concepts or ideas which take the initiative, a "feeling tone," an emotional color, will not be far behind, and will serve to reinforce or weaken the significance of the thought. Conversely, when carried away by a spirited response to life, such primary feelings are likely to be accompanied by all manner of associated thoughts which, again, will test and examine the feeling state to determine its quality and importance. Such is the dual nature of our mental life.

Our aim here, then, is to introduce order, expression, and symbol as the basic manifestations of the imagination when it finds its outlet in art. Following is a brief description of each response:

1. That response which seeks to find and shape a satisfying "visual logic" can be described as *order*—a formal quality described by the Greek sculptor Polycleitus when he said, "The success of a work of art comes about through many numerical relationships, in the process of which a trifle tilts *the balance.*"

2. That which seeks to translate states of *feeling* into their graphic and plastic equivalent is generally known as *expression*—described by Wassily Kandinsky as "the art of internal necessity."

3. That which seeks to translate an *idea* into visual terms, thus depending on the capacity of some element, or elements, in the work to provide meaning through functioning is *symbol*—or, as Paul Gauguin put it, "[that which clothes] the idea in a form perceptible to the senses."

In 1968 the late Julian Huxley came to his old friend Henry Moore for dinner and brought along an elephant's skull as a present. Quoting Alistair Grant,

The huge skull was added to the already vast collection of natural objects, stones, shells, pieces of driftwood and bones in the artist's maquette studio. Moore did not work from his new acquisition straight away. There it sat like some ancient totem, slowly and surely making its presence felt, and it was to influence the artist's work in as radical and important a way as any new love in the life of his fellow artist, Picasso. At last he felt himself ready to start work on the skull theme. The latent ideas that had originated from it immersed Moore in a new and exciting train of thought.[1]

The skull is shown in Figure 8-1. Altogether, the total number of drawings—realized as etchings through the direct use of a needle on a copper plate—reached around forty, and show the original skull transformed in the three ways just described. Such a series of drawings provides a fine opportu-

[1]Alistair Grant, Introduction to *Elephant Skull—Original Etchings by Henry Moore* (Geneva: Galerie Gerald Cramer, 1970).

nity for us to see the results of the artist's mind in action as it seizes on first this, then that aspect of a single object. There is no better way to illustrate how a solitary motif can stimulate the creation of many varied images—drawings which show the imagination occupied with the creative outlets offered by order, expression, and symbol—than through the examples Moore provides in these etchings.

I
The Imagination and Order

Figure 8-2 is a drawing in which the artist is, in his own words, "searching for the skull's internal structure." It is an analytical drawing, a "surgeon's" approach to physiological clarification, clean and precise in that it reduces the three-dimensional complexity of the skull to an ordered linearism of interlocking parts. For an artist like Henry Moore, this need to understand the structural essentials of an object has always been paramount. Once such basics are grasped, the principles of order which underlie surface appearances permit the artist to draw with assurance, and to impart a physical credibility to any further imaginative transformation that the image seeks to embody.

When we move to Figure 8-3 we see this structural searching paying dividends in a fully volumetric drawing where mass and space volumes assume impressive weight and three dimensionality. This composition is inspired by a detail in the skull's internal bone configuration—a detail that becomes in every way "larger than life" as a result of such powerful compositional and graphic treatment. The artist explains that this drawing results from the "rocks, arches and tunnels" he found in the skull, thus making the imaginative associations of shape we have previously discussed. Yet this is not the reason for showing

Figure 8-2
Henry Moore. Searching for the Skull's Internal Structure *1970. Drypoint etching.*
COURTESY OF THE ARTIST.

Figure 8-3
Henry Moore. Rocks, Arch and Tunnel *1970.*
Drypoint etching.
COURTESY OF THE ARTIST.

the work here. Rather, notice that all the parts of this drawing are so arranged that, from left to right and top to bottom, an equable distribution of figure and ground shapes prevails. Thus order—the kind of dynamic balance (as opposed to dull and absolute regularity) of which Polycleitus speaks—is achieved. To produce such a result, the artist must carefully consider every move, so that no misplaced element can disrupt the visual "rightness" or design logic which makes the overall from intelligible and clear—the form which satisfies our intellectual and emotional appreciation of physical order.

But although we can recognize the compositional qualities of order in Figures 8-2 and 8-3—the search for structure in the first case and the proportionate, clear and elegant shaping of rhythmic yet balanced forms in the second—there is little doubt that Figure 8-3 is also a strong expression of feeling, and thus stimulates thought concerning hidden meanings and associations (the role of symbol). This is the kind of problem one usually runs into when trying to analyze a work of art and affix specific labels. The distinctions we are making here are useful basically to draw attention to the *dominant* quality we perceive to be present, that being singled out for teaching purposes.

II
The Imagination and Expression

The whole skull is depicted in Figure 8-4. Notice that the linear treatment here is not as controlled as in the previous drawings; that a concern for structural clarity, for a firm modeling of the parts, and for the kind of elegant reduction of detail found in Figure 8-3 is not evident to the same degree. As far as this drawing is concerned, the artist seems somewhat less objective. The image results as much—if not more—from Moore's excitement with the skull than from thoughtful involvement which leads to analysis and the imposition of order.

Figure 8-4
Henry Moore. Elephant Skull Drawing *1970.*
Drypoint etching.
COURTESY OF THE ARTIST.

The lines are etched on the plate rapidly; in the urgency, if not frenzy, of the needle's attack, the strength of the sculptor's feelings is conveyed. When such emotional vitality is transmitted in this way, then we can say that we face a work of *expression* rather than one of order. Moore always manages to keep a remarkable balance between the two; even though there are plenty of occasions when one or the other is dominant, rarely is either overwhelmingly so. Because strength of feeling plays such an important part in the artist's imaginative response, clarity and elegance of form inevitably give way to a freer and looser treatment.

III
The Imagination and Symbol

Following this train of thought—that order and expression characterize images created from the mental bridgeheads of thought and feeling respectively—what can you say about the drawing in Figure 8-5? Once again Moore focuses on a part of the huge skull—a detail—which catches his eye and holds his interest. And, once more, we observe that individual bone forms are precisely and elegantly stated: As mass volumes they take on a cylindrical and spherical purity. Also, the composition as a whole reveals a firm and well-balanced juxtapositioning of shape against shape, force against force. In other words, it is the ordering and perfecting mind at work again. But then the artist goes on to make the following comment about his drawing, one that shows the image in a new light: "On completing this plate," he writes, "I thought of Piranesi's series of 'Imaginary Prisons'."

With the drawing complete, the artist apparently finds that the form he has made reminds him of Piranesi's drawings—fantasy images of nightmarish prisons, inhuman in scale, which, because of their incredible scale, shape the *idea* of imprisonment as much as they illustrate an actual prison. The Piranesi etching *A Vaulted Building* (Fig. 8-6) reveals the significance of Moore's allusion. The shape and disposition of Piranesi's architectural features, and the spatial regions they form, make up an image which invites comparison with the elephant skull "architecture" of Figure 8-5. Even without the presence of a human figure, the elephantine columns and ribs and their labyrinthine tunnels result in a Piranesi-like monumental scale and sense of enclosure inimical to human dignity and freedom.

The question then is: Was Henry Moore reminded of Piranesi because the physical *appearance* of his own drawing brought to mind the physical appearance of a Piranesi prison fantasy; or was it because in Figure 8-5 he created a sense of scale and enclosure which triggered *thoughts* about incarceration in general—intimidation, depersonalization, loss of freedom, and so on—which were then responsible for the association with the Italian's drawings? It is difficult to say which of the two possibilities was more responsible than the other. But I raise the question because, in so doing, a reasonable explanation of how a work of art can function symbolically emerges. If Moore's response to his own design transcends awareness of its actual, physical configuration, and evokes ideas pertaining to the essential, meaningful implications of the theme, then the image—or parts of the image—are functioning as symbol. In other words, once our response to a work takes us beyond shape association to idea association, we know that something in the work we are viewing is serving as a *visual* analogy for an idea present—not necessarily consciously—in the mind.

Figure 8-5
Henry Moore.
An Imaginary Prison *1970.*
Drypoint etching.
COURTESY OF THE ARTIST.

Figure 8-6
Giovanni Battista Piranesi.
A Vaulted Building with . . .
Barred Window in Center.
Etching. Carceri: Plate 3.
THE NATIONAL GALLERY OF ART,

WASHINGTON, D.C. ROSENWALD COLLECTION.

Thus the bones in Figure 8-5 cease to be bones and become *symbols* of what imprisonment stands for in our thoughts. In this case the artist's imaginative transformation of the original elephant skull caused both bone and skull space to gain this symbolic power; it is also the artist who discovered what had happened *after* he completed the plate.

In Chapter 7 we discussed Graham Sutherland's *Thorn Tree* (Fig. 7-2) to show how an ordinary hedgerow thorn bush could become the motif for an extraordinary series of Thorn Tree images. Take another look at Figure 7-2, in the light of what has just been said about visual symbols. It might now be easier to understand the argument I presented previously, and to see for yourself how Sutherland's imaginative transformation of thorn bush transcends the physical facts and arouses a train of thought about life as a difficult and often painful journey. (It might also be worthwhile at this juncture to reread that part of Chapter 7 which deals with Sutherland's *Thorn Tree*.) Remember, however, that although a work of art's prime effect may be as a catalyst for ideas—as symbol, in fact—this does not preclude the presence of those other imaginative qualities we have called *order* and *expression*. Both are found in *Thorn Tree*, as they are in Livio Valentini's *Serigrafia* (Fig. 8-7).

Figure 8-7
Livio Orazio Valentini. Serigrafia 1971.

How do you principally respond to the Valentini? The design is undoubtedly ordered: It is proportionate and measured in its rhythms, clearly defined and well balanced in its parts, and so satisfies the essential criteria of order. Feeling is also evoked for the bird in its trussed-up state; the expressive qualities of the harshly angled wing and neck and of the more forceful graphic treatment afforded the creature are inescapable. Is there anything more? If you find yourself wondering what Valentini is getting at—why is the bird trussed in a circular frame? Are the trusses bandages? Is it dead or wounded? Is the bird life below going to break free from the egg only to finish up as prisoner, dead or alive, above?—then the drawing is working symbolically. You would be justified in saying to yourself, "When is a bird not a bird?"; and in answering, "When it symbolizes the idea of the spirit of life overcome, the freedom to soar vanquished in the circular prison of nature's own limitations or humanity's trap . . ." This is my particular mental dialogue when faced with *Serigrafia*; you may be thinking other thoughts. The important point is that the image itself occasions such speculation; we are pushed to search for the meaning of the bird motif when bird and context speak to something other than themselves.

WORKBOOK

The Head as Order, Expression, and Symbol

For this project, you are going to use a single motif and attempt to take it through a series of transformations. As we have seen, the artist's eye is receptive to all kinds of phenomena, ready to seize on that which engages the mind, quickens the imagination, and therefore become significant as the motif which may initiate a work of art. Such acts of heightened perception go on all the time in the serious artist's life, and if you intend to continue drawing for yourself you will be no stranger to them. However, working under textbook conditions as we are here, you must pull a motif "out of the bag," as it were, in order to endeavor a learning experiment which, hopefully, will start you off on your own artistic journey.

The human head and face are often used as models for imaginative development into masks: into ritual physiognomies shaped to the demands of order, feeling, or idea, and thus intended to convey to the general spectator important imaginative experiences which otherwise might remain incommunicable. The Greek tragi-comic mask in Figure 8-8, carved in marble, proclaimed its message from the wall of some second-century B.C. building.

The head is a complex object of mass and space volume, an intricate "landscape" of plane and curved surfaces which result from the thrusting, subcutaneous bones of the skull. At the same time, the head is more than just an object: It is the manifestation of person, of personality, and, as such, reveals many aspects of mental life. It is a natural vehicle to use for drawing experiments in which an initial form is transformed to suit an individual's imaginative response. We are surely familiar with the head on both counts—physically as object, and psychologically as "mask"—for we spend a lot of time in front of the mirror.

The head is a difficult object to draw, but at this stage you should anticipate and enjoy challenge. But by way of help, let me suggest that you spend a little time studying Figure 8-9. This African mask shows the overall form of the head simplified to its essential morphology—an oval, pointed at the chin, with the ridge of the nose marking the vertical division which distinguishes left and right sides, the eyes set horizontally at midpoint, the mouth curving

Figure 8-8
Marble Comic Mask *2nd century* B.C. Greece.
NATIONAL ARCHAEOLOGICAL MUSEUM, ATHENS.

Figure 8-9
African Dance Mask. *Ivory Coast.*
AMERICAN MUSEUM OF NATURAL HISTORY, NEW YORK.

to conform to the general curvature of the face, and the principal high points of forehead, planes of nose, cheekbones, and chin—all simply modeled to reveal the form in its broad essentials. If you keep this depiction in mind as the foundation for your initial drawings, you should have little difficulty in ultimately introducing all kinds of distortions that depart radically from the basic, natural shape of the head.

Drawing 1

The model for this exercise is to be yourself. The aim is not to make a portrait likeness, but simply to use the structural reality of your own head, as seen in the mirror, to establish the natural characteristics of the motif before proceeding to effect the various transformations that will herald the change to order, expression, and symbol. In other words, your first drawing is to be a straightforward, naturalistic rendering of the human head which deals as convincingly as possible with its formal structure, and which is aided by drawing from life—from yourself—as and when necessary. Incidentally, for this as for all of these drawings, you may experiment freely with any medium or combination of media. By now you have, no doubt, established certain preferences.

Four drawings by Pablo Picasso show the process of transformation with which you are concerned here. The first of these drawings is seen in Figure 8-10, Picasso's *Head of a Young Man.* Here, the mass of the head is perfectly realized; we can relate the graphic treatment shaping the fundamental structure of planes and curved surfaces to the African mask in Figure 8-9. Your first drawing should try to render the head in the same way, forming the essential characteristics of features and mass.

Drawing 2

With the second drawing you are to attempt the first transformation: the move to *order*. We have discussed order earlier in the chapter, but let us talk about it briefly again in the light of Picasso's *Portrait of Jacqueline* (Fig. 8-11). Notice how, in this drawing, the artist preserves the essential qualities of the planes and curved surfaces that make up the form of the head as mass, yet now goes on to give positive definition to eyebrows, eyes, nose, and mouth. This defining—one might almost say "designing"—of the features gives them an unambiguous shape: one that clarifies their own physical nature, and at the same time provides extra definition to the contextual volumes of the head overall. Also, this clear-cut delineation follows what might be called the laws of classical physiognomic proportion—the regularity of feature and balanced positioning evident in the African mask. These are the factors which result in what I am calling the imposition of order, so far as the head as object is concerned, and which, by and large, were also the issues we discussed when describing a Henry Moore elephant skull drawing as an image representing the "imagination and order."

So, now, you will attempt a new drawing of the original head—one which imposes this classic definition of shape to the various features, and which *emphasizes* proportion and balance, as you see in Figure 8-11. The change that such a firm regularization of features produces, in terms of first and second drawings, is well illustrated by Picasso's two drawings—Figures 8-10 and 8-11—even though the model is not the same for each drawing. *Order*—in the sense in which we are using the term—represents an imaginative move to impart a particular kind of visual clarity to the form: one which delineates the parts firmly, establishes a balanced and harmonious arrangement between them, and imposes apparently ideal proportions overall, all of which serves to satisfy the mental need to both find and create order in terms of our visual sense perceptions.

One more point: The special attention which Picasso has obviously paid to the eyes in *Portrait of Jacqueline* is permissible within this general concept of order. Some overstatement—change in scale or exaggeration of form in the case of an important feature—is acceptable, in the interests of what might be called *idealization*—that is, to approach a perfection which is not to be found in nature. For some artists, order and idealization are synonymous terms. For the Greek sculptors they were the way to beauty.

Figure 8-10
Pablo Picasso. Head of a Young Man *1923. Conté crayon.*
COLLECTION: THE BROOKLYN MUSEUM, CARLL H. DeSILVER FUND.

Figure 8-11
Pablo Picasso. Portrait of Jacqueline *1955. Charcoal and ink.*
PICASSO'S COLLECTION. © 1983. S.P.A.D.E.M., PARIS/V.A.G.A., NEW YORK.

Now you are going to make a drawing which satisfies the demands of *expression*. Two more Picasso heads illustrate what I have in mind: *Head of a Woman* and *Woman in Tears* (Figs. 8-12 and 8-13, respectively). Remember that we have previously allied expression in art to feeling: to the fact that feeling attitudes ranging from serenity to anxiety, pleasure to pain, pessimism to optimism, and so on, can be "expressed"—that is, conveyed—through the work of art. Figures 8-12 and 8-13 show two ways in which this can be achieved. In the case of the former, notice the free and vital nature of the graphic marks themselves. The drawing has been executed at speed and accordingly bears witness to the artist's emotional intensity. Lines and marks are charged with an urgency, a passion which imparts great psychological force to the head and conveys the sense of a living personality. Yet in order to achieve this, the clarity of form we have called "order" has suffered. The shape of the head is less precisely defined, less solidly realized. But, as they say, you cannot have your cake and eat it: When expression is sought through spontaneous and excited drawing action, order must take second place.

Yet in the case of *Woman in Tears* (Fig. 8-13)—a work whose title itself indicates the feeling content involved—the graphic treatment is anything but spontaneous and free; the drawing action is deliberate and patiently controlled, and the overall form of the image is not loosely delineated as in *Head of a Woman,* but firmly stated. If it is not the expressive aspect of the graphic marks themselves which communicates feelings of pain and grief, how are such emotions embodied and conveyed? The answer is by *expressive distortion* of the head itself. By exaggerting certain features and repositioning them—and by redesigning the natural, bony topography of the skull in order to create the suggestion of profile and full face manifesting simultaneously in the one view of the head—a new configuration of planes and curved surfaces is produced. The new thrusting angles of this strange object impart a sense of physical stress to the bone itself, and we associate such

Figure 8-12
Pablo Picasso. Head of a Woman *1924. Ink.*
PICASSO's COLLECTION. ©1983, S.P.A.D.E.M.,
PARIS/V.A.G.A., NEW YORK.

Figure 8-13
Pablo Picasso. Woman in Tears *1937. Ink.*
PICASSO'S COLLECTION. © 1983 S.P.A.D.E.M.,
PARIS/V.A.G.A., NEW YORK.

physiological distortion with the presence of intense psychological pain. If this is not enough, the huge, distraught mouth bites on a handkerchief. Thus it is the harshly unnatural form of the head, with features displaced and blown up out of proportion, rather than the graphic vitality of line and mark, which tells us of grief and conveys the strength of feeling.

Now try to transform your own original "self-portrait" into an image embodying feelings of grief. You may choose whether to employ purely graphic means—lines and marks which in themselves convey feelings of pain and anguish—or whether to create the kind of expressive distortion of form you see in Figure 8-13. Of course, there is nothing to stop you from trying out both methods and making several drawings in which you experiment with the two possibilities. Also, you might want to branch out a little and get away from feelings of grief. If so, then make some drawings of the head which express joy or ecstasy—more in the spirit of Figure 8-8—and try to discover the appropriate graphic expression of such feelings, as well as the most apt expressive distortions of the head as form.

Drawing 4

With your final drawing you face the problem of *symbolic* transformation. We have discussed this issue under the heading *The Imagination and Symbol* earlier in the chapter (go back and reread this passage if you are not sure how symbols work). By way of pictorial illustration refer again to Picasso's *Woman in Tears* (Fig. 8-13). The powerful effect of this drawing is not due entirely to its expressive qualities. There is also a symbolic factor at work. What do you make of the *nail-like* tears? The nail lines themselves—in terms of their vertical and thrusting positions—work graphically as lines of pain. But when we identify the shape they delineate as "nail," a symbolic, as opposed to expressive, process of awareness comes into operation. Nails trigger ideas; we associate them with sharp-

ness, forceful penetration, crucifying, wounding—mental images which relate, inevitably, to our concept of human suffering.

Picasso uses the nail as a symbol; through questioning its meaning in the context of the design we are led to the analogous ideas it conjures up. Such thoughts reinforce the expressive qualities of the drawing, adding a conceptual dimension to a "feeling" one. So, once again we can ask the question, "When is a nail not a nail?" and the answer would be, "When it symbolizes the sharpness of human sorrow."

It is always difficult to deliberately "think up" symbols. They tend to announce themselves when one is involved in work or in life at a deep and essentially significant level. Therefore the best thing to do in a training exercise such as this is to provide a subject which is bristling with possibilities for imaginative development: one which can give rise to all kinds of ideas. Remember that you are still using your original drawing of your head as a model which is to be transformed. The task with this fourth drawing is to find the best symbolic means of turning the head into a design which carries a particular meaning and causes the observer to ponder the concept behind it.

Let us fall back on Greek mythology: Try to create the head of Pluto—or Hades as he was sometimes called—the god of the Underworld. Let us assume that you are responsible for staging a production of Monteverdi's *The Legend of Orpheus,* and have to design the costume and the mask to be worn by Pluto. The mask is to be delicate enough to be worn with no discomfort to the singer, but it is to be strikingly visible and is to convey, through the ideas it generates, what you conceive to be the essential significance of Hades.

Figures 8-14 and 8-15 show one response to the challenge offered by such symbolic transformation: first the observed head as model, and then the symbolic change. In Figure 8-15 snakes and leaves become the means by which Pluto's role of the God of Death is made manifest in the mask. The snake has long been used as a symbol of wisdom, cunning, darkness and mystery, and the supernatural, while leaves have traditionally been a sign of autumn as a season, and thus symbolize life's end. Figure 8-16 reveals an altogether less optimistic transformation: Thoughts about Pluto take a different direction here. Again the snake appears, but without the relief provided by the gentle leaves of autumn.

Now see what you can do for yourself. Snakes are not necessarily the only things that will work symbolically to tell about the Underworld and its guardian—as you can see by looking at Figure 8-17, in which corn-like underground root forms, a fungoid nose, and blind-onioned eyes produce something less than the usual anthropomorphic concept of divinity, yet still produce an image quite suited to the idea of an Underworld god.

Figure 8-14

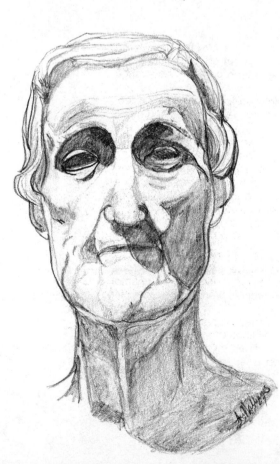

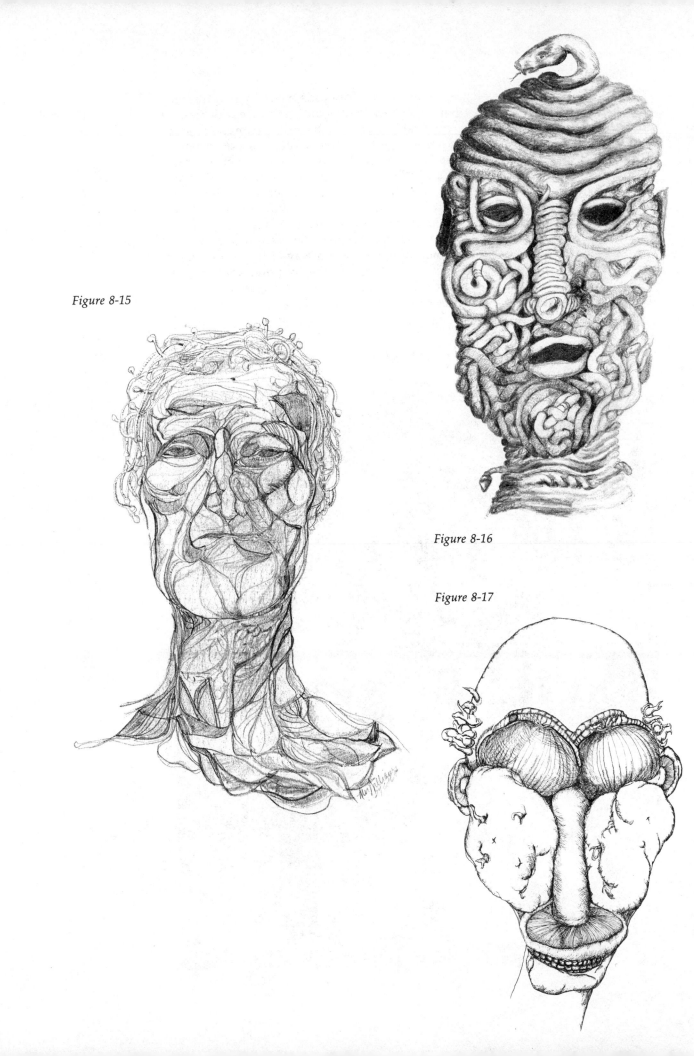

Figure 8-15

Figure 8-16

Figure 8-17

IN CONCLUSION, let us look at some studies of heads made by two master artists in order to reinforce what has been said about the process of transformation, and also to see how the head as motif lends itself to expressive and symbolic change. Figure 8-18 shows a page from Henry Moore's sketch book entitled *Helmet Heads*. What is the symbolic implication of the helmet when it becomes shaped as the human head? What is the artist's reason for taking an object which normally covers and protects the head, and turning it into the head itself? What ideas does it conjure up? Or do you think Moore is just interested in the helmet as a shape in its own right, and in what can be done with it as a design for sculpture? Would you say that these studies show expressive qualities, or does the helmet form represent a way of imposing order on the organic variables of the head? Ask yourself the by now familiar-type question, "When is a helmet not a helmet?" and see what you decide to say. I find that it is indeed the symbolic possibilities that intrigue.

Figure 8-18
Henry Moore. Helmet Heads *1948. Pen, chalk, and watercolor.*
COURTESY OF THE ARTIST.

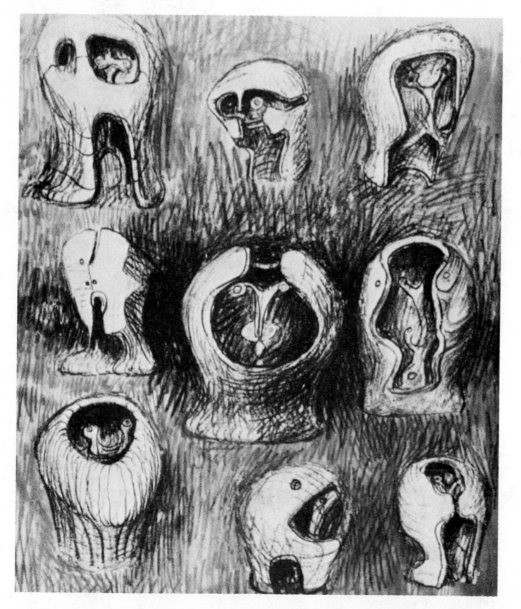

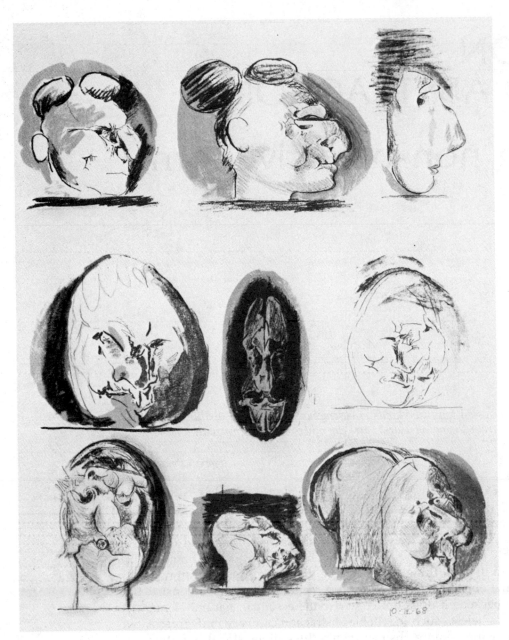

Figure 8-19
Graham Sutherland. Sheet of Studies—Heads *1968. Lithograph.*
From "Graham Sutherland—The Graphic Work," by Roberto Tassi.
EDICIONES POLIGRAFA, BARCELONA.

Graham Sutherland's *Sheet of Studies (heads)* (Fig. 8-19), reveals a variety of transformations which are not easy to categorize. Part symbolic, part expressive, the studies show shifts in facial structure as some areas fall away and others lift up, similar to the effects of an earthquake on the land. Rock forms appear here and there (do they work symbolically?), and expressive distortions abound. Notice how these changes take place *graphically*: a slight shift of a line here, the displacement of a plane or curved surface there. Do you find any one particular study to be charged with feeling, in which the artist is emotionally involved with his subject and expresses this in the drawing? And if one of these images was to be a prototype design for a mask of Pluto—to work both expressively and symbolically—which one would it be?

VISION
AND ABSTRACTION

9

using non-objective form

*There are essentially two kinds of abstraction—one which distills aspects or essences from the object world, and the other which begins with no object at all.**

JOHN SEDGWICK

A̲T THE END of Chapter 7 I said that it would be necessary to examine how abstraction in art serves the creative imagination. As Professor Sedgwick points out, we must recognize two levels of abstraction. One kind of abstraction is inevitably present in any work of art because an image, however true in appearance to the real thing, can never be that thing. It is something "withdrawn" from the object, standing apart as a mental and plastic reconstruction, surely abstract because it does not comprise the essential, natural elements of the object. Nevertheless, such inevitable abstraction can vary in degree. A two-dimensional drawing is more abstract than a three-dimensional sculpture, and the less faithfully either the drawing or sculpture represents the shape of the perceived object, the greater will be the degree of abstraction. The second kind of abstraction, which "begins with no object at all," is what we can truly call *non-objective art*.

You may already be thinking, "Well, if this is the case, we have been involved with abstraction all along—from the first experiments with basic drawing marks." And, of course, you would be right. In fact, those early drawings, when no object was in sight or in mind, produced Workbook pages which could only be described as non-objective. But when we began to examine the nature of perceptual experience in an encounter with the world—to reconstruct, in drawing, figure and ground—we were making images which, although they might vary in the degree of abstraction present, were not totally abstract, not non-objective.

**John P. Sedgwick, Discovering Modern Art (New York: Random House, 1966), p. 201.*

In this final chapter we are going to try to work entirely non-objectively, and to demonstrate how "abstraction of the second kind" serves our imaginative needs. One of the things twentieth-century art has shown is that if the artist is freed from "the tyranny of the object"—as Kandinsky put it—he or she can *invent* forms which, because of their "unworldly" nature, can more directly represent the concepts or feelings which inspired them. In other words, such non-objective configurations are "tailor made" to suit the artist's attitude, but when objects are pressed into service for this purpose, they demand that some attention be paid to their physical appearance, which thus limits the freedom of the artist to create and discover simultaneously the shapes which truly embody personal states of mind.

There is more than one way and more than one source by which non-objective art became a viable movement in our century. But whether one looks back to the way initiated by Cézanne that led to Cubism; to the researches of Mondrian that ultimately produced what he described as "plastic mathematics"; or to the feeling for life exemplified by Vincent van Gogh and that, when experienced by Wassily Kandinsky, resulted in the loss of the object, we see that non-objectivity serves two mental masters. Once again—if we analyze the life of art—we find abstract images serving the conceptual and expressive modes of consciousness no less so than representational work, and so they may equally well be described as either Classical or Romantic.

If we use the terminology logically, the non-objective art of our time may be broadly categorized as that of Abstract Order or Abstract Symbolism—terms which are not in general use—or that of Abstract Expressionism, a title with which we are all familiar.

Let us look briefly at the first of these. Paul Cézanne talked of *"treating nature by the cone, the cube and the cylinder . . . ,"* the basic volumes you see in Figure 9-1. He did not mean by this that artists should impose these

Figure 9-1

shapes on objects or on landscape, but that they should seek to discover how essentially these geometric figures provide a morphological foundation in nature, and structure their drawings accordingly. In so doing the image would be convincing because inessential details would be stripped away, as you see in Cézanne's *"Bibemus" Quarry* (Fig. 9-2). Pablo Picasso and Georges Braque, the founders of Cubism, acknowledged their debt to Cézanne and went further. Although Picasso calls the drawing you see in Figure 9-3 *Standing Female Nude*, the image is just about totally abstract: It is the ordered arrangement of basic geometric shapes which has interested Picasso, not the organic reality of the female body as such or any strong feelings engendered by it.

Piet Mondrian came to the art of Abstract Order more or less independently. A keen student of nature, he searched for the essential aspects of organic structure in butterflies, flowers, trees—all natural forms which interested him. He sought to discover the underlying mathematical order behind things, the kind of geometric precision Samuel Colman constructs in Figure 9-4. This sort of exploration ultimately led Mondrian to eschew nature for geometry, for images so rational and ordered that even curve and diagonal were banished because they disturbed the absolute logic of pure rectilinear proportion. In Figure 9-5 space still flows and figure-ground conformations are varied and ambiguous; despite the geometric overtones the image is pulsing and organically

Figure 9-2
Paul Cézanne. View of *"Bibemus" Quarry 1895. Oil painting.*
COLLECTION: GALERIE PIERRE, PARIS.

Figure 9-4
Samuel Colman. Plan Drawing, Murex Shell.
From "Nature's Harmonic Unity,"
by Samuel Colman.

G. P. PUTNAM'S SONS, NEW YORK AND LONDON.

Figure 9-3
Pablo Picasso. **Standing Female Nude** *1910.*
Charcoal.

METROPOLITAN MUSEUM OF ART, ALFRED STIEGLITZ COLLECTION.

Figure 9-5
Piet Mondrian. Composition in Brown and Gray
1913–14. Oil on canvas.
COLLECTION: THE MUSEUM OF MODERN ART,

NEW YORK. PURCHASE.

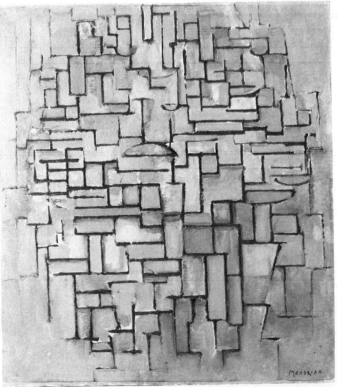

credible. But in Figure 9-6 such qualities disappear, and Mondrian creates a form which, for him, now represents the ideal aesthetic: an unambiguous geometric and mathematical purity which is as absolute and invariable as one can make it—order par excellence.

Wassily Kandinsky, on the other hand, takes a different route to Abstract Expressionism. Observe the contrast for yourself by comparing Kandinsky's *Abstract Composition* (Fig. 9-7) with the works of Cézanne, Picasso, and Mondrian we have just discussed.

Figure 9-7 is reputed to be one of the first non-objective paintings of this century. As Kandinsky has written extensively about his work, perhaps we should let him describe how it came about:

I did many sketches—these tables and different ornaments. They were never trivial, and so strongly painted that the *object dissolved* itself in them Often, too, I have succeeded: I have seen it in the observers. From the unconsciously intended effect of painting on the painted object, which can dissolve itself through being painted, derived my ability to *overlook* the object within the painting. Much later, in Munich, I was once enchanted by an unexpected view in my studio. It was the hour of approaching dusk. I came home with my paintbox after making a study, still dreaming and wrapped up in the work I had completed, when suddenly I saw an indescribably beautiful picture drenched with an inner glowing. At first I hesitated, then I rushed towards this mysterious picture, of which I saw nothing but forms and colors, and whose content was incomprehensible. Immediately I found the key to the puzzle: it was a picture I had painted, leaning against the wall, standing on its side. The next day I attempted to get the same effect by daylight. I was only half-successful: even on its side I always recognized the objects, and the fine finish of dusk was missing. Now I knew for certain that the object harmed my paintings.

A frightening depth of questions, weighted with responsibility confronted me. And the most important: what should replace the missing object . . . ?

It took a very long time before this question . . . received a proper answer from me. Often I look back into my past and am desolate to think how much time I took for the solution. I have only one consolation: I could never bring myself to use a form which developed out of the application of logic—not purely from *feeling* within me. I could not think up forms, and it repels me when I see such forms. All the forms which I ever used came "from themselves"; they presented themselves complete before my eyes . . . they created themselves while I was working, often surprising me.[1]

Just about everything that Kandinsky says here is at odds with Mondrian's position. It is not the concept of order which drives Kandinsky to nonobjectivity, but the power of *mood, of feelings* aroused by the poetic atmosphere of light, space, and color. What Kandinsky discovered that late afternoon in Munich, on returning to his studio, was that a particular organization of colored shapes and spaces *which did not need to be objectively identified* had the authority to move him. The consequence of this discovery is inescapable: Not only is the object not necessary, but it might actually get in the way of finding the visual equivalent for the life of feeling. What Kandinsky discovered is what later became called Abstract Expressionism.

Kandinsky was also a musician, and the relationship between nonobjective visual art and music did not escape him. Music, as an organization

[1]Wassily Kandinsky, "Reminiscences," in *Der Sturm* (Berlin: Hermuth Walden, 1913).

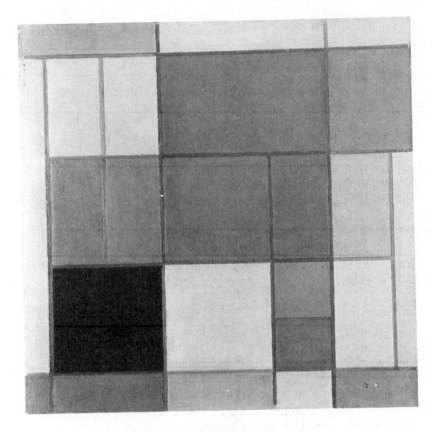

Figure 9-6
Piet Mondrian. Composition C *1920.*
Oil on canvas.
COLLECTION: THE MUSEUM OF MODERN ART, NEW YORK.
LILLIE P. BLISS BEQUEST.

Figure 9-7
Wassily Kandinsky. Abstract Composition *1910. Watercolor.*
COLLECTION: THE LATE MRS. NINA KANDINSKY, PARIS.

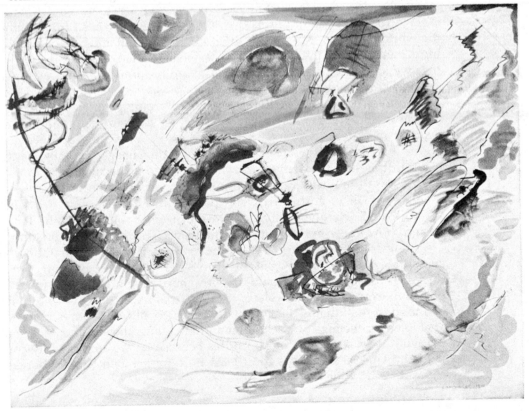

of sounds and silences, is just about totally abstract. The composer is not concerned with representing the sounds of the world around him or her—with auditory objectivity, if you like—but with taking the sounds of the eight- or twelve-tone scale, "fleshing them out" with instrumentation, structuring the rhythms of sonance and interval (silence), and creating a composite auditory experience which comes from him- or herself, not from nature. We would surely all agree that the sounds of mountain streams, rushing winds, cuckoo calls, freight engines do not in themselves constitute the musical form of a symphony or a sonata, and that the whole structure of a musical work springs from the composer's creative faculties rather than from his or her ability to imitate: There is little in nature, except perhaps that marvelous silence which we sometimes "hear," to inspire the art of a Beethoven or a Gershwin. And it rarely occurs to anybody—even to the most naive and musically ignorant listener—to ask what a piece of music is meant to represent. Yet the question is asked constantly of painting or sculpture. Music does not suffer from such perceptual associations, for the sound shape of nature does not influence the auditory imagination as significantly as her sight shape enters into the visual one.

The non-objective art of Kandinsky and others represents a cutting loose from this natural tendency to expect some recognizable association between the created form and space of the visual image and that of the natural world. The question Kandinsky poses is that if the musician is free to invent sound forms that are more internally inspired than externally sensed, then why should the visual artist not be equally free?

Kandinsky used musical analogies frequently in his own writings, and was a good friend and supporter of the innovative twelve-tone composer Arnold Schönberg whose amelodic works—in contrast to traditional, eight-tone melody—were as new to the ear as Kandinsky's paintings were to the eye. Indeed, it has often been suggested that Schönberg's non-objective images should be viewed as "visual music." When we listen to music, what moves us is the structure of sound in its own abstract right, divorced from memories of the world's sounds. Kandinsky suggested that we should be similarly divorced from memories of the world's objects when we look at a work of visual art, that we should be affected by the structure of form and space as a plastic invention in its own abstract right.

Figure 9-7 is said to be the experimental prototype of Kandinsky's first, totally abstract expressionist paintings. It is, as you can see, a random arrangement of marks, shapes, and spaces (and color, which, unfortunately, is missing in this black-and-white reproduction)—a test image, perhaps, as the artist tries out this new freedom to draw and paint non-objectively. Figure 9-8, however, shows the linear structure of a much later non-objective painting: a diagram, if you like, abstracted from the picture *Little Dream in Red* which was made in 1925. Here you can see how much more complete is the form of the design: how linear movements and the respective shapes of figure and ground are integrated to produce an altogether tighter composition than that presented by *Abstract Composition* in Figure 9-7. Again, if the painting were reproduced in full color, you would see how important a role color plays in non-objective expressionist art. Here, it brings this linear design to life, imparting a "mood in red" that is difficult to describe verbally without resorting to poetic analogies for feelings of celebration and joy. Nevertheless, the linear nature of the work does suffice for our purposes because, as we are primarily concerned with drawing, it allows us to at least introduce the structural "bones" of an expressive art which needs no objects.

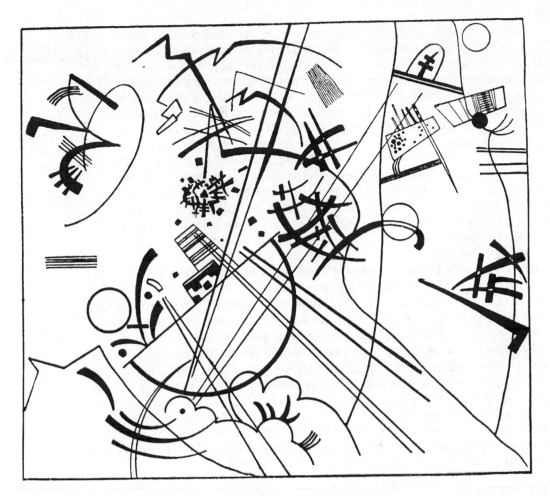

Figure 9-8
Wassily Kandinsky. Little Dream in Red 1925. *Linear structure derived from the painting.*
Appeared in 1926 in the Bauhaus publication "Punkt und Linie zu Fläche," edited by
Walter Gropius and L. Moholy-Nagy.

Let us not forget that it was the chance combination of a particular quality of studio light and a painting lying on its side and so for the moment unrecognizable that enabled Kandinsky to be aroused by a new kind of pictorial form: one which worked directly on a state of mind or feeling, and achieved a response without it being necessary to ask, "What is it meant to be?" When this is the case, art is truly abstract.

WORKBOOK

Sound and Shape

You are now going to try to make non-objective images. You are going to work in such a way that both ordered and expressive aspects may emerge in one drawing. However, depending on the musical choices you make, you may need to make independent drawings to produce the two effects.

The simplest way to initiate the experience of working non-objectively is to employ a stimulus which is itself unrelated to the world of objects. Therefore you are going to use music as your catalyst.

We experience musical form as a sequence of sounds comprising a range of various tones which are sustained for various lengths of time; which possess a certain acoustical strength from the very loud to the very soft; and which are organized around intervals of silence. The silences—or spaces—are also varied in time as long or short intervals. All these factors constitute the elements of music and are capable of being used in any number of permutations. Consequently, as a complex structure of sound and interval, music is capable of engaging us mentally at several levels: we perceive its overall sonic shape in linear time and, as a result, respond intellectually and emotionally to the form. As with the visual arts, musical form can be predominantly ordered and balanced or unsystematic and free flowing. An example of the first would be the music of J. S. Bach, and one of the second would be the sound of Wagner, which immediately conjures up mental images of great sweeps of sound and silence which do not follow the laws of conventional counterpoint. Bach is order; Wagner expression. And yet we should not forget that Bach's order—that marvelous structure of mathematically modulated tone and spatial interval—creates its own mood and stirs a particular kind of feeling; and that Wagner's predominant expressionism, while it shapes the grandest of passions, is nevertheless underpinned by a sonic structure which is less apparent because it follows no precise rules of formal measure or beat, and is overwhelmed—in our auditory perception—by the lyrical intensity of the sound it supports.

Therefore when you are listening to your chosen piece of music, prior to drawing, make sure that you concentrate on discerning both the rhythmic *order* and the feeling *expression* of the sound, even though one or the other will most likely dominate. What you are to do is to try to find the non-objective visual form which is the graphic equivalent of both: you are to shape measure and beat when and where you perceive it, and, in the same drawing, also convey the prevailing feeling mood of the piece.

Graphic, Non-Objective Invention

First you must decide upon some appropriate music to use for this exercise. It really does not matter what sort of music you choose. Although I have used Bach and Wagner as examples of composers creating different kinds of sound, this does not imply that so-called "classical" music will work more effectively for our purposes than, say, contemporary popular music. The important thing is that you choose music which appeals strongly to you, either for its rhythm or its beat, or because you are moved by it. Some people find it advantageous, initially, to work from two or three pieces of music because the contrasts in tempo and mood permit them to discover which is best suited to visual translation. Then they can then go ahead and concentrate on developing the drawing possessing the most potential.

The effectiveness of this exercise depends upon how free and experimental you are in the use of drawing techniques, and on how you exploit particular graphic qualities or unexpected configurations of figure and ground. Thus, I describe the process in general terms rather than step by step. The rest I leave to you.

It is helpful before you begin to assemble a variety of equipment—brush, water, saucer of ink, felt-tip pens and liners, brushes and cut twigs. Do not forget to consider the ever useful finger and finger nail. I would suggest, however, that you start your visual explorations of sound by using a pencil to make the first, tentative design, because this enables you to modify the form of the emerging image by erasing here and strengthening a mark there. In fact, this is the way to proceed: You should gradually develop the image over a period of time as you continue to play the music and learn more about it. At the same time you should enrich the drawing by an increasingly relevant "graphic orchestration." As you proceed, you must be prepared to harness spontaneity of vision with calm and deliberate editing—to be involved in an almost dream-like way with the sound and the graphic emergence of its visual counterpart, yet to be consciously deciding the effectiveness of each line and mark, of each formed figure and each shaped space, and of the overall "rightness" of the composition in terms of both order and expression. You must think of each line in terms of the sound it suggests: high pitched and drawn out, or deep

and throbbing to a pulse. Each point may be a short-lived note or a punctuation halting the flow. Spatial intervals will represent measure and beat. Directional movement over the page of any element or elements of drawing will suggest the rate and travel of sound between high and low tonal ranges. And skeletal or mass characteristics developed in either figure or ground will reflect the appropriate feeling, make changes in tempo, suggest variations in tone.

This is not an easy job; there are a tremendous number of variables. Above all, however, you should try to:

- Utilize the whole of your graphic repertoire;
- Realize how space organization will convey rhythm and measure;
- Be aware of how developing shaped areas of figure or ground serve either expression or order, and so reflect classical or romantic qualities in the music.

Remember, too, that to make a really effective drawing, you must graphically build up the design with repeated hearings of the music—thicken lines here, complete area shapes there, work in light and shadow, determine textural possibilities, and, last but not least, organize the space of the composition to render the music's *rhythmic structure.*

Whether your drawing, or drawings, are a success or not—whether they do or do not work as images in their own right—at least you might have come to appreciate that sheer visual invention can occur without benefit of objects, and that such visual "non-objective-ness" can create as meaningful an image as that which results from more representational drawing. It will be a real coup if you bring this off: Your doing it well will demonstrate that you have acquired a rich graphic "vocabulary" of marks, that you can manipulate figure-ground relationships to fashion a specific result, and that you are capable of mustering the fine mental balance of intuition and reason necessary to determine the form of a work.

George Wray's *Neon Elvis* (Fig. 9-9), though not strictly non-objective, nevertheless provides a good example of how musical rhythms—punctuated sound—can be visually transposed; the drawing also shows how varying graphic treatments can suggest differ-

Figure 9-9
George Wray. Neon Elvis *1980. Ebony pencil on paper.*
COURTESY OF THE ARTIST.

ences in musical tone, changes in the rate of flow of sound, and contrast between cadences of sound and staccato-like "points" of sound. Notice also that vertical, diagonal, and horizontal marks suggest different acoustical properties. And finally, you can see how closely space intervals on the page relate to sound intervals in the flow of music. The interesting question is, if the name "Elvis" was not graphically clear and readable, would the drawing's association with music be less obvious; would it still work as a visual analogy for sound?

Now examine Figures 9-10 to 9-13, and assess the relative success of each in terms of their interesting qualities as drawings *and* their sonic possibilities as visual-musical scores.

Figure 9-10

Figure 9-11

Figure 9-12

Figure 9-13

MY LAST WORD to justify the visual imagination and to conclude this book is taken from Henri Focillon's quotation introducing Chapter 8: The artist's special privilege "is to imagine, to recollect, to think, and to feel *in forms*." This is, after all, what we have been trying to do as we worked through this book. I hope that we have been at least partly successful, and that you have enjoyed the experience of graphically clarifying visual sensations of the world in Part One, and of "imagining in forms" in Part Two.

GLOSSARY

abstract/abstraction An image that possesses no representational links with any object of sense perception. Such an image is entirely non-objective. Degrees of abstraction depend upon the extent to which a work of art shows an object, the world, transformed as the result of creative need and invention.

Abstract Expressionism A movement in the visual arts which became internationally developed after World War II. As the name implies, the images which emerged were non-objective and were generated to express mood and feeling. The emphasis of Abstract Expressionism—sometimes called Action Painting—was on the use of spontaneous and free movement to develop the visual, plastic equivalent of feeling states.

aesthetic A word with a variety of connotations concerning the whole experience of the arts. It:

 a. Refers to that quality in a work of art which we describe as *beauty* or perfection of form.

 b. Implies the *meaningful* nature of art—the feeling and thought which is aroused, whether the form be beautiful or not.

 c. Alludes to the *imaginative* nature of artistic statements: that the "aesthetic" element springs from a deeper level of consciousness.

ambiance The general "atmosphere" that an image suggests—in physical terms: light, airy, and free; or dark, enclosed, and tight; and in psychological terms: happy, brooding, mysterious, intelligible, and so on.

articulation Implying a general spacing of things. The way in which a broad expanse of ground is broken up by means of visual indicators: the proportionate distances involved, the rhythm of such spacing. Similarly with the parts of figure: the proportions, rhythms, and directional movements of limbs and areas which engage visual perception and contribute substantially to the overall form of an image.

Art Nouveau The name given to a movement in arts and crafts, identified about 1895 and taking its name from that of an art gallery. The movement grew throughout the early years of the twentieth century and, from time to time continues to be resurrected. It is characterized by highly stylized, curvilinear forms inspired by the organic exuberance of nature.

autonomy/autonomous Indicates a decision-making process—in terms of initiating and developing a drawing—which occurs unself-consciously. An artist does not always have to deliberate, to assess the pros and cons. Such awareness seems to spring from an independent force of mind—one that operates autonomously and often spontaneously without benefit of normal conscious reasoning.

catalyst Any object or aspect of an object, or any particular or general visual experience, which triggers the mental involvement of an artist and is responsible

for the generation of a work of art. It is also possible for any one of the other senses besides sight—sound or smell, for example—to act as catalyst.

chiaroscuro Strong contrasts in light and shade, which intensify the sense of volume and mass in a drawing, as well as the three dimensionality of space. Such intense contrasts also impart a heightened dramatic power to the graphic image.

classical Signifying those qualities in a work of art which we describe as follows: order, harmony, balance (not a dead, mechanical symmetry but a lively one), formal beauty, reasonably homogeneous proportions, and so on.

cognition The process of knowing in the broadest sense, including perception, memory, judgment, and so on, and the result of such a process. Knowing of this sort embraces both rational and intuitive operations of consciousness. It is a mental process that is both objective and subjective and which can also extend into the action which results. This role of mind is vital in the life of the artist; *feeling* is an opposite—yet interwoven—drive.

conceptual That which is experienced as a mental construct, a proposition of the mind which can, at one level, exist independently of sense experience of the world.

Constructivism A European movement in sculpture, painting, and architecture in the early 1920s. It stressed the purity of abstract, geometric forms, and insisted that *space* is as positive a plastic element in the creation of a work of art as is the solid materiality of figure or object.

content If the physical nature of a work is called "form," then the intangibility of the meaning it suggests is called "content." We have pointed out the artificiality of separating the two terms. Nevertheless, to talk about content is to refer to the spirit of the work of art—its meaning and significance due to the thoughts it carries, the feelings it conveys.

counterpoint A perceived interaction between part and part. Such contrasts can occur over the whole figure-ground situation, or simply in places where the artist desires such measured, proportionate, and rhythmic interplay to occur.

Cubism A movement in the visual arts apparently initiated by Picasso and Braque about 1905. It really has nothing much to do with "cubing" as such, although the pictorial and sculptural results seem to take on such a geometric simplification. Rather, the images represent an attempt to discover a new plastic reality, one which is an amalgam of several different aspects of an object, as back, front, and side are shown simultaneously in one image.

design concept A marking out in the mind. A mental realization of the graphic form best suited to convey a desired content. Applies to the commercial, applied, and visual arts.

doodling Free, ideationless drawing. A random occupying of space with drawing marks.

dynamics The active or static nature of an image which may be experienced in two ways:

 a. By its physical form in terms of figure-ground organization: whether it is still or in motion.

 b. By the psychological quality of its content: whether it is stirring and forceful, or calm and serene.

eclecticism The practice of borrowing from the work of other artists and other periods in such a way that the influence is apparent. When it represents the selective use of particularly valued elements such borrowing obviously goes beyond mere derivationism. Indiscriminate use of such influences may perhaps be better described as mannerism rather than eclecticism.

élan Dash, verve, assurance, enthusiasm.

embryonic The state of being just conceived—of being the nucleus of what will become the fully developed image, either still within the mind or initially formed on the paper.

empathy The experience by a viewer of a particular kind of emotional identification with either an object or an image we call a work of art. It is recognized by that viewer's projecting strongly personal feelings onto the thing perceived—feelings triggered by the thing which have the effect of forging an emotional bond between the viewer and the object or image.

Etruscan Pertaining to the ancient culture of Etruria—that area of Northern Italy in the seventh and eighth centuries which comprises (approximately) present day Tuscany and Umbria.

existential That which is in a tangible state of existence, present to the senses and perceived at the moment of time *now*.

expression/expressive Signifying the release and shaping of feeling and mood through the creation of a work of art.

Futurism Originally, in 1909, a manifesto of Futurist poetry written by Filippo Tommaso Marinetti extolling the beauty of speed and aggressive movement, and vowing to destroy museums. The challenge was taken up by a group of Italian painters who transferred the spirit of the manifesto onto the canvas. Futurism thenceforth became a visual art movement in its own right.

gestalt A school of psychology developed in Germany which asserts that human behavior results from a complex integration of objective and subjective experience, which cannot be reduced to a simple stimulus-response explanation. The gestalt view of visual perception is that each person's awareness will carry a strong personal component, depending on his or her accumulated past experience, as well as on the prevailing physical and psychological aspects of the moment.

gestural drawing When the physical nature of the drawing movement—the body's stance and the action of arm, wrist, and fingers—determines the overall graphic nature of the work, it is called gestural drawing.

graphic elements The basic components of drawings, all of which are made manifest by the use of some staining medium. The elements are: point, line, area shape (figure), area shape (ground), tone, texture, and space.

hatched textures Surface texture created by applying layers of closely shaped lines over each other in a warp- and weft-like weave. The texture can be lighter or darker depending on the closeness of the lines and the number of "woven" layers applied.

image The work of art itself—the drawing, painting, sculpture, architecture. *Graphic image* refers only to the

visual statement created through drawing or painting, or otherwise marking a surface. *Mental image* is the "shape" of idea and feeling (the felt thought) which develops in the mind. Sometimes a more or less complete mental picture will result; sometimes a hint of color or a strangely formed detail will be enough to initiate the imaginative process; again, the mental image may be, in part, verbal—words in the mind. In any event, the outcome for the artist is usually the same: the need to find an equivalent external form. Hence drawing . . . and, of course, all other creative outlets.

immanent A quality or characteristic which is inherently suggested by the form of a work of art: residing in the work, contained by it, dwelling within it.

intuition/intuitive The process by which mental images (both thought and feeling) are brought to mind without benefit of sensory experience of the outside world. Such original and imaginative images do not depend upon one's reaching conclusions rationally from objective experience. It might therefore be said that to be inspired is to be under the sway of one's intuition.

kinesthetic The motor or physiological response to mental experience. The way in which nerve, muscle, and limb act in both the approach to, and actual contact with, the surface on which graphic impressions are to be made.

Minimalism A movement developed within the last ten years, committed to perceptual experimentation in reducing the substantiality of figure in the figure-ground situation to the point where the viewer must exercise both acuity of sight and thought.

monochromatic Literally meaning "one color," the word tends to be applied to works which utilize a range of tone values passing from black through the grays to white. However, any drawing or painting executed in only one color but using all the *values* of that color from dark to light is also monochromatic.

morphology The anatomical, shape characteristics of physical things both organic and inorganic: the distinctive condition of each part and the ways in which they combine to structure the whole. The term implies more than the general shape of an object: The degree of structural complexity and the type of formal unity achieved are also involved.

mystique Suggests that sense of wonder, even awe, which accompanies those moments when the imagination is in full control, and when one is involved in the act of shaping and discovering its forms.

naturalistic Indicates the high degree of objectivity which ensures that a graphic image is a faithful representation of the object perceived.

non-objective art Drawings, paintings, or sculptures in which no recognizable object appears. Non-objective artists invent their own forms without direct reference to the shape of things in the world. Also described as non-figurative, or non-representational art.

"Op" art Short for "Optical" art. A style of art which—following World War II—concentrated on creating visual effects of light, color, and movement, in an abstract vein, in order to create striking illusions.

Paleolithic era Old Stone Age, dating roughly from 45,000 to 10,000 B.C.

pigment A paint medium as opposed to an ink solution. The word carries connotations of thickness: of opacity as opposed to translucency.

plasticity The "elasticity" of shaping: of pushing and pulling a medium around in order to develop a required form. Hence, the "plastic" arts: the arts of pliantly molding a physical substance.

Pointillism A method of painting devised in the late nineteenth century by certain French Impressionists, by which figure and ground were built up from a mosaic of brush-tip point marks carefully modulated in hue so as to produce gradual changes in light to dark values.

prelogical Describes a mental approach to life which depends more on intuitive systems of awareness than on rational and logical ones. Carries connotations of evolutionary development and is applied to early cultures such as the Paleolithic.

romantic Used as a general term to denote that:

 a. The artist's concern is to express mood and feeling.
 b. The work itself is highly individual in nature and represents a strongly personal view.

sensibility/sentient A particular receptivity to all forms of awareness. An alert, if not heightened, consciousness that enables one to see all that is to be seen and to be aware of the meaning residing in the experience. Someone who has these qualities is considered sentient.

shaman In older cultures the person trained in the mysteries—in dealing with supernatural forces, with the unpredictable workings of the natural world, and with the depths of the human pysche. In other words, he or she who is wise and all-knowing. Nowadays the word can generally be applied to all kinds of spiritual leaders in the East and the West, and to all who shed light on human and cosmological "being." From this point of view artists have also been thought of as shamans: It is reasonable to assume that in Paleolithic hunting societies the shamans were also the cave painters, working their magic.

stippling The technique of dabbing on stain or pigment with the end of the brush, as opposed to stroking them on with the side and tip. The best stippling effect—that of a grainy and broken texture—is obtained with a brush made of hog bristle which has a flat (as opposed to pointed) end measuring perhaps one-half inch across.

structure Generally, a rather "loose" word with several connotations. When used in this text the implication is always specific—namely, the way in which a work of art or an object is physically put together.

Surrealism/surreal From the French *surréalisme*, literally above and beyond reality. The Surrealists' program in art and literature (ca. 1916) credited the world of dream and the non-rational images of the unconscious with as much reality as normal, conscious awareness. In Surrealist art we find both realms of experience juxtaposed. In common usage the word "surreal" describes events and experiences which have a touch of the bizarre about them; a dream-like quality removed from normal sense experience.

sympathetic magic The ability to enter, imaginatively, into the life of another living creature by focusing the strength of feeling engendered by it. This leads to the non-rational belief that one possesses the power to influence the course of events affecting the destiny of the creature. We think that one way in which the Pa-

leolithic hunter achieved this was by his expressive depiction of the animal—by the ritual of art. But such identification may also be made with inanimate objects. The British artist John Constable said that he could not adequately paint a tree until he had become the tree, by which he meant until the intensity of his feeling for tree and "treeness" allowed him to become one with the tree.

tone The range of dark or light values present in an image.

transfiguration A synonym for "transformation": the suggestion of significant change from the original resulting in the discovery of new meaning.

vision Although the term in general usage implies the sense of sight—of seeing things with the eye—it may also connote mental imagery of an imaginative and contemplative sort. This latter use of the word is what concerns us here.

wash The broad application of a *flow* of diluted stain or diluted pigment which imparts a fleetness of touch and a lightness and transparency of tone.

INDEX

A

Abstract art, 270–81; compared to representational art, 29, 48–49; and expressionism, 274–77; and order, 271–74; and perceptual stress, 61–62

Abstract Composition, by Wassily Kandinsky, 274, **275**, 276

Abstract expressionism, 271, 274, 276; defined, 282

Abstract in Black and White, by Victor Pasmore, 166, **167**, 168, 170

Abstraction: defined, 282; two levels, 270–71

Abstract order, 271–74

Aesthetic, defined, 282

African dance mask, 261–62, **262**, 263

ALBAUGH, JOHN: *Mount Ranier*, **182**; *Pebble with Holes*, **131**, 131–32; *Warty Gourd*, **151**; *Weathered Wood*, **139**; *Worm-Eaten Wood Form*, 248, **249**

Ambiance, defined, 282

Amiens Cathedral, choir vault, 66, **67**

Amphora, 231, **232**

Analytical Plan and Elevation of the Milkweed, by Samuel Colman, **145**

Anatomical diagrams, **212**, **213**, **214**, **215**

Anatomical Drawing (Shoulder), by Leonardo da Vinci, 106, **107**

Anatomical Exposition of a Tiger, by George Stubbs, 114–17, **116**

Angles of juxtaposition, 168

Arabic calligraphy, 51

Architecture: dynamics, 176; and space composition, 66, 74

Area: as basic mark, 13, 15–16, 17, 36, 50; dynamic implications, 193–94, 205; placement, 61, 68–70

ARISTOTLE, 145

Articulation, defined, 282

Art nouveau, 111, 147; defined, 282

Assemblage, 243

Assemblage, by Ruth Carpenter, 243, **244**

Autonomy, defined, 282

B

BACH, J. S., 278

BACON, FRANCIS, 3

BADT, KURT, 185

Balsam Root, by Constance Speth, 164, **165**

Balustrade of the Solvey Residence, Brussels, by Victor Horta, 111, **112**

BARTNING, OTTO, Sternkirche Project, **113**

Bataille, study for, by Jean Fautrier, **54**

Battle of the Amazons, by Peter Paul Rubens, **175**

BECKMANN, MAX, 77

BERENSON, BERNARD, 65–66

Bird Garden: Winter Morning, by Victor Pasmore, 126, **127**

Birth of the Greek Vase, by Auguste Rodin, 231, **232**

Bladderwort plants, 118, **120**

Boats at Saintes-Maries, by Vincent van Gogh, **19**, 19–20

BOCCIONI, UMBERTO, 191; *Study for Dynamic Force of a Cyclist II*, **190**

Bones I, II, and *III*, by Betty Peebles, **242**, 243

BRANCUSI, CONSTANTIN, *Muse*, 107–9, **108**

BRAQUE, GEORGES, 272, 283

Brasilia Cathedral, by Oscar Niemeyer, 114, **115**

BRION, MARCEL, 1

BROWN, DONALD, *Untitled*, 175, **176**

Brush Drawing, by Pascal Tchakmakian, **51**

Brush Drawing (Series 1), by Reg Butler, 188, **189**

Bull, by Picasso, **23**, 23–24, 185, 243
Bullslaughter Bay, by John Piper, **171**
BUTLER, REG, *Brush Drawing (Series 1)*, 188, **189**
Butterfly Table, by Dan Cooper, 176, **178**

C

Calligraphic line, 51
CARPENTER, RUTH: *Assemblage*, 243, **244**; *Crumpled Aluminum Foil*, **200**; *Found Object*, **240**
Catalyst, defined, 282–83
Cave drawings, 1, 2, 9, 60 *fn*, 222
CÉZANNE, PAUL, 67, 170, 173, 271–72; *Mont Sainte-Victoire Seen from "Bibemus" Quarry*, **170**; *View of "Bibemus" Quarry*, **272**
Chakra Suite Number 4, by Robert Kiley, 37, **38**, **193**, 194
Chess Players in Jerusalem, by Eugène Delacroix, 173, **174**
Chiaroscuro, defined, 283
Chinese brushwork, 51, 81, 82
Church of Die Wies, West Germany, by Dominikus Zimmermann, **84**, 85
Classical, defined, 283
Clematis, by Robert Nix, 118, **120**
Cognition, defined, 283
Collage, 91–92
COLLIER, RUTH, *Girl Bouncing*, 5, **6**
COLMAN, SAMUEL: *Analytic Plan and Elevation of the Milkweed*, **145**; *Plan Drawing, Murex Shell*, 272, **273**
Common Thistle, by Robert Nix, 118, **119**, **144** (detail), **245**
Composite Form—Idea for Sculpture, by Betty Peebles, **152**
Composite forms, 142–48
Composition: equilibrium and turbulence, 166–76; individual aspects, 179–94; and motif, 244; and space perception, 74–85, 85–97
Composition, by Piet Mondrian, 274, **275**
Composition, by Henry Moore, 191, **192**, 193
Composition in Brown and Gray, by Piet Mondrian, 272–74, **273**
Composition of Hanging Bamboo, by Johnson Su-Sing Chow, 81, **82**
Composition with Lines, by Piet Mondrian, 92
Conceptual approach, 22; and deliberate-precision drawing, 24; and texture, 154, 157–59, 162
CONSTABLE, JOHN, 285; *Trees and Water on the Stour*, 16–17, **17**, 194
Constructivism, 67; defined, 283
Content: defined, 283; and form, 223; and gesture, 21–22
Continuous surface directional lines and tones, 130–31, 132–33, 134–39
Contrast: and depth perception, 58–60, 61; and texture, 156
COOPER, DAN, *Butterfly Table*, 176, **178**
Counterpoint, defined, 283

Cow Vertebra, by Robert Nix, 248, **249**
Crumpled Aluminum Foil, by Ruth Carpenter, **200**
Cubism, 67, 271–72; defined, 283
Current, by Bridget Riley, **207**, 207–8
Curved Form, by Barbara Hepworth, 80, **81**
Curved surfaces, 191–93, 199–201
Curvilinear swell, 187, 188, 190–91
Curving Twig, by Robert Nix, 57, **58**, 58–59

D

Daffodils, The (Wordsworth), 230
Death in Venice (Mann), 76
Death of Sardanapalus, by Eugène Delacroix, 173, **174**
DEBUSSY, CLAUDE, 43
Deer of Lascaux, ii, 1, 2, 9
Deformed steel, 155–56, **156**
DELACROIX, EUGÈNE, 140–41, 185, 234; *Chess Players in Jerusalem*, 173, **174**; *Death of Sardanapalus*, 173, **174**; *Lion and Tiger*, **184**, 185; *Massacre at Chios*, 173, **174**; *Studies for Sardanapalus*, **54**; *Tiger*, 22–23, **23**, 24
Deliberate-precision drawing, 24, 46–49
Depth perception, 58–61; perceptual stresses, 61–63; perspective method, 64–66
Design, two- vs. three-dimensional, 74
Design concept, defined, 283
D'HONNECOURT, VILLARD, *Studies*, 48
DIJSSELHOF, GERRIT WILLEM, title page of *Kunst en Samenleving*, 111, **112**
Directional movement, 58–59, 61, 64
Distance, compositional principles, 168
Doodling, defined, 283
Doric Vases, by Amédée Ozenfant, 231, **232**
Double Standing Figure, by Henry Moore, 110, **111**
Drawing: abstract vs. representational, 29; basic marks, 13–21, 30–37; expressive and conceptual approaches, 22–24; as form of self-expression, 5–6, 9–10; free-action vs. deliberate-precision techniques, 24–29, 40–51; gesture and content, 21–22; as magical act, 2–3, 9; vs. painting, 2, 50; role in visual arts, 6–7; tools and supplies, 30
Drawing, by John Flavin, **96**
Drawing, by Henry Moore, **71**
Drawing I, II, and III, by Betty Peebles, **47**, **48**, **49**
Drawing of Linear Flow I, II, and III, by Betty Peebles, 187, **188**, **189**
Drawing: Oval Volumes, by Betty Peebles, **134**
Dual Form with Chrome Rods, by Laszlo Moholy-Nagy, 107, **108**, 109
DUBUFFET, JEAN, *Paix*, **14**
DÜRER, ALBRECHT, 143
Dynamics: defined, 283; equilibrium and turbulence, 166–206; optical, 207–9; and space composition, 82–85

E

Eclecticism, defined, 283
Edge: as line, 17; and mass, 140
EDMONSTON, PAUL: *Falling*, **203**; *Landscape*, **202**; *Organic Form I, II, and III*, 197, **198**, **199**; *Organic Landscape*, **203**; *Rock Landscape*, 202, **203**; *Triptych*, **206**; *Untitled*, **204**
Egg, The, by Graham Sutherland, 246–47, **247**
EISELEY, LAUREN, 166
EISLER, COLIN, 13
Elan, defined, 283
Elephant skull, 254, **255**
Elephant Skull, by Henry Moore, **141**
Elephant Skull Drawing, by Henry Moore, **257**, 257–58, 263
Embryonic, defined, 283
Embryonic cluster, 197–99
Emotions, expression of, 40–43, 44–45. *See also* Expression
Empathy, defined, 283
Energy, compositional aspects, 179–94
Environmental Painting, by Victor Pasmore, **81**
Equilibrium: defined, 171; example, 173; and vitality, 175
Etruscan, defined, 283
Etruscan sculpture, 117
Existential, defined, 283
Expression: defined, 283; drawing as form of, 5–6, 9–10, 40–46; and imagination, 253, 254, 257–58, 261–62, 264–65; in music, 278. *See also* Expressive mode
Expressionism, 40, 43. *See also* Abstract expressionism
Expressive distortion, 264–65
Expressive mode, 22, 24, 40–43; and space, 98; and texture, 154, 157–59, 162. *See also* Expression

F

Falling, by Paul Edmonston, **203**
FAUTRIER, JEAN, study for *Bataille*, **54**
FEININGER, ANDREAS, *Tree Form*, 132, **133**
Figure, vs. object, 105. *See also* Figure-ground relationship
Figure drawing, 210–18. *See also* Anatomical diagrams
Figure Drawing, by William Thompson, 62–63, **63**
Figure-ground relationship, 11–12, 68–73; discovering form in, 230–31, 234–39; and dynamic possibility, 166; methods of structuring, 61–67; optical illusions, 207–9; perception of, 57–61; skeletal shapes, 109; textural weave, 153–65. *See also* Figure; Ground
Figures and Animals in Deep Architectural View, by Gaetano Gondolfi, 64, **65**
FLAVIN, JOHN, *Drawing*, **96**
FOCILLON, HENRI, 253, 281
Foreshortening, 211
Forest Settlement, by Paul Klee, 79, **80**

Form: vs. content, 223; and figure-ground relationship, 11
Found object, 3, 240–43
Found Object, by Ruth Carpenter, **240**
Four Gray Sleepers, by Henry Moore, **130**
Fragment of Underlayer of Oak Bark, by Robert Nix, 226, **227**
Fragments of Melted Glass, by Robert Nix, **129**, 131
Free-action drawing, 24, 40–46
FROMENTIN, EUGÈNE, 22
FRY, ROGER, 228
FULLER, R. BUCKMINSTER, Kaiser Aluminum Dome, Honolulu, 176, **177**
Futurism, 67, 191; defined, 283

G

GABO, NAUM, 67, 77, 78
Garden in Provence, by Vincent van Gogh, **93**, 155, 157
Gardens of Hammersmith, by Victor Pasmore, 89, **90**
GAUDIER-BRZESKA, HENRI, *Nude*, **53**, 54
GAUGIN, PAUL, 254
Geometric Composition, by Bart van der Leck, 82, **83**
Gestalt, defined, 283
Gestural drawing, defined, 283; kinesthetic awareness, 20–22, 43–44
GIACOMETTI, ALBERTO, *Man Pointing*, **116**, 117
GIBSON, JAMES J., 78
GILBERT, STEPHEN, *Structure 14C*, 175, **176**
GILL, ERIC, 221
GILSON, ETIENNE, 4
Girl Bouncing, by Ruth Collier, 5, **6**
GONDOLFI, GAETANO, *Figures and Animals in Deep Architectural View*, 64, **65**
Grande Odalisque, study for, by Jean-Dominique Ingres, **53**
GRANT, ALISTAIR, 254
Graphic Development of Volumes—Mass and Space, by Betty Peebles, **138**
Graphic elements, defined, 283
Great Dome, The, by Paul Klee, **49**
Greek: aestheticism, 145; amphora, 231, **232**; calligraphy, 51; tragicomic mask, 261, **262**
GRIS, JUAN, *Seated Harlequin*, **28**, 28–29
Ground: enlivening with stains and marks, 182–83; four categories, 74. *See also* Figure-ground relationship

H

HAESLER, OTTO, Lobby of private residence, Celle, Germany, 84, **85**
Half Figure, by Henry Moore, 62, **63**
Half-Figure Girl, by Henry Moore, **55**
HARRISON, WALLACE, Presbyterian Church, Stamford, Connecticut, 114, **116**
Hatched textures, defined, 283

Heads, (drawing exercises), 261–66
Head of a Woman, by Pablo Picasso, **264**
Head of a Woman (Fernande), by Pablo Picasso, 191, **192**, 193
Head of a Young Man, by Pablo Picasso, 262, **263**
Hebrides Overture; (Mendelssohn), 44
Helmet Heads, by Henry Moore, **268**
Hen and Chickens Plant, by Robert Nix, **142**, 144, 147
HEPWORTH, BARBARA, *Curved Form*, 80, **81**
HERSCHLER, DAVID, *Spiritual Flight*, 114, **115**
HILDRED, JOHN, Table Study Lamp, **146**, 146–47
Honey Locust Thorn and Shadow, by Robert Nix, **118**
Horizontal Tree, by Piet Mondrian, **100**, 100–101
HORTA, VICTOR, Balustrade of the Solvey Residence, Brussels, 111, **112**
HSIEN, KUNG, *Wintry Mountain*, 60 *fn*, **61**
HUGO, VICTOR, *Satanic Head*, **236**
Human figure, 210–18
HUXLEY, JULIAN, 254
HUYGHE, RENÉ, 173

I

Idealization, 263
Ideas for Sculptures, by Betty Peebles, **48**, 49
Illusions, 207–9
Image, defined, 283–84
Image, by Victor Pasmore, 92–93, **93**
Imaginary Prison, An, by Henry Moore, 258, **259**, 260
Imagination, three basic directions, 253–55
Immanent, defined, 284
Impressionism, 35
INGRES, JEAN-DOMINIQUE, study for *La Grande Odalisque*, **53**, 54
Ink Bamboo, by Li K'an, 111, **113**
Intuition, defined, 284
Intuitive responses, 76
Italian Renaissance, 5, 64, 65

J

Japan: calligraphy, 51; *kakemono* shape, 60 *fn*; tradition of exchanging drawings, 37
Journal (Delacroix), 140
Joy of Life, The, by Henri Matisse, **98**
JUNG, CARL, 222
Juxtaposition, 168

K

Kaiser Aluminum Dome, Honolulu, by R. Buckminster Fuller, 176, **177**

Kakemono shape, 60 *fn*
KANDINSKY, WASSILY, 11, 254, 271, 274–77; *Abstract Composition*, 274, **275**, 276; *Little Dream in Red*, 276, **277**
KILEY, ROBERT, *Chakra Suite Number 4*, 37, **38**, 193, 194; *Water Suite Number 4*, **190**
Kinesthetic, defined, 284
Kinesthetic awareness, 43–44
King's College Chapel, Cambridge, 113–14, **114**
KLEE, PAUL, 1, 5, 143; *Forest Settlement*, 79, 80; *The Great Dome*, **49**; *Portrait of a Scholar*, **75**
KLIMT, GUSTAVE, 8
KRAMER, HARRY, *Torso*, **110**
Kunst en Samenleving, title page, by Gerrit Willem Dijsselhof, 111, **112**

L

Lamp in Glass and Bronze, **146**, 146–47
Landscape: Cézanne's treatment, 170; dynamics of, 201–4; line quality and placement, 71–73; textural weave in, 164
Landscape, by Paul Edmonston, **202**
Landscape, by Claude Lorrain, 19–20, **20**
LA PORTE, MARY, *Rumination 9*, 231, **233**
Lascaux, cave drawings, ii, 1, 2, 9
Leaf Figures, by Henry Moore, **246**
Leaves in the Snow, by Johnson Su-Sing Chow, 82, **83**
LE CORBUSIER, Philip's Pavilion, Brussels International Exhibition, 176, **177**
Legend of Orpheus (Monteverdi), 266
LEONARDO DA VINCI, 4, 8, 58, 106, 226, 228, 230, 231; *Anatomical Drawing (Shoulder)*, 106, **107**; *Mona Lisa*, 106; *Star of Bethlehem and Other Flowers*, **143**; *Storm of Water and Rocks*, 185, **186**; *Viola Odorato: Spikelet of Grammacea*, 149, **150**; *Virgin of the Rocks, The*, 106
Life drawing, 210–18
Light, and texture, 156
LI K'AN, *Ink Bamboo*, 111, **113**
Limbs: of human body, 211; of skeletal object, 109–10, 117, 118, 126
Line: as basic mark, 13, 14–15, 31–34, 40–49; dynamic implications, 183–91, 195–97, 201; edge of stain as, 17; and mass, 128–29, 130, 132, 133, 134–39; Mondrian's use of, 101; quality and placement of, 61, 69–73; and space composition, 88–91, 96–97
Line and Space, by Victor Pasmore, **181**
Linearism, of skeletal form, 109, 117, 118, 126
Linear Motif, by Victor Pasmore, 183, **184**, 185
Linear thrust, 187, 188

Lion and Tiger, by Eugène Delacroix, **184**, 185
Little Dream in Red, by Wassily Kandinsky, 276, **277**
Lobby of private residence, Celle, Germany, by Otto Haesler, **84**, 85
LOCHHEAD, KENNETH, *Outer Reach*, **59**, 59–60, 61–62
LORRAIN, CLAUDE, *Landscape*, 19–20, **20**; *View from Monte Mario*, **205**; *Wooded Landscape*, **16**
Lucite subject to ion implantation, **186**, 187

M

McCLAREN, NORMAN, *Stress*, **141**
Magic, 2–3, 9, 13, 222; sympathetic, 284–85
MANN, THOMAS, 76
Man Pointing, by Alberto Gioacometti, **116**, 117
Marble Comic Mask, 261, **262**
MARINETTI, FILIPPO TOMMASO, 283
Marsh Personage, by Paul Nash, 3, **4**, 222
Masks, 261–62
Massacre at Chios, by Eugène Delacroix, 173, **174**
Mass forms, 108–9, 127–41, 168, 197–99
Mass Forms, by Betty Peebles, **136**
MATHIEU, GEORGES, *Painting*, 185, **186**
MATISSE, HENRI, 98; *Joy of Life*, **98**; *Seated Nude*, **54**
Meander, 187, 188
Mechanical Form, by Robert Nix, 248, **250**
MENDELSSOHN, FELIX, 44
Mer, La (Debussy), 43
Mes Haines (Zola), 221
MICHELANGEO: Palazzo Farnese, 94, **95**; *Saint Matthew*, 158, **159**
MILLER, ROBERT, 62
Mimosa Branch, by Robert Nix, **113**
Mimosa Leaf, by Robert Nix, 118, **119**
Minimalism, 67; defined, 284
Minimal motif, 251–52
MOHOLY-NAGY, LASZLO, *Dual Form with Chrome Rods*, 107, **108**, 109
Mona Lisa, by Leonardo da Vinci, 106
MONDRIAN, PIET, 82, 85, 100, 101, 143; and Abstract Order, 271, 272, 274; *Composition C*, 274, **275**; *Composition in Brown and Gray*, 272, **273**; *Composition with Lines*, **92**; *Horizontal Tree*, **100**, 100–101; *Tree I*, **99**, 99–100, 101
Monochromatic, defined, 284
Monoprint, 236–37 (exercise)
MONTEVERDI, CLAUDIO, 266
Mont Sainte-Victoire Seen from "Bibemus" Quarry, by Paul Cézanne, **170**
MOORE, HENRY, 105, 227–28, 248, 254–55; *Composition*, 191, **192**, 193; *Double Standing Figure*, 110, **111**; *Drawing*, **71**; *Elephant Skull*, 141, **141**; *Elephant Skull Drawing*, **257**, 257–58, 263; *Four Gray Sleepers*,

130; *Half Figure*, 62, **63**; *Half-Figure Girl*, **55**; *Helmet Heads*, **268**; *Imaginary Prison, An*, 258, **259**, 260; *Leaf Figures*, **246**; *Mother and Child*, 63, **64**; *Pen Exercise Number X*, **51**; *Pen Exercise Number XV*, **15**; *Reclining Figure, External Form*, **97**, 97–98, 99, 100; *Reclining Figures*, 132, **133**; *Rocks, Arch and Tunnel*, 255–57, **256**; *Searching for the Skull's Internal Structure*, 255, **256**, 257; *Two-Piece Reclining Figure Number 2*, 128, **129**; *Two Standing Figures*, 24, **25**
Morphology, defined, 284
Mother and Child, by Henry Moore, 63, **64**
Motif, 244–47, 247–51; minimal, 251–52
Mountain Forms, by Linda Lee Shimmin, **147**, 147–48
Mount Rainier, by John Albaugh, **182**
MU-CH'I, *Persimmons*, 68–69, **69**
MULLEN, CARRIE, 251
MUNDT, ERNEST, *Tree Broken by Storm Decides to Live*, **152**
Muse, by Constantin Brancusi, 107–9, 108
Music: drawing in response to, 43–44; and non-objective art, 274–76, 277–80; textural weave, 153
Mystique, 9; defined, 284

N

NASH, PAUL: *Marsh Personage*, 3, **4**, 222; *Wood Fetish: Found Object Interpreted*, 3, **4**
Naturalistic, defined, 284
Negative space, 97–99
Neon Elvis, by George Wray, **279**, 279–80
New Briar Shoots, by Robert Nix, 118, **119**
NEWTON, ERIC, 221
NICHOLSON, BEN, *Still Life—Odyssey*, 180–81, **181**
NIEMEYER, OSCAR, Brasilia Cathedral, 114, **115**
NIX, ROBERT: *Clematis*, 118, **120**; *Common Thistle*, 118, **119**, **144** (detail), **245**; *Cow Vertebra*, 248, **249**; *Curving Twig*, 57, **58**, 58–59; *Fragment of Underlayer of Oak Bark*, 226, **227**; *Fragments of Melted Glass*, **129**, 131; *Hen and Chickens Plant*, **142**, 144, 147; *Honey Locust Thorn and Shadow*, **118**; *Mechanical Form*, 248, **250**; *Mimosa Branch*, **113**; *Mimosa Leaf*, 118, **119**; *New Briar Shoots*, 118, **119**; *Onion*, 127, **128**, 128–29; *Queen Anne's Lace*, **148**; *Saw Briar Tendrils*, 118, **119**; *Skeletal Form of Dry Moss*, 125, **126**; *Spathephyllium Leaf Unfolding*, 246, **247**; *Textures— Bark, Fungus, Grass, and Toad*, 154–55, **155**, 156; *Wild Garlic Stem*, 101, **102**
Non-objective art, defined, 284. *See also* Abstract art

Norham Castle, by J. M. W. Turner, 78, **79**
Notebooks (Leonardo da Vinci), 106
Notes d'un peintre (Matisse), 98
Nude, by Henri Gaudier-Brzeska, **53**
Number 10, by Jackson Pollock, **25**
Number 32, by Jackson Pollock, 25, **26**, 27, 29

O

Object, vs. figure, 105
Object, by Meret Oppenheim, **158**, 158–59
Old Masters (Fromentin), 22
Onion, by Robert Nix, 127, **128**, 128–29
Op art, 207–9; defined, 284
OPPENHEIM, MERET, *Object*, **158**, 158–59
Optical dynamics, 207–9
Order: and imagination, 253, 254, 255–57, 261–62, 263; in music, 278
Organic form, 143–48, 148–51, 152
Organic Form I, II, and III, by Paul Edmonston, 197, **198**, **199**
Organic Landscape, by Paul Edmonston, **203**
Oriental art, 60 fn
Outer Reach, by Kenneth Lochhead, **59**, 59–60, 61–62
OZENFANT, AMÉDÉE, *Doric Vases*, 231, **232**

P

Painting: vs. drawing, 2, 50; as ritual, 222
Painting, by George Mathieu, 185–87, **186**
Paix, by Jean Dubuffet, **14**
Palazzo Farnese, Rome, by Sangallo and Michelangelo, 94, **95**
Paleolithic drawing, 1–2, 5, 9, 60 fn, 222
Paleolithic era, defined, 284
PALMER, SAMUEL, *Valley with a Bright Cloud*, 171, **172**, 173
Participation mystique, 2, 222
PASMORE, JON, 88
PASMORE, VICTOR: *Abstract in Black and White*, 166–67, **167**, 168, 170; *Bird Garden: Winter Morning*, 126, **127**; *Environmental Painting*, 81; *Gardens of Hammersmith*, 89, **90**; *Image*, 92–93, **93**; *Linear Motif*, 183, **184**, 185; *Line and Space*, 181; photograph of, 87, **88**; *Spiral Motif: The Wave*, 252; *Still Life with Bottle and Flowers*, 79–81, **80**; *Window: Garden in Spring*, 182, **183**
Peach, The, by Auguste Rodin, 55, 130–31
Pebble with Holes, by John Albaugh, **131**, 131–32
PEEBLES, BETTY: *Bones I, II, and III*, **242**, 243; *Composite Form—Idea for Sculpture*, **152**; *Drawing I, II, and*

Peebles, Betty (cont.)
 III, **47**, **48**, **49**; *Drawing of Linear
 Flow I, II, and III*, **187**, **188**, **189**;
 Drawing: Oval Volumes, **134**;
 *Graphic Development of Volumes—
 Mass and Space*, **138**; *Mass Forms*,
 136; *Studies*, **198**, 199; *Waft of Lines*,
 188, **189**
Pen Exercise Number X, by Henry
 Moore, 51
Pen Exercise Number XV, by Henry
 Moore, 15
Perception: of figure-ground relation-
 ship, 57–67; heightened, 226–31
Perceptual stress, 61–63
Persimmons, by Mu-Ch'i, 68–69, **69**
Perspective, 64–66
PERUGINO, PIETRO, 65
Philip's Pavilion, Brussels International
 Exhibition, by Le Corbusier, 176,
 177
Photography, 2–3
PICASSO, PABLO, 2, 272, 283; *Bull*, **23**,
 23–24, 185, 243; *Head of a Woman*,
 264; *Head of a Young Man*, 262,
 263; *Portrait of Jacqueline*, **263**;
 Standing Female Nude, 272, **273**;
 Toad, 223–25, **224**; *Woman in Tears*,
 264–66, **265**; *Woman's Head*, 191,
 192, 193
Pigment, defined, 284
Pines, by Hagesawa Tohaku, **66**
PIPER, JOHN, 5; *Bullslaughter Bay*, **171**;
 Raphael: Massacre of the Innocents,
 216; *Slopes of Tryfan*, 171, **172**, 173
PIRANESI, GIOVANNI BATTISTA, *A
 Vaulted Building with . . . Barred
 Windows*, 258, **259**
Plan Drawing, Murex Shell, by Samuel
 Colman, 272, **273**
Planes, 191–93, 199–201
Plasticity, defined, 284
Plum Blossoms, by Tao-chi, **7**, 7–8
Point: as basic mark, 13, 14, 35; dy-
 namic use, 196–97; and space
 composition, 61, 85–91, 92–95
Pointillism, 35; defined, 284
POLLOCK, JACKSON: *Number 10*, **25**;
 Number 32, 25, **26**, 27, 29
POLYCLEITUS, 254, 257
Portrait of a Scholar, by Paul Klee, **75**
Portrait of Jacqueline, by Pablo Picasso,
 263
Positive space, 97–99
Prelogical, defined, 284
Presbyterian Church, Stamford, Con-
 necticut, by Wallace Harrison,
 114–17, **116**
Puget Sound, 166–67, **167**, 168

Q

Queen Anne's Lace, by Robert Nix, **148**

R

Raphael: Massacre of the Innocents, by
 John Piper, **216**
Rational responses, 76

READ, HERBERT, 222
Reclining Figure, External Form, by
 Henry Moore, **97**, 97–98, 99, 100
Reclining Figures, by Henry Moore,
 132, **133**
REMBRANDT VAN RIJN, 143, 234; *Winter
 Landscape*, 60, **61**, 64
Representational art, 29
RILEY, BRIDGET, *Current*, **207**, 207–8
RIMSKY-KORSAKOV, NIKOLAI, 43
Rite of Passage, by Theodore Roszak,
 110, **111**, 117
Rock Landscape, by Paul Edmonston,
 202, **203**
Rocks, Arch and Tunnel, by Henry
 Moore, 255–57, **256**
Rock Surface, by Paul Zelanski, **230**,
 230–31
RODIN, AUGUSTE, 210, 216; *Birth of the
 Greek Vase*, 231, **232**; *The Peach*, **55**,
 130–31
ROESSLER, ARTHUR, 8
Romantic, defined, 284
Rorschach test, 231
ROSZAK, THEODORE, *Rite of Passage*,
 110, **111**, 117
Rubbings, 159–60
RUBENS, PETER PAUL, 22, 143, 173; *Bat-
 tle of the Amazons*, **175**
Rumination 9, by Mary La Porte, 231,
 233
Russian Easter Overture (Rimsky-
 Korsakov), 43

S

Saint Matthew, by Michelangelo, 158,
 159
SANGALLO, GUILIANO DA, Palazzo
 Farnese, 94, **95**
Sardanapalus, studies for, by Eugène
 Delacroix, 54
Satanic Head, by Victor Hugo, **236**
SAUSMAREZ, MAURICE DE, 56
Saw Briar Tendrils, by Robert Nix, 118,
 119
SCHÖNBERG, ARNOLD, 276
Sculpture: ground, 74; and space com-
 position, 81
*Searching for the Skull's Internal Struc-
 ture*, by Henry Moore, 255, **256**,
 257
Seated Harlequin, by Juan Gris, **28**,
 28–29
Seated Nude, by Henri Matisse, **54**
SEDGEWICK, JOHN, 270
SELIGMANN, KURT, *Ultrameuble*, 231,
 233
Sensibility, defined, 284
Serigrafia, by Livio Orazio Valentini,
 260, 260–61
Shaman, defined, 284
Shapes: association of, 231, 240–43;
 categories, 107–9; composite,
 142–48; compositional principles,
 168; and drawing, 8; mass, 127–34,
 134–39; skeletal, 109–17, 118–26;
 and sound, 277–80; and space en-
 ergy, 179–81, 191

Sheet of Studies—Heads, by Graham
 Sutherland, **269**
SHIMMIN, LINDA LEE, *Mountain Forms*,
 147, 147–48
Simplified anatomical system, 211, **212**,
 213, **214**
Skeletal form, 109–18, 118–25; compo-
 sitional principle, 168; dynamic
 implication, 197–99
Skeletal Form of Dry Moss, by Robert
 Nix, 125, **126**
SLOANE, RAPHAEL, *Wild Growth*, **164**
Slopes of Tryfan, by John Piper, 171,
 172, 173
Solid volume, 127–31
South American Indian painting, 145
Space: composition, 74–85, 85–97; and
 figure-ground perception, 57–67,
 68–73; graphic treatments, 182–83;
 positive and negative, 97–101,
 101–4; shaping, 179–81; and tex-
 ture, 154, 155–56, 161–62
Spatial volume, 131–33
Spathephyllium Leaf Unfolding, by Robert
 Nix, 246, **247**
SPETH, CONSTANCE, *Balsam Root*, 164,
 165
Spiral Motif: The Wave, by Victor
 Pasmore, **252**
Spiritual Flight, by David Herschler,
 114, **115**
Stain: and basic marks, 14, 15–16, 17,
 34, 36, 49, 50; and energy, 182–83,
 193–94
Stairway in Berlin, **178**
Standing Female Nude, by Pablo Picasso,
 272, **273**
Starlit Night, by Vincent van Gogh,
 195, **196**
Star of Bethlehem and Other Flowers, by
 Leonardo da Vinci, **143**
Sternkirche Project, drawing for, by
 Otto Bartning, **113**
Still Life—Odyssey, by Ben Nicholson,
 180–81, **181**
Still Life with Bottle and Flowers, by
 Victor Pasmore, 79–81, **80**
Stippling, defined, 284
Storm of Water and Rocks, A, by
 Leonardo da Vinci, 185, **186**
Stress, by Norman McClaren, **141**
String drawings, 238–39
Structure: characteristics, 105; defined,
 284; mass-volume, 127–33, 134–39;
 organic, 142–48, 148–52; skeletal,
 109–17, 118–25; and space percep-
 tion, 56–104 (*see also* Space)
Structure 14C, by Stephen Gilbert, 175,
 176
STUBBS, GEORGE, *Anatomical Exposition
 of a Tiger*, 144–17, **116**
Studies, by Betty Peebles, **198**, 199
Studies, by Villard d'Honnecourt, **48**
Study for Dynamic Force of a Cyclist II,
 by Umberto Boccioni, **190**, 190–91
Subject, recognition of, 226–33, 234–43
Surfaces, 191–93
Surrealism, 159, 231; defined, 284
SU-SING CHOW, JOHNSON: *Composition
 of Hanging Bamboo*, 81, **82**; *Leaves in
 the Snow*, 82, **83**

SUTHERLAND, GRAHAM, 228–29, 244–45, 260; *Egg, The,* 246–47, **247**, 251; *Sheet of Studies—Heads,* **269**; *Thorn Cross,* **245**; *Thorn Trees,* 228–30, **229**, 244
Symbol, and imagination, 253, 254, 258–61, 261–62, 265–66
Sympathetic magic, defined, 284–85

T

Table Study Lamp, by John Hildred, **146**, 146–47
Tactile qualities, 154, 162
TANABE, TAKAO, *Untitled,* **27**, 28, 29
TAO-CHI, *Plum Blossoms,* 7, 7–8
Tate Gallery, London, 3, 78
TCHAKMAKIAN, PASCAL, *Brush Drawing,* **51**
TENNYSON, ALFRED, LORD, 153
Textural weave, 153–61, 161–64, 165
Textures—Bark, Fungus, Grass, and Toad, by Robert Nix, 154–55, **155**, 156
Thinness, 117
Thistles, 153, **154**
THOMPSON, WILLIAM, *Figure Drawing,* 62–63, **63**
Thorn Cross, by Graham Sutherland, **245**
Thorn Trees, by Graham Sutherland, 228–30, **229**, 244, 260
Three dimensionality, linear formations suggesting, 129–30
Tiger, by Eugène Delacroix, 22–23, **23**, 24
Toad, by Pablo Picasso. 223–25, **224**
TOHAKU, HAGESAWA, *Pines,* **66**
Tone: defined, 285; Mondrian's use of, 101) and three dimensionality, 129, 130–31, 132–33
Tools and supplies, 30
Torso, by Harry Kramer, **110**
Transfiguration, defined, 285
Transformation: drawing as means of, 3; and expression, 257–58; of heads, 268–69; and imagination, 261–67; of natural scenes, 222, 224–25, 245; and order, 255–57; and symbol, 258–61
Tree Broken by Storm Decides to Live, by Ernest Mundt, **152**

Tree Form, by Andreas Feininger, 132, **133**
Tree I, by Piet Mondrian, **99**, 99–100, 101
Trees, by Parker R. Waite, **73**
Trees and Water on the Stour, by John Constable, 16–17, **17**, 194
Triptych, by Paul Edmonston, **206**
Triumphant General Crowned by a Flying Figure, 25–27, **26**, 28, 29
Turbulence, 171, 173
TURNER, J. M. W., *Norham Castle,* 78, **79**
Two-Piece Reclining Figure Number 2, by Henry Moore, 128, **129**
Two Standing Figures, by Henry Moore, 24, **25**

U

Ultrameuble, by Kurt Seligmann, 231, **233**

V

VALENTINI, LIVIO ORAZIO, *Serigrafia,* **260**, 260–61
Valley with a Bright Cloud, by Samuel Palmer, 171, **172**, 173
VAN DER LECK, BART, *Geometric Composition,* 82, **83**
VAN EYCK, JAN, 143
VAN GOGH, VINCENT, 271; *Boats at Saintes-Maries,* **19**, 19–20; *Garden in Provence,* **93**, 155, 157; *Starlit Night,* 195, **196**
Vases Doriques, Les, by Amédée Ozenfant, 231, **232**
Vaulted Building with . . . Barred Windows, by Giovanni Battista Piranesi, 258, **259**
View from Monte Marie, by Claude Lorrain, **205**
View of "Bibemus" Quarry, by Paul Cézanne, **272**
Viola Odorato: Spikelet of Grammacea, by Leonardo da Vinci, 149, **150**
Virgin of the Rocks, The, by Leonardo da Vinci, 106
Vision: defined, 221, 285; immediate, 226–33, 234–43

Volume: solid, 127–31; spatial, 131–33; and swell, 168, 170, 173; shaping of, 134–39

W

Waft of Lines, A, by Betty Peebles, 188, **189**
WAGNER, RICHARD, 278
WAITE, PARKER R., *Trees,* **73**
WARD, CLARENCE, **67**
Warty Gourd, by John Albaugh, **151**
Wash, defined, 285
Water Suite Number 4, by Robert Kiley, **190**
WATTEAU, ANTOINE, 143
Wave, The, by Victor Pasmore, **252**
Weathered Wood, by John Albaugh, **139**
Wild Garlic Stem, by Robert Nix, 101, **102**
Wild Growth, by Raphael Sloane, **164**
Window: Garden in Spring, The, by Victor Pasmore, 182, **183**
Winter Landscape, by Rembrandt, 60, **61**, 64
Wintry Mountains, by Kung Hsein, 60 fn, **61**
Woman in Tears, by Pablo Picasso, 264–66, **265**
Woman's Head, by Pablo Picasso, 191, **192**, 193
Wooded Landscape, by Claude Lorrain, **16**
Wood Fetish: Found Object Interpreted, by Paul Nash, 3, **4**
WORDSWORTH, WILLIAM, 230
Workbook, as personal record, 29–30
Worm-Eaten Wood Form, by John Albaugh, 248, **249**
Wrapped Neon One, by George Wray, **157**
WRAY, GEORGE: *Neon Elvis,* **279**, 279–80; *Wrapped Neon One,* **157**

Z

ZELANKI, PAUL, *Rock Surface,* **230**, 230–31
ZIMMERMANN, DOMINIKUS, Church of Die Wies, West Germany, **84**, 85
ZOLA, EMILE, 221